For Ilona,

Gilles

March 2007

The FINAL SACK of NINEVEH

THE DISCOVERY, DOCUMENTATION, AND DESTRUCTION
OF KING SENNACHERIB'S THRONE ROOM AT NINEVEH, IRAQ

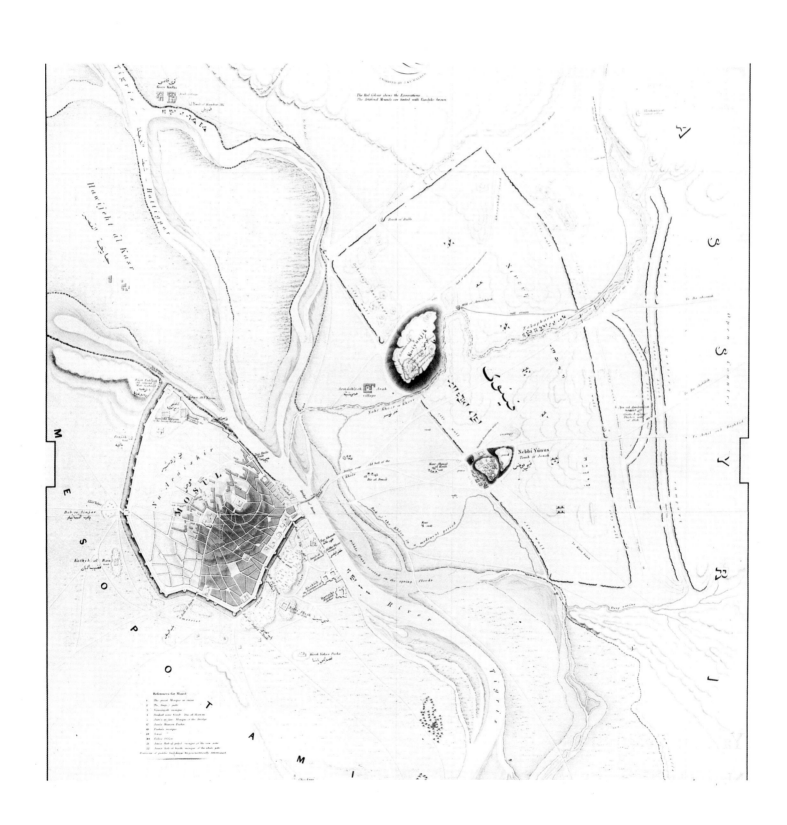

The FINAL SACK of NINEVEH

THE DISCOVERY, DOCUMENTATION, AND
DESTRUCTION OF KING SENNACHERIB'S
THRONE ROOM AT NINEVEH, IRAQ

John Malcolm Russell

Yale University Press

New Haven and London

To my father, Robert R. Russell,
with love

Set in Ehrhardt by Best-set Typesetter Ltd, Hong Kong
Printed in Hong Kong

Library of Congress Cataloging-in-Publication Data

Russell, John Malcolm.
 The final sack of Nineveh: the discovery, documentation, and destruction of Sennacherib's throne room at Nineveh, Iraq / John Malcolm Russell.
 p. cm.
 Includes bibliographical references (p.) and index.
 ISBN 0-300-07418-2 (cloth)
 1. Palace of Sennacherib (Nineveh) 2. Sculpture, Assyro-Babylonian–Iraq–Nineveh (Extinct city) I. Title.
DS70.5.N47R86 1998 98-15067
935–dc21 CIP

fig. 1 (frontispiece): Nineveh, plan by Felix Jones, 1852 (photo: Trustees of the British Museum).

CONTENTS

FOREWORD

When Dr. Muayad Said Damerji, the Director-General of the Iraq Department of Antiquities and Heritage, invited me to bring an archaeological team from the University of California, Berkeley to Nineveh to begin a new series of excavations at the site in 1987, the goal I had in mind was not only to investigate previously untouched areas, but also to expand previous excavations and to document visible archaeological remains on the site. John Russell expressed an interest in joining the expedition in 1989 in order to work in the area of Sennacherib's palace, the site of the first excavations at Nineveh in the 1840s. Apart from the prospect of being joined in the ongoing excavations by a valued friend, this proposed collaboration seemed to offer a notable opportunity to test Russell's new theories about the extent of the palace, while also making it possible to begin to complete and correct the plan of the palace as it was known from earlier excavations. The anchoring point for Russell's work was the throne-room suite, which had been re-excavated by Dr. Tariq Madhloom in the 1960s and which was still the only part of the palace visible above ground at the time that we arrived at Nineveh.

A considerable number of wall sculptures, most of them unpublished, were on display in this part of the palace, and we determined that these were of such importance that they should be documented and published without further delay, i.e. in advance of a final report on the 1987–90 excavations that is also currently under preparation. Russell's original plan had been to document each sculpture in the throne-room suite with photographs and drawings made on the spot, a process that was begun during the 1990 excavation season and which would have required at least one more season to complete. These plans were forestalled by the Gulf Crisis of late 1990. Unable to return to Nineveh, Russell completed the necessary documentation by calling on source material that he had otherwise compiled during 1989 and 1990. In the meantime, John Russell's discovery that sculptures from Sennacherib's palace were being looted illegally and sold with impunity on the international antiquities market suddenly lent a still greater measure of urgency to the publication of the original slabs. This book will make it possible to document the origin of any fragment removed from the palace after 1990, so that both dealers and collectors can readily recognize looted pieces that surface on the market.

Finally I wish to extend my own warm thanks, together with those of the author, to Dr. Muayad Said Damerji for making it possible for us to work at Nineveh, and also to Prudence Harper of the Metropolitan Museum of Art for working with John Russell to bring this project to a swift and successful conclusion. The result is both a lavish presentation of Sennacherib's sculptures and an examination of the toll that archaeology may exact from heritage.

David Stronach
Director, U. C. Berkeley's Excavations at Nineveh

ACKNOWLEDGMENTS

This large project could never have been completed without the support and assistance of many people, to all of whom I am very grateful. David Stronach included me in his group working at Nineveh, thereby making this study possible. Dr. Muayad Said Damerji, Director General of the Department of Antiquities and Heritage of the Republic of Iraq, invited us to excavate at Nineveh and ensured that our stay in Iraq was pleasant and productive. Mr. Manhal Jabur, Antiquities Superintendent for the Northern Region, generously extended assistance and hospitality while we worked at Nineveh, and Mr. Donny George Youkana, Antiquities Documentation Officer, provided expertise and equipment for the initial stage of the documentation project.

Dr. Tariq Madhloom, Director of the Iraqi excavations in Sennacherib's palace from 1965–7, and our foreman Mr. Khalef Bedawi, a participant in those excavations, both freely shared information about their work there. Diana Pickworth, the Nineveh Excavation Photographer, assisted in the preliminary stage of the project and is responsible for several photographs in this book. Gregory Schmitz, Photographer for the Department of Art History and Archaeology at Columbia University, provided essential advice and expertise at every stage. My fieldwork at Nineveh was supported by the Mesopotamian Fellowship of the Baghdad School of the American Schools for Oriental Research and by grants from Linda Noe Laine and Columbia University.

In preparing the publication, I am grateful to Prudence Harper, Curator of the Department of Ancient Near Eastern Art at the Metropolitan Museum of Art, who secured funding for the drawings, read the full manuscript, and generally urged me on. Her response to the emergency facing antiquities in Iraq is an example for us all. The new drawings of Sennacherib reliefs were prepared by Jennifer Hook in collaboration with Denise Hoffman, both of whom exhibited extraordinary talent, skill, and patience. A generous grant from Raymond and Beverly Sackler covered the considerable expenses of making the drawings. Time and research facilities for preparing the drawings were provided by an Andrew W. Mellon senior fellowship from the Metropolitan Museum of Art. John Nicoll, Sally Salvesen, and the staff of Yale University Press recognized the importance of this publication and carried it out with their customary elegance and efficiency.

Many others provided assistance along the way. John Curtis, Julian Reade, Dominique Collon, and Christopher Walker of the British Museum helped me with the A. H. Layard and L. W. King archives. Clyde Curry Smith, Mary Magnan D'Andrea, and Thomas G. Klein shared their documentation of the work of L. W. King and R. C. Thompson at Nineveh. McGuire Gibson, Director of the Oriental Institute's excavations at Nippur, Iraq, arranged the Christmas holiday trip that was my first visit to Nineveh, while I was excavating at Nippur in 1981, and also identified the Ur III statue base that I photographed in storage at Nineveh in 1989. Barbara A. Porter, a doctoral candidate in Ancient Near Eastern Art at Columbia University, identified the Egyptian statue base. Elizabeth A. Hendrix, a conservator at the Metropolitan Museum, read portions of the manuscript, assisted with conservation questions, and cleaned the photographs for publication.

Finally, I extend my deepest thanks and gratitude to the people of Iraq, whose renowned hospitality left me with countless happy memories of my visits to their country. They have had a very tough time recently and deserve better.

J. M. R.

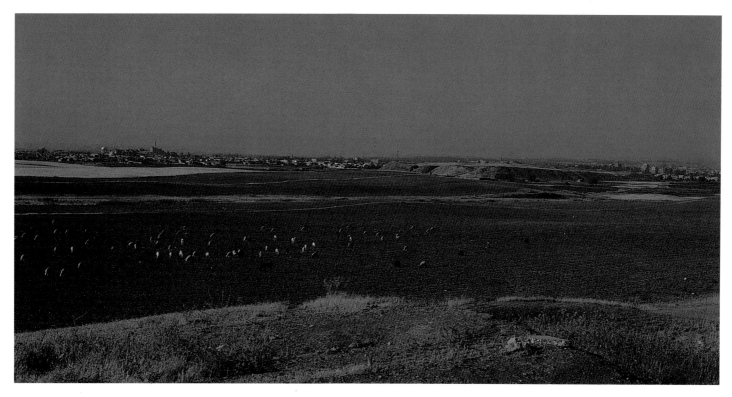

fig. 2: Nineveh, viewed from the northeast corner of the city wall, with the mounds of Nebi Yunus at left and Kuyunjik at right, and modern Mosul in the background, 1989 (photo: author).

fig. 3: Nineveh, mound of Kuyunjik, viewed from the northwest corner of the city wall, 1989 (photo: author).

INTRODUCTION

Immediately following the death of his father, Sargon II, on the battlefield, the Assyrian King Sennacherib (704–681 BC) moved the administrative capital of the Assyrian empire from his father's newly founded city of Dur Sharrukin (Khorsabad) to Nineveh, one of the oldest and most important cities of ancient Assyria (figs. 1, 2, 3). Once on the Tigris, Nineveh is now about a kilometer east of the river, directly opposite modern Mosul in northern Iraq. Surrounded by rich, well watered farm land, it is the site of the most popular ancient Tigris ford and consequently controlled major trade routes in all directions. Sennacherib made Nineveh the largest city in the known world, building a new city wall with as many as eighteen gates, a huge new palace, an arsenal, temples, roads, bridges, and canals.

Sennacherib's new palace, the largest in Assyria, was built in the oldest part of the city, along the southwest side of the citadel mound of Kuyunjik, overlooking the former junction of the Tigris and Khosr rivers (fig. 4). According to Sennacherib's texts, his new "Palace Without Rival" was on the site of an old one in the area between the Ishtar temple and ziggurrat and the Khosr and Tigris rivers. He says he demolished the old building and enlarged its site by constructing a new terrace 914 by 440 cubits (about 500 by 240 meters) in extent.

In the manner of his predecessors, the rooms in or around major reception suites were decorated with wall reliefs and gateway colossi. In Sennacherib's palace this amounted to some seventy rooms, covering an area about 200 meters square at the southwest end of the building, from which a total of some 9880 feet (3011 meters) of wall reliefs was recovered during excavations (fig. 5). Sennacherib's throne-room was decorated with the traditional human-headed bull colossi, inscribed with texts in the spaces between their legs. Bull colossi also occurred in a number of other major doorways. The vast majority of the wall reliefs showed military campaigns, depicted in a lively manner that employed relatively convincing perspective effects. Other subjects included the procurement of building materials and royal processions. Occasionally the relief images were accompanied by brief captions, inscribed next to the king or the cities he encounters. With the fall of Nineveh in 612 BC, the palace was thoroughly burned and many of the reliefs were cracked and scarred by the heat. The upper walls collapsed into the rooms, burying what remained under meters of earth. Nineveh and the Assyrians vanished, except in memory.

Some two and a half millennia after the fall of Nineveh, I was discussing with two colleagues in architecture the idea of creating a computerized virtual reconstruction of that ancient city. They were enthusiastic about the possibilities, but wary that the city did not have sufficient name recognition. It turned out that neither of them could remember ever hearing about Nineveh before they met me, and they were concerned that even the well educated audience for sophisticated virtual reconstructions of historical sites would not recognize the name either. I was astonished that the name of a city that was once the center of the world should provoke no response today, but then I couldn't remember when I had first heard the name either.

Not so long ago, in the days when everyone knew their Bible, the name "Nineveh" would have evoked powerfully concrete associations. According to Genesis (10:8–12), Nineveh, "the great city," was among the first cities to be built after the flood by Noah's descendants,

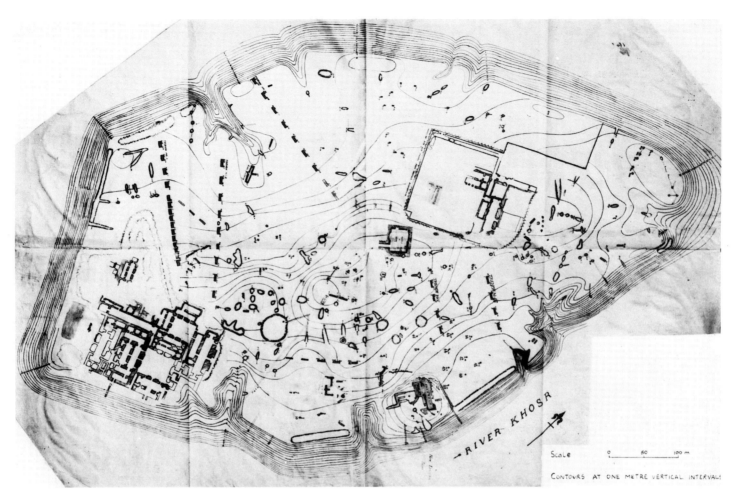

RIVER KHOSR

Scale 0 50 100 m

CONTOURS AT ONE METRE VERTICAL INTERVALS

fig. 4: Nineveh, mound of Kuyunjik, plan by R. C. Thompson,
1904 (photo: Trustees of the British Museum).

fig. 5: Nineveh, Sennacherib's palace, A. H. Layard's final plan,
1853 (after Layard 1853a, facing p. 67).

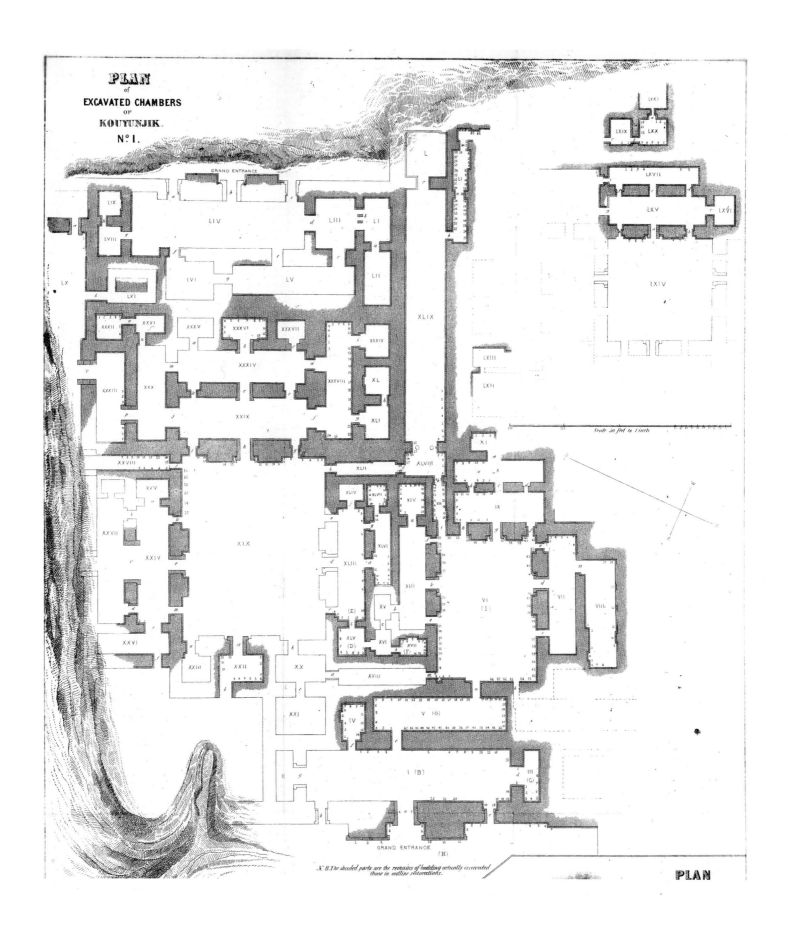

PLAN
of
EXCAVATED CHAMBERS
OF
KOUYUNJIK.
N° I.

GRAND ENTRANCE

Scale 50 feet to 1 inch

GRAND ENTRANCE

N.B. The shaded parts are the remains of building actually excavated those in outline restorations.

PLAN

founded either by Nimrod, "the mighty hunter," or by Asshur. Nineveh was the destination of the reluctant prophet Jonah (3:3, 4:11), who became the instrument of God's forgiveness when his prophecy of destruction brought about the repentance of that "exceeding great city of three days' journey . . . wherein are more than sixscore thousand persons that cannot discern between their right hand and their left, and also much cattle." Nineveh, "the bloody city," was also the target of Nahum's graphic prophecy of destruction, a city so hated by the Israelites that after its fall Nahum (3:1–7) wondered "who will bemoan her? whence shall I seek comforters for thee?"

Nineveh was the capital of the Assyrian empire, characterized by Isaiah (10:5) as the rod of God's anger. For readers of the Bible, the most famous king of this awful empire was Sennacherib, who laid waste many of the cities of the southern Israelite kingdom of Judah, and appeared to be on the brink of capturing its capital city, Jerusalem, when the angel of the Lord intervened one night "and smote in the camp of the Assyrians an hundred fourscore and five thousand, and when they arose early in the morning, behold, they were all dead corpses." Sennacherib abandoned the siege and returned to Nineveh, where he was assassinated by his sons "as he was worshipping in the house of Nisroch his god" (II Kings 19:35–7). In the nineteenth century, popular familiarity with this story was reinforced by Byron's memorable "The Assyrian came down like the wolf on the fold / And his cohorts were gleaming in purple and gold . . ." which used to be recited by school children.

Though these biblical stories bore little or no relationship to the historical Nineveh, they gave the name "Nineveh" a recognition factor that ensured popular interest in the archaeological rediscovery of Nineveh and Assyria in the nineteenth century. Thus the first bestseller in archaeological literature was A. H. Layard's *Nineveh and Its Remains* (1849), and thereafter, every book about ancient Assyria, even those dealing with other sites, was sure to include "Nineveh" in its title. This story of the nineteenth-century rediscovery of ancient Assyria, one of the greatest tales of archaeological adventure, has been told elsewhere (Larsen 1996, Russell 1997a). For our present purposes, it is sufficient to note that the rediscovery of the physical remains of the ancient Assyrian cities marked a major turning point not only for the European perception of Assyria, but also for the ruins themselves.

1 HISTORIOGRAPHY

The ancient stone buildings of Egypt, Greece, and Rome have been exposed to forces of erosion, both natural and human, ever since their construction. Their entire existence has been a gradual process of deterioration. Those that have survived to the present have been able to do so through a combination of factors that may include great mass, durable material, careful construction, remote location, and later maintenance or conservation. Assyrian buildings, by contrast, were built primarily of mud brick, a highly perishable material when exposed to the elements, but very durable when buried underground. The lower part of the walls in some rooms in Assyrian palaces and temples were lined with stone slabs decorated with relief sculptures. When these buildings collapsed or were destroyed, the material from the upper walls filled in the lower parts of the rooms, burying and protecting the lower walls and sculptures beneath a mass of earth. From that moment on, the deterioration of the structure was arrested, and its remains were preserved in virtually the same condition as when they were buried.

In cases where the building was not destroyed by fire, but simply collapsed or was pushed down, as with the palace of King Assurnasirpal II at Nimrud, the buried sculptures could be preserved in nearly new condition. When the building was destroyed by fire, however, as was the case with Sennacherib's palace at Nineveh, the burning roof first fell into the rooms, creating heat so intense that the wall slabs were often badly cracked and scarred. In such cases the buried remains could be very fragile indeed. In either case, whether sound or fragile, when the sculptured wall slabs were buried, their clock essentially stopped.

With their excavation in the nineteenth century, the clock started again. The process of excavation, no matter how carefully undertaken, sets in motion the processes of deterioration. Sculptures were removed from their stable millennia-old environment, and thrust into a new environment where they were subject, among other perils, to airborne pollution, flowing water, the excrement of creatures great and small, freezing and thawing, being rubbed against by passing people and livestock, vandalism, spoliation, and looting.

There are a variety of ways to reduce or eliminate the danger from some of these perils, but the only way to halt all of the processes of deterioration is to reestablish a stable equilibrium between the sculptures and their environment. There are two ways to accomplish this. The first is to remove the sculptures from the site, either directly to a controlled sealed environment designed especially to balance the chemical activity within the stone itself, or to neutralize the destructive processes within the stone and then keep it in a controlled environment. This is probably the best way to avoid any further damage, but it is expensive, both initially and over the long term, and difficult to accomplish when hundreds of sculptures are involved.

The second-best way is to cover the sculptured surfaces with clean, salt-free sand or earth, and rebury them. This eliminates most external threats and over time the stone will again establish an equilibrium with its environment. One disadvantage of this method is that during the period while the stone and earth are getting used to one another, chemical processes of deterioration may continue within the stone. Another disadvantage is that burying the sculptures makes the slabs themselves unavailable for further viewing or study – they may

only be seen in publication. The overwhelming advantages of this method are that it has a very low initial cost, no long-term cost, and the stone is protected from everything except intrusions from roots, burrowing creatures, and water table fluctuations.

As we will see, the excavators of Sennacherib's throne room suite resorted to these and other expedients to preserve the sculptures once they had been excavated. Nevertheless, each time they were exposed to the air, something was lost, and the longer this exposure continued without adequate protection, the more extensive was the damage. It would seem therefore to be imperative to record the sculptures fully at the moment of their first excavation, before any information was lost to deterioration. This was not done, either at the time of their first excavation in 1847 by the British adventurer A. H. Layard, or when they were excavated a second time in 1903 by the British philologist L. W. King. There were a variety of reasons for this, including limitations of time, materials, and funds, but foremost among them was that neither Layard nor King was interested in the sculptures as an ensemble.

Layard employed his limited time primarily in two ways. The first was in drawing interesting slabs that were well enough preserved to make good book illustrations, preserving isolated episodes selected from the original continuous visual narratives of Assyrian history. The other was in selecting, extracting, packing, and shipping well preserved sculptures to the British Museum, in the case of Sennacherib's throne-room suite, only one small fragment (pl. 59). In either case, Layard's method was highly selective, favoring visual interest and museum-quality condition over comprehensiveness. The same was true for the publication of Layard's finds, which, without government support, was limited to a selection of his drawings and a brief narrative description.

In this aspect at least, his work compares very unfavorably to that of his immediate predecessors and models in Assyrian archaeology, Paul Botta and Eugène Flandin, who excavated part of Sargon's palace at Khorsabad between 1842 and 1844. During these excavations, the artist Flandin made at least a sketch of every sculptured slab that was uncovered, and many slabs were also recorded in detailed drawings (see fig. 31). Layard might have done the same if the British Museum had provided an artist to assist him, though the brief period of just over a month that he spent excavating and recording Sennacherib's throne-room suite before leaving for England probably would not have been sufficient time for a Flandin-style documentation. However that may be, it is sobering to note that *no* subsequent excavation of an Assyrian palace has even come close to providing the thorough documentation that Botta and Flandin published for Khorsabad, the very first Assyrian excavation.

After he had finished with them, Layard apparently reburied most of the sculptures of the throne room suite, and they evidently remained buried until they were reexcavated by L. W. King in 1903. King was not really interested in the sculptures at all. His instructions from the British Museum were to secure as many clay tablets as he could, at the lowest possible cost. He excavated the throne-room suite because Layard had found a few tablets in his trenches there and King hoped that more might be found by completely clearing these rooms. He did make photographs of selected reliefs, but again only a fraction of those he uncovered. He also consulted a stone mason about the feasibility of moving some of the slabs, but was told that they were too badly damaged, so he reported that he reburied them all. King did not publish any account of his work at Nineveh.

The Iraqi archaeologist Tariq Madhloom reexcavated the sculptures in 1965, but again his interest seems not to have been to publish all of the sculptures, but rather to use them as a barrier to modern development of the palace mound of Kuyunjik. Rather than have a publication represent the sculptures, he had the sculptures represent themselves. Restored and reerected in a semi-enclosed structure, the sculptures were called upon to protect the site by serving as a conspicuous reminder of the antiquity and importance of Nineveh. The sculptures did in fact protect the mound of Kuyunjik from development, but would they be able to protect themselves?

I first visited Iraq as a graduate student in 1981, as member of the Oriental Institute's excavation at Nippur. The excavation director, McGuire Gibson, generously arranged a field trip

to northern Iraq, and this was the first time I set foot in Sennacherib's palace. I was aston-
ished at the number of sculptures that were on display, many of them relatively well pre-
served. I photographed as much as I could, but our time was short and the December light
poor. We concluded our visit by enjoying tea and hospitality in the house of the museum
guard, perched on an unexcavated rise just behind the throne room area. After returning
home to the United States, I changed my dissertation topic from the palace of Assurbanipal
to the palace of Sennacherib.

In 1989 I returned to Nineveh, this time for a more extended stay. In the meantime, the
guard had died and, because of budget limitations due to the war with Iran, had not been
replaced. Since my first visit, I had completed my dissertation on Sennacherib's palace, and
now had returned as a member of the University of California Berkeley team, to supervise
excavations at the eastern end of the palace. By that time, I knew how unique the sculptures
housed in the site museum were. As the most completely preserved relief cycles known in the
palace, they provided valuable information on visual narrative composition in Assyrian palace
decoration. Comparison of Layard's drawings and King's photographs with the surviving
remains, made it clear that some of the sculptures did not survive the repeated exposures,
while others had deteriorated considerably since Layard's day. It therefore seemed important
to document them fully without further delay, both because of their historical importance,
and so that there would be a permanent record in the event the originals suffered further loss
or deterioration. If necessary, such a record could also serve as a guide for future conserva-
tion efforts.

I was not prepared at that time to undertake a comprehensive photographic documenta-
tion of every relief, but with the assistance of Donny George Youkana of the Iraq Department
of Antiquities and Heritage, and Diana Pickworth, the excavation photographer, we were able
to take overall views of most of the slabs in both black and white and color, using Mr.
Youkana's flash equipment for illumination. The resulting photographs were generally satis-
factory as record shots of the sculptures, but most of them were not adequate for study or
publication purposes. My inexperience with flash photography was frequently manifested in
uneven illumination or incorrect exposure, and even the correctly exposed pictures were
often difficult to read because of the relatively small size of the figures on these large slabs. I
resolved to try to do better the next year. I also photographed a number of interesting sculp-
tural fragments in on-site storage facilities, and hoped to make a fuller record during a sub-
sequent season.

In 1990 I returned, prepared to record every slab fully in an overall view plus detailed
views of all sculptured areas. In addition to serving as a record in their own right, these
detailed photographs would be used as the basis for preliminary drawings of selected slabs.
The photographic and drawing procedures are described more fully below. My plan was to
check the new drawings against the original sculptures when we returned to Nineveh in 1991,
but the Gulf Crisis intervened, and we were not able to return. The artists and I did, how-
ever, complete the drawings, working exclusively from the photographs, with the intention of
including the full documentation of the throne room suite in the forthcoming Nineveh exca-
vation report. Unfortunately, it recently became clear that the publication of the sculptures
could not wait until the remainder of the excavation report was ready. For Sennacherib's
throne room reliefs, time had run out.

The necessity of documenting the site became devastatingly clear in late summer 1995,
when I was shown a photograph of a fragment of an Assyrian relief for sale on the interna-
tional antiquities market (pl. 276). There is no doubt that this fragment came from a slab that
had been intact in the Nineveh site museum in 1990, but which had since been broken up by
looters (figs. 6–7). Soon thereafter, I was shown photographs of two more fragments that had
been in storage at Nineveh in 1989, but which were also on the art market (fig. 8, pl. 209). It
proved impossible to determine who was offering these three fragments for sale, or where
they were being kept, so I published a note in *IFARreports* (May 1996) to alert prospective
buyers that these sculptures would be poor investments. Since they are documented as

fig. 6: Nineveh, Sennacherib Palace Site Museum, Room V, Slab 43, condition before looting, 1989 (photo: author).

belonging to a museum in Iraq and have no export permits, Iraq would have clear legal grounds to reclaim them from any purchaser. Furthermore, possession of these fragments was a violation of the United Nation sanctions against Iraq, which meant that they could be confiscated by customs authorities.

I was concerned that more looted Assyrian sculptures would appear on the market, but saw no further examples for more than a year. In November 1996, I was contacted by a lawyer acting on behalf of a prospective purchaser who had photographs of ten more Assyrian sculptures that were said to be on the market. The lawyer wanted to know if the sculptures were being sold legitimately. They were not. One was a fragment of a lion hunt relief of Assurnasirpal II from the vicinity of the Nabu temple at Nineveh, which was being stored at Nineveh in 1989 (fig. 9). The other nine were further fragments of wall relief from the Sennacherib Palace Site Museum (figs. 10–13, pls. 248-75). Each fragment came from a

fig. 7: Nineveh, Sennacherib Palace Site Museum, Room V, Slab 43, condition after looting, 1997 (photo: courtesy of Muayad Damerji).

different slab, and most of them had been broken from the middle of a slab. Recent photographs of the site show that the looters destroyed whole slabs to extract the best-preserved bits. A few months later, the lower part of a corner slab appeared on the market, broken in half, leaving only a hole in the ground where it had been (figs. 14, 15).

Why was this happening? Iraq has a rich and varied heritage, and this heritage has been coveted by the Western world since the nineteenth-century heyday of imperial acquisition. Then, "like the wolf on the fold," representatives of European governments descended on

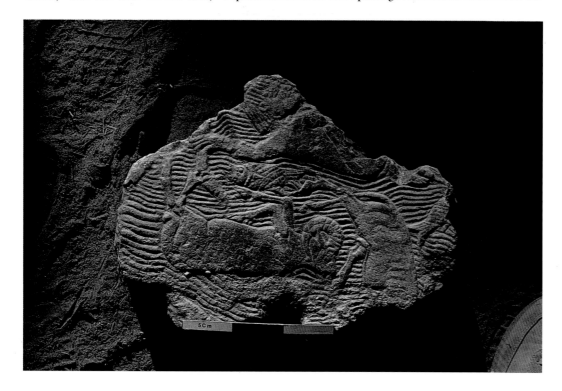

fig. 8: Formerly Nineveh, Sennacherib Palace Site Museum, possibly from the West Façade, fragment showing two dead sheep and a dead man floating in water, 1989 (photo: author).

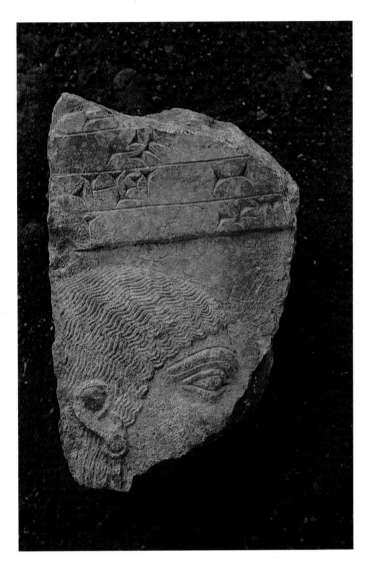

the palaces of Mesopotamia and sacked them to fill the halls of the British Museum, the Louvre, and the Königlichen Museen in Berlin. Numerous sculptured slabs found their way into smaller collections in England and America as well.

The most spectacular of these was a group of twenty-six Assyrian sculptures, including two human-headed lion and bull colossi, which were presented by Layard to his cousin, Lady Charlotte Guest, a distinguished scholar of Welsh literature, mother of ten, and wife of the wealthiest industrialist in England. She displayed them at her home, Canford Manor in Dorset, in the Nineveh Porch, a Gothic Revival garden pavilion built especially for them by Charles Barry, the architect of the Houses of Parliament. The bulk of this collection is now in the Metropolitan Museum of Art in New York. Their story is told in my book, *From Nineveh to New York: The Strange Story of the Assyrian Reliefs in the Metropolitan Museum and the Hidden Masterpiece at Canford School* (1997).

Today Assyria is in fashion again, and its sculptures are bringing unprecedented prices. In 1992, while doing research for *From Nineveh to New York*, I discovered an original sculpture still in place in the Nineveh Porch at what is now Canford School. In 1994 this sculpture was sold by the school at auction for £7.7 million ($12 million), by far the highest price ever paid for an antiquity. To protect and promote its irreplaceable patrimony in the face of such powerful market forces, modern Iraq has an excellent antiquities department, and its people have a very high level of pride in their national heritage. In the recent past, very few antiquities left the country, because every Iraqi carefully guarded that inheritance. This attitude is essential for a country that possesses hundreds of major archaeological sites and tens of thousands of smaller ones. Even in the best of times, it would be impossible to guard all these sites without the cooperation of the Iraqi people.

The United Nations sanctions against Iraq in the wake of the occupation of Kuwait caused unprecedented dangers for its archaeological legacy while forbidding any form of international assistance in heritage matters. Because of the sanctions, little money was available for the preservation of the past, at the same time that newly impoverished Iraqis, squeezed between ruinous inflation and critical shortages of basic necessities, were forced to seek new sources of subsistence income. For heritage, the combination of local desperation and international demand is a recipe for disaster. Some Iraqis with nothing left to sell evidently turned to selling off bits of the nation's rich patrimony. The Department of Antiquities and Heritage responded by actively trying to staunch the flow of antiquities out of the country, but it was severely constrained by a limited budget, its inability to import photographic supplies (forbidden by the sanctions) or outside technical and scholarly expertise, and by the absence of international cooperation.

My discovery that the palace museum had been looted was reported in a number of international newspapers and periodicals, and the *Archaeology* magazine web site published all of the looted fragments, together with views of the intact slabs from which they were taken.[1] The value of such publicity was confirmed when a London solicitor wrote to me, stating that his client had purchased a Sennacherib fragment and applied for a British export license, only to be informed that the piece was among the ones published in my first *IFARreports* article. The solicitor assured me that if the sculpture proved to have been stolen, his client would return it to its true owner.

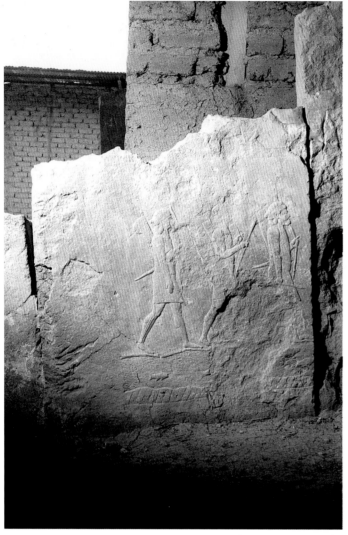

fig. 10: Nineveh, Sennacherib Palace Site Museum, Room V, Slab 1, condition before looting, 1989 (photo: author).

fig. 11: Nineveh, Sennacherib Palace Site Museum, Room V, Slab 1, condition after looting, 1997 (photo: courtesy of Muayad Damerji).

Early in 1997, a small group of concerned scholars, including myself, met at the Metropolitan Museum of Art in New York to discuss what might be done to stop the looting of the Sennacherib Palace Site Museum and the sale of looted sculptures abroad. We agreed that one problem was that looted sculptures could be traded with impunity, as there was no published record of the sculptures *in situ*. The first step, therefore, was to publish fully the relief decorations in the site museum at Nineveh, not only because of their unique art-historical importance, but also because a readily accessible publication would make it possible for museums, collectors, scholars, dealers, and law-enforcement authorities to identify looted sculptures, and thereby remove the incentive for further plundering of the site.

The goal of this publication is to create a broad awareness of what was once at Nineveh and what happened to it, preserving the palace on paper at least, and hopefully preserving the original by making further looting unprofitable. In addition, the publication could serve as an essential record when the site itself is eventually conserved and restored. Finally we hope that by drawing attention to the problem of heritage loss in Iraq under the sanctions, the book might help to persuade the U. S. State Department and the U. N. Security Council to treat threats to cultural heritage as a humanitarian issue. Only with their permission can outside scholars and experts assist with an on-site assessment of damage to the palace, or participate in necessary conservation

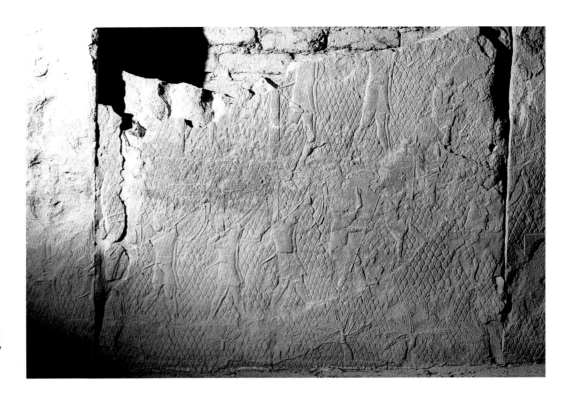

fig. 12: Nineveh, Sennacherib Palace Site Museum, Room V, Slab 16, condition before looting, 1989 (photo: author).

and preservation measures. We agreed that it was urgent to complete this publication immediately, in order to protect what still survives of the palace. Yale University Press recognized the importance and urgency of this project, and agreed to undertake publication at once.

This book is the result of those deliberations. Its core is the photographs, drawings, and plan of Sennacherib's throne room suite. Its short text consists of a brief discussion of the excavation and documentation of the throne room area, and descriptions of the individual pieces as necessary. In addition to highlighting the unique and important aspects of the sculptures, the text documents their progressive deterioration as the result of archaeological intervention, from their relatively good state of preservation when first discovered, to their ruinous condition today. This raises the difficult question of who shares the responsibility for protecting cultural property.

My answer is that we all do.

fig. 13: Nineveh, Sennacherib Palace Site Museum, Room V, Slab 16, condition after looting, 1997 (photo: courtesy of Muayad Damerji).

THE SOURCES FOR THIS STUDY

In documenting the original appearance and subsequent fate of Sennacherib's throne-room suite, I drew on the records of the three archaeologists who excavated it, as well as studying the exposed remains myself. The earliest documents derive from the excavations of A. H. Layard. The two most important sources here were Layard's drawings of individual slabs and his handwritten descriptions of the finds in each room. His drawings are the clearest documentation for the subject and condition of individual reliefs at the time of their first excavation. All those from the throne-room suite are reproduced here. The greatest limitation of the drawings as a source is that Layard drew only a small selection of the total number of slabs. Furthermore, the drawings are not accurate in every detail, and landscapes in particular seem sometimes to have been filled in when Layard was not in front of the slab.

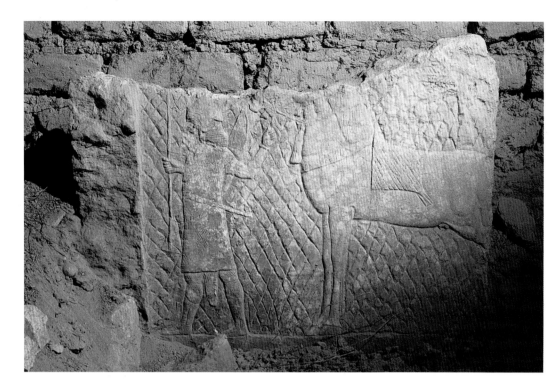

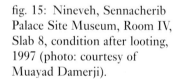

fig. 14: Formerly Nineveh, Sennacherib Palace Site Museum, Room IV, Slab 8, condition before looting, 1989 (photo: author).

fig. 15: Nineveh, Sennacherib Palace Site Museum, Room IV, Slab 8, condition after looting, 1997 (photo: courtesy of Muayad Damerji).

For slabs that were not drawn, we must rely on the written descriptions in Layard's field notebooks. Descriptions of individual slabs are usually brief, but they sometimes give a general sense of the subject and condition of the relief. They can be quite misleading concerning condition, however, as they often exaggerate the degree of deterioration of slabs, possibly as a justification for not drawing them. Nevertheless, they are sometimes the only record we have of the subject of reliefs that were subsequently partially or completely destroyed.

A source that was useful specifically in ascertaining the condition of the human-headed bull colossi in the doorways was Layard's copies of the inscriptions carved in the spaces between the legs of these figures. Though there is no description of the condition of the figures noted on these copies, the degree of completeness of the text is a good indication of the state of preservation of the part of the figure on which it is carved.

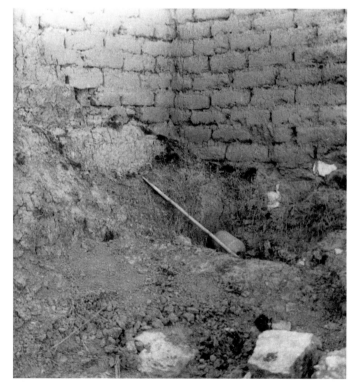

I have only cited Layard's published narrative accounts, *Nineveh and Its Remains* and *Discoveries in the Ruins of Nineveh and Babylon*, when they provide information that is not in the drawings or written accounts. This is rarely the case, as his published accounts were based almost wholly on the drawings and notebooks. Indeed, a close reading of his description of the reliefs from these rooms in *Nineveh and Its Remains* reveals that the only reliefs that Layard described in detail are the ones that he drew, and that he was simply describing the drawings. For the purposes of this study, the drawings themselves are sufficient.

The plans of the throne-room suite that Layard published in *Nineveh and Its Remains* and *Discoveries in the Ruins of Nineveh and Babylon* give a good sense of the general layout of the rooms and the distribution of slabs, but they are inaccurate in proportion and detail. Room V, for example, is too short in his plans, and a number of relief

slabs were omitted from Rooms I and V. I will return to this problem in the discussion of architecture.

There are neither descriptions nor drawings from the time of L. W. King's excavations in Rooms I and V, but he did take a number of photographs of the reliefs following his reexcavation of them. In June 1903, King wrote to his immediate superior, E. A. W. Budge, Keeper of the Department of Egyptian and Assyrian Antiquities in the British Museum:

> I have found an Armenian named Garabêt alias Abkâr Zardalijân who is staying in the town [Mosul] and knows how to develop photographs, so after some trouble we raised the necessary acids & have tried developing our film (which I did not mind spoiling) as an experiment. The result is not so very bad and I will try another with some photos of the diggings next week.[2]

King did not refer to his photography thereafter, and I do not know whether most of his photographs were developed in Mosul or after he got home to London. In any event, they vary in quality from excellent to terrible, with most of them falling into the range of fair to poor. This is in part because he seems to have been using primitive equipment under conditions of extreme heat and dust, and in part because of later deterioration of the negatives and prints prior to being copied onto more permanent negative stock. Indeed, King's original acetate negatives have now disintegrated. In a few cases, King took several photographs of the same subject, from which I selected the best example to reproduce here. Often, though, only a single photograph was available, and their shortcomings will be abundantly clear. Because most of King's photographs of Nineveh have not previously been published, I include the negative numbers in the captions, as these are not otherwise available.

Despite the generally poor quality of his photographs, they are of great importance as the first purely objective documentation of the throne-room reliefs. Unfortunately, as with Layard's drawings, King photographed only a fraction of the total number of reliefs, and in many cases he seems to have been more interested in capturing a particular detail or showing a sequence of several slabs, rather than documenting individual slabs. King reported in his letters to the British Museum that Layard's plan in this area was inaccurate, but he does not seem to have made a corrected version.

There is very little published documentation from Madhloom's re-excavation of the throne-room suite. Though he told me that drawings were made of the sculptures and they were presumably photographed as well, only a few photographs and no drawings from his work have appeared to date. Of those, the majority are details from individual slabs or views of the overall excavation. Only four slabs were reproduced in legible full views. Madhloom also published a considerably improved plan of the throne-room suite, but it still varies in detail from the preserved remains.

My own documentation is primarily photographic. As a visitor to Nineveh in 1981, I made a partial photographic record of the reliefs in the site museum. These were of great value in documenting recent loss to the reliefs, as they were made only about a decade after Madhloom's restoration of the reliefs, and at a time when the structure was in good repair and the guard was still living on the site. The 1981 photographs, therefore, were the best documentation I had for the condition of the reliefs shortly after the construction of the site museum.

My 1989 and 1990 photographs of the reliefs are by far the most exhaustive documentation that I know of. Though a few of the reliefs had begun to deteriorate, due primarily to the death of the site guard and budgetary exigencies brought on by the war with Iran, they were still in substantially the same condition as when Madhloom reexcavated them. At the same time, I made a new measured plan of the suite as it had been restored. Though I do not know how closely the restoration followed the archaeological remains in every detail, it is clear from the surviving original remains that the restoration is generally very close to the original. I do believe that my plan is an accurate representation of the remains as they were in 1990.

HISTORY OF THE EXCAVATIONS

In the late spring of 1847, following nearly two years of very successful excavations on the palaces and temples at the Assyrian site of Nimrud (ancient Kalhu), the young British adventurer and amateur archaeologist Austen Henry Layard turned his attention to the mound of Kuyunjik, which he hoped housed the remains of ancient Nineveh. He had worked briefly at the site in 1846, but had left empty-handed, defeated by the great depth of earth that covered the Assyrian levels. This time he began excavating in a deep ravine on the southeast side of the mound, and soon struck the sculpture-lined walls of the south end of the throne room of Sennacherib's palace. In the remaining month before his departure for England, he excavated all of the throne-room suite except for the façade, and parts of several surrounding rooms. When he returned to Nineveh in 1849, he finished clearing the throne room façade, and excavated some sixty more rooms to the southwest of the throne room, recording a selection of the sculptures in drawings. For the great number of slabs that he did not draw, Layard kept a brief account of their subjects in his excavation notebooks, which I have recently published (Russell 1995). These were the sources from which he abstracted the selection of drawings and brief descriptions in his published accounts, and they are the sources I have drawn on in documenting his finds for the catalogue in this study.

Either in the course of his own excavations or during the excavations of his immediate successors, most of Layard's trenches in the throne-room suite were apparently filled back in. An exception was the area around Door *a* of Room V, where the bull colossus on the south jamb was still exposed when Leonard William King reconnoitered Nineveh for the British Museum in October 1901. In reporting damage to sculptures at the site, he wrote "The winged bull which was left uncovered in the palace of Sennacherib has also suffered" (see figs. 27, 28).[3] As King's reports on his excavations in the throne-room area have never been published, they are cited in some detail here. They are of two types: lengthy narrative summaries of his work which were submitted to the Museum Trustees, and weekly letters to the head of his department, E. A. Wallis Budge, and to the director of the British Museum, Edward Maunde Thompson.

Following his reconnaissance visit, King reported that many of the old excavation trenches in Sennacherib's palace had been filled in by the combined action of dumping by previous excavators, the collapse of trench walls and tunnel ceilings, and plowing for agriculture. Because of this obliteration of the earlier excavations, King had difficulty identifying specific rooms in some areas of the palace, though its general outlines were clear enough. Of other areas, he wrote, "the chambers have not again been filled in; consequently the lines of many of the walls from which the sculptures have been taken are clearly defined, and in one or two places portions of sculptured slabs are still visible in situ."[4]

After King's visit, the British Museum decided to resume excavations at Nineveh, and King was sent back to the site, where he directed excavations from January 1903 to June 1904. Initially, his instructions were "to complete the clearing and sifting of the earth above the palace of Sennacherib in order to find tablets similar to those already found on its site by Layard, George Smith, H. Rassam, and Dr. Budge."[5] The actual digging in the southeast part of the palace, the area of the throne room, commenced at the beginning of March 1903. On 6 March, King wrote: "I have started work on the S.E. and N.W. portions of the palace of Sennacherib where the earth has not yet been sifted, and am removing it down to the level of the pavement."[6] Two weeks later, he reported "On the E. side of the palace we are working on . . . a corner of the great court VI, and have begun to clear room V," that is, the inner room of the throne-room suite.[7]

By the beginning of April, he was employing three hundred men for his excavations on Sennacherib's palace (fig. 16): "On the E. side we . . . are still at work on rooms XLV and V; here the earth is 20 to 21 feet thick . . . Of the slabs lining the walls in room V, there are three, representing Sennacherib in his chariot and the storming of a city which I hope to be able to remove for the I[mperial] O[ttoman] Museum."[8] The British Museum's interest was not

in sculptures, however, but in tablets, as King wrote to Budge in late April: "I also began clearing the chambers on the E. side and in the S.E. corner of the palace as Layard says he found tablets here when tunneling along the walls of the rooms . . . We have found a few tablets and fragments." By this time, King had abandoned his initial plan of dumping all the earth he excavated over the edge of the mound. Instead, he was following the example of his predecessors, including Budge, to whom he wrote: "In the case of [the men] working outwards from inside I am following your plan of getting rid of the debris and at the same time of protecting the broken walls and pavements by covering the rooms again with earth as we finish clearing them."[9] This method was not only more efficient, but it also protected fragile remains from extended exposure.

As King reexcavated the rooms first discovered by Layard, he found fault with Layard's plan of the building. At the end of April, he wrote: "Layard's plans are not only incomplete but in some cases extraordinarily inaccurate and they will have to be done again."[10] At the beginning of May, King elaborated somewhat on this point in a letter to the Director: "During this month we have continued the work of clearing Sennacherib's palace, and on the East side have finished rooms V and XLV . . . The edge of the mound is farther away from the palace than Layard put it and his plan in other parts that I have cleared is not accurate as to the size of the chambers, the position and arrangement of the doorways, etc."[11] And the draft of this letter adds: "Room V, for instance, is 20 feet longer than he makes it."[12] Unfortunately, King does not report that he drew a corrected plan of the rooms he excavated, and there is no evidence that he did so. Save for a rough, ambiguous sketch of a new entrance at the west side of the palace, there is no record of the actual plan of the rooms he excavated.

On 12 May 1903, King submitted to the British Museum Trustees a preliminary report on his excavations. He stated that he had finished removing and sifting the earth from a corner of Court VI and from Room V, and that they were currently working in Room I. He went into considerable detail on the sculptures in Room V:

In most of the rooms cleared the sculptured slabs which lined the walls are only preserved for a foot or two above the pavement and in many places they have entirely disappeared. Room V forms an exception, for here the walls are standing and several of the slabs are complete, although their sculptured surface has been cracked all over by the fire. If we had found any large body of tablets, I should have recommended that we should attempt the removal of the best of these for the I. O. M [Imperial Ottoman Museum]; but, apart from the risk of breaking them, there appears at present no reason for incurring the expense of their removal and transport. Moreover, I have had a stonemason to examine them, and he tells me he could cut only a very small slice from their backs and even then they would probably smash into small pieces: I therefore recommend that we cover them again with earth.[13]

Based on his experience with the palace to that point, King no longer supported the initial proposal to clear the palace in its entirety: "We have found up to date sixty-four tablets and fragments . . . I naturally feel that this is an inadequate return for the money and labour spent on the excavations during the last ten weeks, and, from my observation of the ground in the different parts we have cleared or tested, I have been gradually led to doubt whether the expense of completely clearing the palace would be justified."[14] A few days later, King elaborated on his misgivings about clearing the entire palace in a letter to Budge: "I need hardly say that if we had an unlimited supply of money, I should be only too glad to be allowed to do it. But as we have gone on digging and the fragments have got scarcer instead of increasing I have had pictures of a Treasury official with a grin working out the price at which each fragment has been procured."[15]

King recommended abandoning the plan to sift the fill over the entire palace, but to continue clearing the areas they had begun, including "the chambers on the E. side beyond Room V. Parts of these chambers appear to have been already examined, but in view of Layard's statement that he found tablets here I think the debris should be sifted as far as the E. entrance."[16] Budge concurred; in the cover letter he submitted to the Trustees with King's report, he recommended that King finish clearing the rooms on the east side, the area of the throne room, and this was approved.[17] At the beginning of June, King wrote that he was continuing the excavations at the east side of the palace, but had found no tablets.[18] A month later, things were not much better: "During the past month we have found altogether one hundred and one tablets and fragments, of which thirty-seven are rather small pieces. Four of these were found in Room I on the E. Side of the palace."[19]

In a letter to the Director in the middle of June, King again referred to the condition of the sculptures in Room V, stating that since his last report "the surface of several of them had begun to flake away from the heat of the sun, and in order to prevent further damage I have begun to cover with earth those which from their position are more exposed to the sun."[20] A month later, just prior to his departure for Lake Van to escape the summer heat, King wrote to Budge: "During this last week we have been most of the time filling in sculptures which still remained exposed, and shall just have time to get all shipshape by tomorrow evening. There won't be any risk now of these being smashed up for lime."[21]

With the resumption of excavations in September, King continued to employ one work gang in finishing the clearance of the east side of the palace, in accordance with Budge's recommendation to the Trustees.[22] At the beginning of November, he wrote: "During the month we have finished clearing the earth round the entrance and exterior wall of Sennacherib's palace on the E. side."[23] By this time, King's attentions had shifted away from Sennacherib's palace. His most important excavations on Kuyunjik took place elsewhere on the mound, in the period between his return from Lake Van and his departure for England in June 1904.

His final report to the Trustees, written after his return to England, devoted only a few lines to the generally unsatisfactory excavations in the area of Sennacherib's throne room: "On the Eastern side of the palace we cleared the rooms around the entrance and trenched

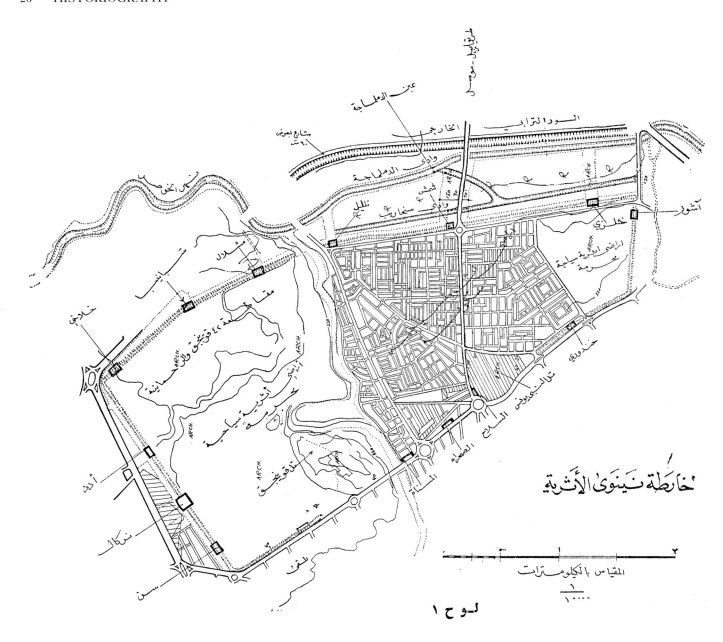

خارطة نينوى الأثرية

المقياس بالكيلومــترات

لـوح ١

fig. 17: Nineveh, plan by T.
Madhloom showing modern
urbanization south of the
Khosr River, 1968 (after
Madhloom 1968, Arabic p. 61).

beyond the exterior wall . . . Only a few scattered fragments were found in Room I on the
E. side of the palace . . . On the E. side of the palace Layard's plan of the chambers was
corrected."[24]

No further excavations were carried out on Sennacherib's palace until 1965, when the Iraq
Department of Antiquities and Heritage reexcavated the throne room suite. According to
Tariq Madhloom, the excavator, "this step was dictated by the fact that the new wave of the
housing scheme is threatening to overflow the historical area."[25] The growth of suburban
Mosul had already caused the village of Nebi Yunus, originally confined to the mound of
Nebi Yunus, to expand so much that it filled the southern half of the walled area of ancient
Nineveh (figs. 17, 18). Now, development was threatening to jump the Khosr River and cover
the northern half of the ancient city, including Kuyunjik, as well.

Between 1965 and 1967, Madhloom reexcavated Rooms I, IV, V, and the throne-room
façade (Layard's "Court H").[26] Most of the sculptures were apparently found in much the
same condition as King left them, except that a number of sculptures at the northern end of
Room I had disappeared, casting doubt on King's claim that he had reburied them. It was

decided to preserve this part of the palace as a site museum. The mud brick walls of the rooms were restored to a height of four meters, and Rooms IV and V were fully covered, and Room I partially covered, by a metal roof (fig. 19). The relief slabs were consolidated and reinstalled in their original locations.

It is not clear how many of the slabs were removed for restoration and then reinstalled. Madhloom reports that the initial plan was to reinstall the slabs in a footing of cement and gravel, but this proved impractical. The slabs therefore either remained in place or were reerected on their original foundation, consisting of a layer of bitumen at the bottom, to protect the slabs from rising damp, atop which was a layer of stone particles, probably waste stone from the sculpting, and a layer of sand.[27] As the goal of Madhloom's excavation and restoration of the palace was to create a physical barrier to development on the mound of Kuyunjik, there was apparently no plan to publish the results, and his work received only cursory publication in the journal *Sumer* and in a guidebook to the site of Nineveh.[28]

DESCRIPTION OF THE DOCUMENTATION WORK

My preliminary photographic documentation in the palace museum in 1981 and 1989 has already been described. Starting in the 1990 season, I planned to carry out a complete systematic documentation of the architecture, inscriptions, and sculptures in the site museum, a project that I expected would require at least two seasons to complete. This would involve making a careful measured plan of all of the exposed architectural remains, photographs and hand copies of all the unpublished inscriptions, and a full photographic record of all

fig. 18: Nineveh, traffic and modern buildings, viewed from Nebi Yunus looking north with the city wall in the foreground and the mound of Kuyunjik in the background, 1989 (photo: author).

fig. 19: Nineveh, Sennacherib Palace Site Museum, view from the west with the city walls in the middle distance and the Gebel Maklub in the background (photo: author).

the surviving sculptures, supplemented where necessary by drawings of slabs that were otherwise difficult to read.

This work was in addition to my regular excavations at the eastern and western ends of the palace, which were going on at the same time, and so it was necessary to do the documentation work by myself during the afternoon rest period. In order to make the most efficient use of the limited time on the site, I decided to make the detailed photographs of the sculptures during the 1990 season. Following the close of the season, the photographs would serve as the basis for preliminary drawings of the reliefs, which would then be checked and completed in front of the originals when we returned to Nineveh in 1991.

Because its low carving and monochrome or mottled surface can mask sculptural detail, Assyrian reliefs are not easy to photograph even under ideal conditions. The key to successful results is to have full control over the lighting. In practice, this means being able to eliminate incident light and illuminate the relief with electric photographic floodlamps, by placing a bright lamp or lamps to one side to bring out the relief through highlights and shadows, and a softer lamp directly beside the camera to illuminate detail in the shadows. With electric lamps, the positions and intensities of the light sources can be adjusted until the best results are achieved.

Photographic conditions in the Sennacherib Palace Site Museum were far from ideal. There were two major problems. First, there was no electrical power source, so I could not use photographic lamps. This meant that I would have to use flash units, which meant that I could not see the effect of the lighting until the film was developed. Second, I could not control the ambient light. This was less of a problem in Rooms IV and V, which were completely roofed over and therefore relatively dark even in the afternoon. It was much more serious in

Room I, where the roof extended only a short distance beyond the walls, and which was therefore much more brightly lit at all times of day. There was nothing I could do about this, since the mound was only open during daylight hours.

Prior to the 1990 season, I discussed the problems of the project with my indispensable guide in all matters photographic, Gregory Schmitz, photographer for the Department of Art History and Archaeology at Columbia University. He recommended the following system, which I used with considerable success. The camera was a fully manual 35 mm Nikon F body fitted with a "normal" Nikkor-S 50 mm lens. This seemed a good choice to minimize the amount of optical distortion of spatial relationships in the reliefs, while still allowing me to work in the available space. This lens did not work well for doorjambs, however, which I had to photograph obliquely or in sections due to the narrowness of the doors. The film was black-and-white Kodak T-Max 100, exposed at ISO 64 to maximize its range.

Illumination was provided by two Vivitar 283 flash units. One was mounted on a stand, placed obliquely off to the side of the relief and set at full power to provide the primary, raking illumination. This flash was powered by a Quantum QB-1 rechargeable lead cell battery and was triggered by a Weil WP-XL flash slave. The other flash was mounted directly on the hand-held camera and set at minimum power to provide fill illumination. It was powered by internal AA alkaline batteries and triggered by the shutter release. This arrangement gave me great flexibility and speed in placing the lights, as there were only two units involved (the camera and the remote flash) and no connecting cords.

Exposures were determined with a Minolta Autometer IIIF used as a flash meter. The shutter speed on the camera was set for flash (1/60 second) and exposures were controlled with the aperture setting. This was determined by placing the light meter in front of the relief facing toward the camera, firing the flashes, and using the meter reading to set the aperture. The resulting exposures were generally quite satisfactory, especially in Rooms IV and V. In Room I, the bright ambient light considerably decreased the effect of the oblique flash, even when fill flash was not used, with the result that those reliefs sometimes seem less well defined in the photographs, and variations in surface coloration of the stone are more pronounced.

My main objective in this project was to record the surviving sculptures in detail, and then to publish each piece in a way that conveys that detail. Each slab was therefore photographed both in a full view and in close-up details of all sculptured areas. All told, I took about six hundred black-and-white pictures of the palace museum in May 1990, in addition to about three hundred more in both black-and-white and color in 1981 and 1989. I processed the film manually upon my return home, using Agfa Rodinal developer at 1:100 dilution and 22°C (72°F) for twelve minutes. Prints were made with a Durst M601 enlarger fitted with a Nikkor 50 mm lens, on Ilford Multigrade IV Deluxe RC glossy paper, developed in Dektol developer at 1:2 dilution for one and a half minutes.

With Iraq's occupation of Kuwait two months after my departure, and the resulting war and U. N. sanctions, it became apparent that my return to Nineveh would be postponed indefinitely. Instead of using the photographs as the basis for preliminary drawings, which could be corrected when we returned to Nineveh in 1991, now the photographs were the sole source from which to make the drawings. Given the uncertainty of future travel to Iraq, I decided to proceed with what I had.

For publication purposes, I divided the sculptures into three groups. The first group comprised those reliefs that were in sufficiently good condition to be readily legible from photographs alone. The second group comprised those slabs for which the sculptured surface was so badly destroyed that its original subject was completely illegible. Both of those groups of sculptures would be published only in photographs. The third group comprised slabs on which the relief was partially preserved, but difficult to read because of surrounding damage. That group of reliefs would only be legible if photographs were published together with drawings of the sculptured areas.

A few of the reliefs in this third group had been drawn by Layard, but the majority had not, so I collaborated with two artists, Jennifer Hook and Denise Hoffman, in making 1:5

scale drawings of thirty-two reliefs that had not previously been drawn.[29] This may sound easy to those who have not tried it, but it proved to be a very time-consuming and expensive process. We faced two serious problems. The first was that the reliefs we planned to draw were, by definition, those that were too badly damaged to be clearly legible, and it is difficult to make an accurate drawing of a subject that you cannot see clearly. The second problem was that the photographs were a two-dimensional transcription of the three-dimensional relief surface. With photographs, we could not change our viewing angle or move the light source in order to resolve an unclear passage, as we could do in front of the originals. Of the infinite number of possible viewing angles and distances, and lighting angles and intensities for each relief, we had to make do with only the ones captured in the photographs.

The drawings occupied most of my time for a period of eighteen months, from March 1992 to August 1993. We adopted a procedure that we hoped would maximize the amount of detail in the drawings while minimizing the number of errors. For each relief sculpture that was to be drawn, I selected the best overall view of the slab as the basis for the drawing. I then enlarged that negative to a scale of 1:5 and printed the image in sections that when assembled together covered the whole slab. I also made 8 × 10 prints from all of my negatives of details of that slab, to be used for reference.

For each slab, Jennifer Hook made the initial 1:5 pencil drawing by tracing it on mylar from the 1:5 photographic enlargement, and then adding and correcting details by consulting the reference photographs. Denise Hoffman, who served as the artistic consultant, then checked the drawing against the photographs and offered further suggestions. When both of them were satisfied with the drawing, it was passed on to me. My role was to try to identify and eliminate spurious lines that were the result of damage, and to see if my knowledge of Assyrian comparanda enabled me to see details that should be there, but which might be worn or obscured by damage.

Needless to say, I often saw things that the artists insisted were not there (and may not have been), simply because I thought that they should be there. Likewise, I often insisted that perfectly clear patterns that did not fit the Assyrian comparanda were merely damage, while the artists argued for their inclusion. Our usual solution was to omit disputed passages, on the theory that we could add them in later if necessary, when we were again able to examine the originals. Not surprisingly, as the three of us became ever more familiar with Assyrian relief sculpture, the number of disputed passages declined, but every drawing still represents a three-way compromise.

When the pencil drawings were completed to everyone's satisfaction, Jennifer Hook then made ink copies on mylar of each one for publication. The results, which constitute a beautiful and fundamental contribution to our knowledge of Assyrian sculpture, are published here. The corpus of some six hundred black-and-white 8 × 10 photographs that were used in preparing the drawings will be deposited in the archives of the Department of Ancient Near Eastern Art in the Metropolitan Museum of Art in New York, where they will be available for study by interested scholars.

2 SENNACHERIB'S THRONE-ROOM SUITE

ARCHITECTURE

The architecture of Sennacherib's throne-room suite as it was available to visitors after 1967 was the product of Madhloom's restoration. The original mud brick walls were poorly preserved, so Madhloom replaced them with new walls, also built of mud brick. In 1990, the original brickwork was still visible in a few areas projecting from Madhloom's restorations, notably at the south end of the outer west wall, where the ancient bricks may form part of a doorjamb at the south end of Room XVIII, and at the north end of the same wall, where they evidently form part of the north buttress beside Door *a* (figs. 20, 21). Small areas of original brickwork were also visible at both ends of the north wall of Room I, which Madhloom apparently did not restore, and above the drain in Room IV (fig. 22). Everywhere else, it appears that the original mudbrick was either encased by or replaced by modern brick.

As was the usual practice in Assyrian palaces, the bases of the stone wall slabs were buried sufficiently deeply so that the slabs could stand without other support. It appears that Madhloom did not dig out the bases of most of the slabs that required restoration, but rather restored them *in situ*. The new walls were then built behind the slabs, leaving an air space between the backs of the slabs and the face of the wall (see fig. 34).[30] Since the restoration of the sculptures and walls did not necessitate the removal of the wall slabs, most of them should have remained where Sennacherib put them. These original remains – the ancient mud brick and the surviving wall slabs – were the primary source material for modern plans of the architecture of the throne-room suite.

There are four published plans of Sennacherib's throne-room suite: two made by Layard in the course of his excavations in 1847 and 1849–51, one made by Madhloom of his excavations in 1965, and one made by me in the course of my documentation work in 1990. Interestingly, there are significant variations among the plans in matters of room size and proportions, as well as in the arrangement of architectural details and sculptural fittings. This is due in part to the differing purposes for which each plan was drawn, and in part to inadequate recording by the excavators. For this publication, all four plans were scanned into Adobe Photoshop, where they were cleaned up and provided with consistent metric scale bars. To facilitate comparison, all four plans are reproduced here to the same scale.

For reasons that will be explained below, none of these plans can be considered definitive. I will, however, use my own plan as the standard against which I will compare the others, since my plan is the only one that I know was measured in every detail directly from the original remains (pl. 1). While it may contain small measurement errors in the placement of certain features, it should be correct in its measurement of wall lengths and door locations. The primary goal of my plan was to show the location of all of the surviving sculptures in the throne-room suite. In order to measure this, I stretched a steel meter tape along the entire length of each wall and noted the location of the edge of each sculptural and architectural feature. These measurements were then used to produce a 1:100 scale plan.

There are several limitations to my plan. The greatest of these is that I was only able to show the walls as they had been restored. As already noted, the original brickwork was rarely

fig. 20: Nineveh, Sennacherib Palace Site Museum, Room XVIII, original mudbrick, possibly marking the location of the south doorjamb, 1990 (photo: author).

visible, and it was not always possible to be certain how closely Madhloom's restoration followed the original plan. This was more of an uncertainty in unsculptured areas, however, as it appeared that most of the sculptures had not been moved from their original positions, and therefore the positions of sculptured walls and doorways seemed secure. A related limitation was that floor features such as thresholds and pavements were covered by a thick protective layer of earth, and we only removed this to expose the stone threshold in Door *e*. For other such fittings, one must turn to Madhloom's plan.

Another limitation is that because of time and labor constraints (I worked on my own in a very limited amount of time), I assumed that apparently parallel walls were truly parallel and that corners were right angles. The preferred procedure of using multiple measuring points to determine the location of corners and doorways would have required more time than I had, and seemed unnecessary for my purpose. In fact, though, Madhloom's restoration proved to be remarkably regular. In the case of Room V, a long room with all of the corners preserved, the west wall measured 42.40 m and the east wall 42.10 m in length, while the north wall was 7.43 m and the south wall 7.57 m. In view of the great lengths involved, I judged these differences to be negligible and drew the length as 42.25 m and the width as 7.5 m. Similarly, the width of the throne room was 12.51 m at both the north and south ends (the lengths of the two long walls cannot be compared as I could not locate the south end of the west wall).

Despite these limitations, I believe my plan is the one that most accurately represents the existing remains. A particular strength is that, unlike all of the previous plans, it shows all of the surviving sculpture slabs, and represents their actual dimensions. This is the only plan, therefore, on which one may see the placement and size of the niche opposite Door *a* of the throne room, and it is the only one that shows all of the slabs on the west walls of Rooms I and V.

To turn now to the other plans, the first example was published by Layard in *Nineveh and Its Remains* (1849), following the conclusion of his first excavation campaign at Nineveh of May–June 1847 (pl. 2). This is only a partial plan of the suite, as the south end of the throne room and its outer façade had not yet been excavated. At this point, Layard was still designating the rooms in the palace with letters, so that the rooms he later labeled I, III, IV, V, and VI are here designated B, G, A, C, and I. Layard also changed most of the door designations

for his second plan. To my knowledge, Layard's manuscript version of this plan has not been located. The published version is so sketchy and inaccurate that I wonder if Layard prepared any sort of measured plan while at the site, or whether he simply compiled it from his notes, drawings, and possibly sketch plans. Though the published plan gives a good sense of the general layout of the suite, its catalogue of inaccuracies is enormous. Immediately noticeable is the north arrow, which is oriented according to the convention that Layard used to describe the alignment of the rooms, rather than to true or magnetic north.

The dimensions and arrangement of sculptured slabs Layard showed for the rooms are also inaccurate. Room V (C) is shown as slightly too wide and much too short (8.1 × 36.9 m) compared with my own measurements (7.5 × 42.25 m). As we have seen, King also observed that Layard's plan showed Room V as twenty feet (6.1 m) shorter than its actual length, which would then be 43 m, a figure very close to my own. Perhaps Layard's shortening of this room is related to the omission in his notes of three slabs from the west wall and two from the east wall, which may have led him to reconstruct the wall lengths as considerably shorter than they should have been.[31] Similarly, Layard showed the excavated part of Room I (B) as 1 m wider and 1.7 m shorter than I found it to be (13.3 × 31.5 m, instead of my 12.25 × 33.2 m). Again, Layard's shortening of Room I may be related to the omission from his notes of sculptured slabs from both the east and west walls.

Other inaccuracies in Layard's first plan include the omission of the return inside the south jamb of the door to Room IV (A), the incorrect location of the slab with the niche (his Slab "5") in Room I (B), and the representation of the heads of all of the doorway colossi as flush with the wall, instead of projecting as they should be. Virtues of the plan include its representation of the arrangement of the sculptures in Room III, now apparently completely lost, and the apparently correct plan of the buttress to the south of Door *b/a* in Court VI (I).

Layard's second plan of the throne-room suite, published in *Discoveries in the Ruins of Nineveh and Babylon* (1853), is essentially a copy of the first plan, with the throne-room façade added onto the east side and the orientation of the north arrow corrected (pl. 3). These improvements notwithstanding, this plan is even less accurate than its predecessor. The widths of Rooms I and V are virtually the same in the old and new plans, but in the new plan both rooms are even shorter than before, which also results in Room III being placed further to the south. Other changes in the new plan are that Room IV is significantly longer, the jamb in Door *m* of Court VI is shorter, and Door *a* of Court VI is somewhat further to the north, resulting in a considerably lengthened buttress on the façade to the south of the door.

In the second plan, Layard attempted to restore the south end of the throne room by adding an end wall and alcove, Room II, that mirror the arrangement of the north end. While such an alcove probably occurred in the throne room of the later North Palace of Assurbanipal, there is no archaeological evidence for it here. The standard plan for a throne room at this time would have a solid wall in this position, as in the throne rooms of the slightly earlier main palace and Palace F at Khorsabad, built by Sennacherib's father, Sargon II. Layard further assumed that Room I was symmetrical to either side of the central door, *a*, which resulted in a total restored length of nearly 56 m. Madhloom's later discovery of part of the

fig. 21: Nineveh, Sennacherib Palace Site Museum, Court VI, Door *a*, north buttress, original mudbrick, 1990 (photo: author).

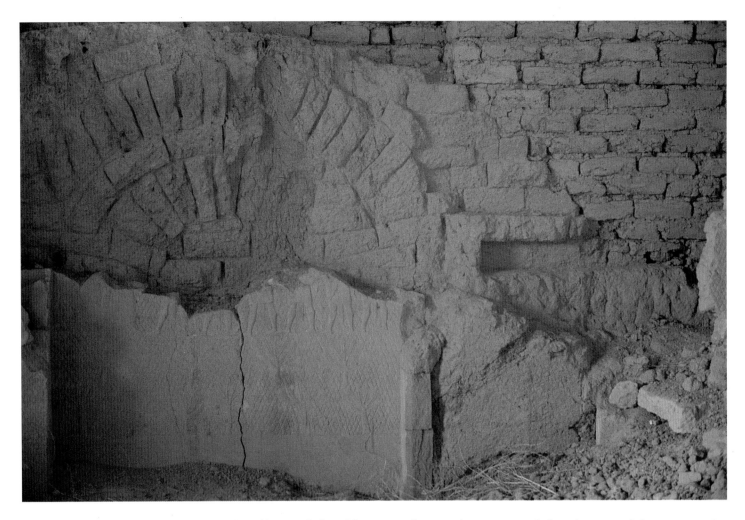

fig. 22: Nineveh, Sennacherib Palace Site Museum, Room IV, Slab 6 with original mudbrick arch above drain, 1981 (photo: author).

south wall proved that this assumption was incorrect, and that the part of the room to the north of Door *a* was considerably longer than the part to the south.

The plan of Madhloom's 1965–7 excavation of the throne-room suite is far superior to those of Layard (pl. 4). Not only does it represent the sizes and proportions of the rooms correctly, but it also shows architectural fittings that Madhloom excavated and subsequently reburied. These include the pavement in Room IV, the brazier tracks in Room I, and the pavement slabs in the doorways. It also solved a mystery in Layard's plans by showing the bases of some of the wall slabs from the south wall of Room I, a few of which were still visible at the time of my visit, thereby definitively establishing the location of this wall (fig. 23).

Madhloom's plan is not, however, without problems. Probably the most serious of these is that neither published copy of Madhloom's plan has an accurate scale bar. In the copy published in *Sumer* 23 (1967), the scale bar is about half the size it should be, while in *Nineveh* (1976) it is about 2.5% too small. Fortunately, Madhloom's text specified the excavated dimensions of the throne room (11.5 × 51 m) and Room V (7.5 × 47 m). Unfortunately, the length of 47 m that he gave for Room V in both the English and Arabic versions of his text is 5 m too long, and is clearly an error for the actual length of 42 m. In the version of his plan reproduced here, I have adjusted the scale to conform to his published dimensions.

The resulting plan is in most respects close to my own, with the notable exception that in Madhloom's plan, throne-room Doors *a* and *c* are roughly 1.5 m to the north of where I placed them. I cannot account for this difference, which is of importance for determining the alignment of Door *a* and the niche on the wall immediately opposite: in Madhloom's plan, the niche is centered directly opposite the door, while in mine, the niche is set about 1.5 m to the north, slightly off center. I stretched a tape from the southwest corner of the south colossus in Door *a*

to the north wall and found the distance to be 31.29m. Madhloom's plan gives the same span a length of 29.59m. Madhloom's version looks better and conforms more closely to the alignment of the niche shown in the published plans of the throne rooms of Assurnasirpal II and Sargon II.[32] As I can find no evidence of error in my own measurement, however, I am inclined to accept it, but would like to check it against the original when that is again possible.

Despite its apparent general accuracy, Madhloom's plan has several curious omissions and additions. It omits the sculptures and wall at the south end of the throne-room façade, even though the wall has been restored and the bases of the sculptures were still there. Likewise, although part of the original east walls of Room XVIII and Court VI were visible at the time of my visit, they were not included in Madhloom's plan. It also omitted Slabs 1–4 in Room I and Slabs 7–8 in Court VI, did not indicate the greater thickness of the two slabs opposite the main door, and elsewhere made little effort to show the correct width of individual wall slabs. Madhloom's plan shows the walls and sculptures of Room III as preserved, however, though there was no evidence for them at the time of my visits. Furthermore, his placement of the slabs in Room III does not accord with Layard's. It is possible that Madhloom found the bases of the walls and slabs here and reburied them, but Room III is not mentioned in his published text, and as drawn, it appears to have been copied from Layard.

To summarize, each of the four published plans of the throne-room suite includes significant information that is not on the others, and each of them has significant shortcomings. To some extent, these shortcomings could be remedied by uncovering all of the surviving remains down to the original floor level and making a definitive measured plan of whatever survives. Without question, this should be done, if only to reconcile the differences between the two most recent published plans. It may be some time before this is possible, however, and in any event, a new plan cannot include the considerable amount of architectural and sculptural information that has been destroyed since Layard's day.

As a provisional response to the strengths and limitations of the four existing plans, therefore, I have compiled a composite plan that draws the available evidence together, in order to present a synthesis of what is known of Sennacherib's throne-room suite (pl. 5). The composite plan uses my plan as the basis for room size and proportion, and for the dimensions of

fig. 23: Nineveh, Sennacherib Palace Site Museum, Room I, bases of Slabs 34–5 near the southeast corner of the room (photo: author).

the surviving wall slabs and doorway sculptures. It also shows the paving details in the doorways and in Rooms I and IV from Madhloom's plan, as well as the wall slab that he discovered near the west end of the south wall of Room I. The dimensions and slab arrangement of Room III, the southeast corner of Court VI, and the north end of Court H are taken from Layard's first plan, while the restoration of the sculptures on the Court H façade is from his second. At the north ends of Court H and Court VI, Layard's slab divisions were omitted, as they seemed unreliable. At the south end of Room I, a niche similar to that opposite Door *a* has been restored, following the pattern of the throne rooms of Assurnasirpal II at Nimrud and Sargon II at Khorsabad.[33]

The restored plan of the throne-room suite is very similar to the plan of Sargon's throne room at Khorsabad. The elements of the plan have been discussed fully by Turner in his study of the layout of Assyrian reception suites.[34] Briefly, the throne-room façade, Court H, would have faced into a large open courtyard, much of which has been lost in the ravine that is now directly in front of the façade. Room I was the throne room itself, with the throne dais placed in front of the niche in the south wall. A secondary or temporary dais could have also been located in front of the niche in the west wall, opposite Door *a*. These two locations are connected by a row of grooved stone paving slabs. These may have served as tracks for a wheeled hearth, which could have been moved to provide warmth to either location. The function of Room III is not clear in Sennacherib's palace, but in every other Assyrian palace, this shallow chamber provided access to a stairwell. Therefore, Turner suggested restoring a door at the west end of the north wall of Room III, leading to a hypothetical stairwell in the unexcavated space to the north. The paved floor of Room IV indicates that it was used for ablutions and/or libations. Madhloom told Turner that the slab in the niche was pierced by two adjacent drain holes.[35] Room V was what Turner termed the "retiring room" of the suite. It evidently served as the vestibule that connected the residential quarter of the palace with the throne room, the space through which the king would have entered and left the throne room.

SCULPTURE

Sennacherib's throne-room suite contains the largest concentration of published reliefs in his palace. Nearly every relief slab in Rooms I, IV, and V is documented in a photograph or drawing, and there is a reasonably full description of the sculptures in Room III as well. This is the only place in the palace where we can study the structure of the relief cycles for an entire suite, and while the decoration of the throne-room suite may not be representative of other suites in the palace, it is nevertheless of great interest as these are the most important, and presumably to some degree the most public, rooms in the palace. This section presents a room-by-room description of the subjects of the wall reliefs. For each room, I have divided the reliefs up into sequences, each of which seemed to me to represent a distinct historical episode. In the conclusion, I comment on some of the patterns that emerge.

COURT H

The wall slabs to the north of the façade buttresses were once sculptured with a historical subject, but this was erased in antiquity, leaving only traces of the original carving at the bottom of the slabs. This may be seen on Slabs 15 and 16, where the remains of reeds and palm trees are preserved at the bottom, above which the surface of the slab has been chiseled smooth, possibly in anticipation of recarving (pls. 22, 23). The flora marks the setting as Babylonia, but the specific subject is lost.

ROOM I

Parts of five more-or-less distinct visual sequences were reported on the reliefs in Room I, the throne room, though the division between sequences was not always clear. Three of these sequences occupied Slabs 1 to 20, the entire length of the west wall. On the basis of an epigraph

on Slab 1 and a unique image of the king in his carrying chair on Slab 7, it seems that some, and probably all, of the reliefs on this wall depicted events from Sennacherib's fifth campaign to the north, against the city of Ukku and the cities on Mt. Nipur (the modern Judi Dagh).

By contrast, the two preserved sequences on Slabs 20a–29 of the east wall depicted Sennacherib's third campaign, to the Levantine coast. Though no legible epigraphs were preserved, it seems most likely that these two sequences showed the flight of Luli of Sidon and the Assyrian victory over the Egyptians at Eltekeh.

There was room for another sequence on Slabs 30–33, but the fragmentary remains of these slabs appeared to be uncarved. If this is true, then these sculptures may have been unfinished, carved at a higher level above the floor, or erased prior to recarving. The preserved sequences may be briefly summarized as follows:

Sequence 1 (pls. 30–40): This sequence read from left to right on Slabs 1–4, and right to left on Slabs 5–4. On Slabs 1–2, the Assyrian army was depicted carrying off booty toward the right in front of a burning city, which according to the damaged epigraph was apparently Ukku (Frahm 1994). On Slabs 2–3, the Assyrians proceeded rightward into wooded mountains, where they rounded up fugitive enemy soldiers. These prisoners were marched off to the Assyrian fortified camp on Slab 4, where they were received by the enthroned king. On Slab 5, prisoners and booty from a burning city, labeled A-ta-un-[. . .], were marched off to the left, also towards the Assyrian camp on Slab 4.

Sequence 2 (pls. 38–44): This sequence apparently comprised Slabs 5–14, though most of these reliefs were already lost when Layard excavated them. The sequence seems to have depicted the Assyrian army accompanying a procession of prisoners, perhaps the same ones captured in the sequence on Slabs 1–5. The direction of movement on the preserved slabs was from left to right. The sequence began on the right half of Slab 5, where Assyrian soldiers descended from the mountains driving a file of prisoners toward the right. This continued onto the left end of Slab 6, and then after a break, the procession continued at the bottom of Slab 7 with two files of figures: a procession of prisoners and booty below and the king in his carrying chair accompanied by soldiers (fig. 24). The reliefs on Slabs 8–13 were all lost, and their subject is not known. They may have continued the processions from Slab 7, or have shown another battle, siege, or more mountain skirmishes. The sequence apparently concluded on Slab 13 or 14, where processions of Assyrian courtiers and bound prisoners approached the king enthroned in his fortified camp.

Sequence 3 (pls. 43–53): This sequence comprised Slabs 20–14, and was read from right to left. It began on Slabs 20–19 with a battle in the mountains, where the Assyrians triumphed over their enemies and brought down captives and severed heads toward the left. After a break for the lost Slabs 18–17, the sequence continued on Slabs 16–14 with two files of Assyrian soldiers proceeding to the left, apparently returning from the battle. These processions probably terminated at the Assyrian fortified camp on Slab 14 or 13.

Sequence 4 (pls. 54–60): This sequence, which comprised Slabs 21–20a, read for the most part from right to left. On the upper part of Slabs 21–20d and all of 20c, the Assyrian army was shown attacking a coastal city on Slabs 20b–a. The architecture was depicted with the typically western features of windowed towers and round shields on the ramparts. As the Assyrians approached from the right, the inhabitants of the city fled by ship to the left. At the bottom of Slabs 20d–21 was a procession of prisoners from the defeated city, moving toward the right. The setting and action of this sequence appear to correspond with Sennacherib's account of his defeat of King Luli of Sidon, although Jaffa has recently been suggested as an alternative identification (Gallagher 1997).

Sequence 5 (pls. 61–74): This sequence, comprising Slabs 29–22, read from right to left. It presumably originally began on Slab 29, which was no longer preserved, perhaps with an image of the Assyrian fortified camp. On Slab 28 was a typical western walled city, with windows at the tops of the towers and round shields on the battlements. It appeared to be deserted except for a man holding a standard(?) on the highest tower. The orchard in the foreground is notable for its detailed depiction of grapevines and pomegranate and fig trees (fig.

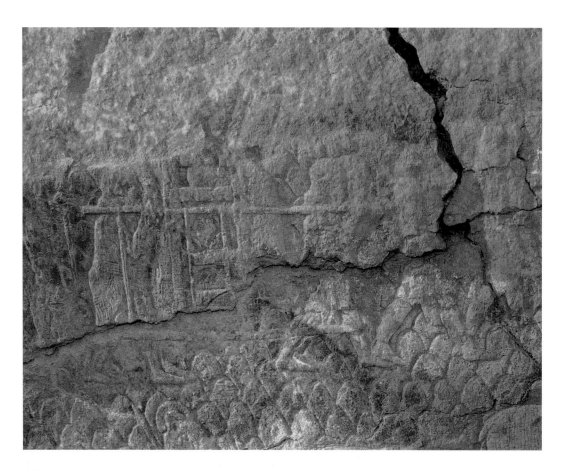

fig. 24: Nineveh, Sennacherib Palace Site Museum, Room I, Slab 7, detail of the king in his sedan chair, 1990 (photo: author).

25). At left were dismounted cavalrymen of the Assyrian army, who stood behind the king's chariot on Slab 27. On Slabs 27–25 was the Assyrian army moving toward the left, with the chariots and dismounted cavalry at the rear with the king, and archers and spearmen at the front. On Slab 25, the vanguard of the Assyrian army joined battle with an enemy force of cavalry, chariots, and foot soldiers, which extended over onto Slab 24. At the top of Slab 24, Assyrians brought carts and animals out of an enclosure, probably the camp of the enemy. The outcome of the battle was shown on Slab 23: fleeing enemy chariots, cavalry, and foot soldiers were driven toward the left into a river by pursuing Assyrian cavalry. The landscape continued onto Slab 22. The architecture here was typical for Sennacherib's representations of the Levant, which would make this his third campaign (Russell 1991: 161). The great battle shown outside a city might then have been Sennacherib's defeat of the Egyptian army at Eltekeh, which is the only field battle that Sennacherib reported during that campaign.

Sequence 6? (pls. 75, 76): As noted above, at least one of these slabs, 33, seemed to be unsculptured. If these slabs were originally sculptured, then there is no longer any evidence of their subject.

Non-historical subjects (pls. 41, 42): Slabs 6 and 7 were thicker than usual to accommodate a niche that was cut into their upper part. The preserved part of the niche on Slab 7 contained both feet of a large-scale anthropomorphic figure at right, and the left foot of a similar large figure in a tassel-fringed garment at left, both facing left. The full composition probably showed the king and a winged figure depicted twice, symmetrically flanking the central image of a stylized tree. By analogy with Assurnasirpal II's throne room at Nimrud, this same image should have been repeated in a niche behind the throne base at the south end of the room, now completely lost.

Conclusions: Taken as a whole, the preserved sequences in Sennacherib's throne room generally read from south to north, proceeding away from the enthroned king at the south end of the room. This followed the pattern established in the relief sequences of the throne room

of Assurnasirpal II at Nimrud, where action also emanated outward from the king. If the identification of the reliefs on the west wall as representing the fifth campaign is correct, this would invalidate my previous identification of all of the Room I reliefs with the third campaign (Russell 1991: 161–4). It would also vindicate Winter's assertion that two different campaigns were depicted in this most important of rooms, the decoration of which would then be a visual summary of the extent of the empire (Winter 1981: 19–20).

Room III

The analysis of the relief sequences in Room III presents greater difficulties than for the other rooms in the throne-room suite. Only half of the reliefs in this room were preserved when Layard excavated them, and all of these are now apparently lost. Only two of them are known from Layard's drawings, and the remainder only from his brief descriptions (pls. 77, 78). Still, it is possible to get a general sense of their sequence. It is clear from the landscape and an epigraph that identified a defeated city as Dilbat, that the subject was a campaign in Babylonia, probably the first campaign. Unlike the reliefs in the other rooms in this area, which all showed campaigns in mountainous regions, the reliefs in Room III were divided into two registers by a river that ran across their center, and the relief sequences in the upper and lower registers appear to have been independent of one another. These two sequences are summarized here. Note that, contrary to his usual pattern in this area, Layard numbered the reliefs in Room III in a counterclockwise direction.

Lower sequence: The lower register, which was better preserved than the upper, read from right to left. According to Layard, Slabs 1–3 showed horsemen proceeding leftward above a river, following behind the king's chariot on Slab 4. On Slabs 5–7, in front of the chariot, were rows of Assyrian spear bearers and archers, also proceeding to the left. Their goal was apparently the city

fig. 25: Nineveh, Sennacherib Palace Site Museum, Room I, Slab 28, detail of orchard, 1989 (photo: author).

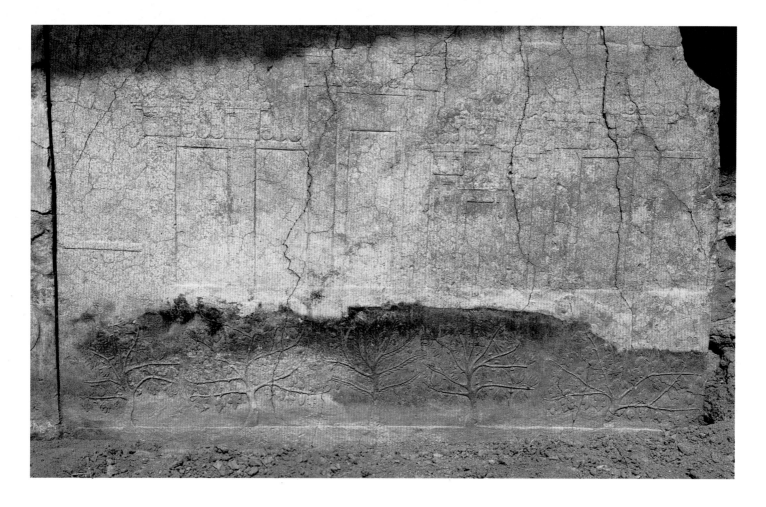

of Dilbat on Slab 8, which was shown being sacked by Assyrian soldiers while Sennacherib looked on from his chariot at the upper right. Interestingly, the epigraph reads: "Dilbat I besieged, I conquered, I carried off its spoil," but the images appear to have omitted the conquest and only showed the sack of the city.

Upper sequence: The upper register, which was mostly lost, also apparently read from right to left. At the right side of Slab 4 was an Assyrian archer firing to the right from behind a siege shield, suggesting that the lost top part of Slabs 1–3 showed the siege of an enemy city. The remainder of the top part of Slab 4 showed the legs of an Assyrian soldier proceeding to the left. The tops of Slabs 5 and 6 were missing. Layard reported the king's chariot on Slab 7, but did not indicate which way it was facing. On Slab 8 were Assyrian soldiers chopping down date palms, which may be connected with the sack of Dilbat represented directly below. There are at least two ways to interpret the preserved evidence. One is that the soldier to the left on Slab 4 was following a procession of prisoners from the defeated city, which continued across the lost top parts of Slabs 5 and 6 to Slab 7, where the king in his chariot received it. The king would then have had his back to the palm choppers. An alternative possibility is that Slabs 4–6 showed files of Assyrian soldiers marching leftward behind the king's chariot, which would then have been facing left on Slab 7 as he supervised the destruction of the palm grove.

Conclusions: The limited information that may be derived from Layard's occasional drawings and verbal descriptions is better than nothing, but is clearly not the equal of the full photographic record that is available for the other rooms. Even for seriously damaged slabs, the amount of information contained in photographs and drawings is much more conducive to a range of possible investigations, from the identity of the subjects to the structure of the sequences.

Room IV

Room IV. was decorated with two relief sequences that were apparently similar to one another. Both showed processions of people carrying things, but because of the loss or poor state of preservation of the upper parts of the slabs, it was not clear whether the subject was tribute or booty. Since no fighting was shown, and none of the figures appeared to be bound, tribute seems more likely. Both sequences proceeded from left to right.

Sequence 1 (pls. 81–93): This sequence covered Slabs 2–9. The preserved part of Slab 2 showed only a wooded mountainous landscape. On Slabs 3–4 was a city wall, above which were two processions of figures apparently carrying tribute to the right, escorted by Assyrian soldiers. These processions continued across Slab 5 and onto Slab 6, where the Assyrian soldier at the head of the procession was at the far left. He faced a pair of figures in long robes, probably the scribes who recorded the tribute, behind whom was a line of six soldiers. Slab 7 was lost, but probably showed the king in his chariot, facing left to review the tribute. Behind him, on Slabs 8–9, were Assyrian soldiers with led horses, also facing left.

Sequence 2 (pls. 94–104): A very similar sequence, comprising Slabs 10–15, commenced on Slab 10 with another city wall. From the right side of this city, on Slab 11, issued two processions of figures carrying tribute to the right, accompanied by Assyrian soldiers. On Slab 12, the head of the lower procession met a pair of figures in long robes facing left, who appeared to be using a balance to weigh the tribute. Behind them was the beginning of a file of Assyrian soldiers facing left, and these continued on Slabs 13–15 with Assyrian soldiers and led horses. The king in his chariot may have been on the upper part of Slab 13, but that part was lost.

Non-historical subjects (pls. 79, 80): Doorjamb Slabs 1 and 16 were each carved with a pair of guardian figures, the front one with human legs and feet, and the back one with human legs and the feet of a bird. A well preserved example of this subject is shown in fig. 26. The other place we would expect to find apotropaic figures is on Slab 6, which stood at the back of a niche with a drain. Although slabs in similar locations in the palaces of Assurnasirpal II and Assurbanipal were carved with special protective figures, this was not the case here.[36]

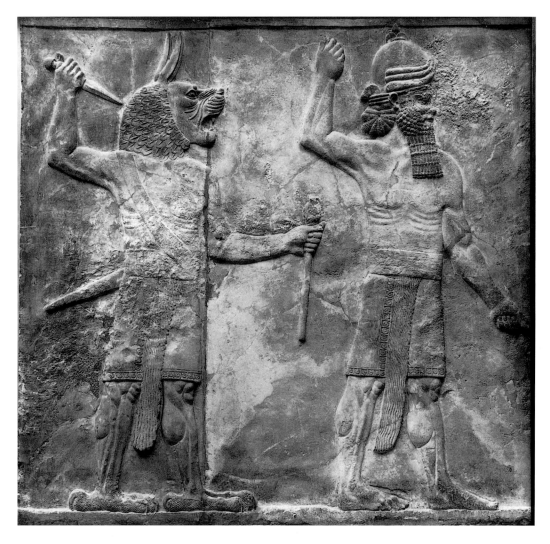

fig. 26: Nineveh, Sennacherib's palace, Room XXXI, Door *o*, west jamb, guardian figures, width: 286 cm, British Museum, WA 118932 (photo: Trustees of the British Museum).

Conclusions: Though the upper part of most of these slabs is lost, enough was preserved to suggest that the subject in this room was not military victories, as in the other rooms of the throne-room suite, but rather the delivery of tribute. Alternatively, though this would be unusual, these images may have shown the aftermath of victory, focusing exclusively on the removal of booty from the two cities. In either case, the subject in this small private ablution room, adjacent to the throne dais in Room I, was purely the accumulation, rather than the expenditure, of wealth.

Room V

Room V was decorated with five distinct relief sequences, all of which apparently depicted Sennacherib's second campaign to the Zagros mountains to the east of Assyria.

Sequence 1 (pls. 105–21): This sequence, which comprised Slabs 1–9, wrapped around the south end of the room and read from left to right. The subject was the conquest of a city in the mountains. Slabs 1–3 depicted Assyrian soldiers advancing toward the right in three lines. On Slabs 3–7, Assyrian archers and slingers assaulted the enemy city from both sides. The aftermath of the victory was on Slabs 6–9, where severed enemy heads and files of prisoners were paraded before a pair of scribes and the king in his chariot, accompanied by soldiers and led horses. Behind the king, at the far right, was the Assyrian fortified camp.

Sequence 2 (pls. 122–47): This sequence comprised Slabs 10–23, covering most of the west wall of the room, and was read from right to left. Again, the subject was the conquest of a city by the Assyrian army. The sequence began on Slab 23, adjacent to Door *a*, with a view of the

mountainous landscape. Most of Slabs 22–21 were lost, but at the bottom was a row of sol-
diers with led horses facing left, probably the cavalry units of the advancing Assyrian army.
The two slabs to the left of these, 20–19, were also almost completely lost, but should have
showed more led horses and Assyrian footsoldiers moving to the left. Slabs 18–15 showed the
actual attack on the city, with Assyrian slingers, archers, and spear bearers converging on it
from both sides. In the center, the enemy defenders were dispatched with the sword and
spear. Slabs 15–13 showed the aftermath of the siege, two rows of prisoners with livestock
and booty driven off to the left. On Slabs 12–10, the king in his chariot, facing right and
accompanied by soldiers and led horses, reviewed the spoil. The epigraph above him
identified the city as Kasuṣi(?), which is otherwise unattested. Behind him, on Slab 11, was
the Assyrian fortified camp, which was apparently shared with Sequence 1.

Sequence 3 (pls. 148–64): This sequence comprised Slabs 24–34, wrapping around the
north end of the room. The subject here was again the Assyrian assault on a city in the moun-
tains. The sequence read from left to right. It is too bad that Layard did not describe the
appearance of Slabs 24–9, as only the lower parts survived in 1965, and their subject was
uncertain. All that survived on Slabs 24–5 were trees against a mountain pattern. Surpris-
ingly, the surviving parts of the unusually narrow Slabs 26–9 were unsculptured. There is
now no way to know whether the upper part of these slabs was originally sculptured, or
whether the entire slabs were left uncarved. If they were sculptured, they should have showed
the approach of the Assyrian army from the left.

There were two parallel sequences on Slabs 30–4, one above and the other below.
According to Layard, the upper sequence on Slabs 30–30a showed the Assyrian assault on a
city, only a fragment of which survived at the right edge of Slab 30. On the upper part of
Slabs 31–3 was the procession of prisoners from the defeated city, driven to the right to be
recorded by the usual pair of scribes and reviewed by the king in his chariot, accompanied by
soldiers and led horses. The Assyrian fortified camp was at the far right, on Slab 34. The
lower sequence on Slabs 30–34 showed Assyrian cavalry pursuing fleeing enemy horsemen,
evidently fugitives from the city on Slab 30a. On Slabs 30–32, Assyrian horsemen were
shown riding to the right over mountains, while on Slabs 33–4 they caught up with their
quarry and dispatched the hindmost.

Sequence 4 (pls. 164–79): This sequence, comprising Slabs 35–43, covered roughly the
north half of the east wall. Again the subject was the Assyrian assault on a city, identified in
an epigraph as [Aranz]iaš, and again the action proceeded from left to right. The approach
of the Assyrian army was not depicted. Instead the sequence began on Slabs 35–40 with the
assault, as Assyrian spear bearers mounted the city walls from all directions on siege ladders,
under the covering fire of Assyrian archers. The inevitable outcome was depicted at the bot-
tom of Slabs 37–40, where processions of prisoners and livestock were driven off to the right.
At the bottom of Slabs 41–2 were Assyrian soldiers and led horses facing left. Above them
should have been the king in his chariot, receiving the booty, but this part was lost. The
sequence ended on Slab 43 with the Assyrian fortified camp.

Sequence 5 (pls. 180–93): The final sequence in Room V extended across Slabs 44–51, end-
ing at Door *e*. Again the subject was the Assyrian assault on a city, with the action proceed-
ing from left to right. On Slabs 44–6, the Assyrian army overran a walled city beside a river
in a wooded mountainous landscape, apparently by using a ramp and siege machines. The
aftermath was on Slabs 47–51, where victorious Assyrian soldiers deposited enemy heads in
front of the king in his chariot, behind whom were soldiers with led horses. The usual pris-
oner procession was probably shown on the upper part of Slabs 46–7, now lost.

Conclusions: The emphasis in Room V was clearly on military prowess, as one enemy city
after another fell before the onslaught of the Assyrian king and army. Though four of the five
sequences read from left to right, the same direction in which one would read a cuneiform
inscription, the exception (Sequence 2) covers most of the west wall. The flow of the narratives
on the long walls of Room V, therefore, was from north to south, the opposite of the direction
of flow of the sequences in the throne room. In addition, the sequences flow outward to either

side from inner court Door *a*, leading the viewer's eye along both walls toward the south end of the room, where Door *e* led to the throne room.

COURT VI

Only three sculptured slabs (7, 7a, 8) in the southeast corner of Court VI were excavated for the Sennacherib Palace Site Museum. In order to understand their original context, it is necessary to look at the other reliefs that Layard reported on this stretch of wall. Two sequences that depicted a campaign in a mountainous region were represented on Slabs 1–15 in this area. The same subject continued along the rest of the south and west walls of Court VI, but those are beyond the scope of this study.

Sequence 1 (pls. 195–200): This sequence, which comprised Slabs 1–9, was read from left to right. On Slabs 1–2, the king and his army descended to the right from high mountains into an open vine-filled river valley bounded by wooded hills. A damaged epigraph stated that Sennacherib was on his way to conquer this region. There is no record of the sculpture on Slabs 3–6, but they probably showed the same subject as Slab 7, namely lines of Assyrian soldiers marching to the right through the same landscape. The marching sequence ended on Slab 9 with a representation of an Assyrian fortified camp.

Sequence 2 (pls. 200–201): This sequence comprised Slabs 9–13, and probably extended to Slab 15. In this sequence, the action proceeded in both directions. At the top and bottom of Slabs 10–13, Assyrian cavalry rode to the right in the hills and beside the river, massacring enemy archers. In the center of Slabs 13–10, two processions of prisoners and livestock left a burning city, the capture of which must have been depicted on the unrecorded Slabs 15–14. The prisoners were driven to the left to be listed by the scribes and reviewed by the king in his chariot. The fortified camp behind him on Slab 9 served as both the starting point for the attackers and the terminus of the booty review.

SUMMARY

A close analysis of the sculptural remains in Sennacherib's throne-room suite permits a considerable refinement of previous characterizations based only on a selection of the reliefs. The throne room itself, Room I, now appears to have been decorated with two different campaigns: the fifth campaign, to the north, on the west wall, and the third campaign, to the west, on the east wall. Each of these long walls appears to have featured at least one major triumph, the conquest of Ukku on the west wall and, possibly, the defeat of the Egyptians at Eltekeh on the east wall. Another geographical area was represented in the alcove at the north end of the throne room, which showed the conquest of Dilbat in Babylonia during the first campaign. A Babylonian campaign was also depicted on the throne-room façade, but this was later erased and cannot now be identified. The geographical circuit was completed in Room V, which showed the defeat of a series of cities, including Kasusi and [Aranz]iaš, in the course of the second campaign, to the Zagros mountains in the east. This seems also to have been the subject in the southeast corner of Court VI.

If these identifications are correct, therefore, Sennacherib's campaigns to the north, south, east, and west were all prominently displayed in the throne-room suite, and three of these (north, south, west) would have been visible from anywhere in the throne room. Room IV appears to have introduced another subject – though the location of its setting cannot now be identified, its subject appears not to be military action, but rather the peaceful delivery of tribute, which was, after all, one of the primary objectives of the military threat. The placement of this subject in Room IV, which appears to have been a private ceremonial space, suggests that while visitors to the throne room were presented exclusively with a public message of Assyrian military invincibility, the king and his attendants also perceived the rewards of Assyrian power. This is perhaps comparable to the subject on the northeast side of Court VI, which showed the use of captive labor to fashion and deliver bull colossi for the palace at Nineveh. Those reliefs too would have been more accessible to courtiers than to visitors. The messages of the throne-room suite reliefs, then, seems to have been a warning to visitors, and a promise to the courtiers.

INSCRIPTIONS

I have published elsewhere a study on all of the inscriptions in Sennacherib's throne-room suite (Russell 1998). Here, I will only summarize the main characteristics of each inscription, with references to the fuller study.

The spaces between the legs of all the colossi on the throne-room façade and in the doors of Sennacherib's throne-room suite were inscribed with long texts that described the construction and appearance of the palace, in most cases prefaced by a historical summary or, in one case, a full annalistic text. All of these texts are identified in Russell 1998, Catalogue 3. This summary begins with the colossi on the throne-room façade and then proceeds to those in the doorways.

Concerning the inscriptions on the colossi numbered 1, 3, 10, and 12 of the throne-room façade, Layard (1853a: 138) reported: "On the four bulls of the façade were two inscriptions, one inscription being carried over each pair, and the two being of precisely the same import."[37] To the contrary, my examination of the remains of the inscriptions on Bulls 1, 3, and 12 showed that the same text was repeated in full on each of the four bulls. These fragmentary inscriptions, which have not been published elsewhere, are included here as Appendix 1 (pls. 202–7). From these fragments, it is possible to reconstruct most of the original text, which began with a brief historical summary of Sennacherib's first six campaigns, and concluded with a palace building account. The details of the individual exemplars are given in the Catalogue.

Three additional texts were inscribed on the colossi in the doors of the throne-room suite. In every case, the inscription was carried across both colossi in the door, beginning on one and concluding on the other. The shortest text was a long palace building account, inscribed on the smallest of the colossi, in Court H, Door *c*, and Court VI, Door *a*. The same building account, prefaced by a brief summary of the conquests of Sennacherib's first five years, was on the larger colossi in Room I, Doors *d* and *e*. The longest text, which consisted of the same building account prefaced by a full annalistic account of Sennacherib's first six years, was inscribed on the largest colossi, in Court H, Door *a*, the main entrance to the throne room.

Two patterns seem clear here. First, in the doorways, larger colossi generally carry longer texts. This is not true, however, for the colossi on the throne-room façade, each of which was carved with the same relatively short text. Second, the inclusion of a five-campaign summary on the colossi in Room I, Doors *d* and *e*, suggests that the texts on the colossi in the interior of the throne room were carved before those on the façade and its main door, all of which record six campaigns.

Two other types of inscriptions were found in Sennacherib's throne-room suite. Brief explanatory captions were carved on a number of the reliefs in the throne-room suite: Room I, Slabs 1, 5, 14, 27, Room III, Slab 8, Room V, Slabs 11, 32, 37, 43, and Court VI, Slab 2. General information for each one is included here in the catalogue. Full editions are published in Russell 1998, Catalogue 4. In addition, brief inscriptions that identified the king and palace were carved on the threshold slabs in throne room Doors *a* and *e*. I have published the full texts elsewhere.[38]

3 PATTERNS OF DESTRUCTION

When the documentation for Sennacherib's throne-room suite over the period from its first excavation until the present is examined, it becomes clear that a considerable part of the structure has been destroyed during that time. The greatest part of this destruction appears to have occurred in three phases, each of which was characterized by a different primary destructive force: collecting, exposure, and looting. This section details the causes and effects of each of these destructive forces.

The first destruction phase, collecting, was associated with Layard's initial excavation of the palace in search of Assyrian antiquities for the collections of the British Museum. Layard himself did very little damage to the throne-room suite, however, apart from initiating the processes of deterioration through the very act of excavation. Because of time and financial constraints during his first period of excavation at Nineveh, he only removed a single sculpture from the throne-room suite, a piece from the bottom of Slab 20c in Room I. During his second excavation campaign at Nineveh, he removed many more sculptures, but these all came from the new areas he was excavating, to the west of the throne-room suite. The most substantial loss to the throne room during the phase of collecting for the British Museum was apparently instigated by Layard from London in 1854, three years after he had left Nineveh. At this time, the philologist Henry Rawlinson was overall supervisor of the British Museum excavations in Assyria. In a letter to Sir Henry Ellis, Principal Librarian (Director) of the British Museum, Rawlinson complained about Layard wanting the great pair of bull colossi in the central door of the throne room for the British Museum.[39] Rawlinson complied, but in order to save weight, he exported only the inscription with its account of Sennacherib's siege of Jerusalem. All of the sculptured parts were destroyed in the process of being sawn away, leaving only the plain bases of what were once the largest of the Assyrian colossi.

The process of destruction through exposure began after Layard's departure from Nineveh in 1851. With the help of Layard's notes, drawings, and plans, it is relatively easy to identify which areas later suffered loss, but it is not always possible, in the absence of intermediate documentation, to state when this loss occurred. It appears that either Layard or his later nineteenth-century successors at Nineveh backfilled most of the trenches in the throne room area, as King reported that he had to reexcavate this part during his search for tablets. At least one area, however, around Door *a* of Court VI, may not have been backfilled, as King found the south bull colossus here completely exposed to the elements when he first visited Nineveh in 1901. King photographed this bull from both sides and noted: "The winged bull which was left uncovered in the palace of Sennacherib has also suffered" (figs. 27, 28).[40]

The most striking thing about this bull in King's photographs, however, is not the damage it has suffered, but rather the disappearance of everything around it. The north bull in the doorway had vanished, as had Slabs 1–6 in Court VI. It is more difficult to judge the extent of the loss in Room V, but it appears that the deep trench shown in the photograph extended across the reliefs in the northwest quarter of the room. According to Layard's text copy and notes, at least the inscribed part of the north bull was preserved at the time of his excavations, and according to his notes and drawings, Slabs 1 and 2 in Court VI, and Slabs 18, 30, and 31 in Room V were preserved to a considerable height. Presumably, the deep trench and exposed

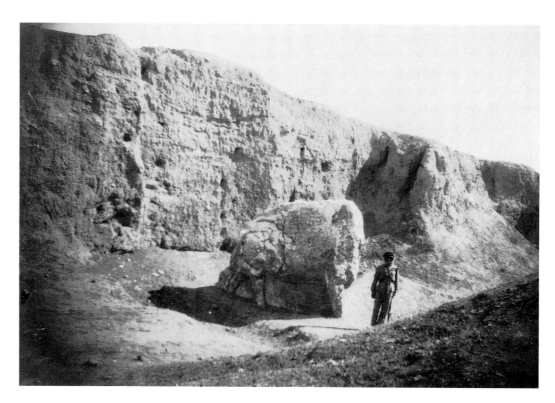

fig. 27: Nineveh, Sennacherib's palace, Court VI, Door *a*, Bull 2, from the front, 1901, photo by L. W. King, neg. PS 257455 (photo: Trustees of the British Museum).

south bull shown in King's photographs explain the disappearance of the other sculptures in this vicinity. I cannot account for the presence of this trench, but it may be that following the removal of Slabs 63–7 from Court VI to the British Museum, this area was not considered worth backfilling.

The most drastic examples of destruction through exposure, however, occurred at the north end of the throne room following the close of King's excavations in the area in 1903.

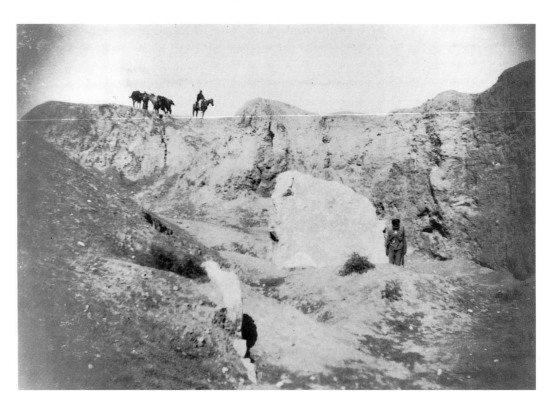

fig. 28: Nineveh, Sennacherib's palace, Court VI, Door *a*, Bull 2, from the back, 1901, photo by L. W. King, neg. PS 257454 (photo: Trustees of the British Museum).

King's photographs show all of the following sculptures as preserved either to their full height or to a substantial height: Court H, Door *c*, Bull 2; Room I, Door *d*, both bulls; Room I, Slabs 20, 20a, 20b, 20c, 20d, 21, 24, and 25. When Madhloom reexcavated this area in 1965, the bulls in Door *d* and Slabs 20a, 20b, 20c, 20d, and 21 had completely disappeared, and only the lower part remained of the others. It seems clear that despite King's claim to have reburied this area, the sculptures at the north end of the throne room either remained exposed, or were later uncovered and destroyed.

Two other areas suffered substantial loss of sculptures sometime between Layard's and Madhloom's excavations, but this destruction cannot be dated. None of the sculptures from Room III appear to have survived at the time of Madhloom's excavations. Given his record in this area, King is the logical suspect. It appears from his photographs that he excavated this room, but no sculptures are visible, and they may already have disappeared before he got there (pls. 24, 25). The other area of substantial undated loss is the throne-room façade, Court H. According to Layard's drawings, Slabs 4, 5, 10, 11, and 12 were preserved to a considerable height, and Malan showed Slab 9 as similarly preserved. By the time of Madhloom's excavations, all of these sculptures had disappeared. This was the last area to be excavated by King, and with no further earth being dug nearby to dump here, he may not have bothered to backfill it.

Madhloom's excavation of the throne-room suite and its conversion into a site museum in 1967 did not result in any dramatic deterioration to the surviving reliefs. Small pieces became detached from a few slabs over time and were presumably put into storage pending conservation, and the upper part of one relief, Slab 23, collapsed between 1989 and 1990 (fig. 29).

fig. 29: Nineveh, Sennacherib Palace Site Museum, Room I, Slab 23, 1990 (photo: author).

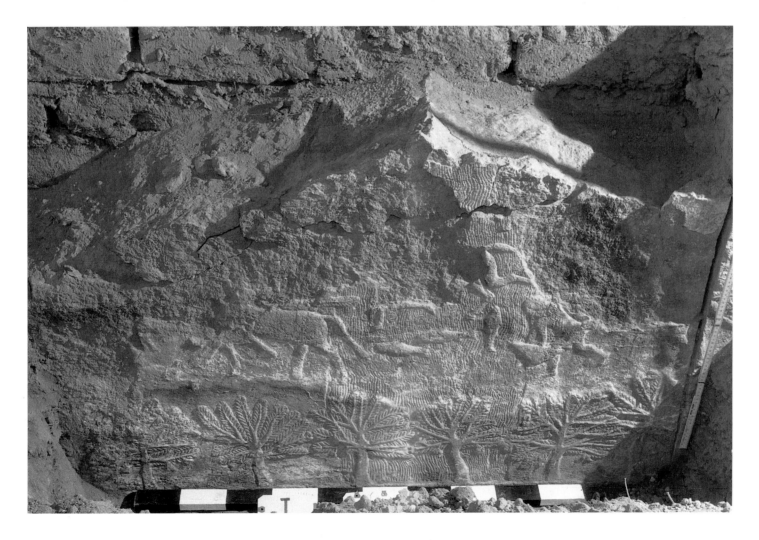

Indeed, by 1990, after twenty-five years of Mosul air and weather, the sculptures were ready for a thorough conservation assessment and treatment program. One of the things I hoped to accomplish through the throne-room documentation project was to develop international support for a collaborative conservation program between the Iraq Department of Antiquities and Heritage and international preservation organizations. Given the historical and artistic importance of Sennacherib's palace, I believed that such a program would be relatively easy to fund and implement.

International sanctions against Iraq in the wake of the occupation of Kuwait ended those hopes and triggered the third destructive phase, looting. Iraq was sealed off from all but humanitarian collaborations. The sanctions placed unprecedented survival pressures on a populace that is among the most heritage-conscious in the world. Shortages of basic necessities, coupled with international demand for Assyrian art, fueled a plague of archaeological looting that would have been unimaginable before the sanctions. One of the victims of this looting was the Sennacherib Palace Site Museum. Twelve relief fragments, broken from eleven different reliefs on display in the museum, were known to be on the international art market – Slabs 7, 16, and 24 from Room I, Slabs 4 and 8 from Room IV, and Slabs 1, 15, 16, 17, 39, and 43 from Room V – and there were presumably more fragments that I had not seen (fig. 14, pls. 135–6, 248–77). Although United States restrictions on travel to Iraq have prevented me from assessing the destruction first-hand, recent photographs of the site confirm that these and other slabs have been reduced to piles of rubble. In addition, three fragments from storage areas were on the market (figs. 8, 9, pl. 209).

The process by which large relief slabs were converted into small marketable fragments is noteworthy. In cases where the surrounding relief surface was not well preserved, these parts were broken away to create a well-preserved fragment, as on slabs V:15 and V:39. A similar case is a fragment, IV:4, that shows small figures behind a city wall. The large figures directly above the city were completely broken away, evidently so that their large scale would not distract from the interest of the miniature scene below.

In several cases (I:24, V:1, V:39) fragments were squared off to give the impression that these are complete, self-contained compositions. All of the fragments were mounted vertically on bases, in some cases without respect to the sculpture's original orientation. Fragment V:1 was squared off diagonally and then mounted vertically, so that the figure seemed to be falling forward, quite unlike its original position on the slab. Whoever mounted these fragments knew so little about Assyrian art that they did not realize that a lozenge pattern in the background, which represents mountains, is always oriented vertically. Fragment V:17, which shows a cowering crouching figure, was mounted so that the man is oriented as if standing, with the result that the mountain pattern angles to the left. Fragments V:39 and I:16 are also tilted. The most dramatic example of this is fragment V:16, which showed a pair of archers shooting toward a city on top of a mountain. The piece was mounted so that the archers shoot horizontally, with the mountain pattern almost horizontal behind them.

These examples of trimming and reorienting show how important context is in understanding the significance of each fragment, and how much crucial information is lost in the breaking up of a sculptured slab into fragments for the antiquities market. Viewed in isolation, these fragments carry no hint of their original meaning or context. Not only have unique cultural artifacts been destroyed, but even the fragments that remain have been reduced to incomprehensible ciphers, the meaning of which was lost with the destruction of the full composition.

As I write this, the present location of all but one of these looted fragments is unknown. Anyone who is offered them for purchase is requested to notify the seller that the sculptures were removed illegally from Nineveh, and to ask the seller to turn them over to an Iraqi embassy or interests section, Interpol, or to a customs agency, so that they may be returned to Iraq. Potential buyers of Sennacherib fragments should be aware that very few such pieces appear legitimately on the market, and that many more fragments may have been smuggled out of Iraq, either from relief slabs known to have been broken up, or from

other slabs in the palace museum. Any Sennacherib relief fragment should be treated with great caution.

Today the Sennacherib Palace Site Museum at Nineveh represents a world heritage disaster of the first magnitude. Immediate emergency conservation measures are required to preserve what remains of its sculptures. Unfortunately, the same United Nations sanctions that have contributed to the destruction of the palace museum also prohibit any form of international cultural assistance within Iraq. Though the United Nations Security Council treats humanitarian assistance as an exception to the sanctions, no such exception has been allowed for the preservation of heritage. Using its veto on the Security Council, the United States has repeatedly denied permission for international teams to assess damage and threats to the cultural patrimony of Iraq in the wake of the Gulf War, despite the urgent need for documentation and conservation due to wartime damage, postwar looting, and emergency agricultural development. This hostility may reflect a widespread western perception that modern Iraq has no significant heritage, even while claiming ancient Mesopotamia as its "Cradle of Civilization." This disaster also highlights the role of the West as a myopic consumer of heritage, rather than cherishing it as a vanishing irreplaceable shared resource.

Sadly, one of the recurring themes in this study is that Sennacherib's palace is no longer what it once was. It is a great shame that the building was destroyed in antiquity, but this was an inevitable consequence of the sack of Nineveh. It is an even greater shame that so much of what remained of the building has been destroyed since its excavation in the nineteenth century. Was this also inevitable? This study has examined the patterns of deterioration and destruction in Sennacherib's throne-room suite since the mid-nineteenth century. My purpose here has been not to point fingers, but to argue that just as heritage is a shared cultural resource, so too is its preservation a collective responsibility. As long as the maintenance of heritage remains only a local or minority concern, while others work actively to destroy it, aided by those who work to prevent constructive remedies, the type of heritage disaster exemplified by Sennacherib's palace will continue to be as inevitable as it is commonplace.

RECOMMENDATIONS

In the case of Assyrian palaces, as with the remains of all past cultures, it is worth remembering that they're not making any more of them. Once we've used them up, they're gone for good. The story of the excavation of Sennacherib's throne-room suite at Nineveh, and of the forces that have subsequently destroyed much of it, suggests three specific recommendations that might help to prevent other such tragedies. Though only the first of these recommendations is commonly acknowledged as essential, all three seem self-evident in light of the realities of heritage preservation.

The first recommendation, often cited, but less often implemented, is that every archaeological excavation should be fully documented and fully published. The tragedy of Sennacherib's throne room is not only that so much of it has been destroyed, but that so much was destroyed without ever having been recorded. Botta and Flandin, the founders of Assyrian archaeology even before Layard, clearly appreciated the importance of making a full record of their finds, and their sponsor, the French government, understood that the scientific value of the excavations was only as good as the quality of its publication. Had Layard, King, Madhloom, and their sponsors followed the example of Botta and Flandin, we would know as much today about Nineveh as they did when they excavated it.

Every excavator knows that archaeological remains are often either too useful to modern consumers or too fragile to survive exposure, and that significant deterioration begins to occur within days of the initial excavation. The moment of excavation is the time when archaeological remains contain the greatest amount of ancient information. If that moment is not used to make the fullest possible record, then something is lost forever. And if those records are not published adequately, then the excavations have no historical value, and the

information that was recovered is itself at risk of being lost. Without publication, excavation represents only the pointless destruction of a site.

My second recommendation is that as soon as a site has been excavated and recorded, it should be reburied immediately. Once they have been recorded, archaeological remains have served the purpose for which they were excavated. Immediate and complete backfilling is the cheapest and safest way to preserve what remains for future investigations. In cases where the standing remains are of such interest that it is deemed desirable to display them to the public, this should be done only with a full commitment to providing the substantial immediate and long-term funding necessary to preserve the site.

These first two recommendations are the responsibility of archaeologists and their sponsors, and these groups would probably generally agree on their value. My final recommendation involves everyone, and will probably not evoke general agreement. I recommend that the preservation of heritage be formally declared an international humanitarian priority, rather than a pawn to be manipulated by narrow national political interests. Three major steps have already been taken in this direction with the 1954 Hague *Convention for the Protection of Cultural Property in the Event of Armed Conflict*, the 1970 *UNESCO Convention on the Means of Prohibiting and Preventing the Illicit Import, Export and Transfer of Ownership of Cultural Property*, and the 1995 *UNIDROIT Convention on Stolen or Illegally Exported Cultural Objects*, though none of these conventions has been universally ratified.

But these conventions are meaningless unless the parties involved comply with their provisions. Despite the 1954 Hague Convention, which the United States did not ratify, no specialists in the archaeology and heritage of Iraq are known to have been consulted by American military planners until late February 1991, five weeks after the bombing of Iraq began, and then only after a letter to the *Washington Post* expressed the concern of American and European scholars. Following the cessation of hostilities, the Iraq Department of Antiquities and Heritage requested assistance from UNESCO in assessing damage to cultural property. UNESCO and others repeatedly applied to the United Nations Security Council for permission to assist Iraq in this endeavor, and permission has repeatedly been denied. Furthermore, the existing conventions make no provision for the protection of heritage against the effects of economic warfare, even though in the case of Iraq, the isolation and impoverishment wrought by prolonged trade sanctions and travel restrictions has led to far greater devastation of heritage than the armed conflict did.

In late 1994, an international group of archaeologists met in Baghdad to discuss the crisis facing Iraq's heritage. Their conclusions and recommendations are very much in line with my own:

> We, the participants in the conference, believe that an embargo legitimately can never include a cultural component, since culture and the cultural heritage of any country are the common property of all human beings. Any action which harms the cultural heritage of Iraq, as the current embargo does, damages the cultural heritage of the entire world. The cultural sphere, including antiquities, must be freed from the embargo. We would emphasize action to address the most urgent needs: (a) practical intervention to stop the smuggling and the trading of stolen antiquities from Iraq and (b) helping the responsible Iraqi authorities in the rehabilitation of the Iraqi museum system, starting first with the Iraq Museum in Baghdad. A high priority must also be given to the assessment of damage due to illicit excavations, followed by the establishment of a system for monitoring the areas under greatest risk. We appeal to the Director General of UNESCO to ask that UNESCO carry out in Iraq its constitutional task: the protection of a heritage belonging not only to the Iraqi people but also to mankind.[41]

Today, the United States, through its veto on the U. N. Security Council, holds heritage hostage to a political objective, while facilitating its exploitation by outside market forces. In Iraq today, as well as in other countries where heritage is at risk due to the effects of warfare and isolation, we are now witnessing the destruction of world heritage on a scale compared

to which the burning of the ancient library of Alexandria is but a pale flicker. We have been taught that the willful destruction of heritage – the burning of books – is the suppression of freedom and knowledge. The original archive of our fascinating Mesopotamian predecessors is the as yet very incompletely examined archaeological record, just below the surface of Iraq and in its museums. That magnificent archive endured largely intact for millennia, until 1991, when we began in earnest to destroy it, unread. The permanent legacy of the sanctions is the destruction of a fundamental part of our common heritage and once this is gone, it is gone forever. To the age-old question "Where do I come from?" we will at last be able to provide a final answer: "I don't know – we burned the library."

NOTES

1 Alberge 1997, Anon. 1996a, 1996b, 1996c, Crossette 1996a, 1996b, Daniszewski 1996, Harrington 1996, 1997, Paley 1997, Russell 1996a, 1996b, 1996c, 1997b, Watson 1997.

2 King to Budge, 5.VI.03 (King 1903c: no. 322, D'Andrea 1981: 163).

3 King 1902: 8, D'Andrea 1981: 83.

4 King 1902: 5, D'Andrea 1981: 80.

5 King 1903a: 1, D'Andrea 1981: 97.

6 King to E. M. Thompson, 6.III.03 (King 1903b: no. 6, D'Andrea 1981: 147).

7 King to E. M. Thompson, 19.III.03 (King 1903d).

8 King to E. M. Thompson, 2.IV.03 (King 1903b: no. 9, D'Andrea 1981: 148).

9 King to Budge, 23.IV.03 (King 1903c: no. 318, D'Andrea 1981: 151).

10 King to Mr. Henry Dudley Barnham, [30.IV.03] (King 1903d).

11 King to E. M. Thompson, 2.V.03 (King 1903b: no. 10, D'Andrea 1981: 155–6).

12 King to E. M. Thompson, 2.V.03 (King 1903d).

13 King 1903a: 6, D'Andrea 1981: 99.

14 King 1903a: 5, D'Andrea 1981: 99.

15 King to Budge, 20.V.03 (King 1903c: no. 320, D'Andrea 1981: 158).

16 King 1903a: 8, D'Andrea 1981: 100.

17 Budge to BM Trustees, 8.VI.03, Report No. 4172, stamped #1814. London, British Museum, Central Archives, Excavation Papers, "Excavations at Nineveh. Kouyunjik. 1902–5 (King)" (copy D'Andrea 1981: 95–6).

18 King to E. M. Thompson, 1.VI.03 (King 1903b: no. 15, D'Andrea 1981: 161).

19 King to E. M. Thompson, 1.VII.03 (King 1903b: no. 19, D'Andrea 1981: 174).

20 King to E. M. Thompson, 12.VI.03 (King 1903b: no. 16, D'Andrea 1981: 166).

21 King to Budge, 17.VII.03 (King 1903c: no. 328, D'Andrea 1981: 180).

22 King to Budge, 18.IX.03 (King 1903c: no. 332, D'Andrea 1981: 192); draft letter, King to E. M. Thompson, 8.X.03 (King 1903e: 4–5, 7–9; original apparently lost).

23 King to E. M. Thompson, 4.XI.03 (King 1903b: no. 29, D'Andrea 1981: 211).

24 King 1904: 2–4, D'Andrea 1981: 109–10.

25 Madhloom 1976: 51.

26 For a view of the site at the beginning of the excavations, see Madhloom 1976: pl. 20a.

27 Madhloom 1969: 47–8.

28 el-Wailly 1965, 1966; Madhloom 1967, 1968, 1969, 1976.

29 The drawings were made possible by a very generous grant from the Raymond and Beverly Sackler Foundation.

30 Madhloom 1976: 44.

31 Russell 1995: 73–74.

32 Meuszynski 1981: plan 3; Loud 1936: fig. 71.

33 Meuszynski 1981: plan 3; Loud 1936: fig. 71.

34 Turner 1970: 183–94.

35 Turner 1970: 192.

36 Assurnasirpal II, Rooms I, L: Budge 1914: pl. 41, 42b; Assurbanipal, Room F: Barnett 1976: 40, pl. xx.

37 Layard 1853a: 138.

38 Russell 1991: 269, Russell 1998: chapter 7.

39 Rawlinson to Ellis, 13.V.1854. London, British Museum, Central Archives, Excavation Papers, box labeled "Layard 1846, Rawlinson 1854."

40 King 1902: 8, D'Andrea 1981: 83.

41 Anon. 1995.

THE PLATES

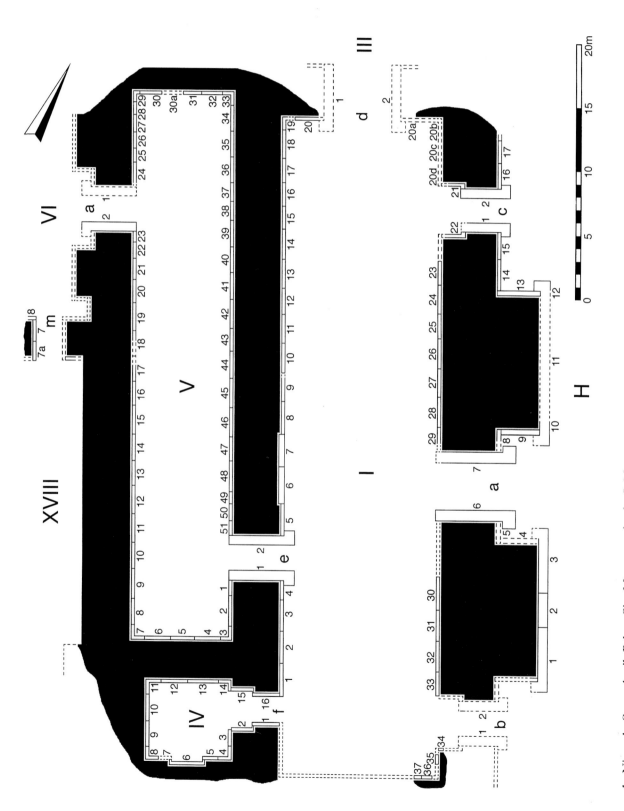

1: Nineveh, Sennacherib Palace Site Museum, plan by J. M. Russell, 1990 (source: author).

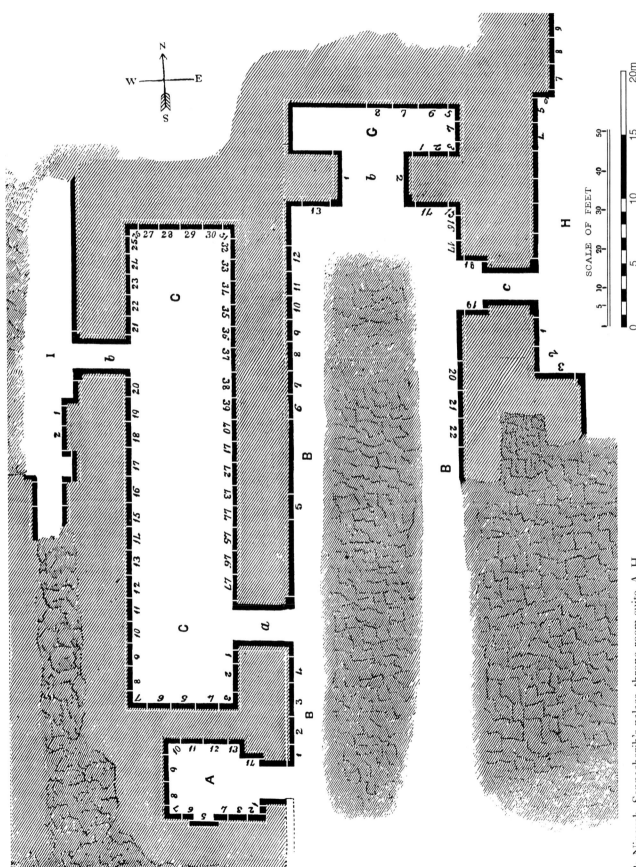

2: Nineveh, Sennacherib's palace, throne-room suite, A. H. Layard's first plan, 1849 (after Layard 1849a, vol. 2, facing p. 124).

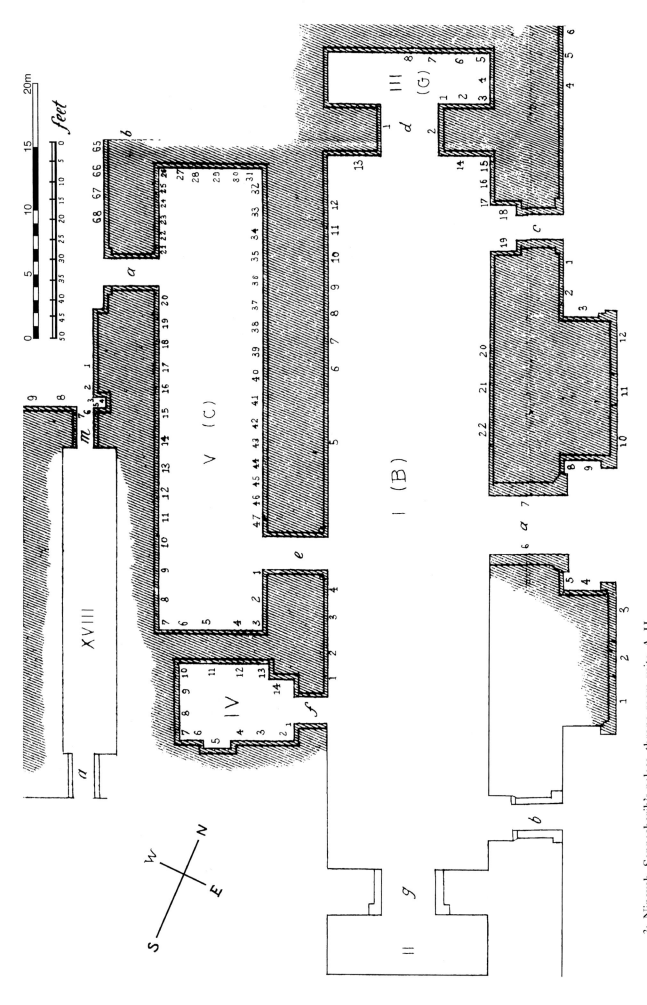

3: Nineveh, Sennacherib's palace, throne-room suite, A. H. Layard's second plan, 1853 (after Layard 1853a, facing p. 67).

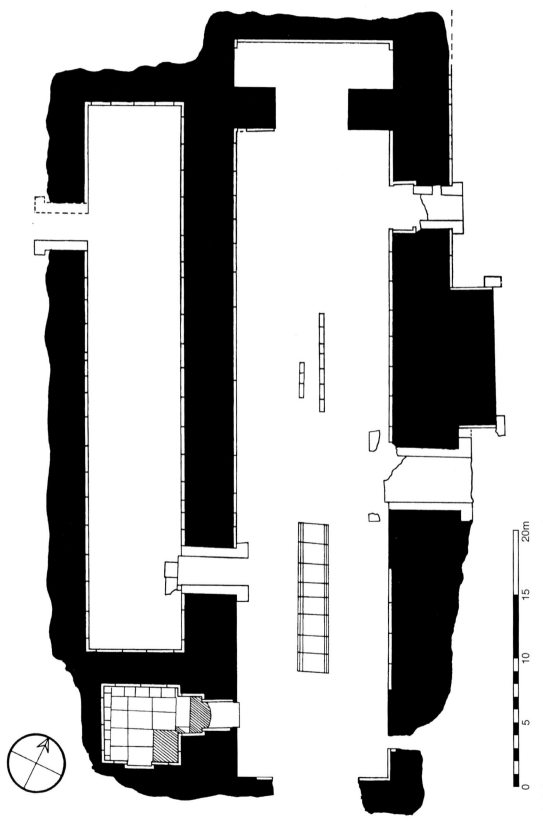

4: Nineveh, Sennacherib Palace Site Museum, plan by T. Madhloom, 1967 (after Madhloom 1967, pl. IX).

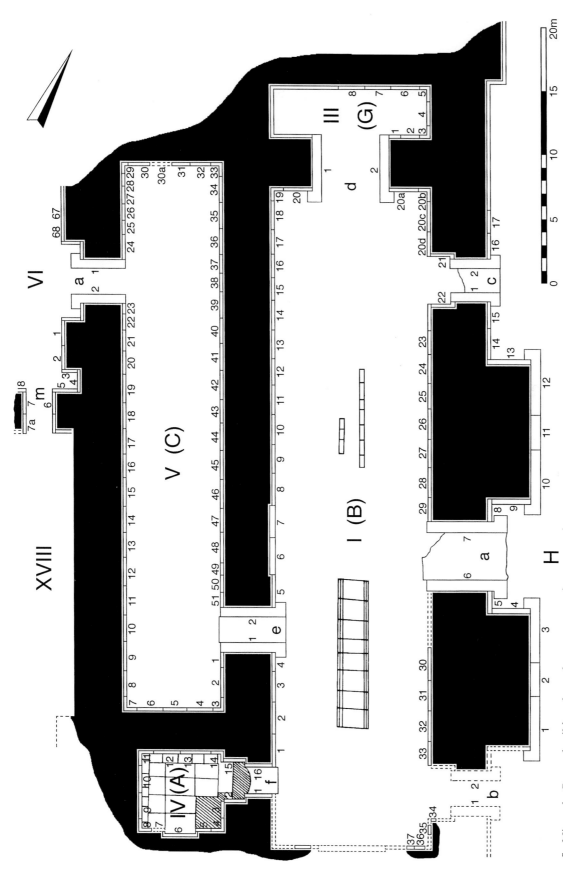

5: Nineveh, Sennacherib's palace, throne-room suite, composite plan by J. M. Russell (source: author).

6: Nineveh, Sennacherib Palace Site Museum, Court H, Door *c*, Bull 1, 1990, not to scale (photo: author).

7: Nineveh, Sennacherib Palace Site Museum, Court H, Door *c*, Bull 2, 1990, not to scale (photo: author).

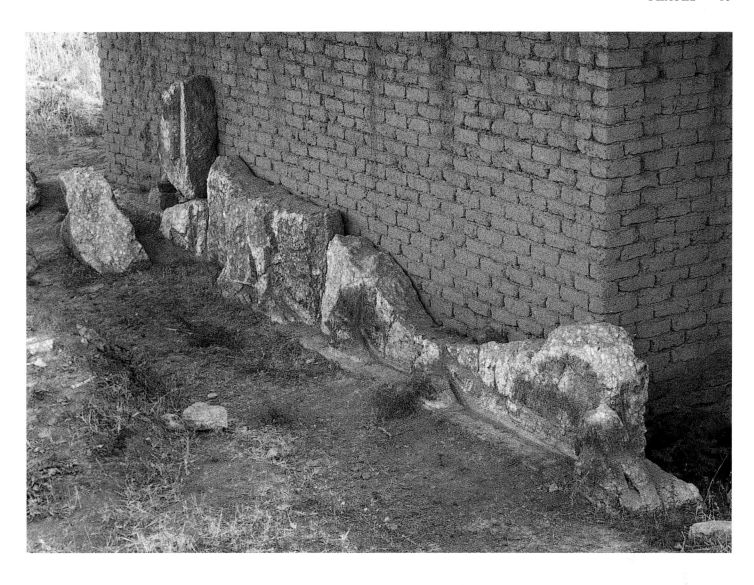

8: Nineveh, Sennacherib
Palace Site Museum, Court H,
Bulls 1–3, general view, 1989,
not to scale (photo: author).

9: Nineveh, Sennacherib
Palace Site Museum, Court H,
Bull 1, 1990, not to scale
(photo: author).

10: Nineveh, Sennacherib Palace Site Museum, Court H, Slab 2, whole, 1990, not to scale (photo: author).

11: Nineveh, Sennacherib Palace Site Museum, Court H, Bull 3, 1990, not to scale (photo: author).

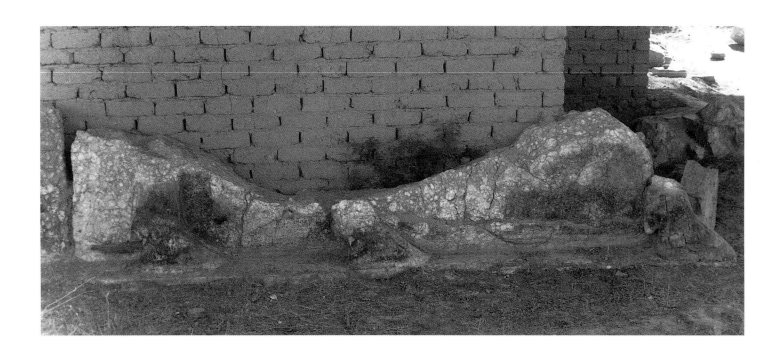

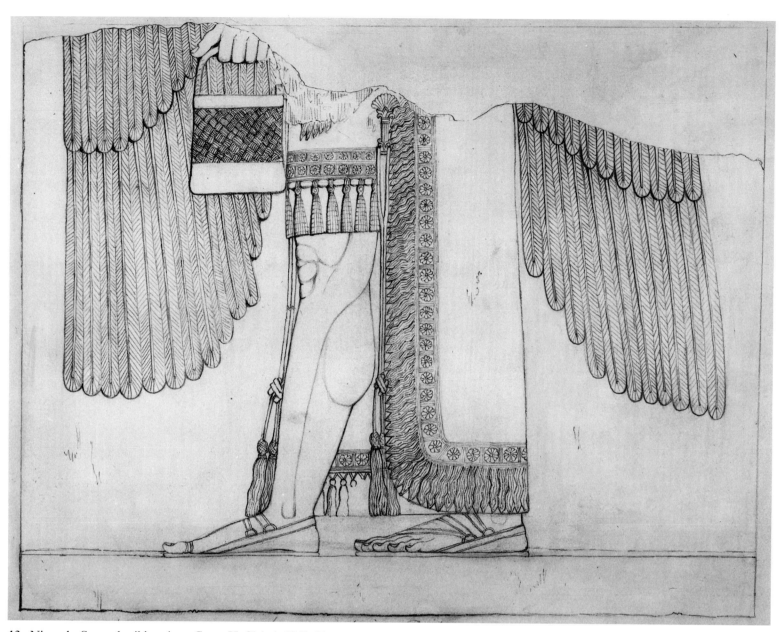

12: Nineveh, Sennacherib's palace, Court H, Slab 4, 1849–51,
not to scale, drawing probably by A. H. Layard, Or. Dr. IV, 1
(photo: Trustees of the British Museum).

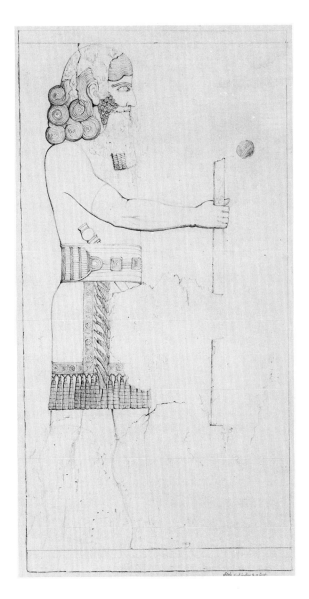

13: Nineveh, Sennacherib's palace, Court H, Slab 5, 1849–51, scale 1:12, drawing probably by A. H. Layard, Or. Dr. IV, 2 (photo: Trustees of the British Museum).

14: Nineveh, Sennacherib Palace Site Museum, Court H, Bull 6, sawn base, 1990, not to scale (photo: author).

15: Nineveh, Sennacherib Palace Site Museum, Court H, Bull 7, sawn base, 1989, not to scale (photo: author).

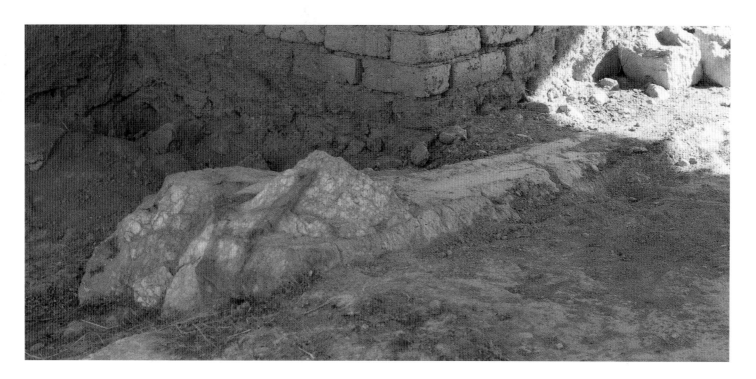

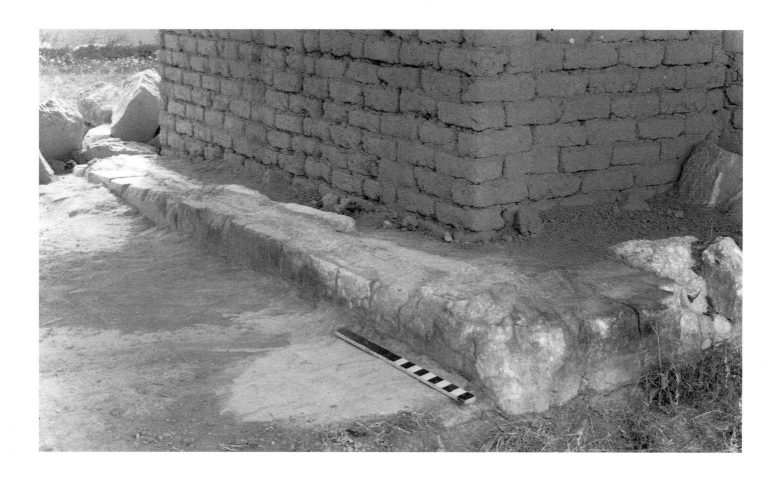

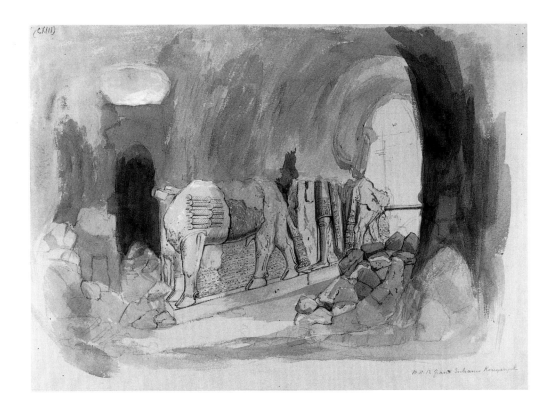

16: Nineveh, Sennacherib's palace, Court H, Bulls 7 and 10–12, 1849–51, not to scale, brown wash drawing, probably by A. H. Layard or F. C. Cooper, Or. Dr. II, 49b (photo: Trustees of the British Museum).

17: Nineveh, Sennacherib's palace, Court H, Bulls 10–12, 1849–51, not to scale, drawing probably by A. H. Layard, Or. Dr. I, 33 (photo: Trustees of the British Museum).

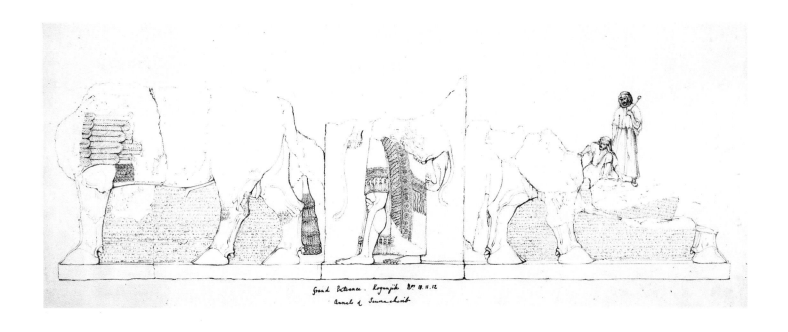

18: Nineveh, Sennacherib
Palace Site Museum, Court H,
Bull 10, 1990, not to scale
(photo: author).

19: Nineveh, Sennacherib
Palace Site Museum, Court H,
Bull 12, whole, 1989, not to
scale (photo: author).

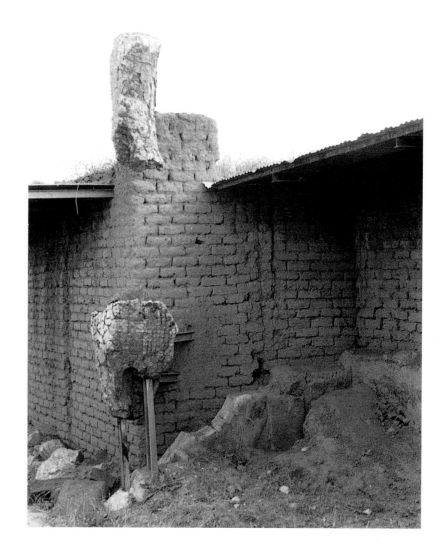

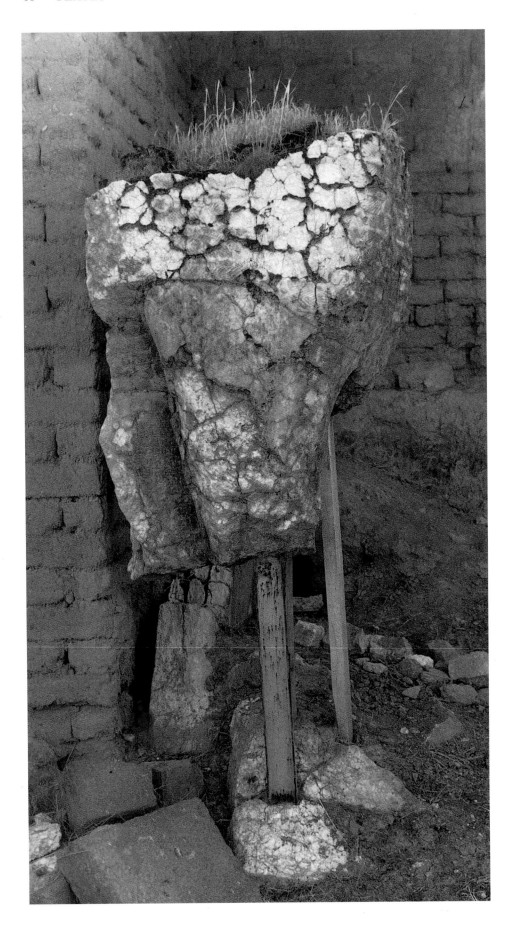

20: Nineveh, Sennacherib Palace Site Museum, Court H, Bull 12, inscribed fragment, 1990, not to scale (photo: author).

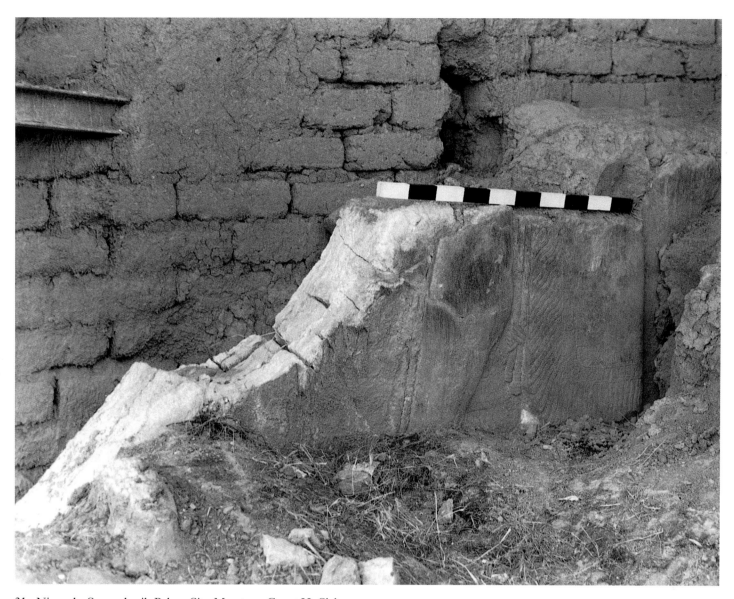

21: Nineveh, Sennacherib Palace Site Museum, Court H, Slab
13, 1990, not to scale (photo: author).

22: Nineveh, Sennacherib Palace Site Museum, Court H, Slab
15, 1989, scale 1:12 (photo: author).

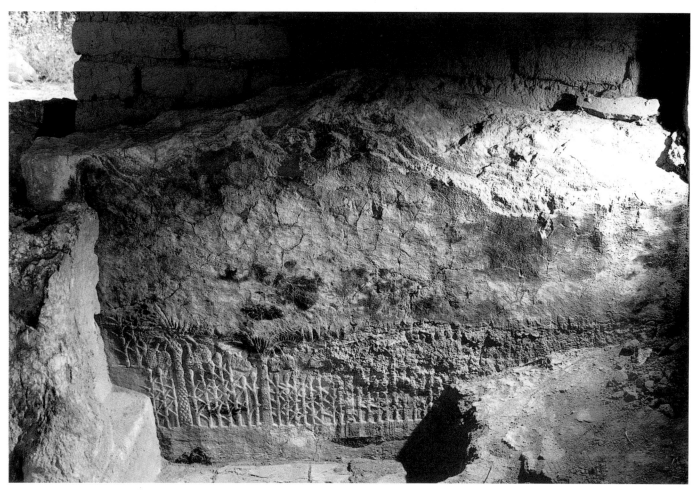

23: Nineveh, Sennacherib Palace Site Museum, Court H, Slab 16, 1990, scale 1:12 (photo: author).

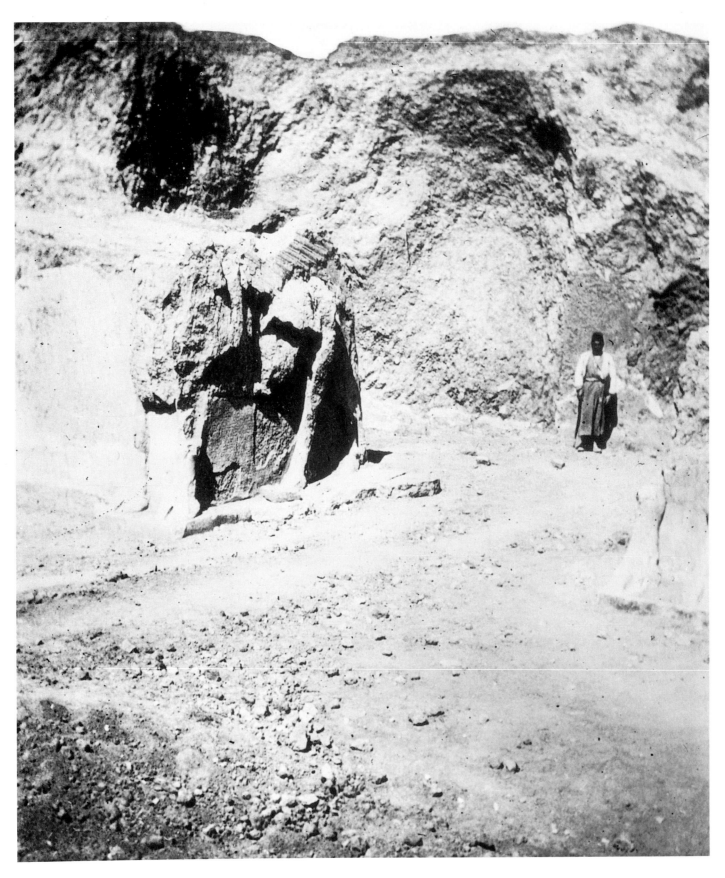

24: Nineveh, Sennacherib's palace, Room I, Door *d*, Bull 1,
1903–4, not to scale, photo by L. W. King, neg. PS 056505
(photo: Trustees of the British Museum).

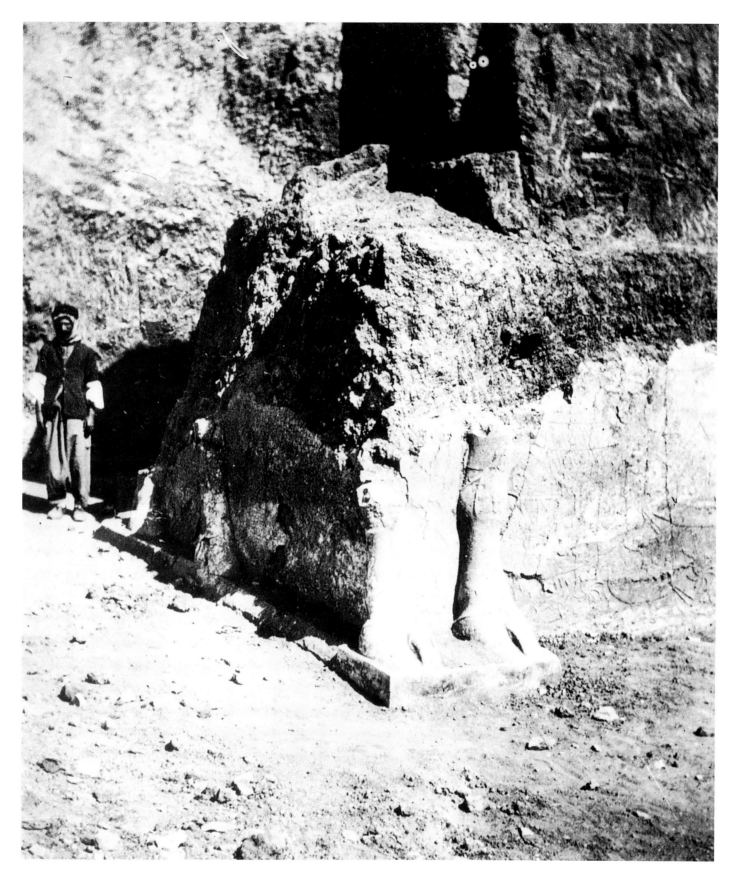

25: Nineveh, Sennacherib's palace, Room I, Door *d*, Bull 2,
1903–4, not to scale, photo by L. W. King, neg. PS 056507
(photo: Trustees of the British Museum).

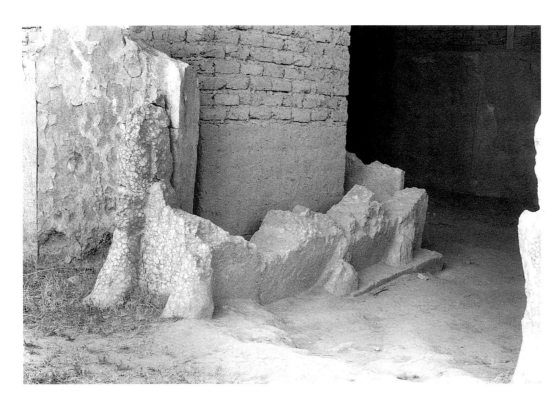

26: Nineveh, Sennacherib Palace Site Museum, Room I, Door *e*, Bull 1, 1989, not to scale (photo: author).

27: Nineveh, Sennacherib Palace Site Museum, Room I, Door *e*, Bull 2, 1989, not to scale (photo: author).

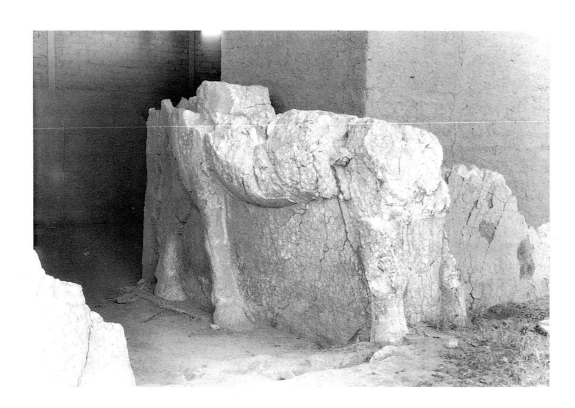

28: Nineveh, Sennacherib
Palace Site Museum, Room I,
Door *e*, threshold, 1990, not to
scale (photo: author).

29: Nineveh, Sennacherib's
palace, Room I, Door *e*,
threshold, 1847, not to scale,
drawing by A. H. Layard, Or.
Dr. V, 56 (photo: Trustees of
the British Museum).

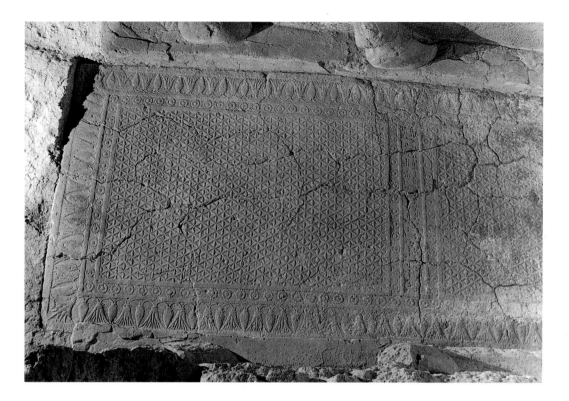

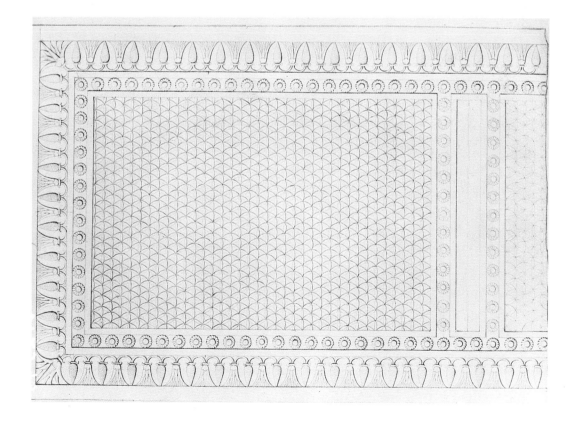

30. Nineveh, Sennacherib Palace Site Museum, Room I, Slab 1, 1990, scale 1:12 (photo: author).

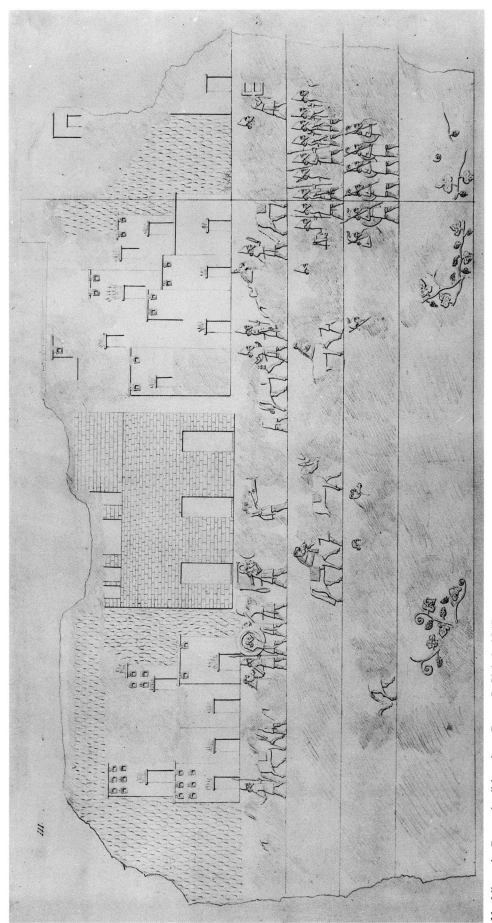

31: Nineveh, Sennacherib's palace, Room I, Slab 1, 1847, not to scale, drawing by A. H. Layard, Or. Dr. IV, 3 (photo: Trustees of the British Museum).

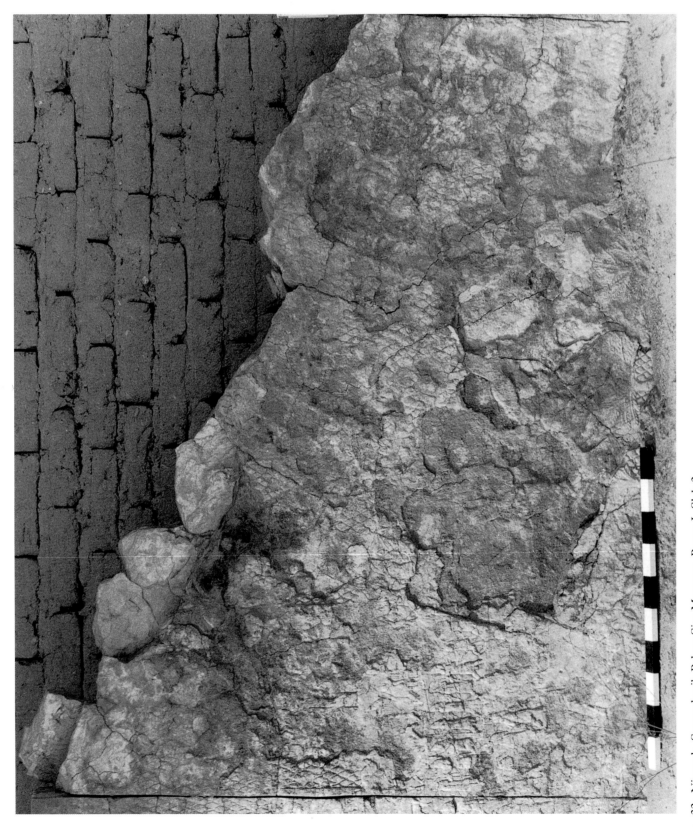

32: Nineveh, Sennacherib Palace Site Museum, Room I, Slab 2, 1990, scale 1:12 (photo: author).

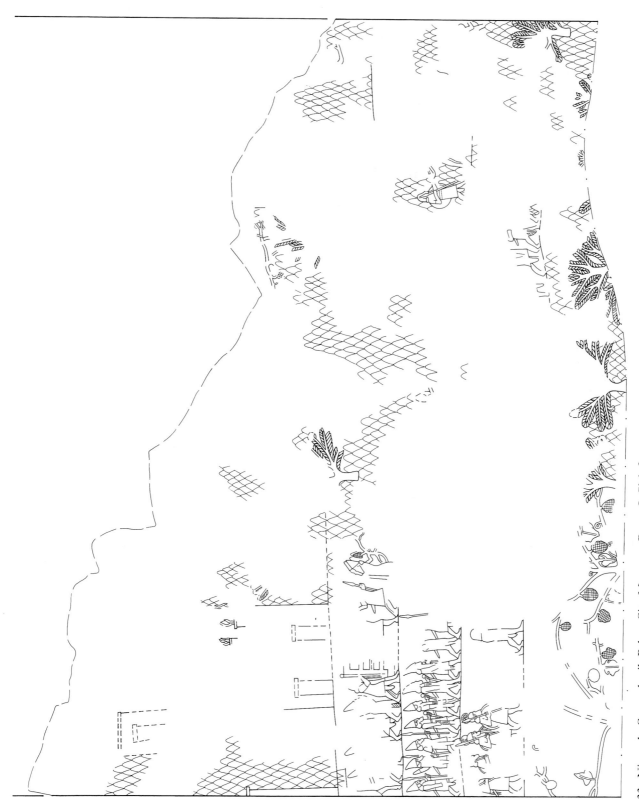

33: Nineveh, Sennacherib Palace Site Museum, Room I, Slab 2, 1990, scale 1:12, drawing by Jennifer Hook in consultation with Denise L. Hoffman and the author (source: author).

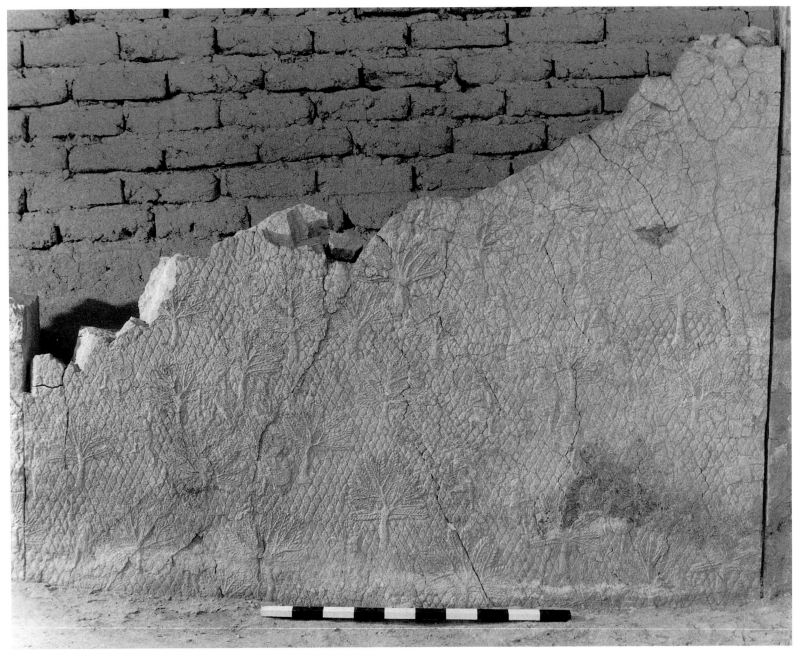

34: Nineveh, Sennacherib Palace Site Museum, Room I, Slab 3,
1990, scale 1:12 (photo: author).

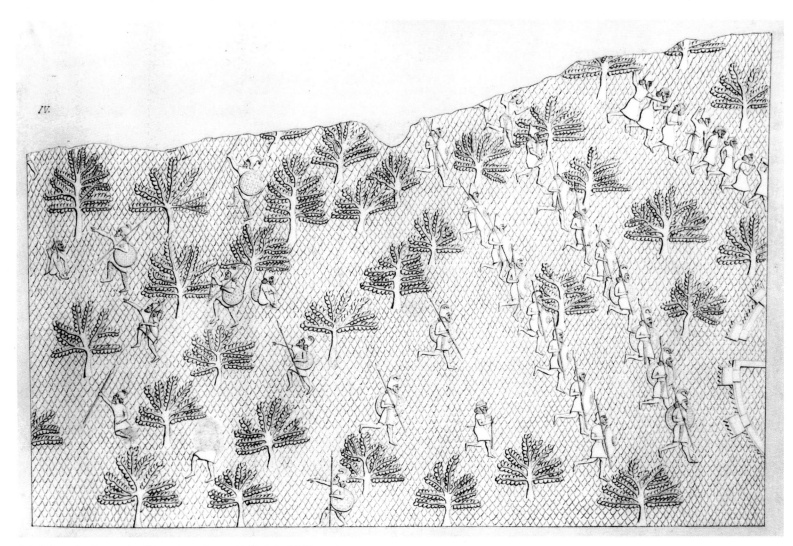

35: Nineveh, Sennacherib's palace, Room I, Slab 3, 1847, scale
1:12, drawing by A. H. Layard, Or. Dr. IV, 4 (photo: Trustees of
the British Museum).

36: Nineveh, Sennacherib Palace Site Museum, Room I, Slab 4, 1990, scale 1:12 (photo: author).

37: Nineveh, Sennacherib
Palace Site Museum, Room I,
Slab 4, 1990, scale 1:12,
drawing by Jennifer Hook in
consultation with Denise L.
Hoffman and the author
(source: author).

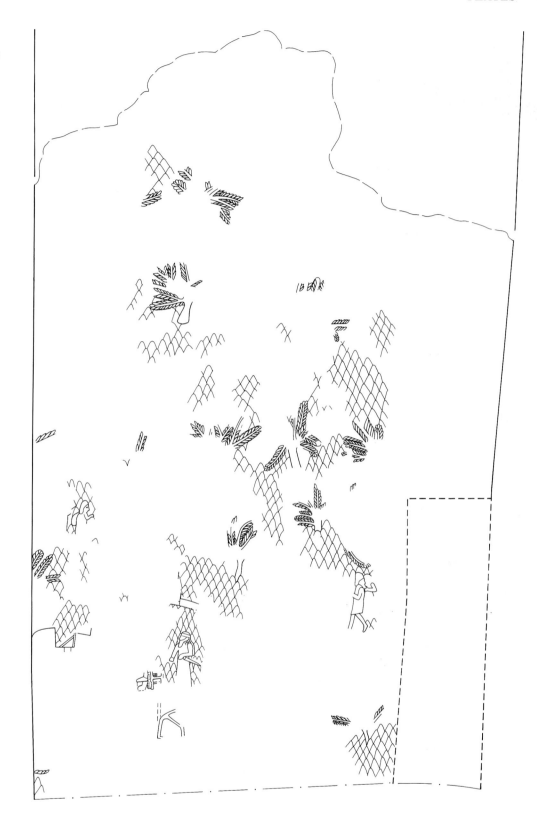

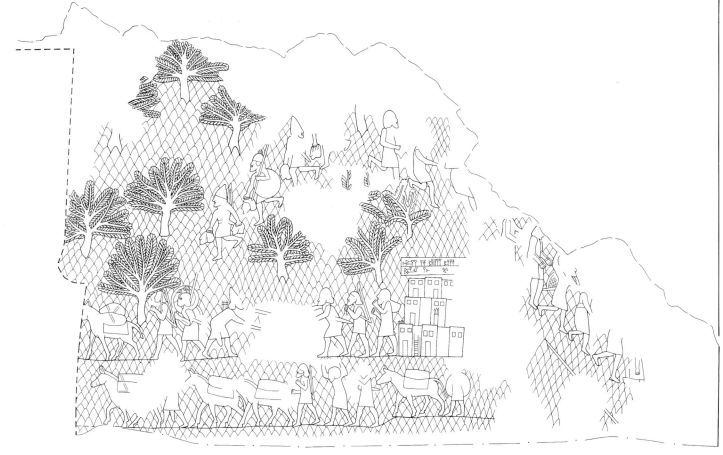

40: Nineveh, Sennacherib's palace, Room I, Slab 5, partial
view, plus adjacent Slab 6 to right, now lost, 1903–4, not to
scale, photo by L. W. King, neg. PS 139271 (photo: Trustees
of the British Museum).

38: Nineveh, Sennacherib Palace Site Museum, Room I, Slab
5, 1990, scale 1:12 (photo: author).

39: Nineveh, Sennacherib Palace Site Museum, Room I, Slab
5, 1990, scale 1:12, drawing by Jennifer Hook in consultation
with Denise L. Hoffman and the author (source: author).

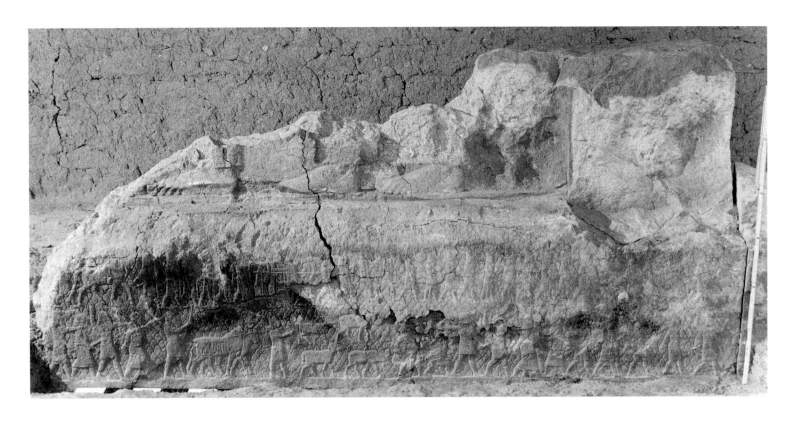

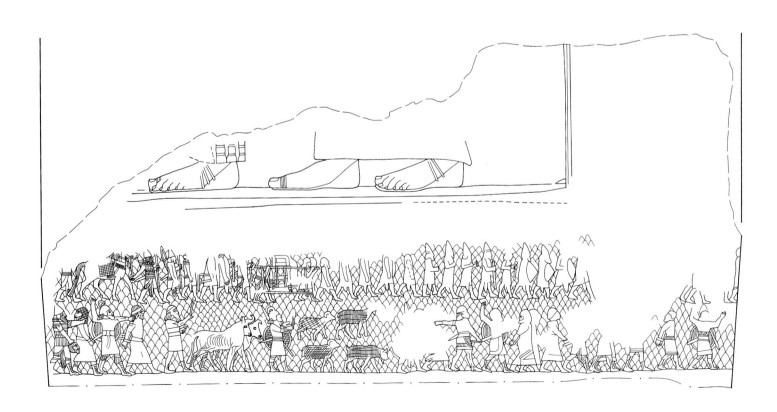

41: Nineveh, Sennacherib Palace Site Museum, Room I, Slab 7, 1990, scale 1:12 (photo: author).

42: Nineveh, Sennacherib Palace Site Museum, Room I, Slab 7, 1990, scale 1:12, drawing by Jennifer Hook in consultation with Denise L. Hoffman and the author (source: author).

43: Nineveh, Sennacherib's palace, Room I, Slab 14?, 1847, scale 1:12, drawing by A. H. Layard, Or. Dr. IV, 5 (photo: Trustees of the British Museum).

44: Nineveh, Sennacherib Palace Site Museum, Room I, Slab 14, 1990, scale 1:12 (photo: author).

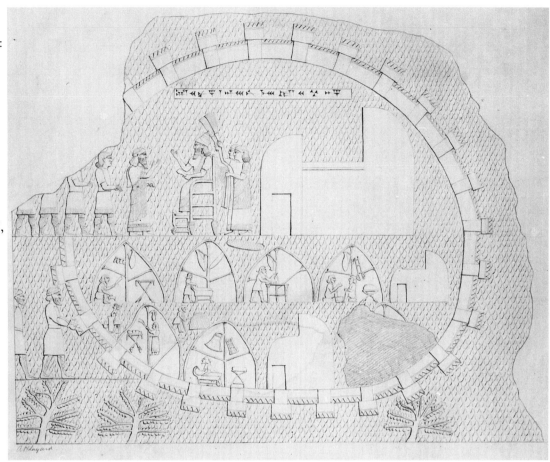

45: Nineveh, Sennacherib Palace Site Museum, Room I, Slab
15, 1989, scale 1:12 (photo: author).

46: Nineveh, Sennacherib Palace Site Museum, Room I,
Slab 15, 1990, scale 1:12, drawing by Jennifer Hook in
consultation with Denise L. Hoffman and the author
(source: author).

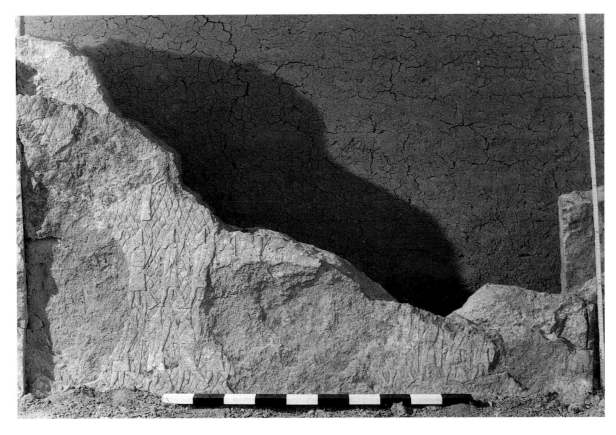

47: Nineveh, Sennacherib Palace Site Museum, Room I, Slab 16, 1990, scale 1:12 (photo: author).

48: Nineveh, Sennacherib Palace Site Museum, Room I, Slab 16, 1990, scale 1:12, drawing by Jennifer Hook in consultation with Denise L. Hoffman and the author (source: author).

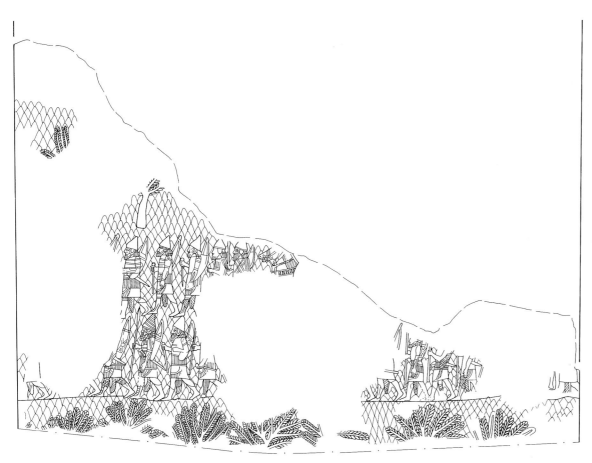

49: Nineveh, Sennacherib
Palace Site Museum, Room I,
Slab 17, 1990, scale 1:12
(photo: author).

50: Nineveh, Sennacherib
Palace Site Museum, Room I,
Slab 19, 1990, scale 1:12
(photo: author).

51: Nineveh, Sennacherib
Palace Site Museum, Room I,
Slab 19, 1990, scale 1:12,
drawing by Jennifer Hook in
consultation with Denise L.
Hoffman and the author
(source: author).

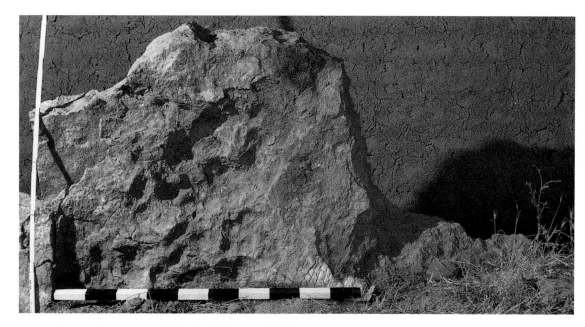

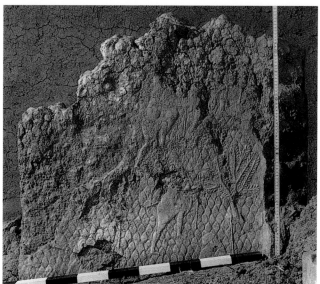

53: Nineveh, Sennacherib's palace, Room I, Slab 20, 1847, scale 1:12, drawing by A. H. Layard, Or. Dr. IV, 6 (photo: Trustees of the British Museum).

52: Nineveh, Sennacherib Palace Site Museum, Room I, Slab 20, 1990, scale 1:12 (photo: author).

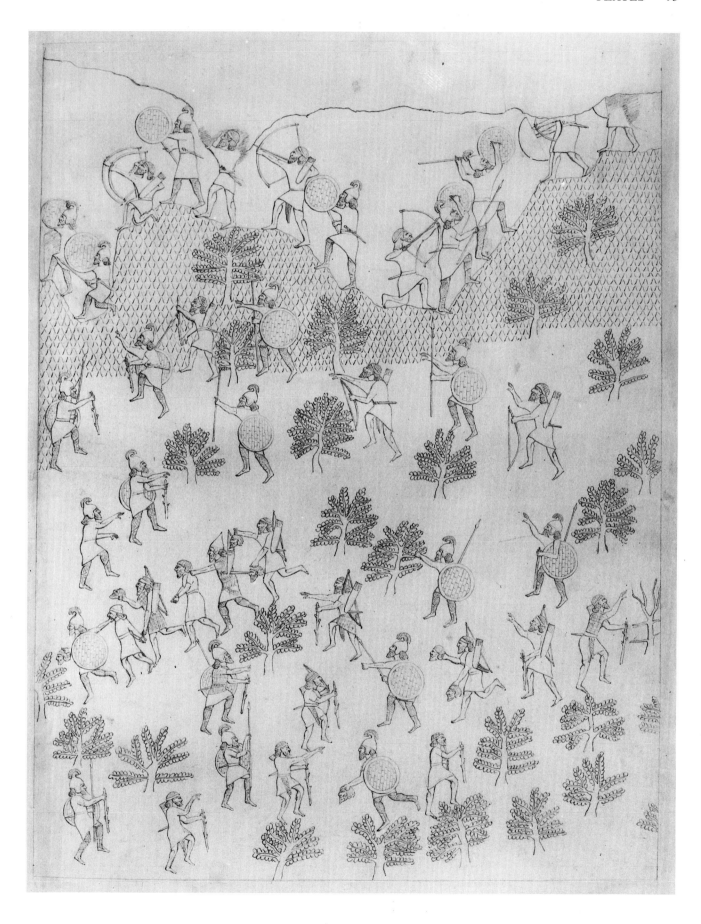

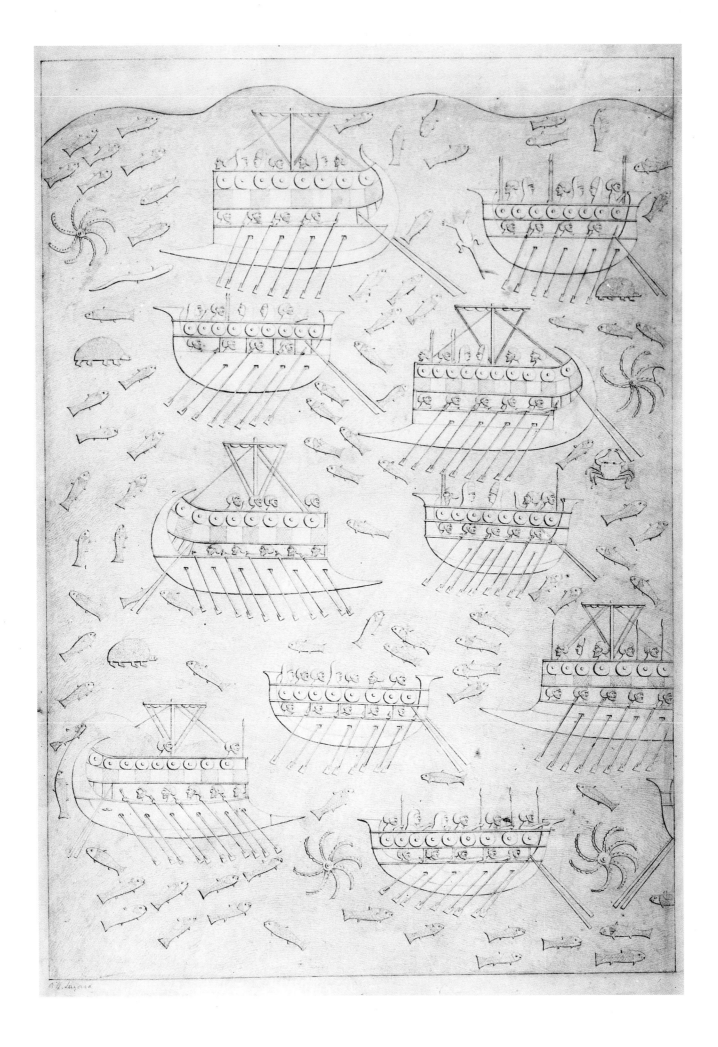

54: Nineveh, Sennacherib's palace, Room I, Slab 20a, 1847,
scale 1:12, drawing by A. H. Layard, Or. Dr. IV, 7 (photo:
Trustees of the British Museum).

55: Nineveh, Sennacherib's palace, Room I, Slab 20b, 1847,
scale 1:12, drawing by A. H. Layard, Or. Dr. IV, 8 (photo:
Trustees of the British Museum).

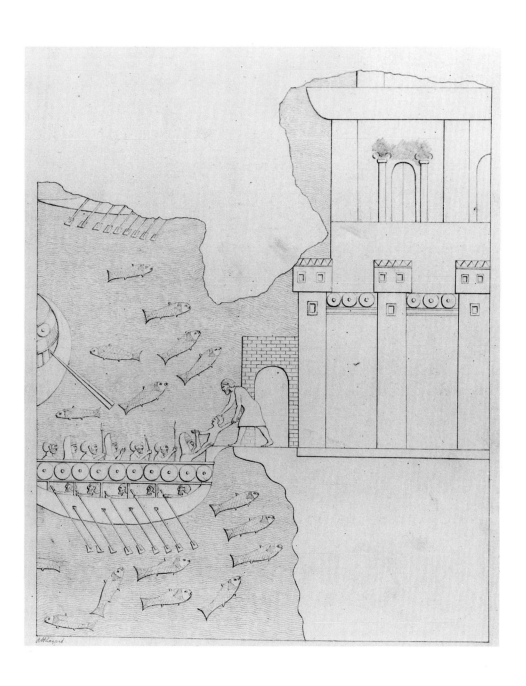

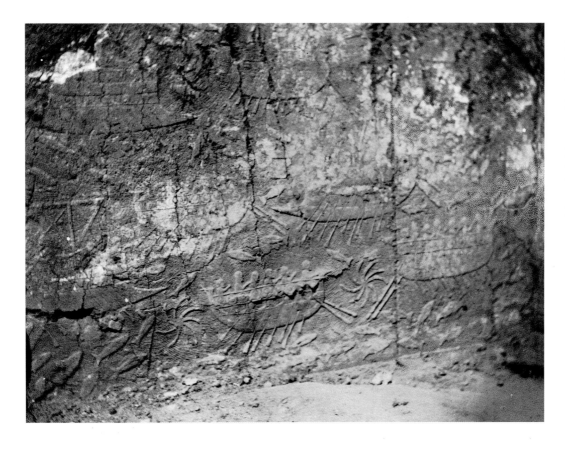

56: Nineveh, Sennacherib's palace, Room I, Slabs 20a–b, detail, 1903–4, not to scale, photo by L. W. King, neg. PS 139270 (photo: Trustees of the British Museum).

57: Nineveh, Sennacherib's palace, Room I, Slabs 20a–b, detail, 1903–4, not to scale, photo by L. W. King, neg. PS 56504 (photo: Trustees of the British Museum).

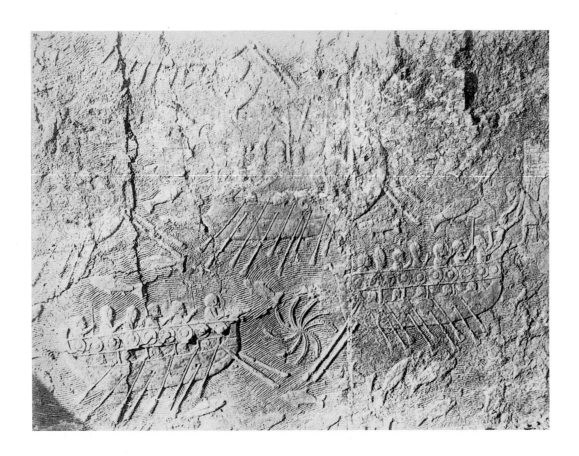

58: Nineveh, Sennacherib's
palace, Room I, Slabs 20c–d,
1903–4, not to scale, photo by
L. W. King, neg. PS 056506
(photo: Trustees of the British
Museum).

59: Nineveh, Sennacherib's
palace, Room I, Slab 20c,
fragment removed by Layard,
not to scale, width: 74 cm,
British Museum, WA 124789
(photo: Trustees of the British
Museum).

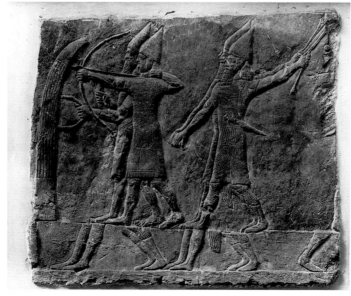

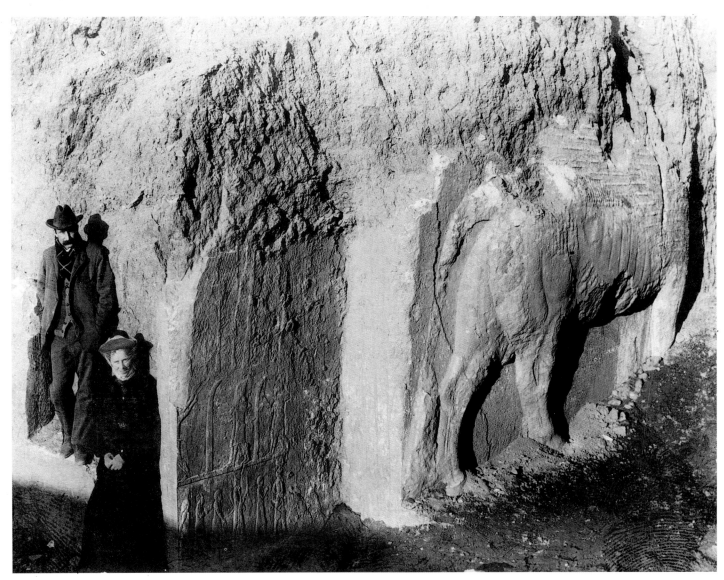

60: Nineveh, Sennacherib's palace, Room I, Slabs 20d–21, with
Court H, Door *c*, Bull 2 at right, 1903–4, not to scale, photo by
L. W. King, neg. PS 139286 (photo: Trustees of the British
Museum).

61: Nineveh, Sennacherib
Palace Site Museum, Room I,
Slab 22, 1990, scale 1:12
(photo: author).

62: Nineveh, Sennacherib Palace Site Museum, Room I, Slab
23, 1989, scale 1:12 (photo: author).

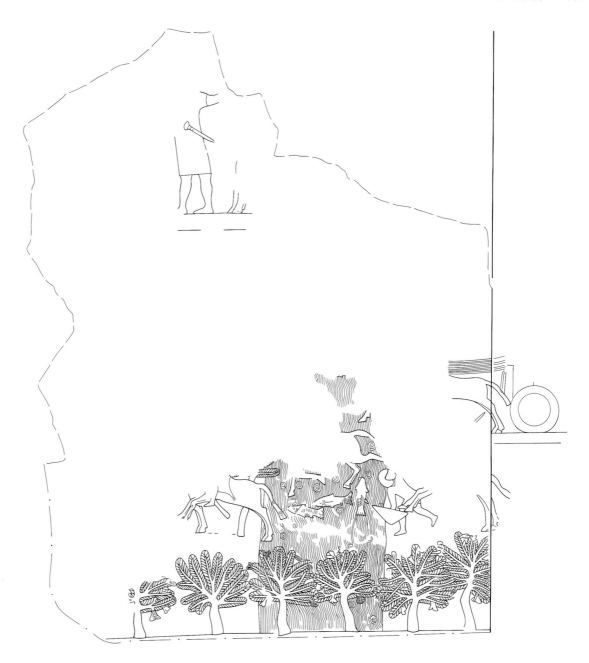

63: Nineveh, Sennacherib Palace Site Museum, Room I, Slab
23, 1989, scale 1:12, drawing by Jennifer Hook in consultation
with Denise L. Hoffman and the author (source: author).

65: Nineveh, Sennacherib's palace, Room I, Slab 24, 1847, scale 1:12, drawing by A. H. Layard, Or. Dr. IV, 9 (photo: Trustees of the British Museum).

64: Nineveh, Sennacherib Palace Site Museum, Room I, Slab 24, 1990, scale 1:12 (photo: author).

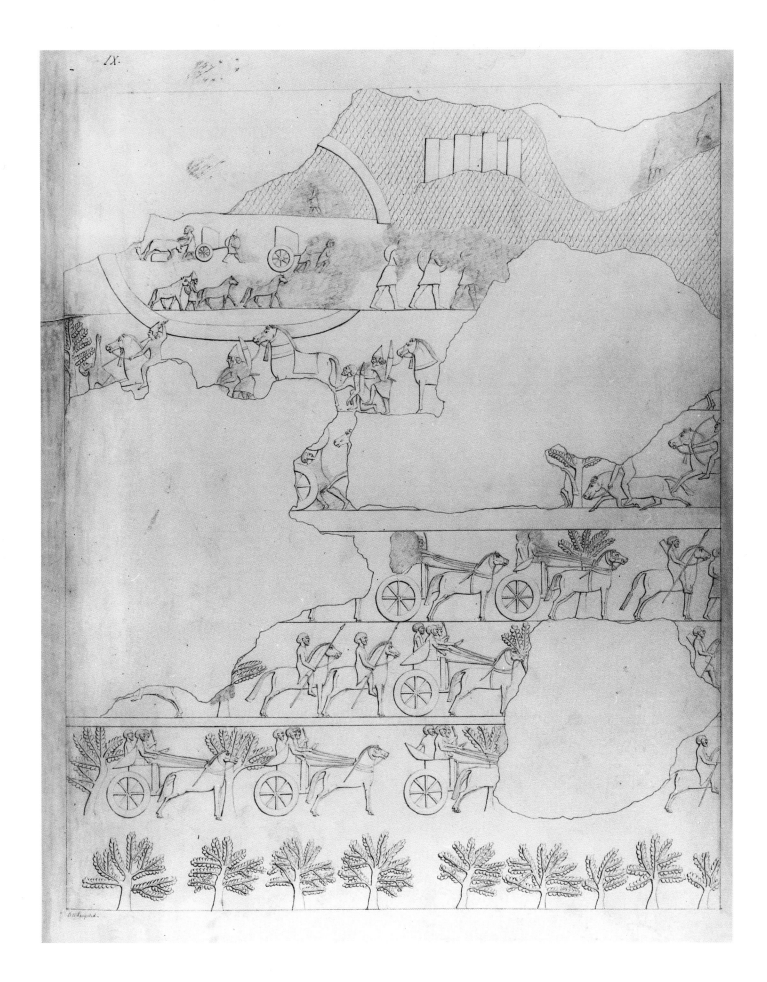

IX.

66: Nineveh, Sennacherib Palace Site Museum, Room I, Slab
25, 1989, scale 1:12 (photo: author).

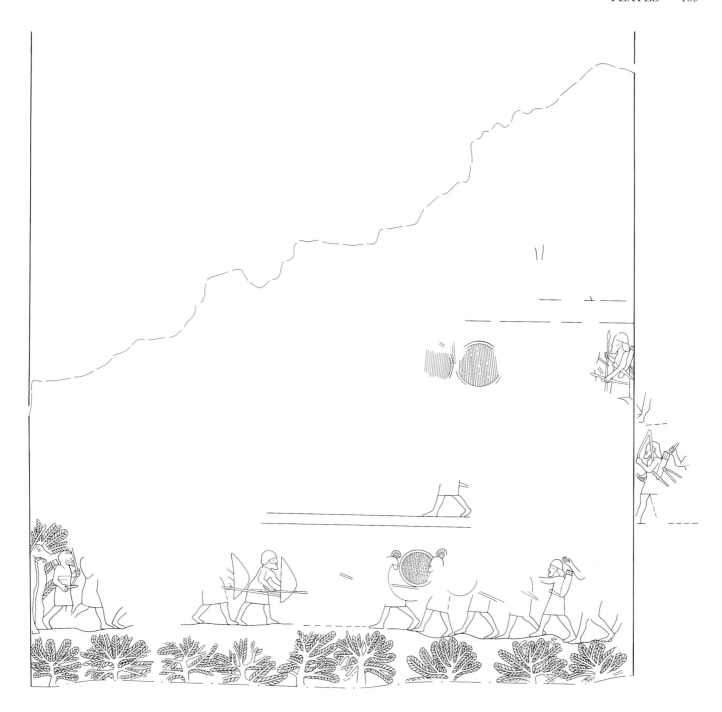

67: Nineveh, Sennacherib Palace Site Museum, Room I,
Slab 25–26, 1990, scale 1:12, drawing by Jennifer Hook
in consultation with Denise L. Hoffman and the author
(source: author).

69: Nineveh, Sennacherib Palace Site Museum, Room I, Slab
27, detail of epigraph, 1990, not to scale (photo: author).

68: Nineveh, Sennacherib Palace Site Museum, Room I, Slab
26, 1990, scale 1:12 (photo: author).

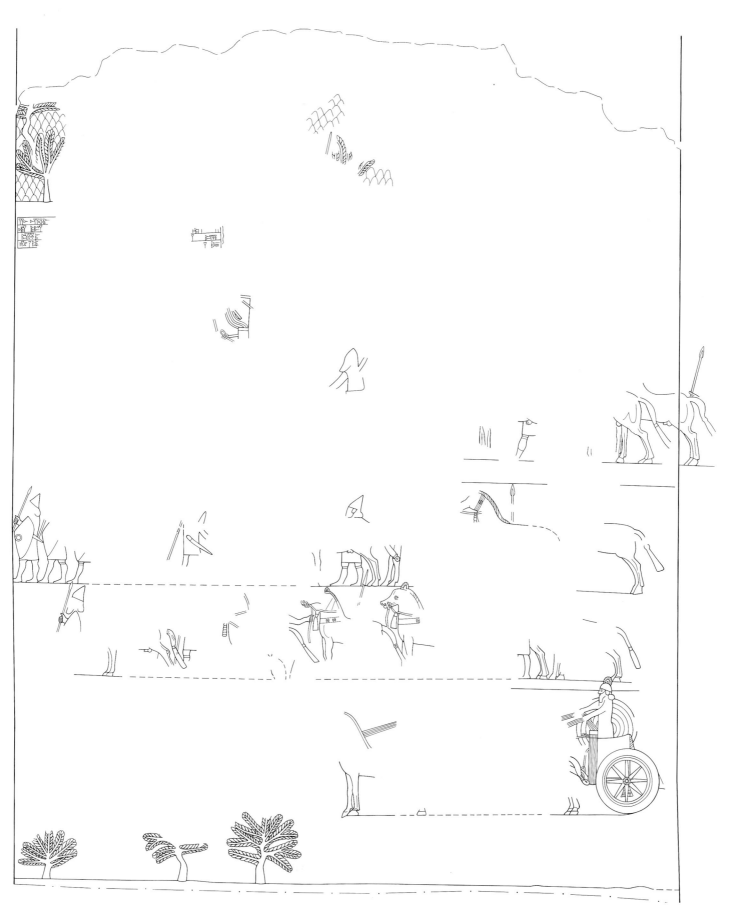

70: Nineveh, Sennacherib Palace Site Museum, Room I, Slab 27, 1989, scale 1:12 (photo: Diana Pickworth).

71: Nineveh, Sennacherib Palace Site Museum, Room I, Slab 27, 1990, scale 1:12, drawing by Jennifer Hook in consultation with Denise L. Hoffman and the author (source: author).

72: Nineveh, Sennacherib Palace Site Museum, Room I, Slab 28, 1990, scale 1:12 (photo: author).

73: Nineveh, Sennacherib's palace, Room I, Slab 28, scale 1:12, 1854–5, drawingby William Boutcher, Or. Dr. VI, 17 (photo: Trustees of the British Museum).

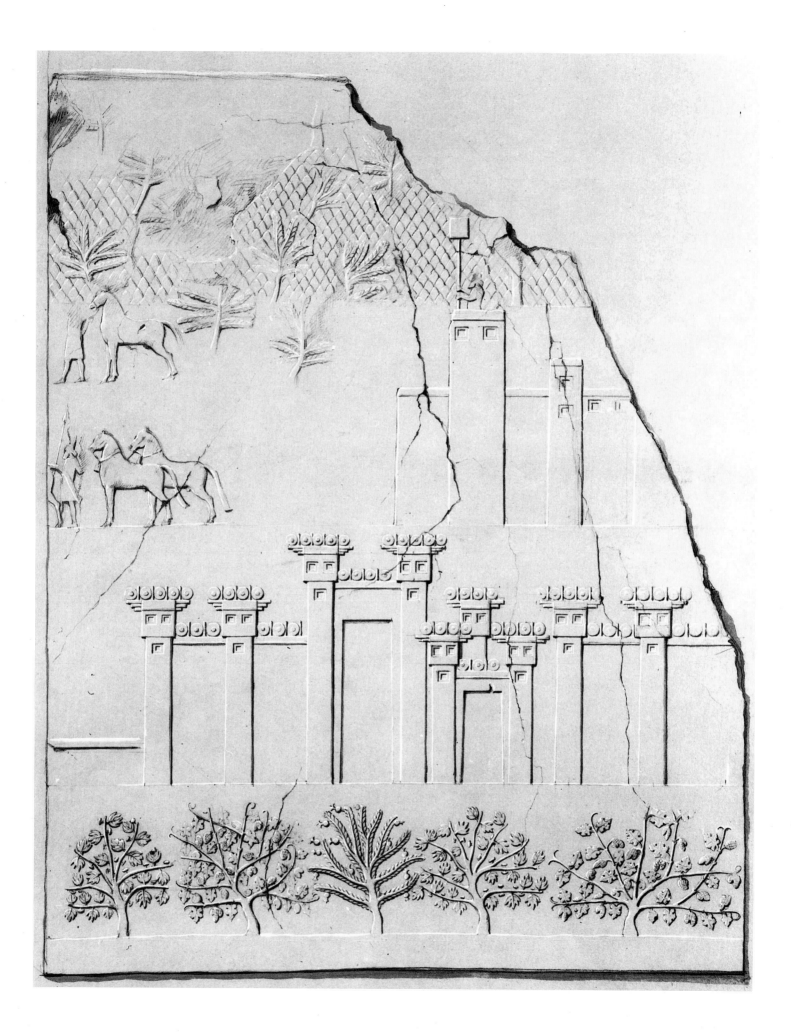

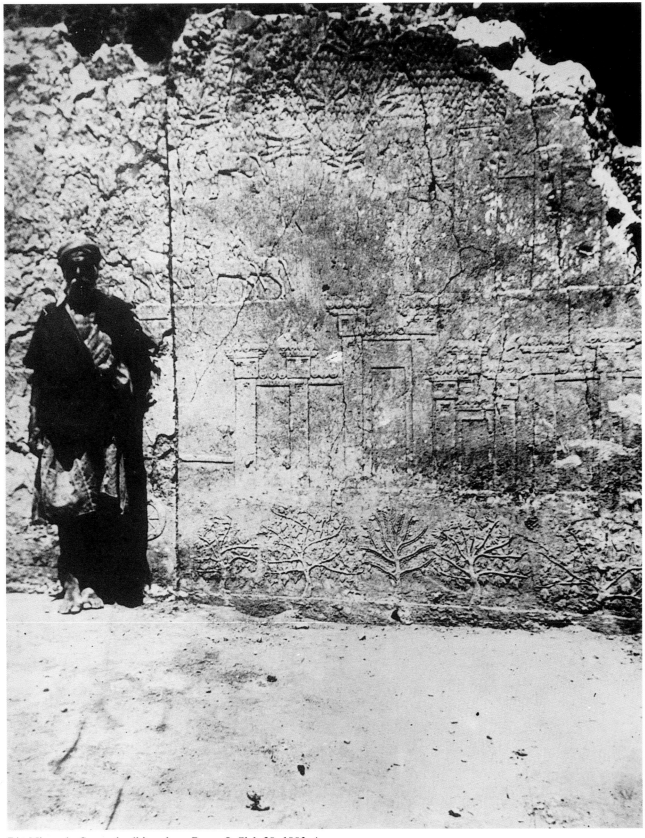

74: Nineveh, Sennacherib's palace, Room I, Slab 28, 1903–4,
not to scale, photo by L. W. King, neg. PS 056503 (photo:
Trustees of the British Museum).

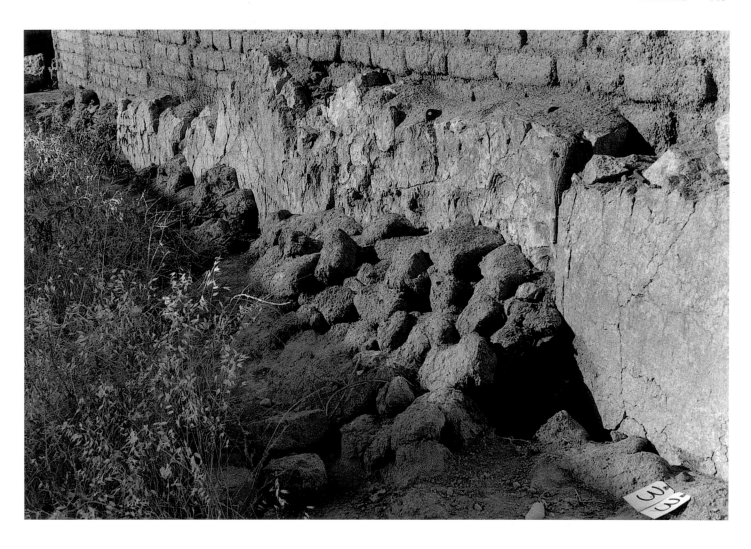

75: Nineveh, Sennacherib
Palace Site Museum, Room I,
Slab 30–33, view, 1990, not to
scale (photo: author).

76: Nineveh, Sennacherib
Palace Site Museum, Room I,
Slab 33, 1990, scale 1:12
(photo: author).

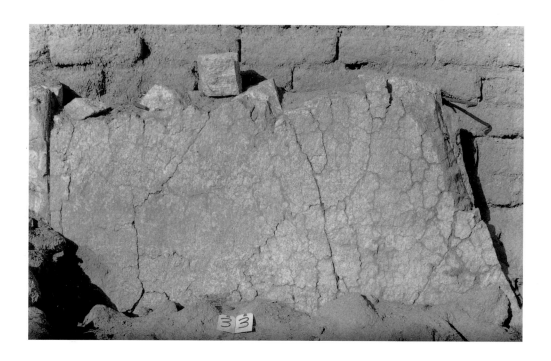

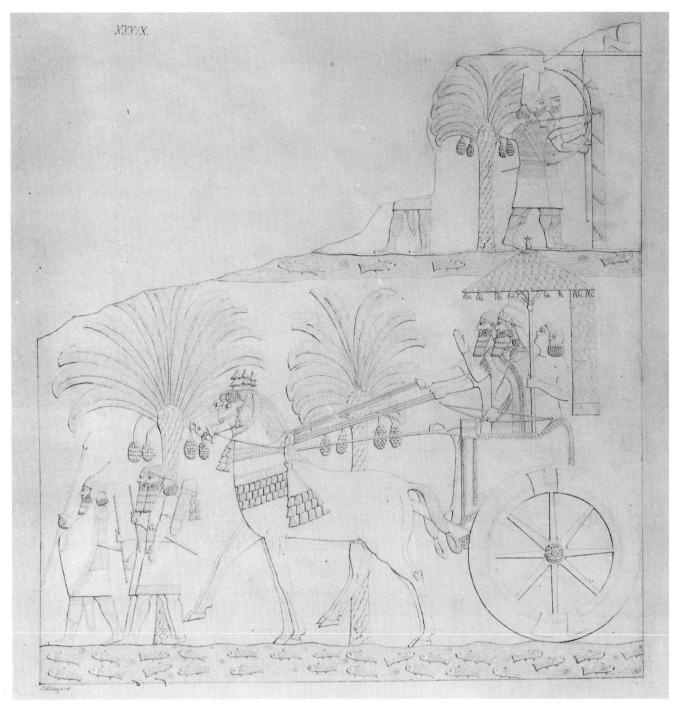

77: Nineveh, Sennacherib's palace, Room III, Slab 4, 1847, scale 1:12, drawing by A. H. Layard, Or. Dr. IV, 39 (photo: Trustees of the British Museum).

78: Nineveh, Sennacherib's palace, Room III, Slab 8, 1847, scale 1:12, drawing by A. H. Layard, Or. Dr. IV, 41 (photo: Trustees of the British Museum).

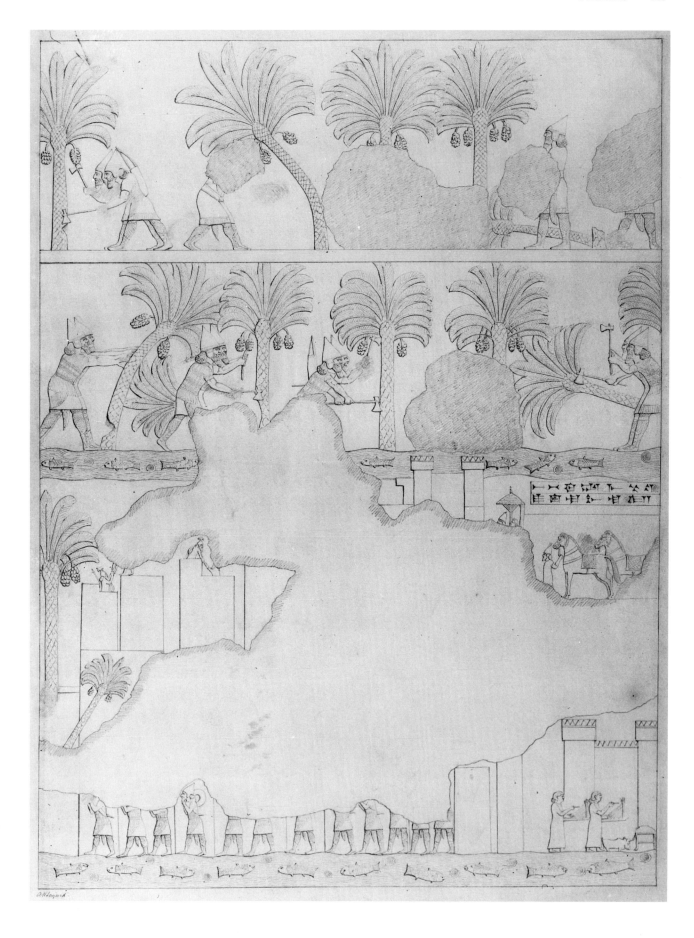

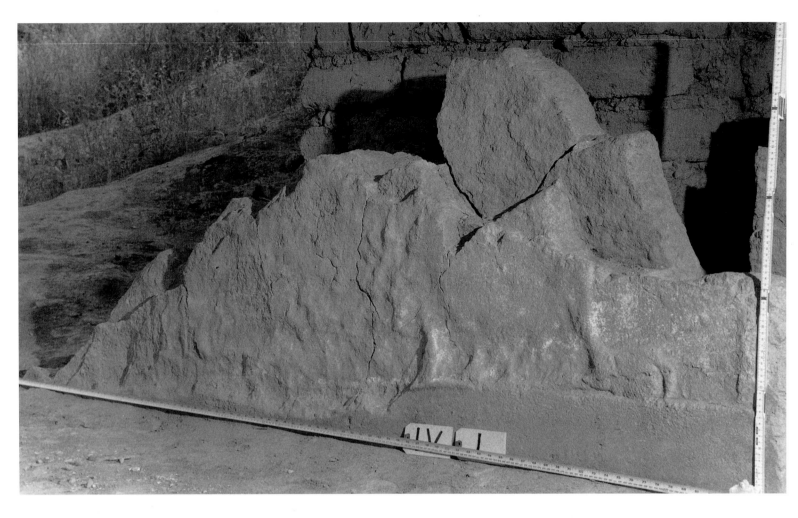

79: Nineveh, Sennacherib Palace Site Museum, Room IV, Door *f*, Slab 1, 1990, scale roughly 1:12 (photo: author).

80: Nineveh, Sennacherib Palace Site Museum, Room IV, Door *f*, Slab 16, 1990, scale 1:12 (photo: author).

81: Nineveh, Sennacherib Palace Site Museum, Room IV, Slab 2, 1990, scale 1:12 (photo: author).

82: Nineveh, Sennacherib Palace Site Museum, Room IV, Slab 3, 1990, scale 1:12 (photo: author).

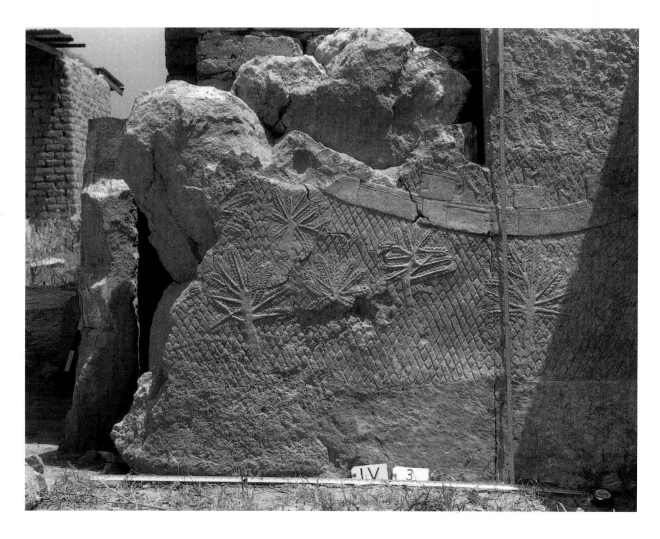

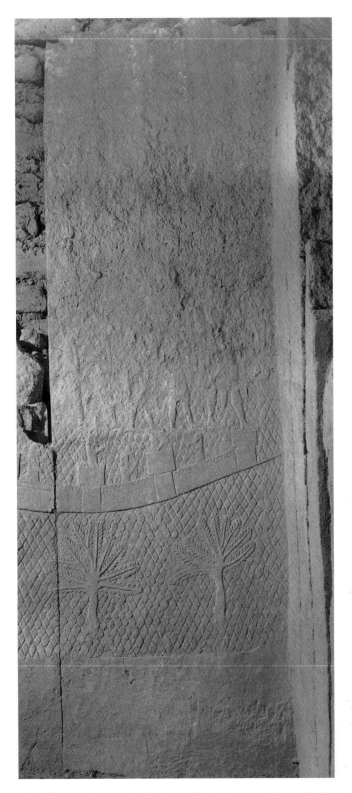

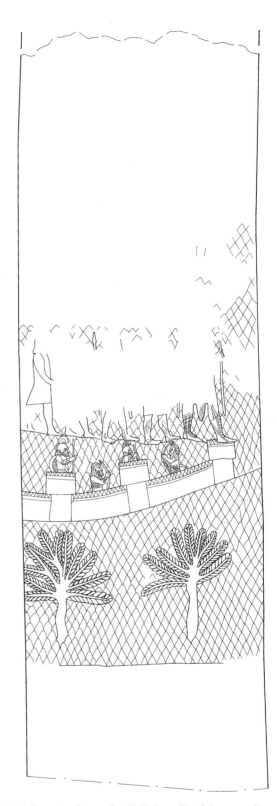

83: Nineveh, Sennacherib Palace Site Museum, Room IV, Slab 4, left panel, 1989, scale 1:12 (photo: author).

84: Nineveh, Sennacherib Palace Site Museum, Room IV, Slab 4, left panel, 1990, scale 1:12, drawing by Jennifer Hook in consultation with Denise L. Hoffman and the author (source: author).

85: Nineveh, Sennacherib Palace Site Museum, Room IV, Slab 4, right panel, 1990, scale 1:12 (photo: author).

86: Nineveh, Sennacherib Palace Site Museum, Room IV, Slab 4, right panel, 1990, scale 1:12, drawing by Jennifer Hook in consultation with Denise L. Hoffman and the author (source: author).

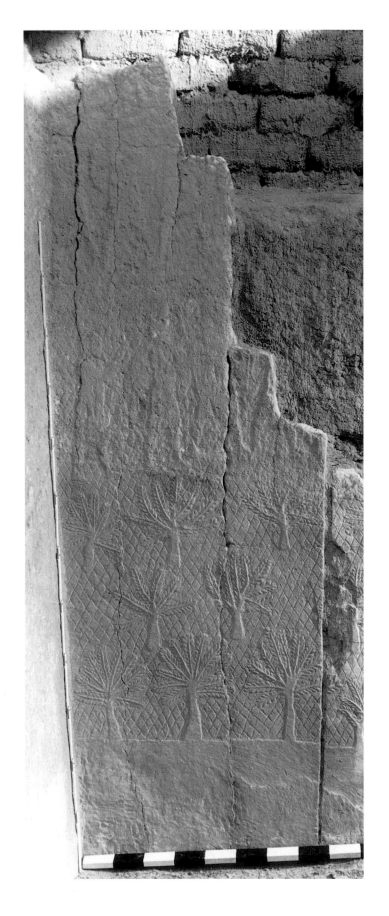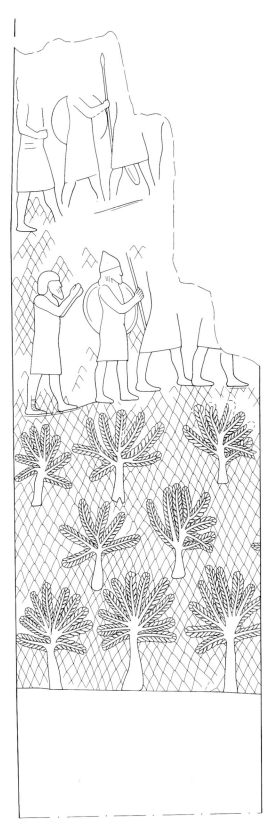

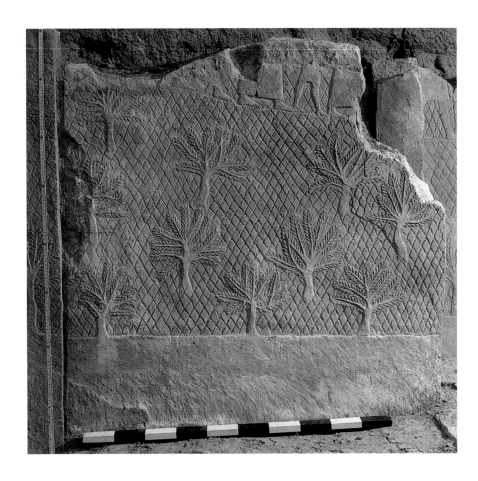

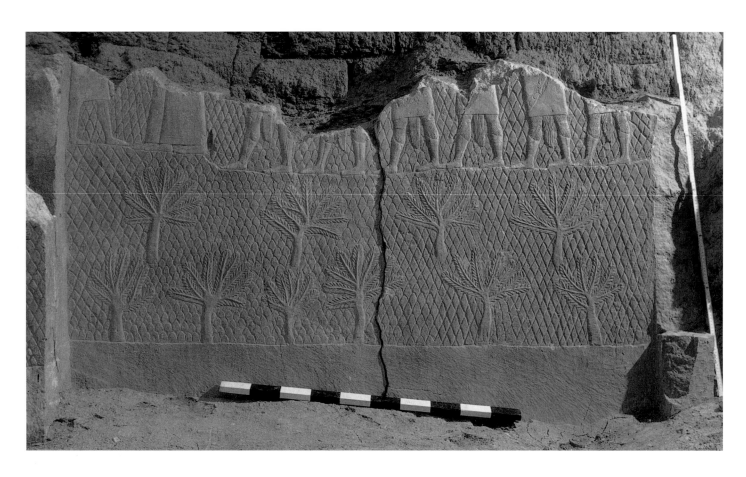

90: Nineveh, Sennacherib Palace Site Museum, Room IV, Slab 8, left panel, 1990, scale 1:12 (photo: author).

91: Nineveh, Sennacherib Palace Site Museum, Room IV, Slab 8, upper right panel, 1990, scale 1:12 (photo: author).

92: Nineveh, Sennacherib Palace Site Museum, Room IV, Slab 8, lower right panel, 1990, scale 1:12 (photo: author).

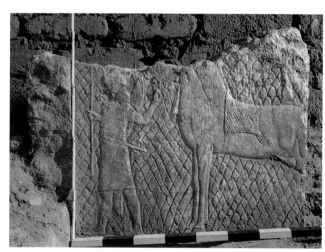

87: Nineveh, Sennacherib Palace Site Museum, Room IV, Slab 5, main part, 1990, scale 1:12 (photo: author).

88: Nineveh, Sennacherib Palace Site Museum, Room IV, Slab 5, sculptured right edge, and Slab 6, left return, 1990, scale 1:12 (photo: author).

89: Nineveh, Sennacherib Palace Site Museum, Room IV, Slab 6, 1990, scale 1:12 (photo: author).

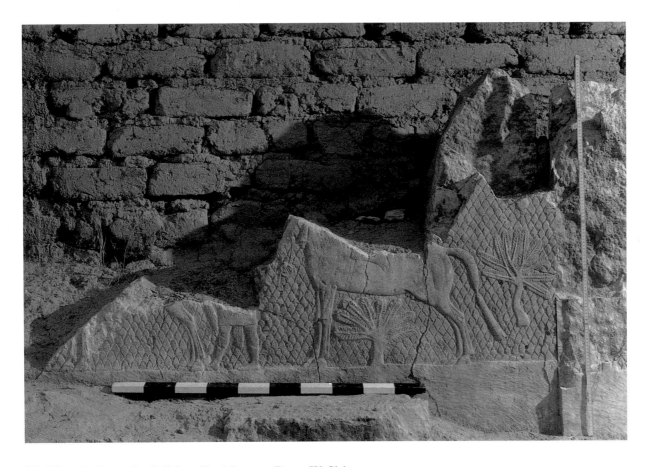

93: Nineveh, Sennacherib Palace Site Museum, Room IV, Slab
9, 1990, scale 1:12 (photo: author).

94: Nineveh, Sennacherib Palace Site Museum, Room IV, Slab
10, 1989, scale 1:12 (photo: Diana Pickworth).

95: Nineveh, Sennacherib Palace Site Museum, Room IV, Slab
10, 1990, scale 1:12 (photo: author).

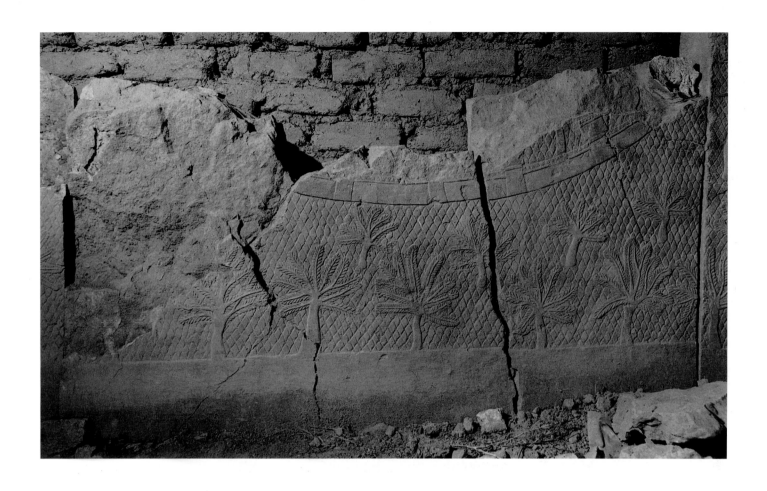

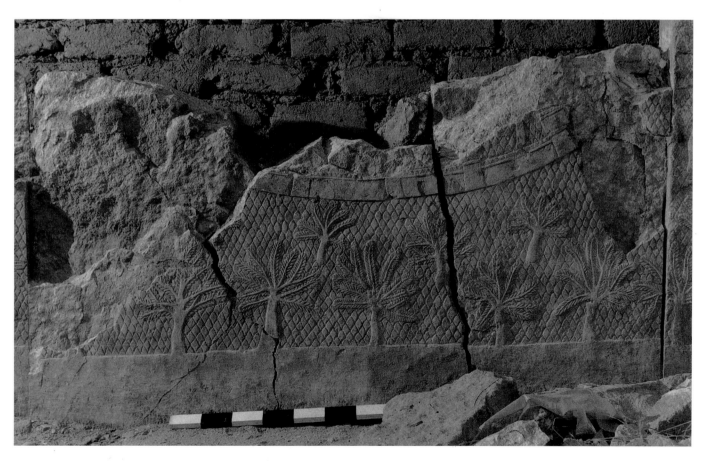

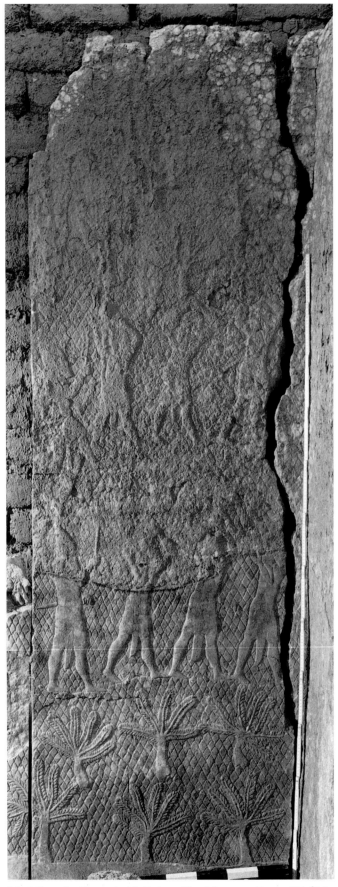

96: Nineveh, Sennacherib Palace Site Museum, Room IV, Slab 11, left panel, 1990, scale 1:12 (photo: author).

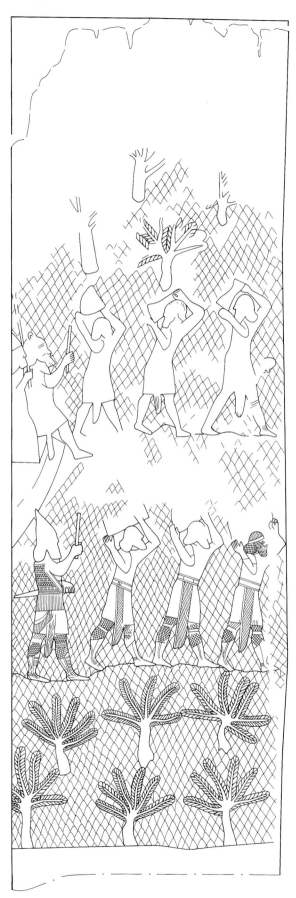

97: Nineveh, Sennacherib Palace Site Museum, Room IV, Slab 11, left panel, 1990, scale 1:12, drawing by Jennifer Hook in consultation with Denise L. Hoffman and the author (source: author).

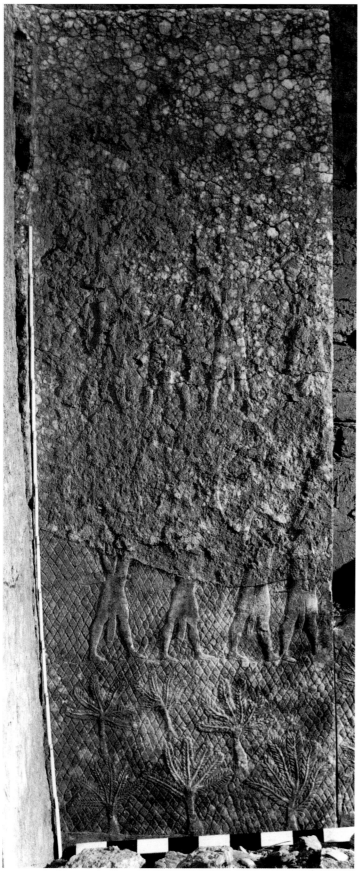

98: Nineveh, Sennacherib Palace Site Museum, Room IV, Slab 11, right panel, 1990, scale 1:12 (photo: author).

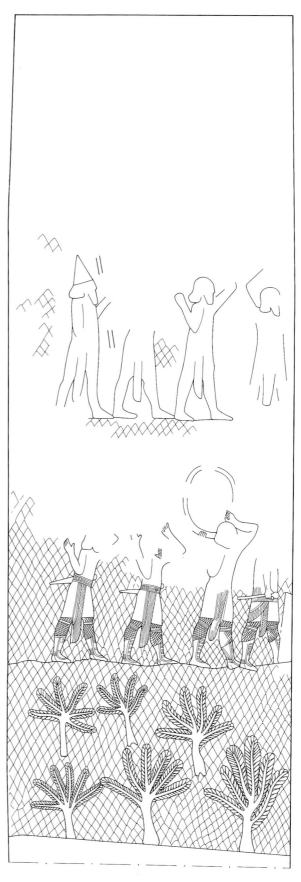

99: Nineveh, Sennacherib Palace Site Museum, Room IV, Slab 11, right panel, 1990, scale 1:12, drawing by Jennifer Hook in consultation with Denise L. Hoffman and the author (source: author).

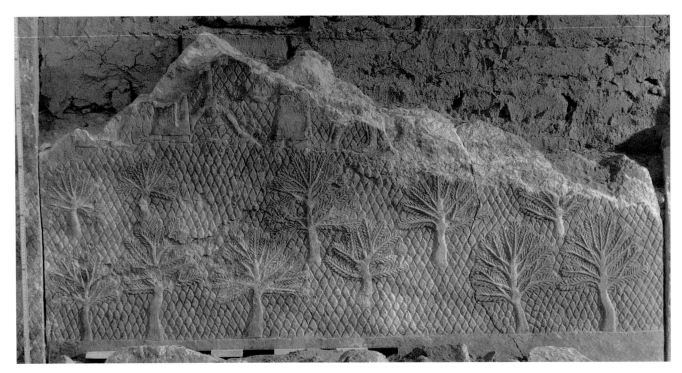

100: Nineveh, Sennacherib Palace Site Museum, Room IV, Slab104: Nineveh, Sennacherib Palace Site Museum, Room IV, Slab 12, 1990, scale 1:12 (photo: author).

101: Nineveh, Sennacherib Palace Site Museum, Room IV, Slab 13, 1990, scale 1:12 (photo: author).

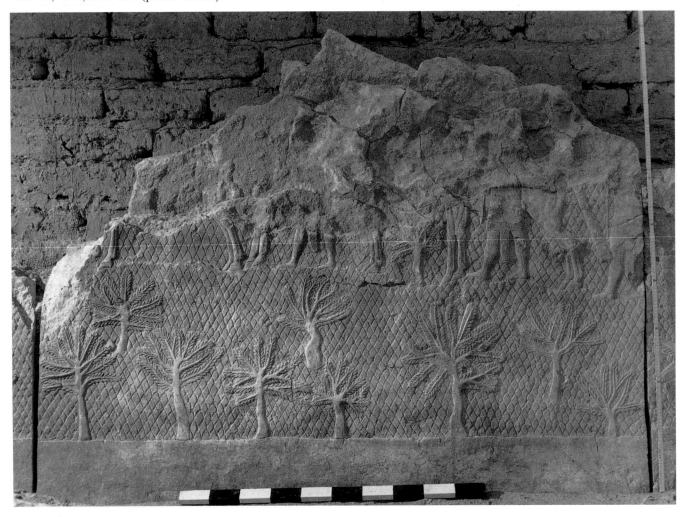

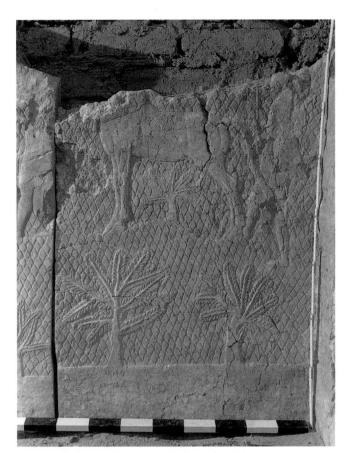

102: Nineveh, Sennacherib Palace Site Museum, Room IV, Slab 14, left panel, 1990, scale 1:12 (photo: author).

103: Nineveh, Sennacherib Palace Site Museum, Room IV, Slab 14, right panel, 1990, scale 1:12 (photo: author).

104: Nineveh, Sennacherib Palace Site Museum, Room IV, Slab 15, 1989, scale 1:12 (photo: Diana Pickworth).

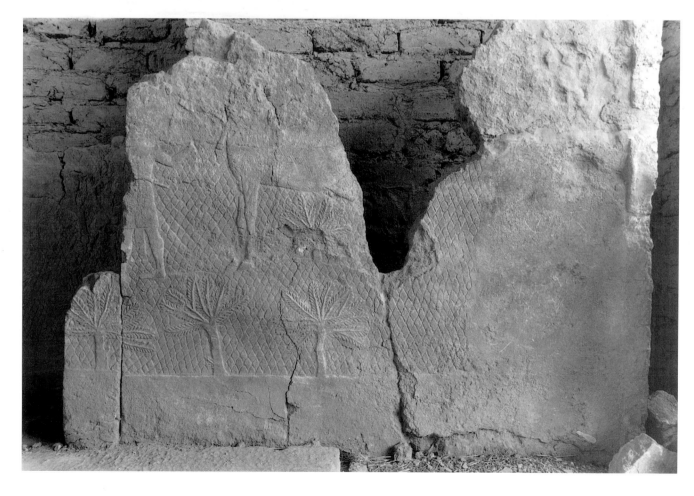

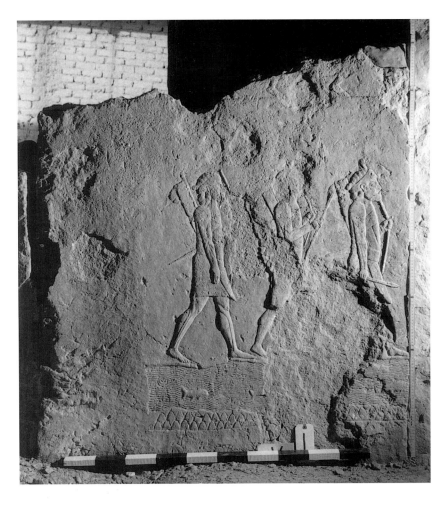

105: Nineveh, Sennacherib Palace Site Museum, Room V, Slab 1, 1990, scale 1:12 (photo: author).

106: Nineveh, Sennacherib's palace, Room V, Slabs 1 and 3, details, 1847, not to scale, drawing by A. H. Layard, Or. Dr. IV, 12 (photo: Trustees of the British Museum).

107: Nineveh, Sennacherib Palace Site Museum, Room V, Slab 2, 1990, scale 1:12 (photo: author).

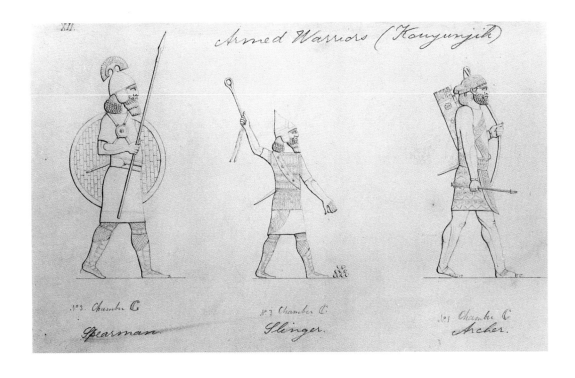

110: Nineveh, Sennacherib Palace Site Museum, Room V, Slab
4, 1990, scale 1:12 (photo: author).

108: Nineveh, Sennacherib Palace Site Museum, Room V, Slab
3, left panel, 1990, scale 1:12 (photo: author).

109: Nineveh, Sennacherib Palace Site Museum, Room V, Slab
3, right panel, 1990, scale 1:12 (photo: author).

111: Nineveh, Sennacherib Palace Site Museum, Room V, Slab
5, 1990, scale 1:12 (photo: author).

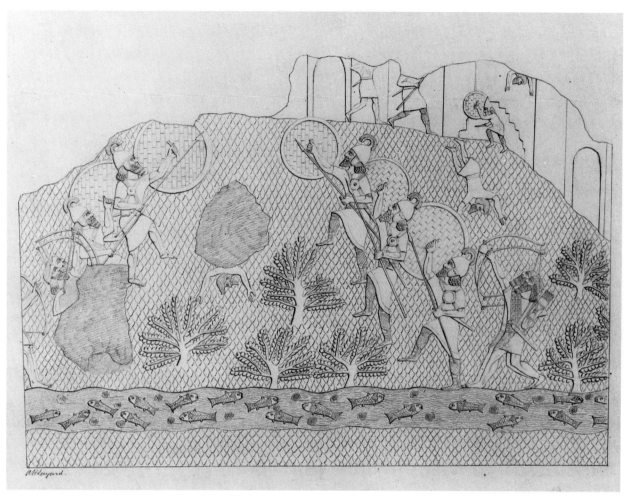

112: Nineveh, Sennacherib's palace, Room V, Slab 5, 1847, scale
1:12, drawing by A. H. Layard, Or. Dr. IV, 40 (photo: Trustees
of the British Museum).

V 16

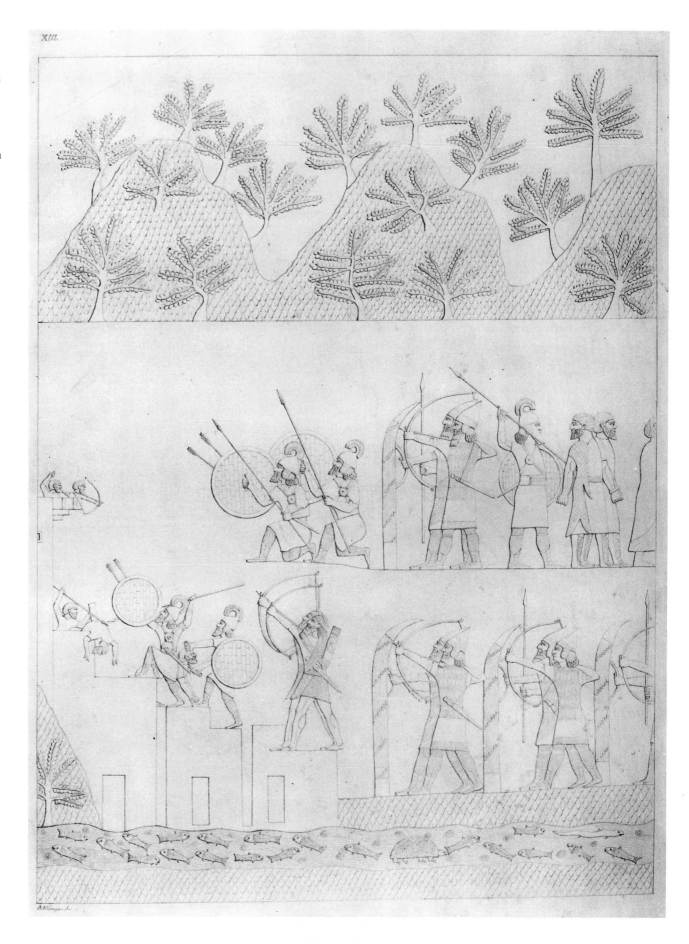

113: Nineveh, Sennacherib Palace Site Museum, Room V, Slab 6, 1990, scale 1:12 (photo: author).

114: Nineveh, Sennacherib's palace, Room V, Slab 6, 1847, scale 1:12, drawing by A. H. Layard, Or. Dr. IV, 13 (photo: Trustees of the British Museum).

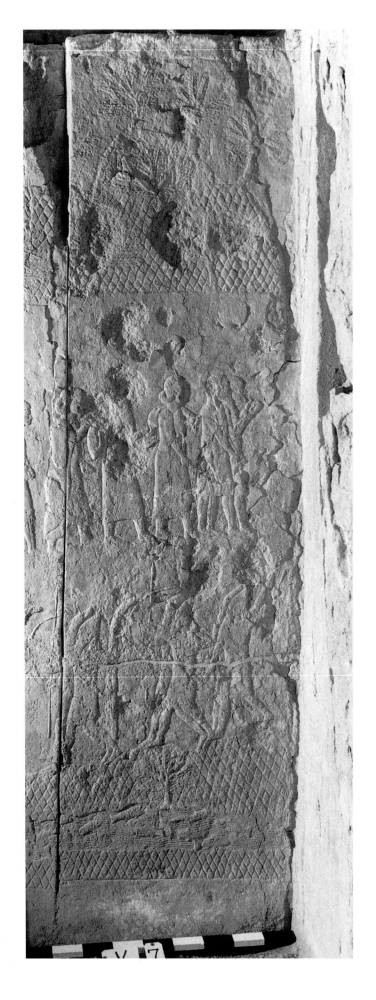

115: Nineveh, Sennacherib
Palace Site Museum, Room V,
Slab 7, left panel, 1990, scale
1:12 (photo: author).

116: Nineveh, Sennacherib
Palace Site Museum, Room V,
Slab 7, right panel, 1990, scale
1:12 (photo: author).

117: Nineveh, Sennacherib's
palace, Room V, Slab 7, right
panel, 1847, scale 1:12,
drawing by A. H. Layard, Or.
Dr. IV, 14 (photo: Trustees of
the British Museum).

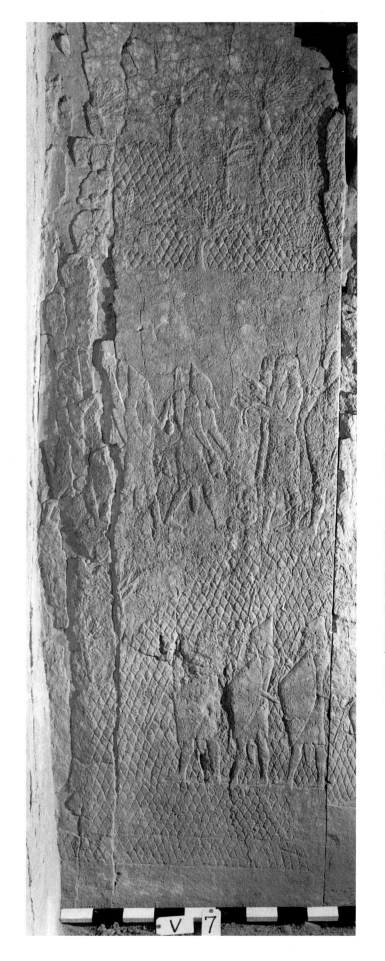
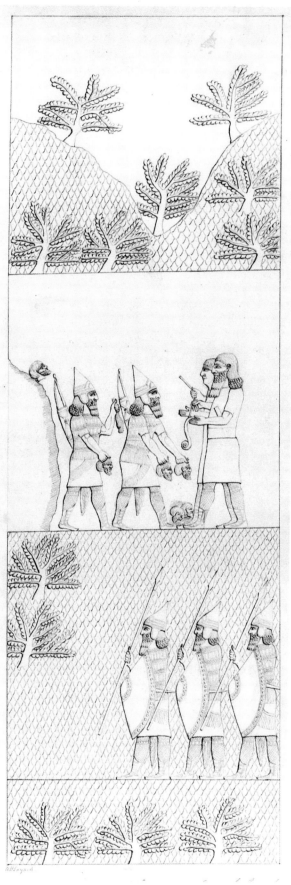

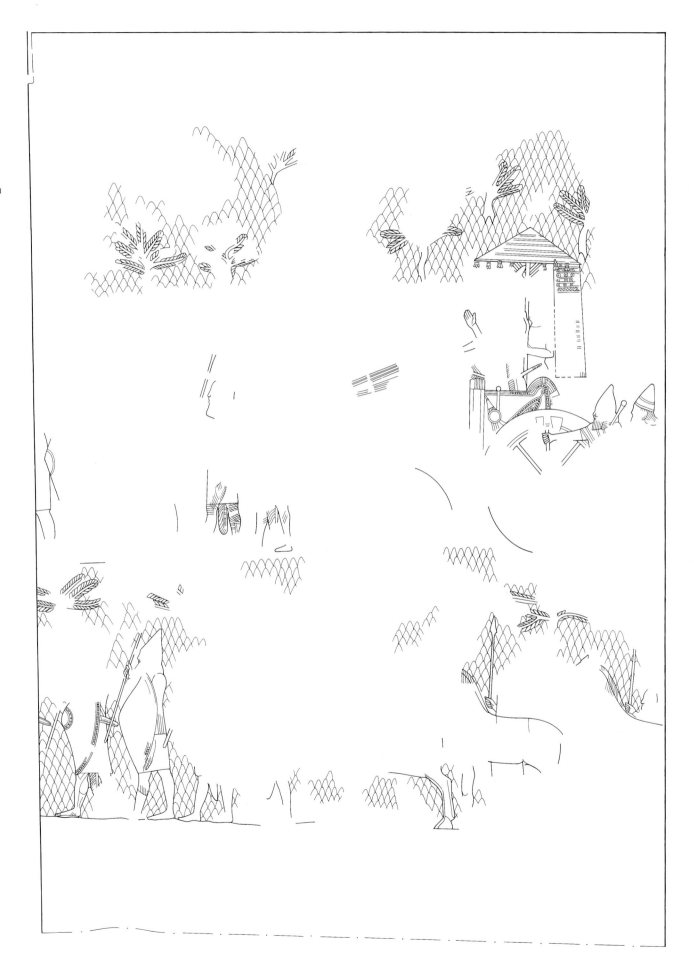

120: Nineveh, Sennacherib
Palace Site Museum, Room V,
Slab 9, 1990, scale 1:12 (photo:
author).

121: Nineveh, Sennacherib
Palace Site Museum, Room V,
Slab 9, detail of camp, 1990,
not to scale (photo: author).

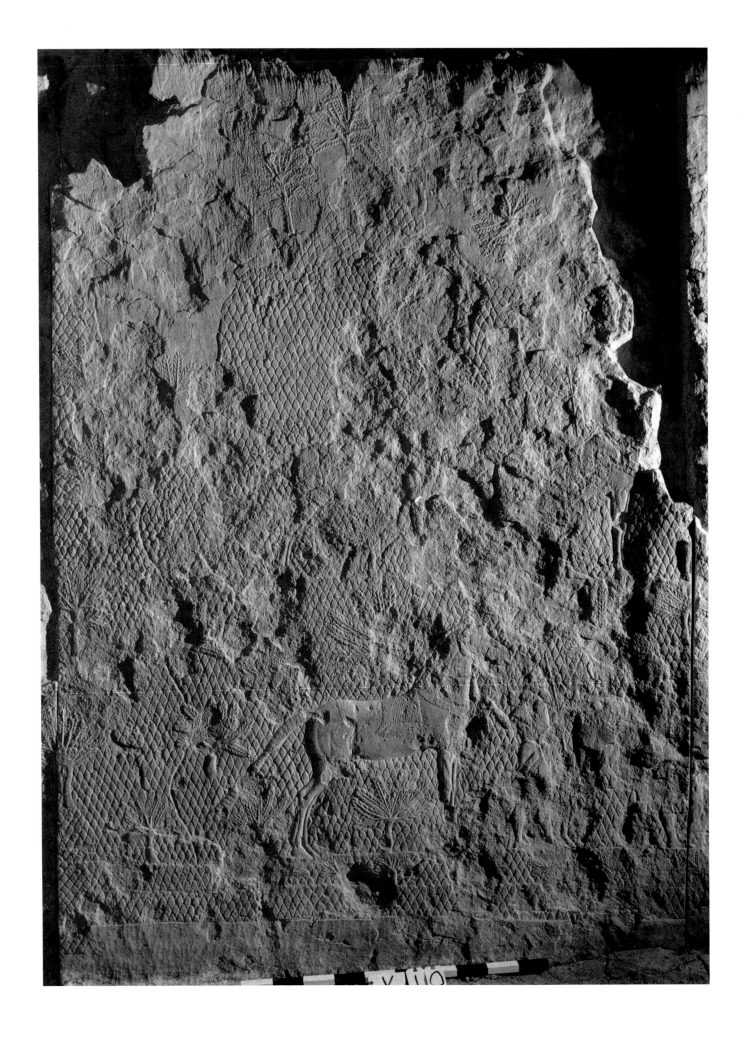

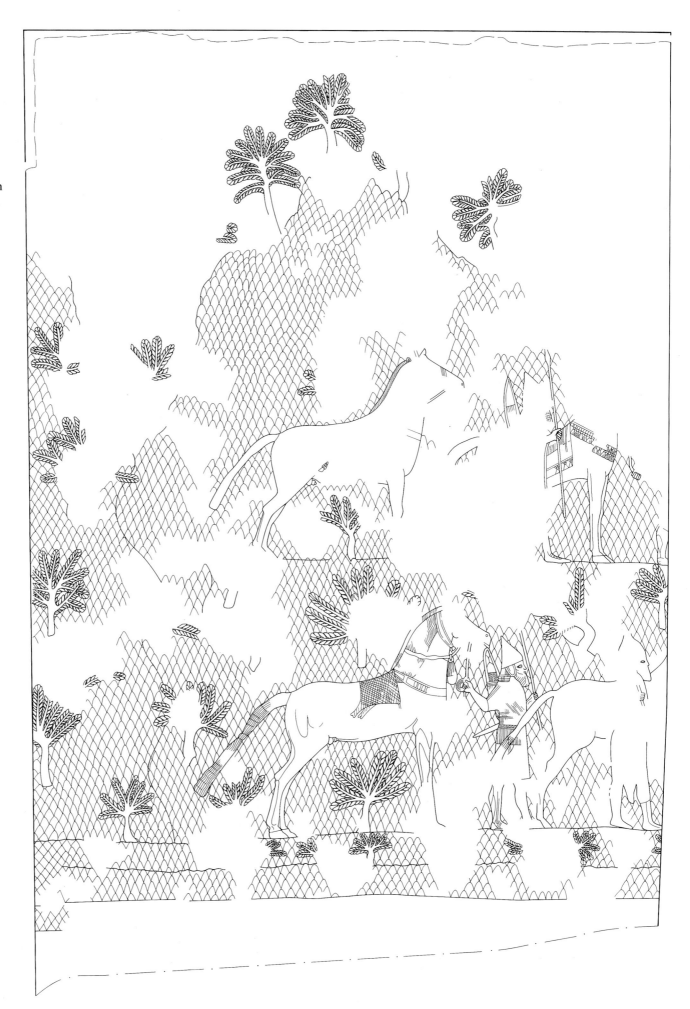

122: Nineveh, Sennacherib Palace Site Museum, Room V, Slab 10, 1990, scale 1:12 (photo: author).

123: Nineveh, Sennacherib Palace Site Museum, Room V, Slab 10, 1990, scale 1:12, drawing by Jennifer Hook in consultation with Denise L. Hoffman and the author (source: author).

124: Nineveh, Sennacherib Palace Site Museum, Room V, Slab
11, 1990, scale 1:12 (photo: author).

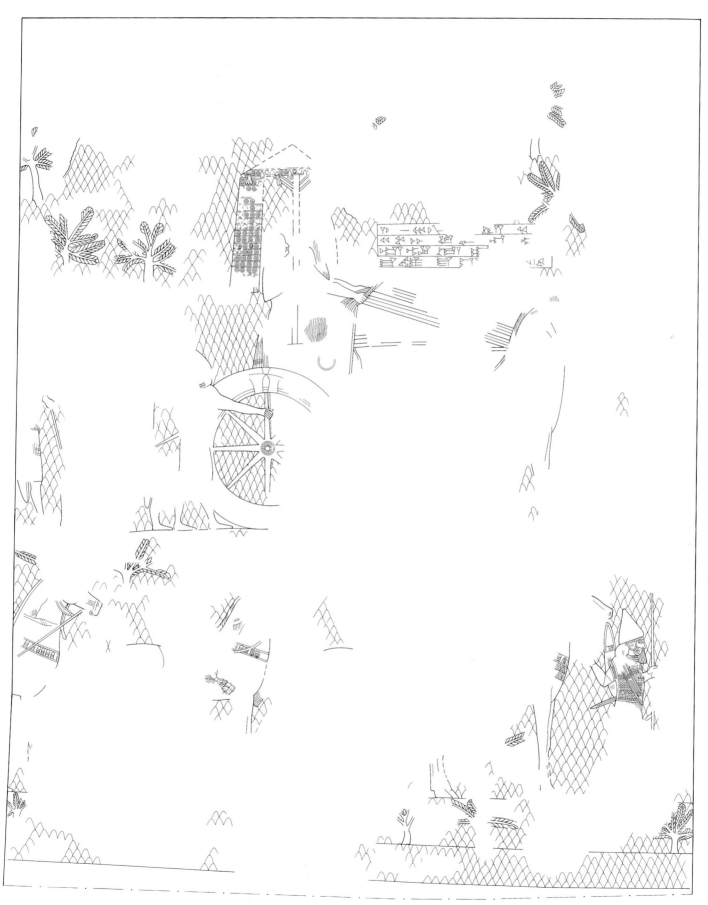

125: Nineveh, Sennacherib Palace Site Museum, Room V, Slab 11, 1990, scale 1:12, drawing by Jennifer Hook in consultation with Denise L. Hoffman and the author (source: author).

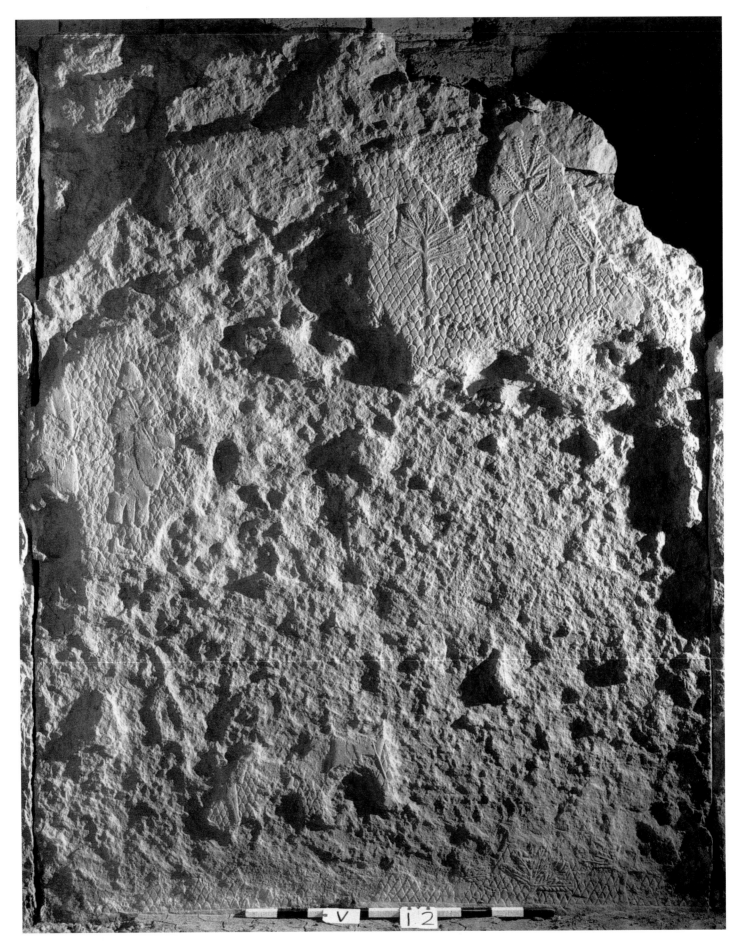

126: Nineveh, Sennacherib Palace Site Museum, Room V, Slab
12, 1990, scale 1:12 (photo: author).

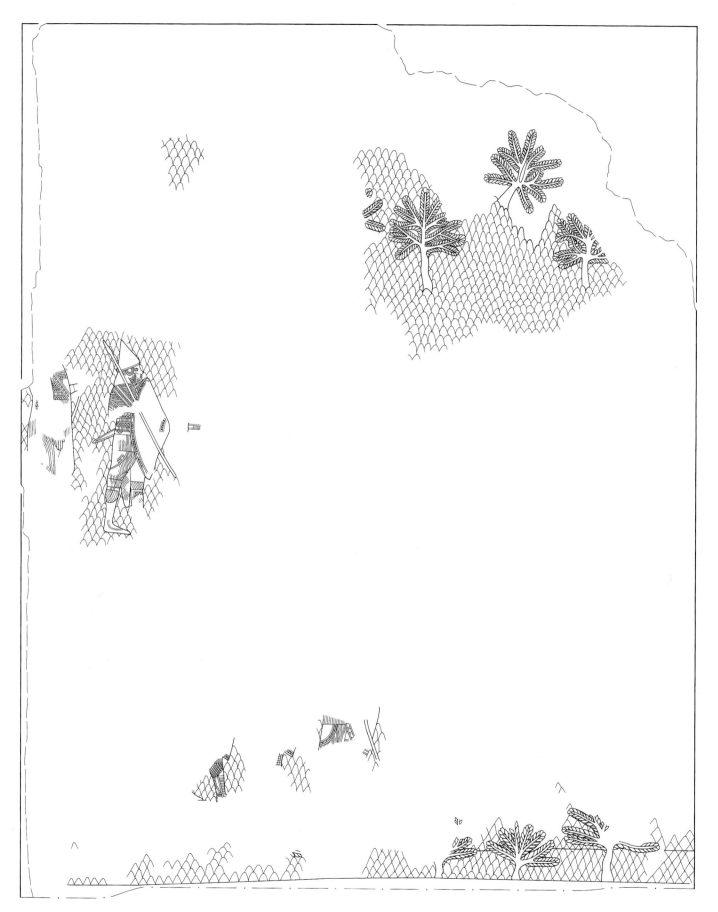

127: Nineveh, Sennacherib Palace Site Museum, Room V, Slab
12, 1990, scale 1:12, drawing by Jennifer Hook in consultation
with Denise L. Hoffman and the author (source: author).

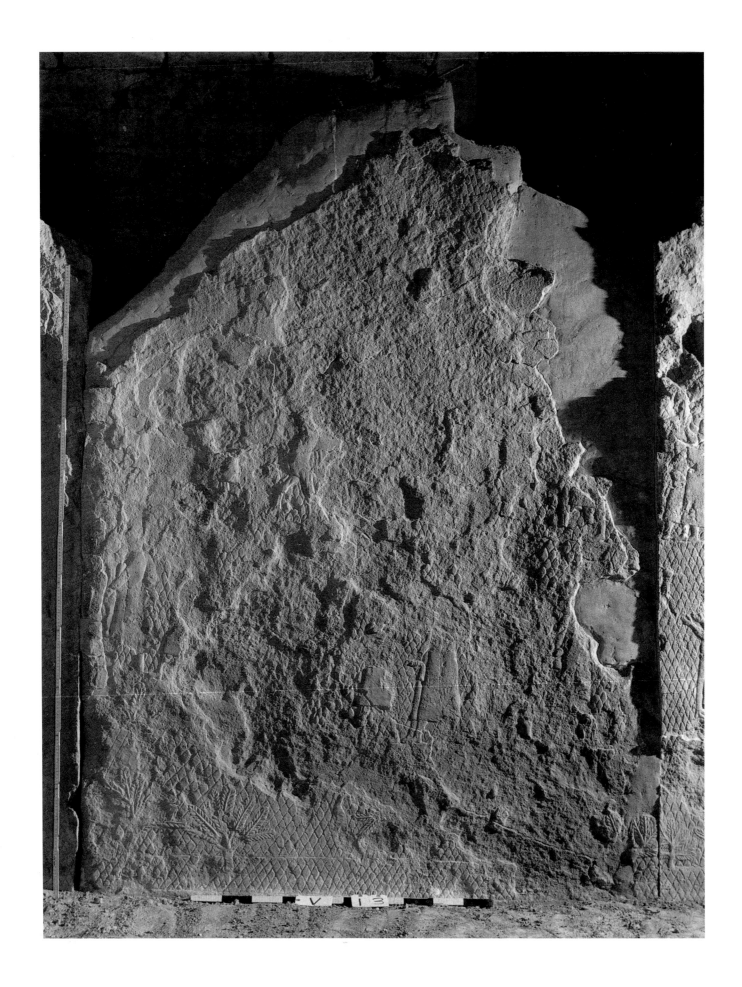

128: Nineveh,
Sennacherib Palace Site
Museum, Room V, Slab
13, 1990, scale 1:12
(photo: author).

129: Nineveh,
Sennacherib Palace Site
Museum, Room V, Slab
13, 1990, scale 1:12,
drawing by Jennifer Hook
in consultation with
Denise L. Hoffman and
the author (source:
author).

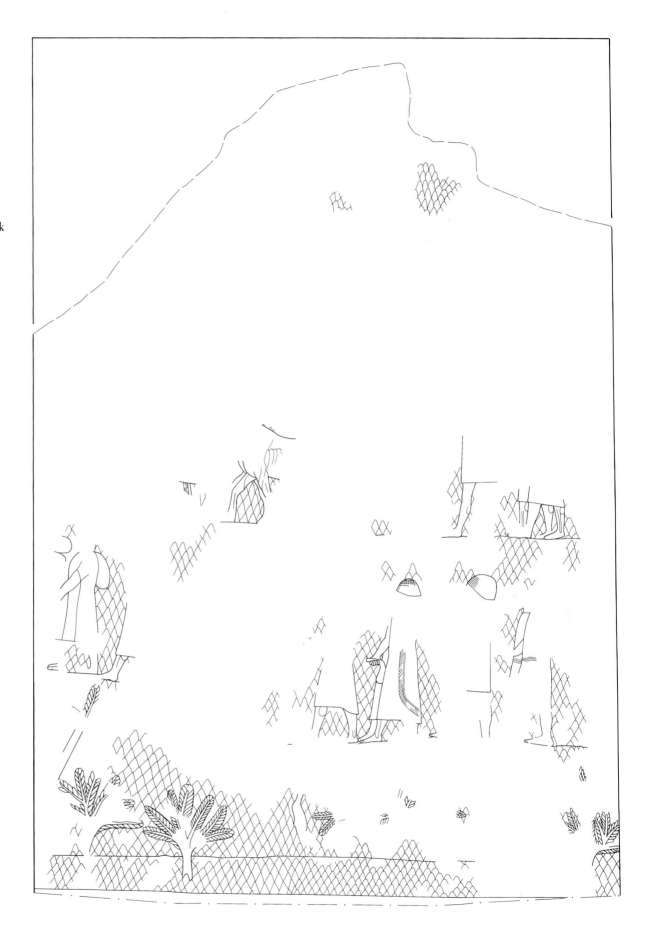

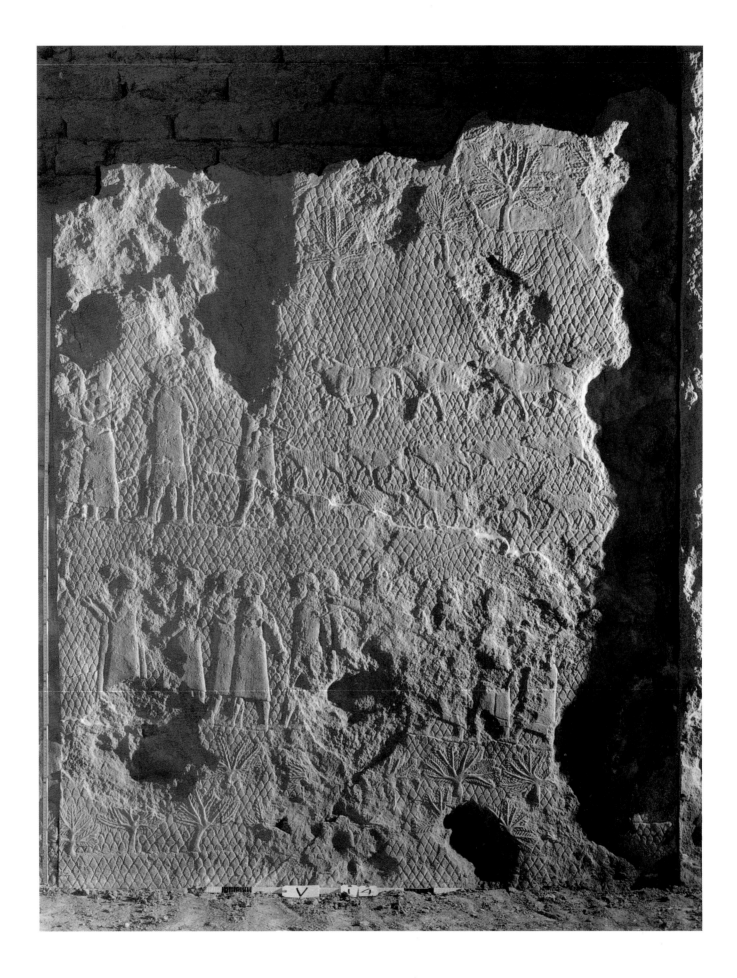

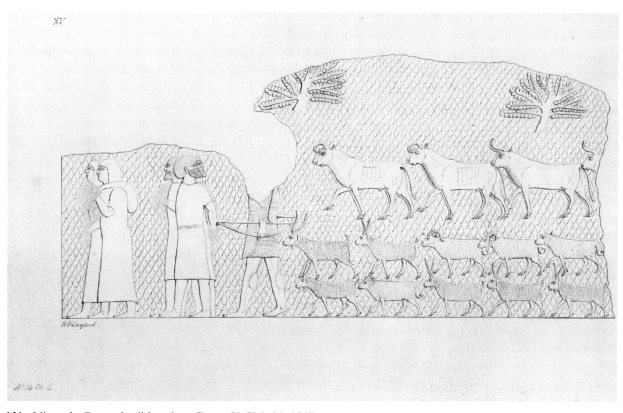

131: Nineveh, Sennacherib's palace, Room V, Slab 14, 1847,
scale 1:12, drawing by A. H. Layard, Or. Dr. IV, 15 (photo:
Trustees of the British Museum).

130: Nineveh, Sennacherib Palace Site Museum, Room V, Slab
14, 1990, scale 1:12 (photo: author).

132: Nineveh, Sennacherib Palace Site Museum, Room V, Slab
15, 1990, scale 1:12 (photo: author).

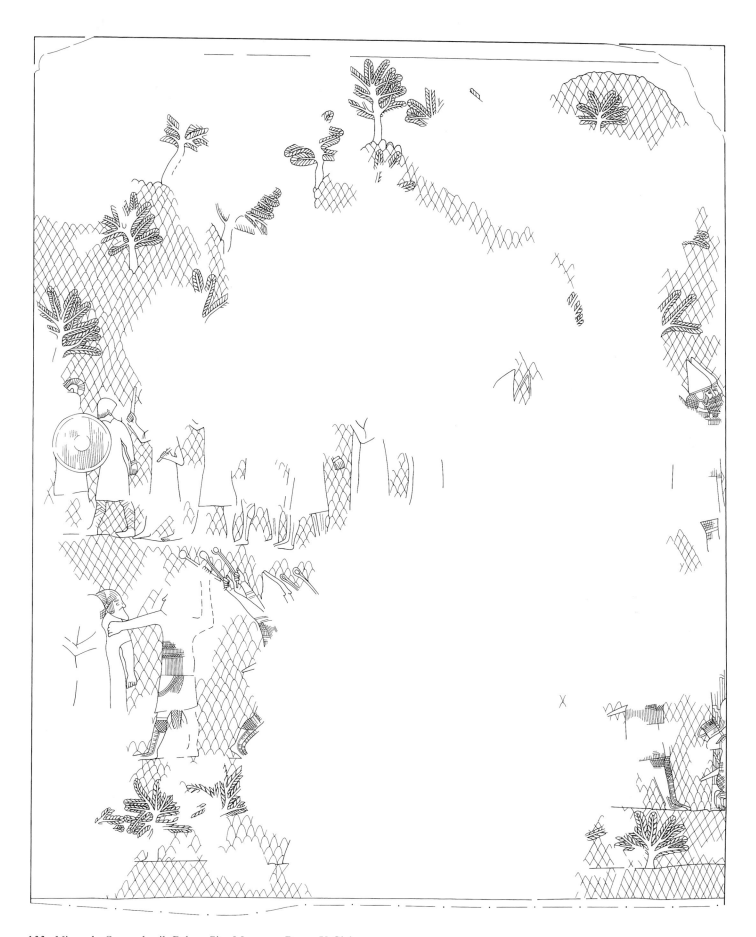

133: Nineveh, Sennacherib Palace Site Museum, Room V, Slab
15, 1990, scale 1:12, drawing by Jennifer Hook in consultation
with Denise L. Hoffman and the author (source: author).

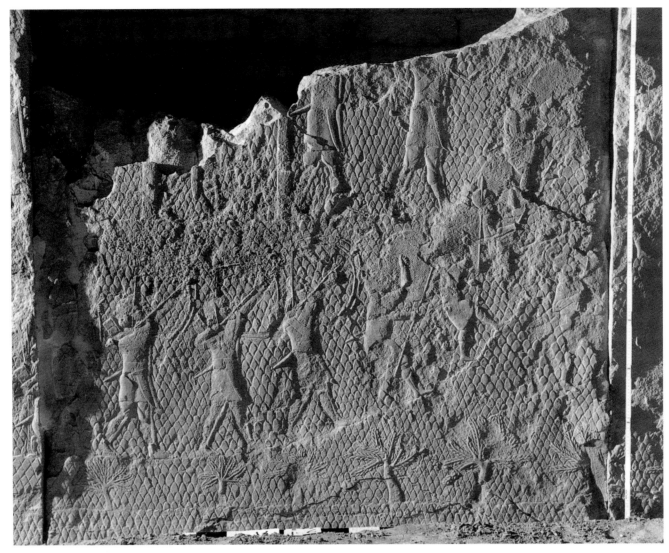

134: Nineveh, Sennacherib Palace Site Museum, Room V, Slab
16, 1990, scale 1:12 (photo: author).

135: Nineveh, Sennacherib
Palace Site Museum, Room V,
Slab 16, detail of looted area,
1990, not to scale (photo:
author).

136: Nineveh, Sennacherib
Palace Site Museum, Room V,
Slab 17, detail of looted area,
1990, not to scale (photo:
author).

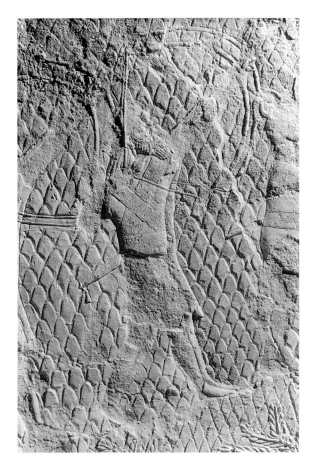

137: Nineveh, Sennacherib Palace Site Museum, Room V, Slab 17, 1990, scale 1:12 (photo: author).

138: Nineveh, Sennacherib's palace, Room V, Slab 17, 1847, scale 1:12, drawing by A. H. Layard, Or. Dr. IV, 16 (photo: Trustees of the British Museum).

139: Nineveh, Sennacherib Palace Site Museum, Room V, Slab 17, 1990, scale 1:12, drawing by Jennifer Hook in consultation with Denise L. Hoffman and the author (source: author).

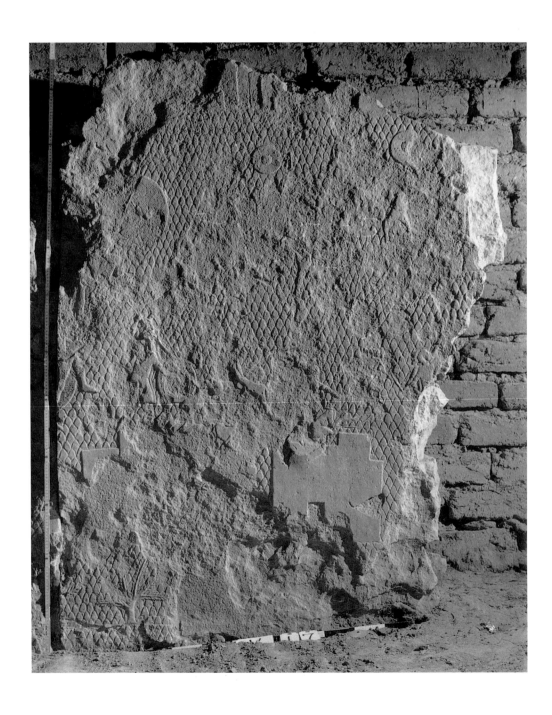

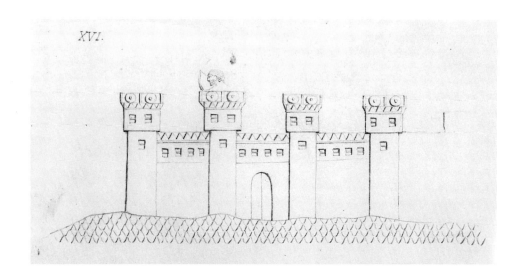

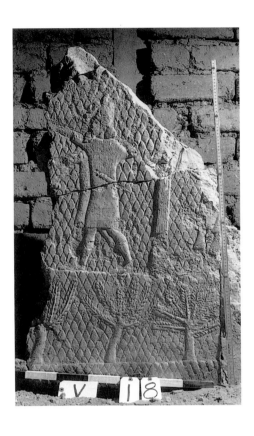

140: Nineveh, Sennacherib Palace Site Museum, Room V, Slab 18, 1990, scale 1:12 (photo: author).

141: Nineveh, Sennacherib Palace Site Museum, Room V, Slab 19, 1990, scale 1:12 (photo: author).

142: Nineveh, Sennacherib Palace Site Museum, Room V, Slab 20, 1990, scale 1:12 (photo: author).

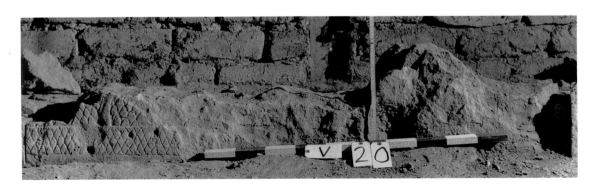

143: Nineveh,
Sennacherib Palace Site
Museum, Room V, Slab
21, 1990, scale 1:12
(photo: author).

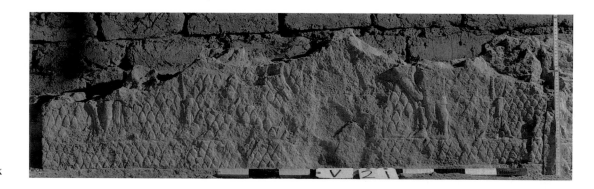

144: Nineveh,
Sennacherib Palace Site
Museum, Room V, Slab
21, 1990, scale 1:12,
drawing by Jennifer Hook
in consultation with
Denise L. Hoffman and
the author (source:
author).

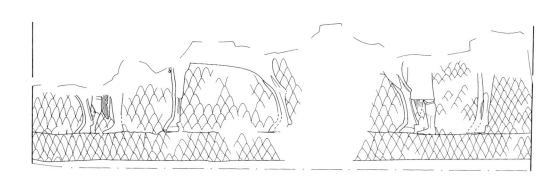

145: Nineveh,
Sennacherib Palace Site
Museum, Room V, Slab
22, 1990, scale 1:12
(photo: author).

146: Nineveh,
Sennacherib Palace Site
Museum, Room V, Slab
22, 1990, scale 1:12,
drawing by Jennifer Hook
in consultation with
Denise L. Hoffman and
the author (source:
author).

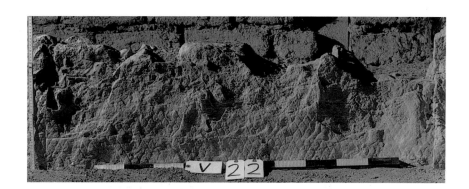

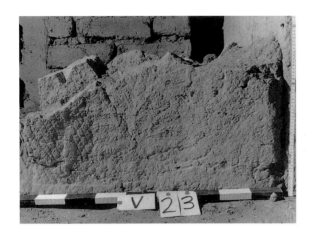

147: Nineveh, Sennacherib Palace Site Museum, Room V, Slab 23, 1990, scale 1:12 (photo: author).

148: Nineveh, Sennacherib Palace Site Museum, Room V, Slab 24, 1990, scale 1:12 (photo: author).

149: Nineveh, Sennacherib Palace Site Museum, Room V, Slab 25, 1990, scale 1:12 (photo: author).

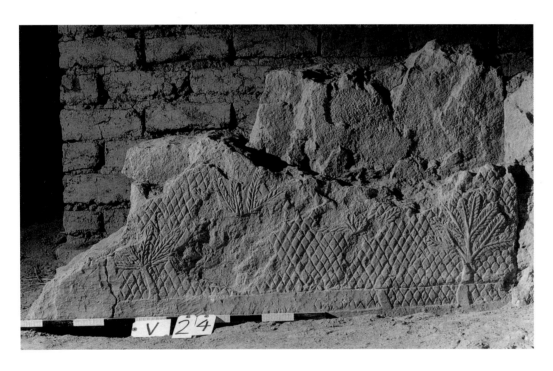

150: Nineveh, Sennacherib
Palace Site Museum, Room V,
Slab 26, 1990, scale 1:12
(photo: author).

151: Nineveh, Sennacherib
Palace Site Museum, Room V,
Slab 27, 1990, scale 1:12
(photo: author).

152: Nineveh, Sennacherib
Palace Site Museum, Room V,
Slab 28, 1990, scale 1:12
(photo: author).

153: Nineveh, Sennacherib
Palace Site Museum, Room V,
Slab 29, 1990, oblique view,
scale roughly 1:12 (photo:
author).

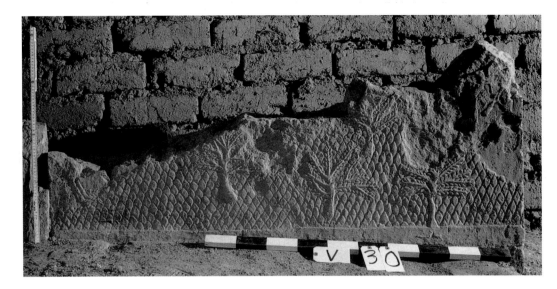

154: Nineveh, Sennacherib
Palace Site Museum, Room V,
Slab 30, 1990, scale 1:12
(photo: author).

155: Nineveh, Sennacherib
Palace Site Museum, Room V,
Slab 30, 1990, scale 1:12,
drawing by Jennifer Hook in
consultation with Denise L.
Hoffman and the author
(source: author).

156: Nineveh, Sennacherib
Palace Site Museum, Room V,
Slab 31, 1990, scale 1:12
(photo: author).

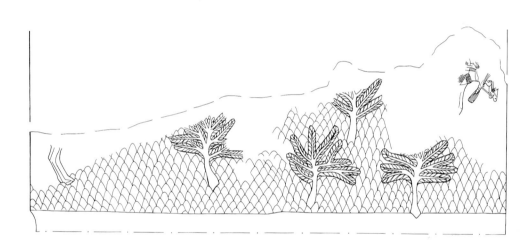

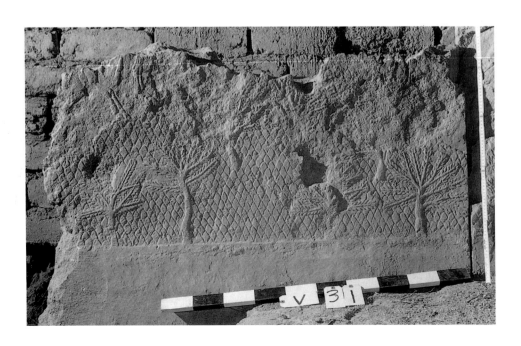

157: Nineveh, Sennacherib
Palace Site Museum, Room V,
Slab 32, detail of king, 1990,
not to scale (photo: author).

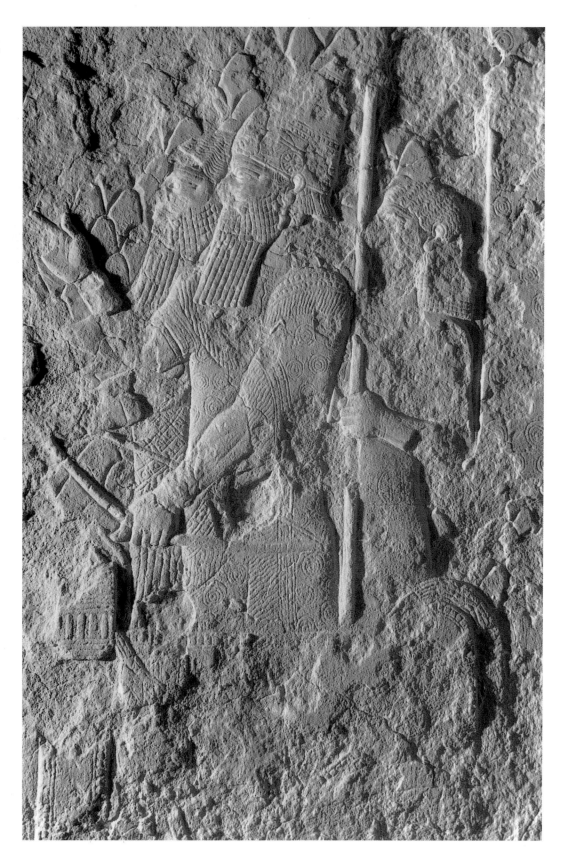

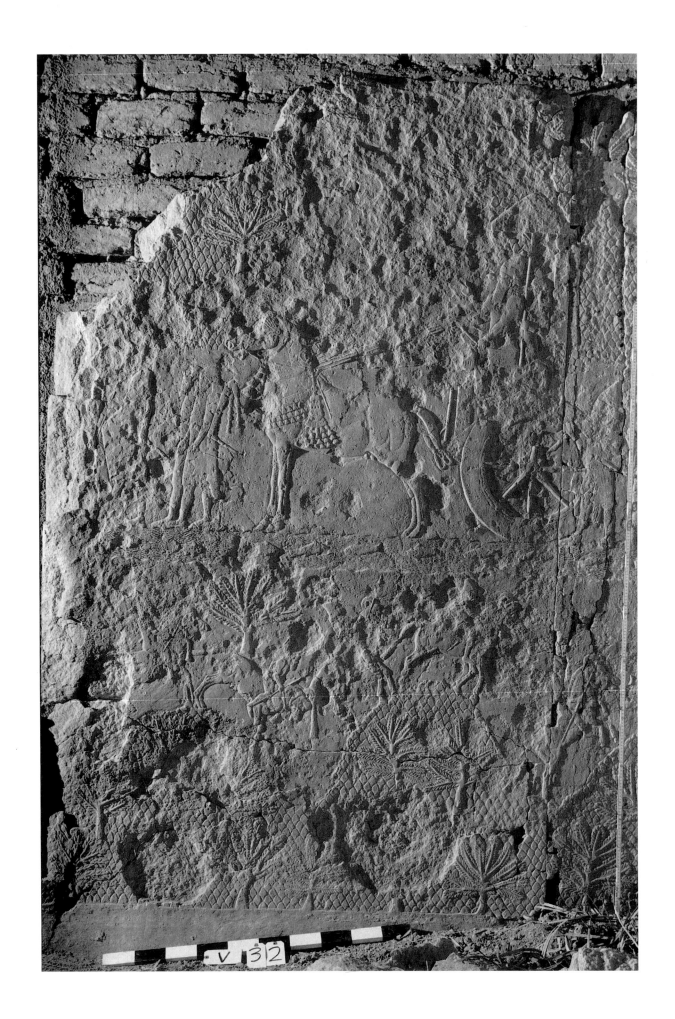

158: Nineveh, Sennacherib
Palace Site Museum, Room V,
Slab 32, 1990, scale 1:12
(photo: author).

159: Nineveh, Sennacherib's
palace, Room V, Slab 32, 1847,
scale 1:12, drawing by A. H.
Layard, Or. Dr. IV, 17 (photo:
Trustees of the British
Museum).

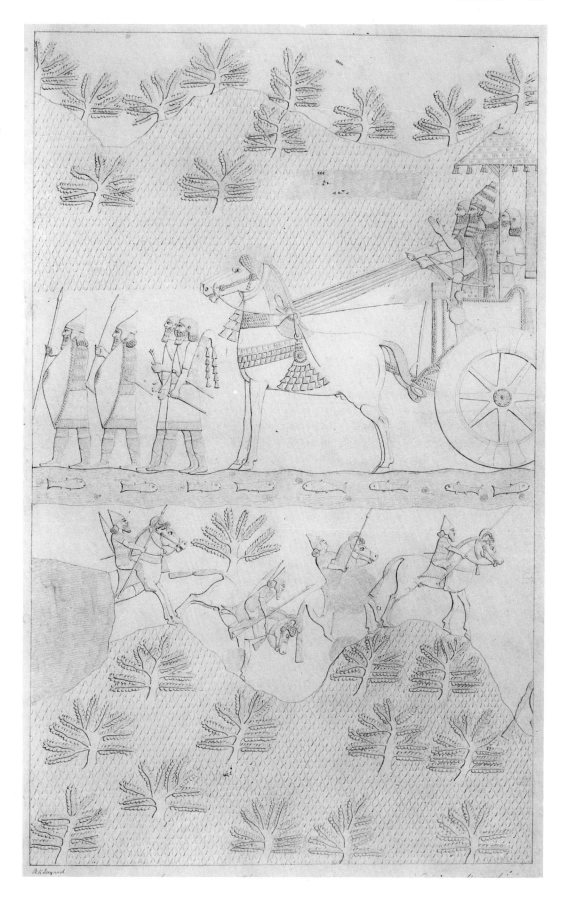

160: Nineveh, Sennacherib Palace Site Museum, Room V, Slab 33, left panel, detail of uncarved figures at top right, 1990, not to scale (photo: author).

161: Nineveh, Sennacherib Palace Site Museum, Room V, Slab 33, left panel, 1990, scale 1:12 (photo: author).

162: Nineveh, Sennacherib Palace Site Museum, Room V, Slab 33, right panel, 1990, scale 1:12 (photo: author).

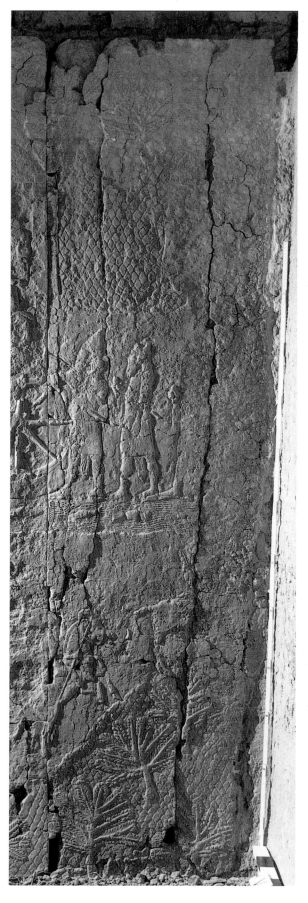
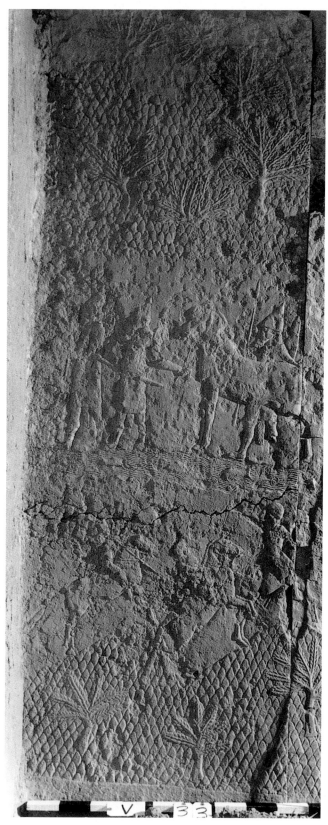

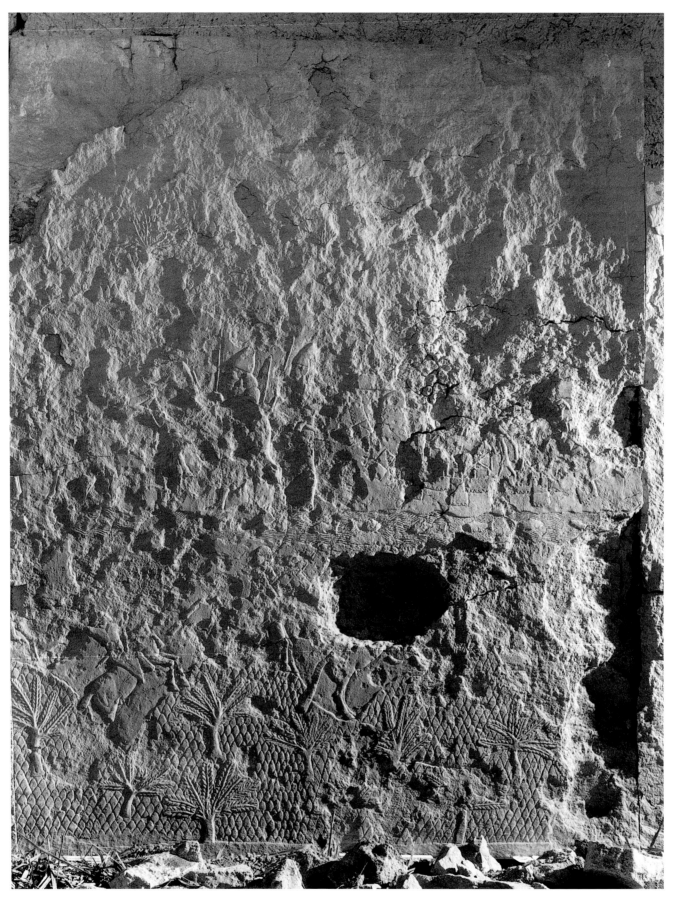

163: Nineveh, Sennacherib Palace Site Museum, Room V, Slab
34, 1990, scale 1:12 (photo: author).

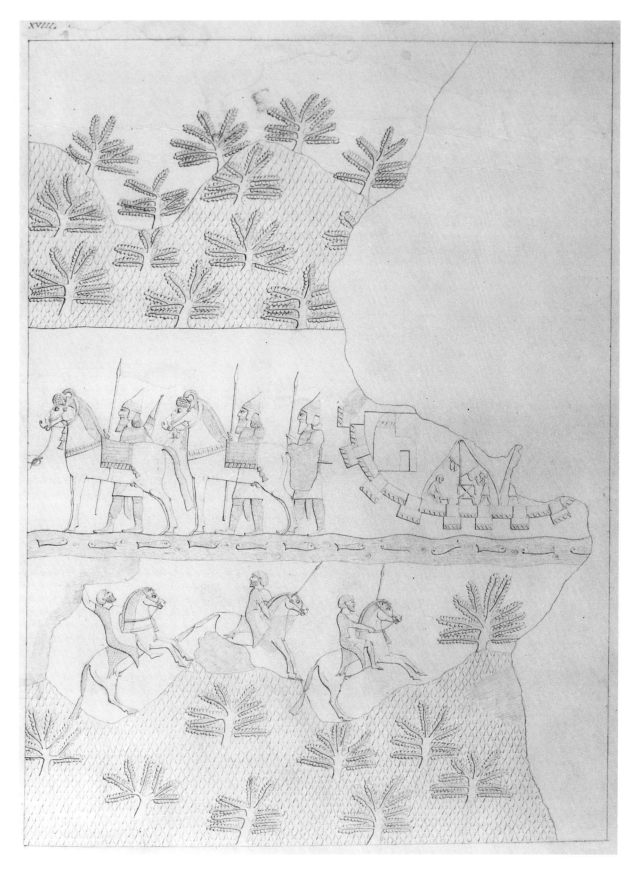

164: Nineveh, Sennacherib's palace, Room V, Slab 34, 1847,
scale 1:12, drawing by A. H. Layard, Or. Dr. IV, 18 (photo:
Trustees of the British Museum).

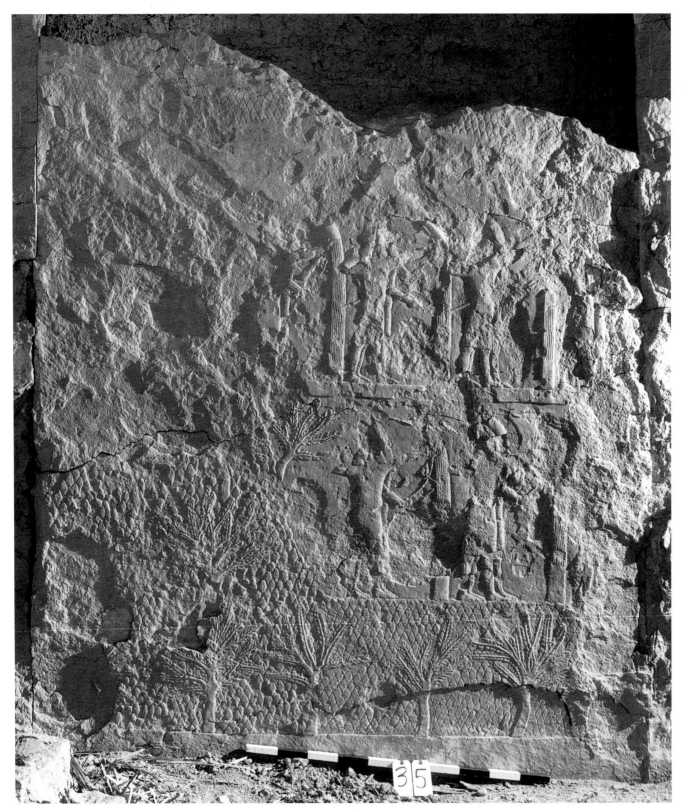

165: Nineveh, Sennacherib Palace Site Museum, Room V, Slab 35, 1990, scale 1:12 (photo: author).

166: Nineveh, Sennacherib Palace Site Museum, Room V, Slab 35, 1990, scale 1:12, drawing by Jennifer Hook in consultation with Denise L. Hoffman and the author (source: author).

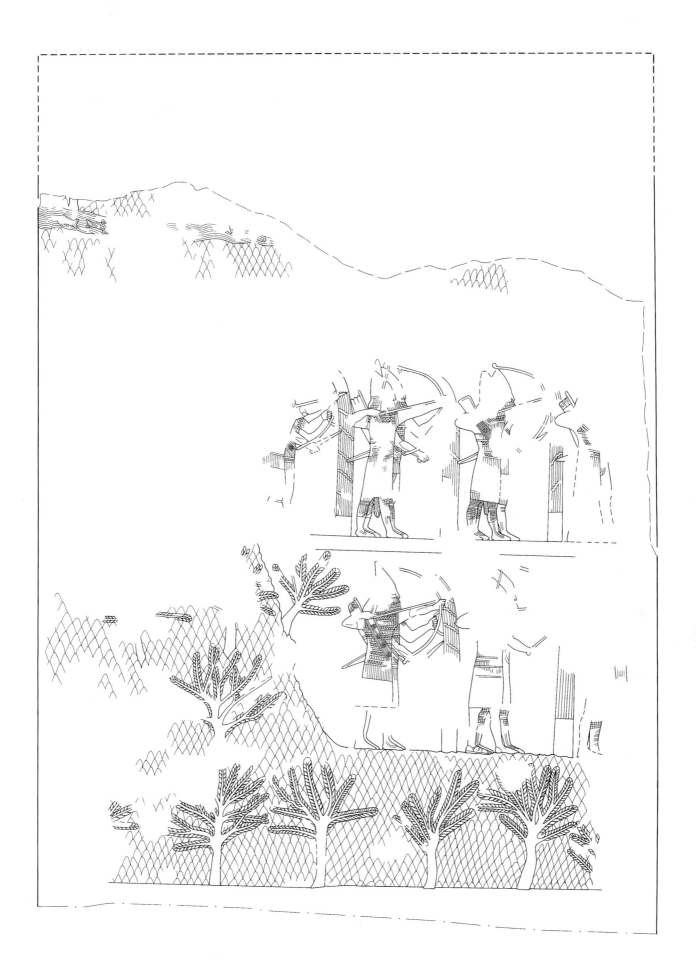

167: Nineveh, Sennacherib Palace Site Museum, Room V, Slab
36, 1990, scale 1:12 (photo: author).

168: Nineveh, Sennacherib Palace Site Museum, Room V, Slab
36, 1990, scale 1:12, drawing by Jennifer Hook in consultation
with Denise L. Hoffman and the author (source: author).

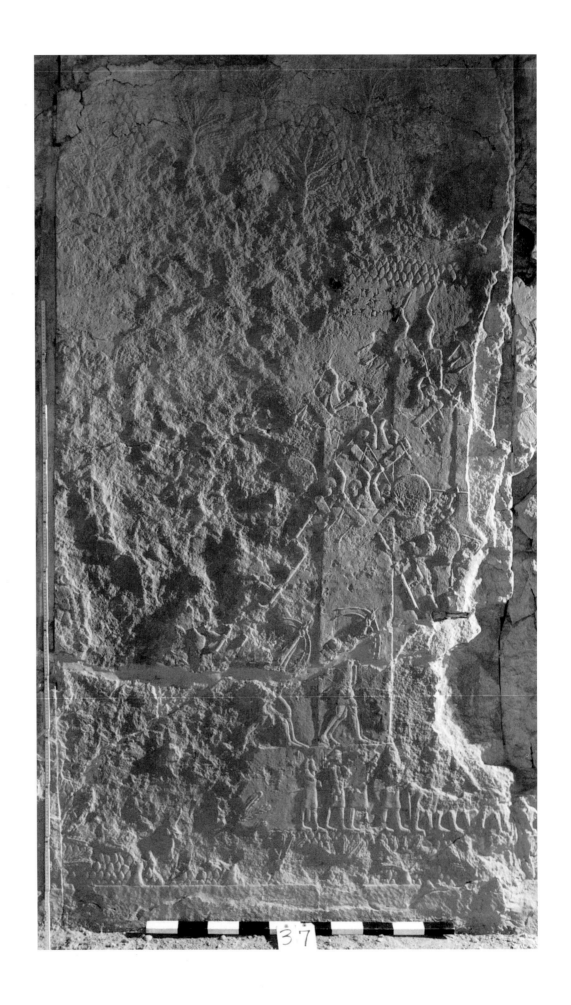

169: Nineveh, Sennacherib
Palace Site Museum, Room V,
Slab 37, 1990, scale 1:12
(photo: author).

170: Nineveh, Sennacherib's
palace, Room V, Slab 37, 1847,
scale 1:12, drawing by A. H.
Layard, Or. Dr. IV, 19 (photo:
Trustees of the British
Museum).

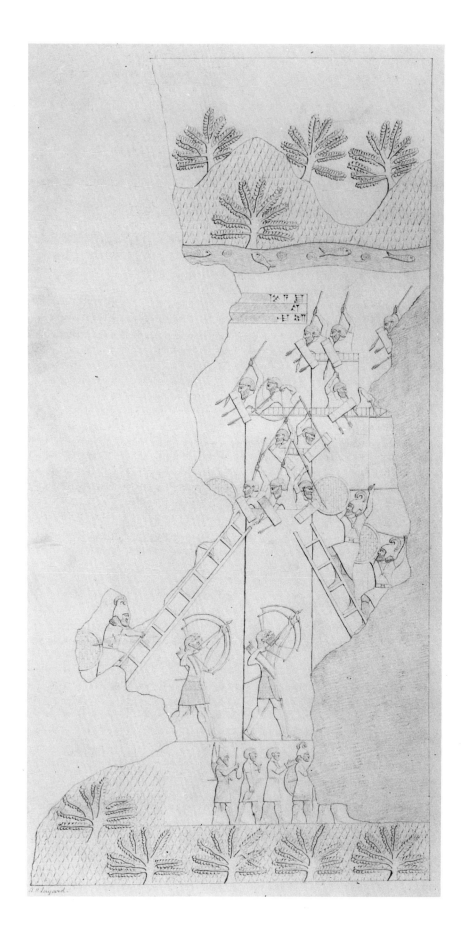

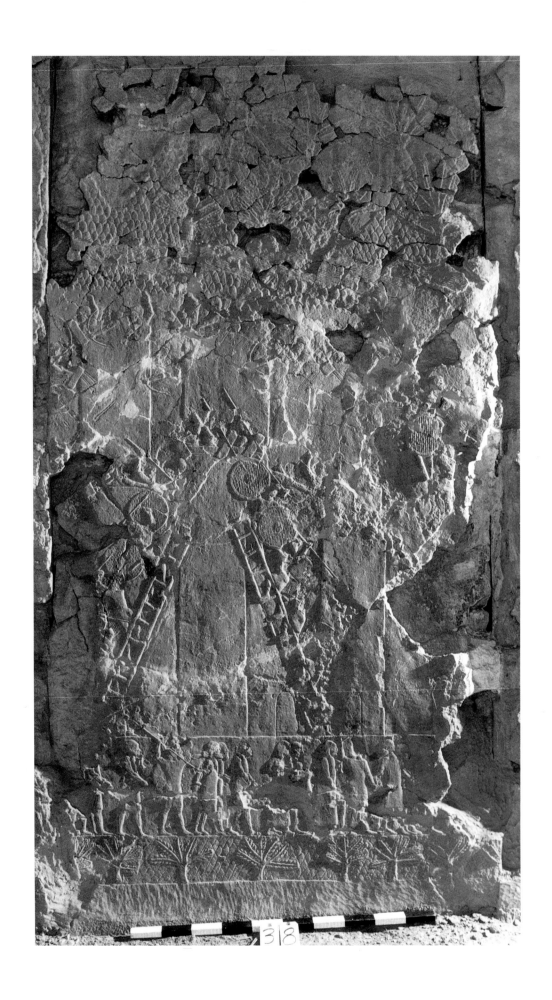

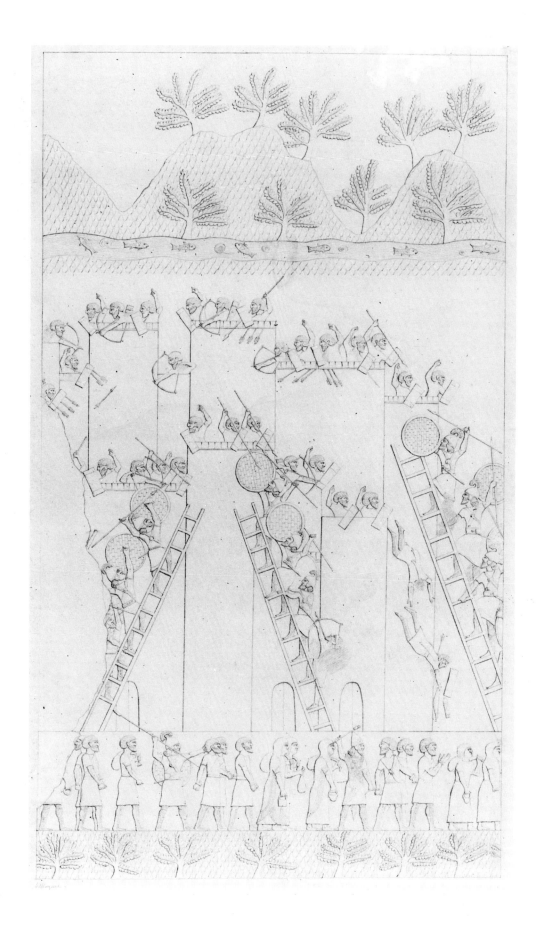

171: Nineveh, Sennacherib Palace Site Museum, Room V, Slab 38, 1990, scale 1:12 (photo: author).

172: Nineveh, Sennacherib's palace, Room V, Slab 38, 1847, scale 1:12, drawing by A. H. Layard, Or. Dr. IV, 20 (photo: Trustees of the British Museum).

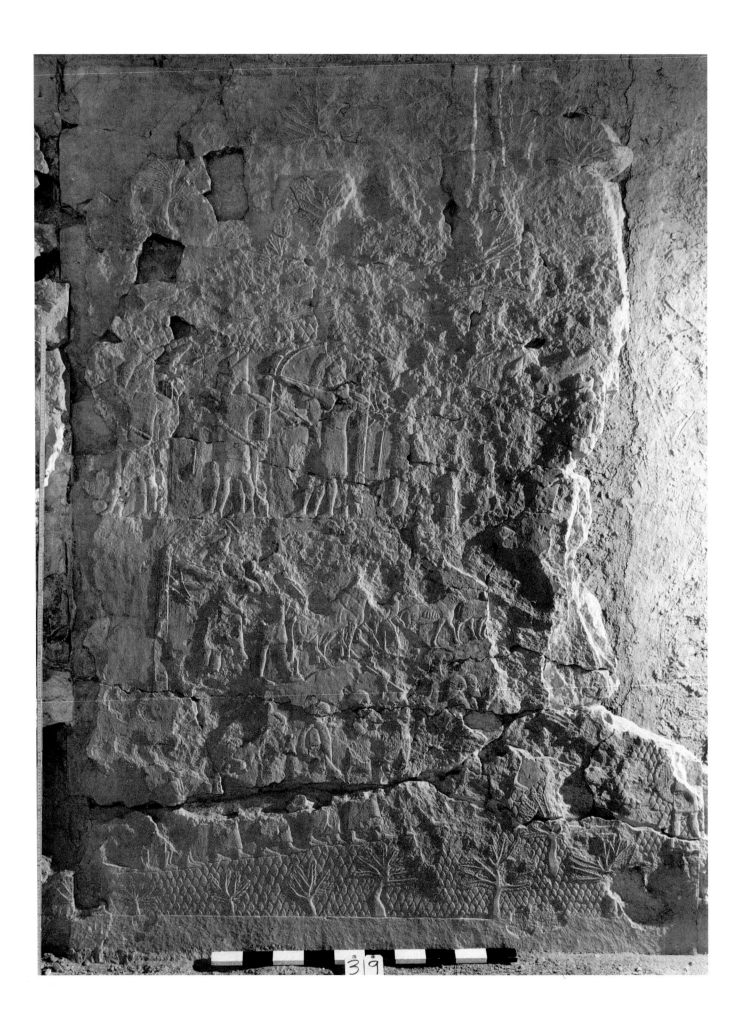

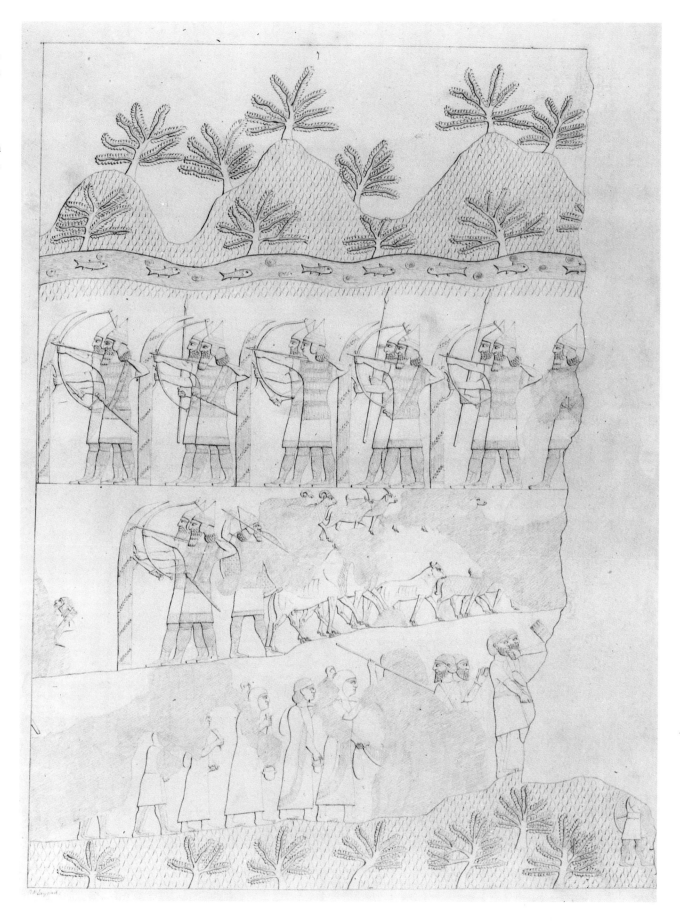

173: Nineveh, Sennacherib Palace Site Museum, Room V, Slab 39, 1990, scale 1:12 (photo: author).

174: Nineveh, Sennacherib's palace, Room V, Slab 39, 1847, scale 1:12, drawing by A. H. Layard, Or. Dr. IV, 21 (photo: Trustees of the British Museum).

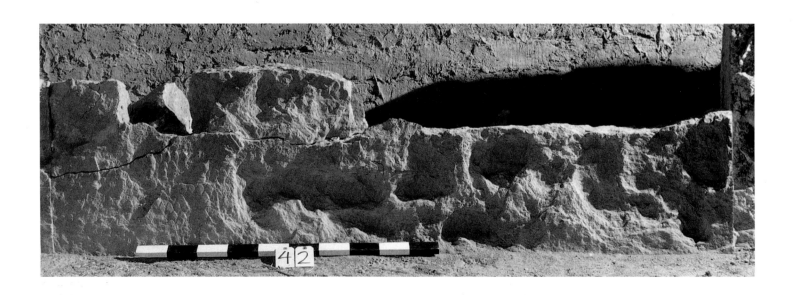

175: Nineveh,
Sennacherib Palace Site
Museum, Room V, Slab
40, 1990, scale 1:12
(photo: author).

176: Nineveh,
Sennacherib Palace Site
Museum, Room V, Slab
41, 1990, scale 1:12
(photo: author).

177: Nineveh,
Sennacherib Palace Site
Museum, Room V, Slab
42, 1990, scale 1:12
(photo: author).

178: Nineveh,
Sennacherib Palace Site
Museum, Room V, Slab
43, 1990, scale 1:12,
drawing by Jennifer Hook
in consultation with
Denise L. Hoffman and
the author (source:
author).

179: Nineveh,
Sennacherib Palace Site
Museum, Room V, Slab
43, 1990, scale 1:12
(photo: author).

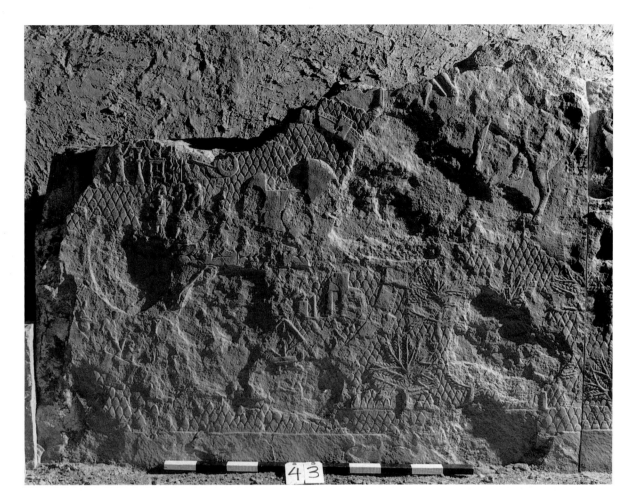

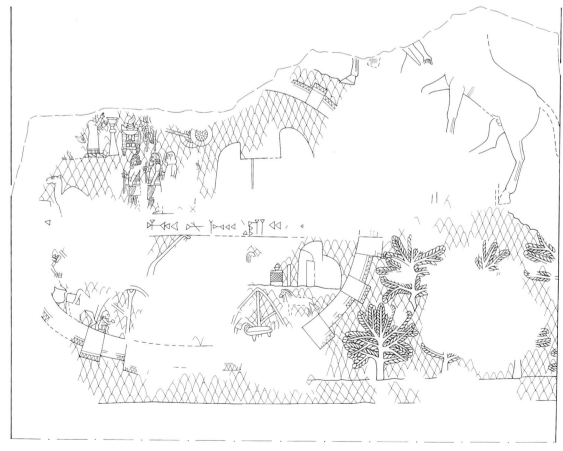

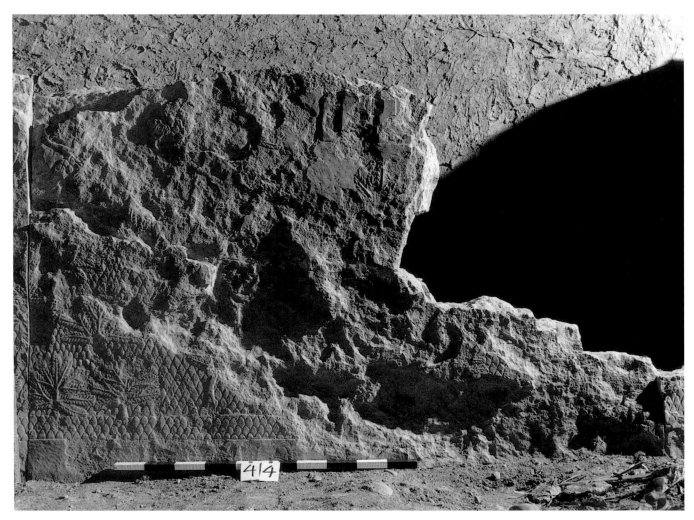

180: Nineveh, Sennacherib Palace Site Museum, Room V, Slab
44, 1990, scale 1:12 (photo: author).

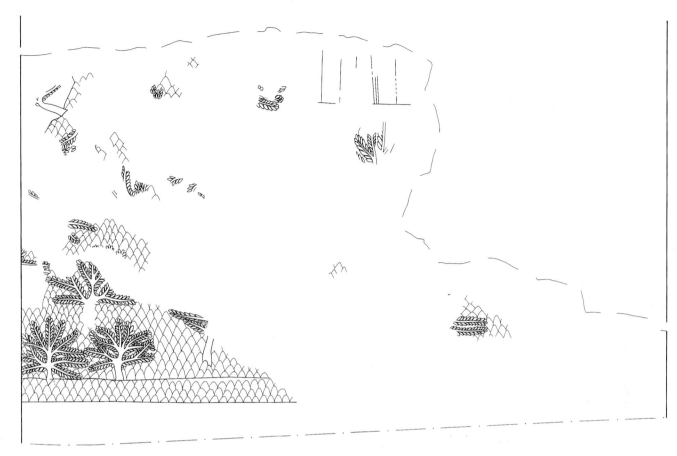

181: Nineveh, Sennacherib Palace Site Museum, Room V, Slab
44, 1990, scale 1:12, drawing by Jennifer Hook in consultation
with Denise L. Hoffman and the author (source: author).

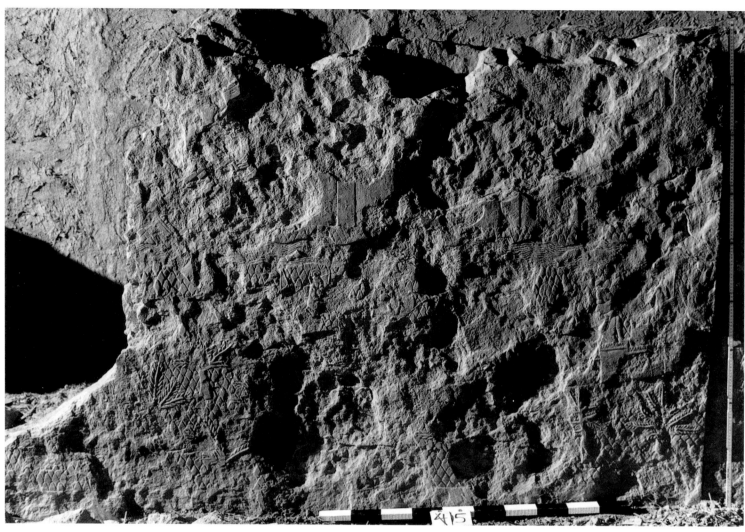

182: Nineveh, Sennacherib Palace Site Museum, Room V, Slab
45, 1990, scale 1:12 (photo: author).

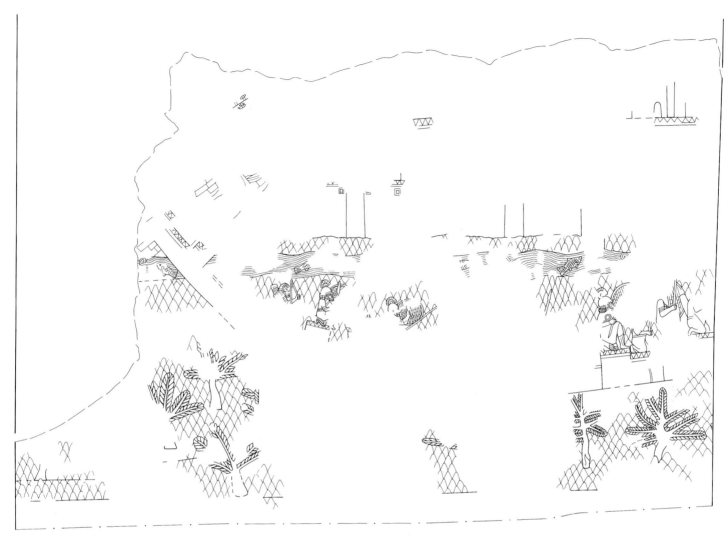

183: Nineveh, Sennacherib Palace Site Museum, Room V, Slab
45, 1990, scale 1:12, drawing by Jennifer Hook in consultation
with Denise L. Hoffman and the author (source: author).

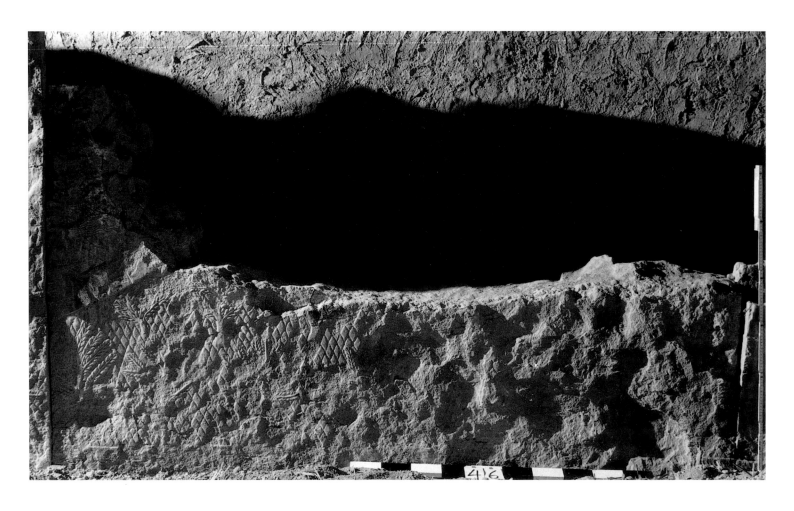

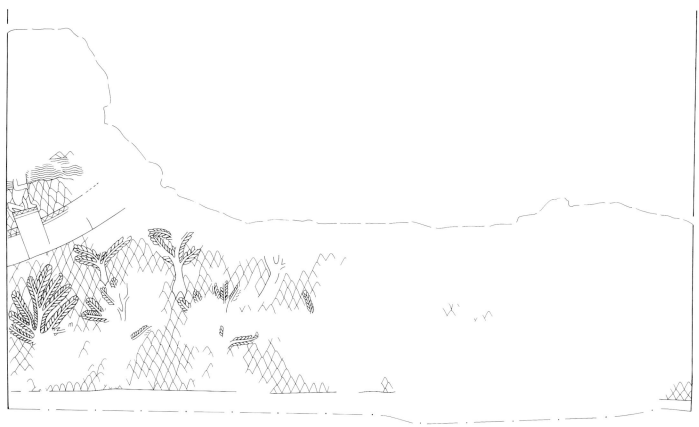

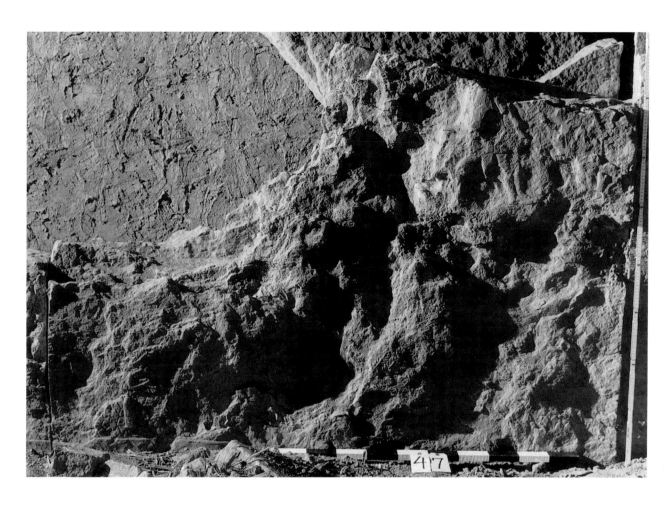

184: Nineveh, Sennacherib Palace Site Museum, Room V, Slab 46, 1990, scale 1:12 (photo: author).

185: Nineveh, Sennacherib Palace Site Museum, Room V, Slab 46, 1990, scale 1:12, drawing by Jennifer Hook in consultation with Denise L. Hoffman and the author (source: author).

186: Nineveh, Sennacherib Palace Site Museum, Room V, Slab 47, 1990, scale 1:12 (photo: author).

187: Nineveh, Sennacherib Palace Site Museum, Room V, Slab 47, 1990, scale 1:12, drawing by Jennifer Hook in consultation with Denise L. Hoffman and the author (source: author).

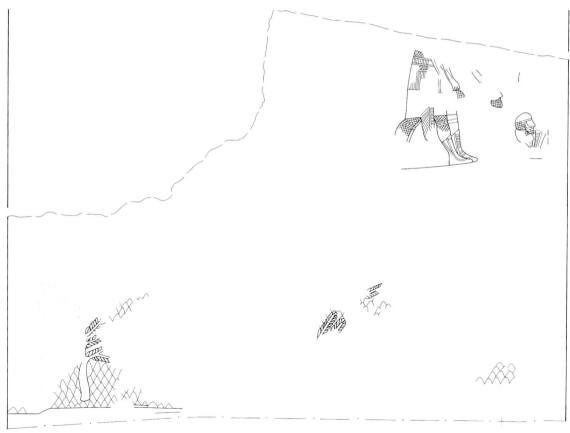

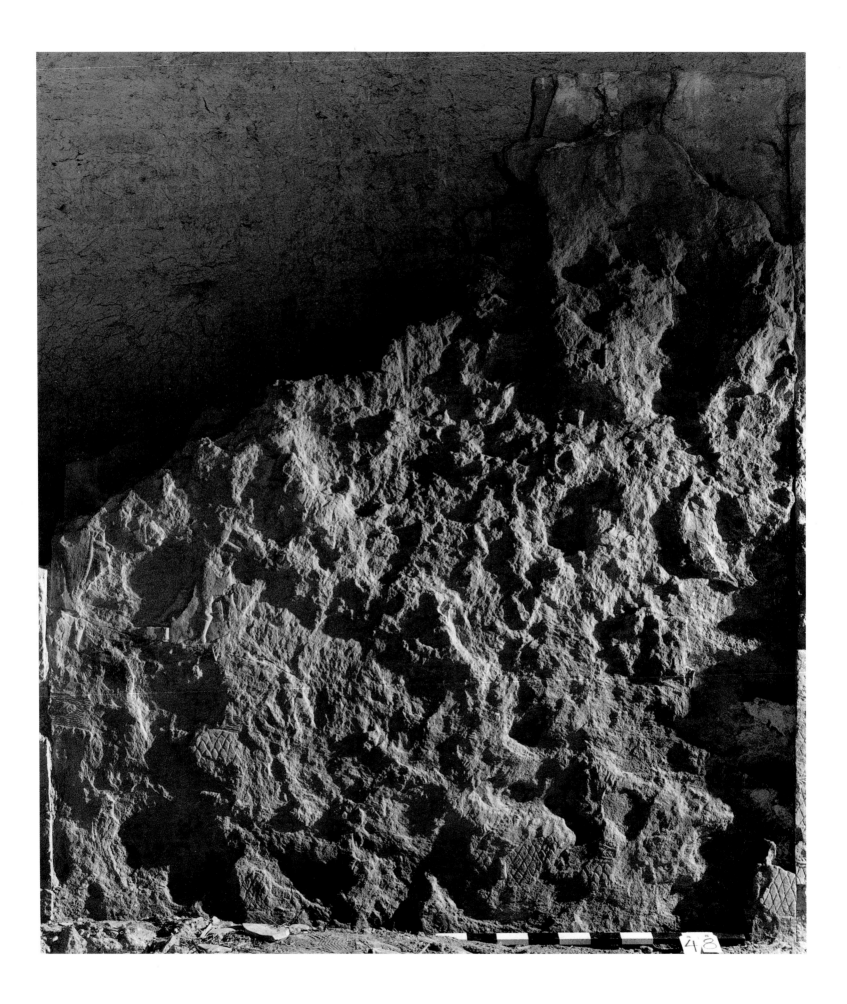

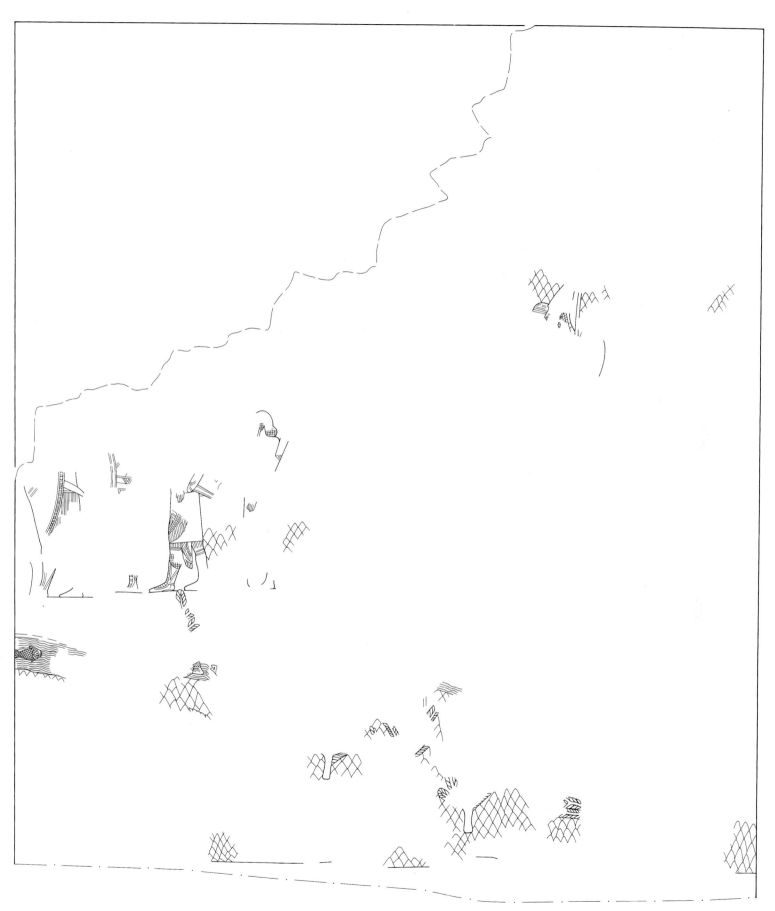

188: Nineveh, Sennacherib Palace Site Museum, Room V, Slab 48, 1990, scale 1:12 (photo: author).

189: Nineveh, Sennacherib Palace Site Museum, Room V, Slab 48, 1990, scale 1:12, drawing by Jennifer Hook in consultation with Denise L. Hoffman and the author (source: author).

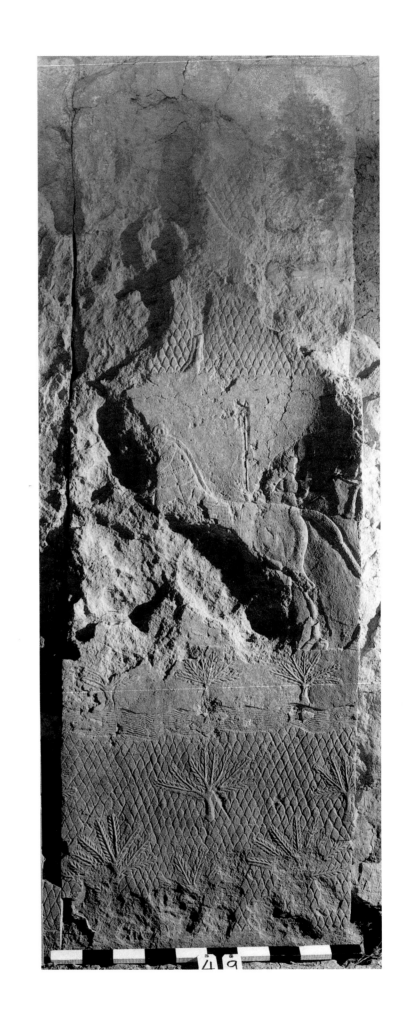

190: Nineveh, Sennacherib Palace Site Museum, Room V, Slab 49, 1990, scale 1:12 (photo: author).

191: Nineveh, Sennacherib's palace, Room V, Slab 49, 1847, scale 1:12, drawing by A. H. Layard, Or. Dr. IV, 22 (photo: Trustees of the British Museum).

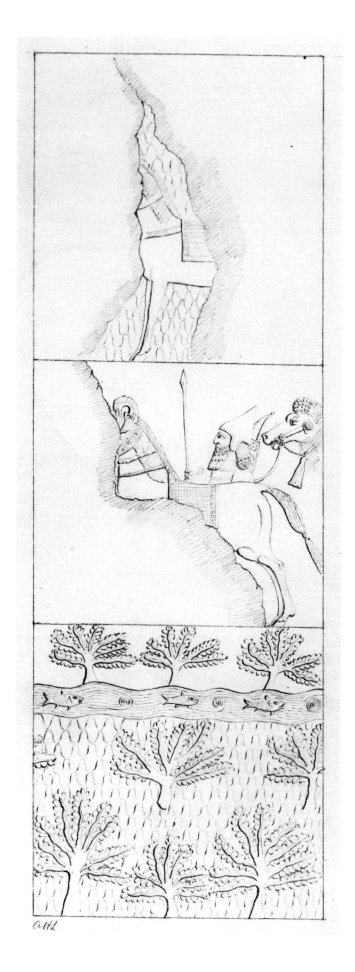

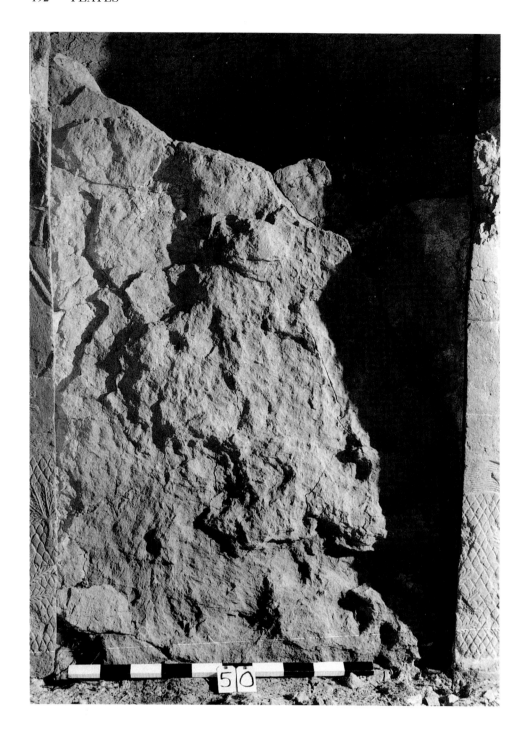

192: Nineveh, Sennacherib
Palace Site Museum, Room V,
Slab 50, 1990, scale 1:12
(photo: author).

193: Nineveh, Sennacherib
Palace Site Museum, Room V,
Slab 51, 1990, scale 1:12
(photo: author).

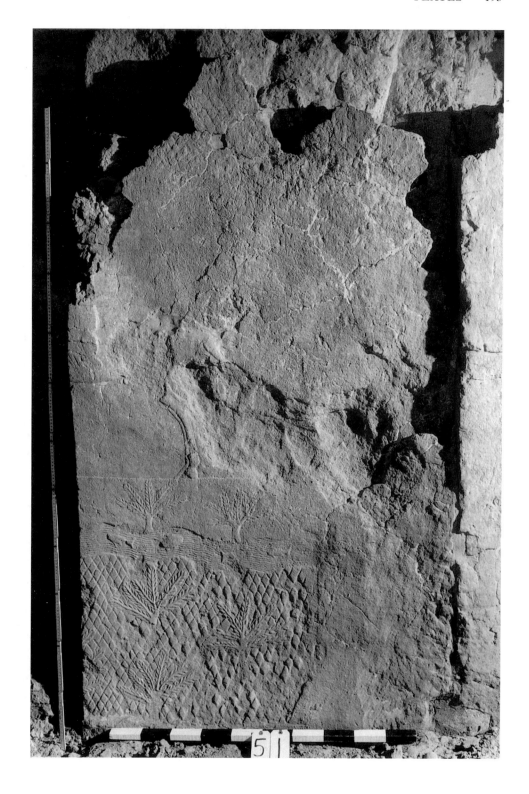

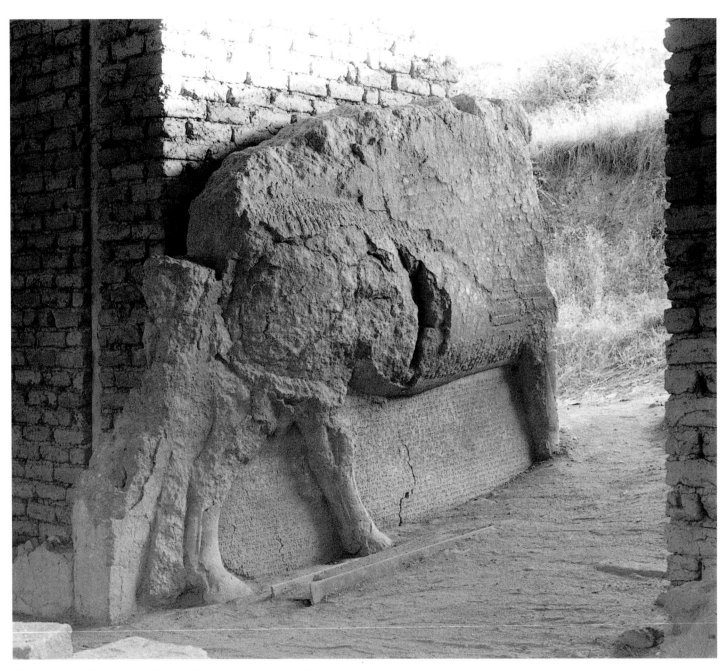

194: Nineveh, Sennacherib Palace Site Museum, Court VI,
Door *a*, Bull 2, 1989, not to scale (photo: author).

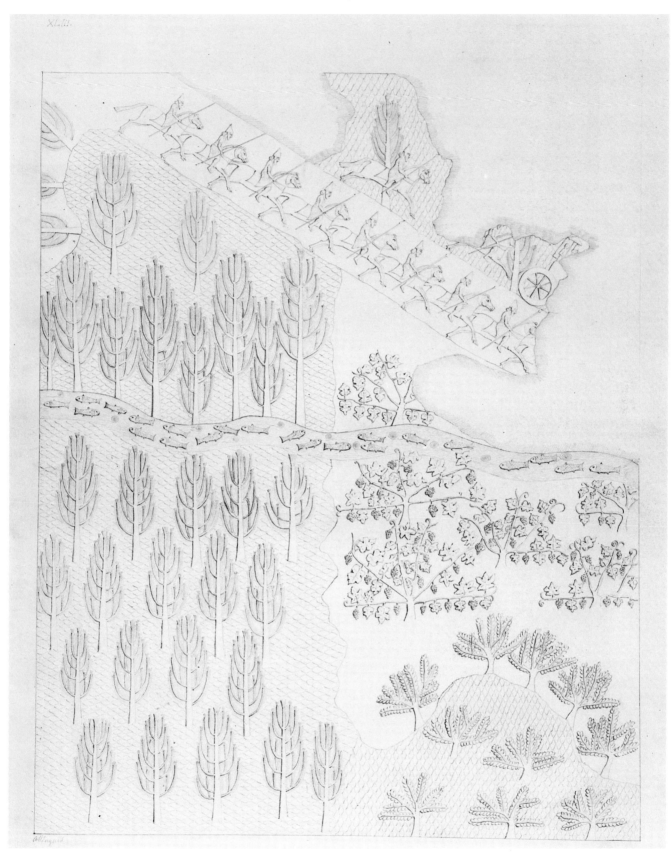

195: Nineveh, Sennacherib's palace, Court VI, Slab 1, 1847,
scale 1:12, drawing by A. H. Layard, Or. Dr. IV, 43 (photo:
Trustees of the British Museum).

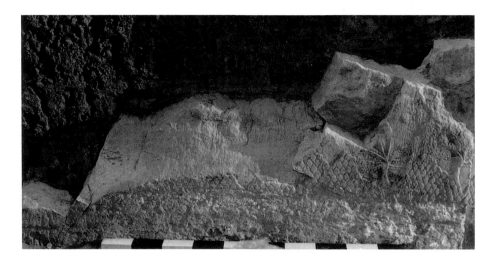

196: Nineveh, Sennacherib Palace Site Museum, Court VI, Slab 7a, 1990, scale 1:12 (photo: author).

197: Nineveh, Sennacherib Palace Site Museum, Court VI, Slabs 7a, 7, 8, oblique view, 1990, not to scale (photo: author).

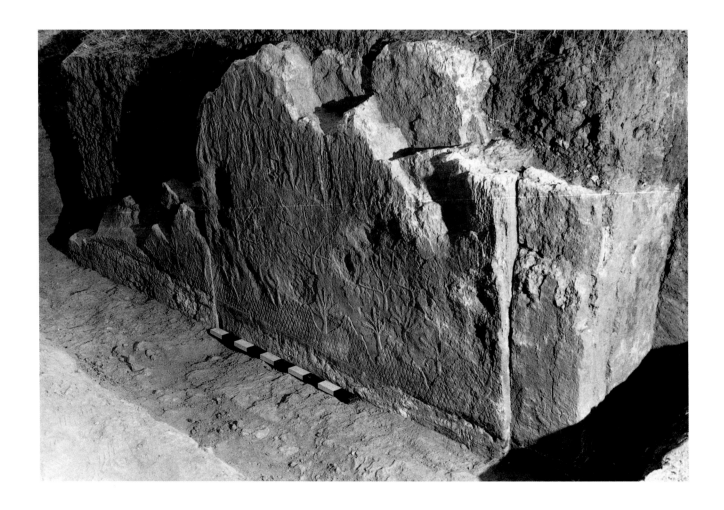

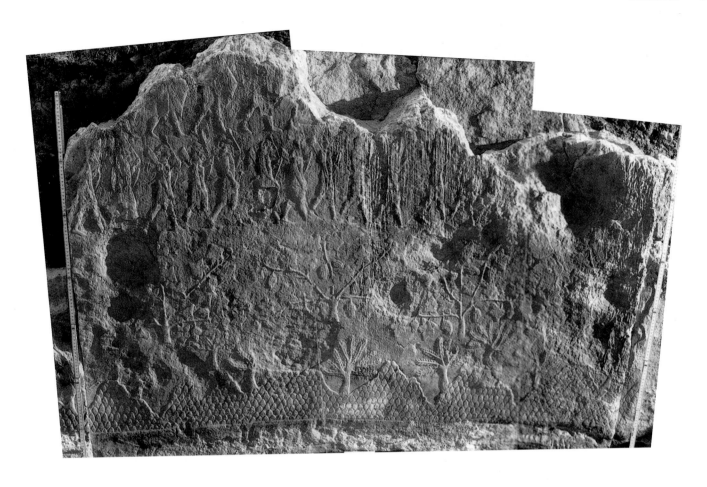

198: Nineveh, Sennacherib
Palace Site Museum, Court
VI, Slab 7, montage of three
photos, 1990, scale 1:12 (photo:
author).

199: Nineveh, Sennacherib
Palace Site Museum, Court
VI, Slab 8, 1990, scale roughly
1:12 (photo: author).

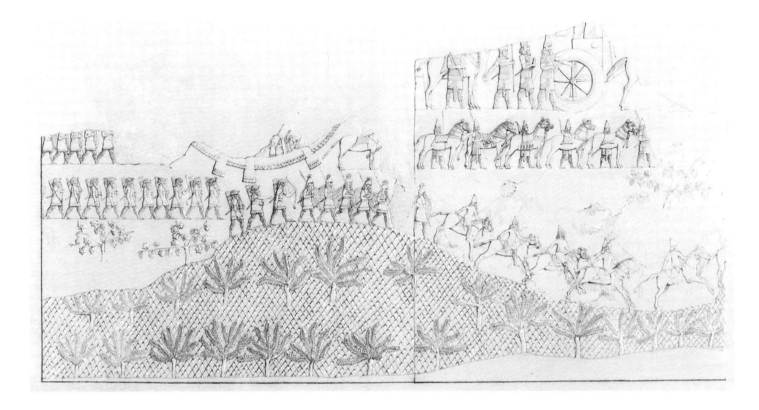

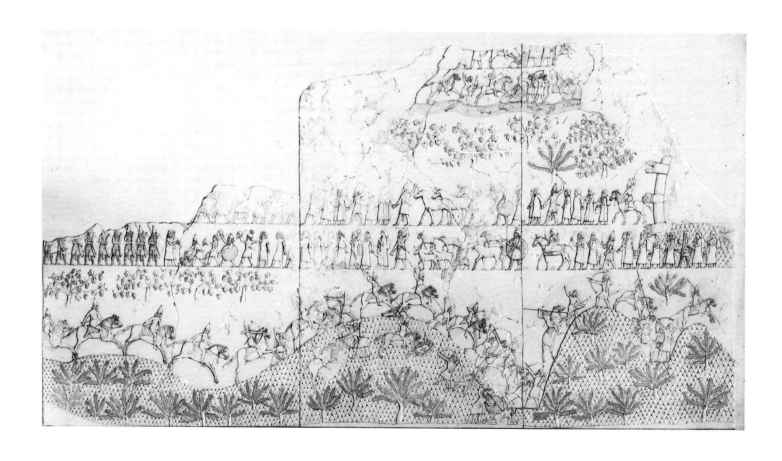

200: Nineveh, Sennacherib's palace, Court VI, Slabs 9–10, 1847, not to scale, drawing by A. H. Layard, Or. Dr. IV, 44 (photo: Trustees of the British Museum).

201: Nineveh, Sennacherib's palace, Court VI, Slabs 11–13, 1847, not to scale, drawing by A. H. Layard, Or. Dr. I, 70 (photo: Trustees of the British Museum).

202: Nineveh, Sennacherib Palace Site Museum, Court H, Bull 1, detail of inscription on leg fragment, 1989 (photo: author).

203: Nineveh, Sennacherib Palace Site Museum, Court H, Bull 1, detail of inscription on base, 1989 (photo: author).

204: Nineveh, Sennacherib Palace Site Museum, Court H, Bull
3, detail of inscription between hind legs, 1989 (photo: author).

205: Nineveh, Sennacherib Palace Site Museum, Court H, Bull
3, detail of inscription under belly, left part, 1989 (photo:
author).

206: Nineveh, Sennacherib Palace Site Museum, Court H, Bull
3, detail of inscription under belly, right part, 1989 (photo:
author).

207: Nineveh, Sennacherib Palace Site Museum, Court H, Bull 12, detail of inscription, 1989 (photo: author).

from left to right

208: Nineveh, Sennacherib Palace Site Museum, led(?) horse in a wooded mountainous landscape, 1989 (photo: author).

209: Formerly Nineveh, Sennacherib Palace Site Museum, two lines of laborers towing an object towards the right, originally from Room XLIX, 1989 (photo: author).

210: Nineveh, Sennacherib Palace Site Museum, Sennacherib in his chariot, with a river and walled city(?) above, 1989 (photo: author).

211: Nineveh, Sennacherib Palace Site Museum, fragment of a Sennacherib inscription, possibly from a bull colossus, 1989 (photo: author).

212: Nineveh, Sennacherib Palace Site Museum, head and right arm of a protective doorway figure, 1989 (photo: author).

213: Nineveh, Sennacherib Palace Site Museum, Assyrian soldiers marching in front of a river, 1989 (photo: author).

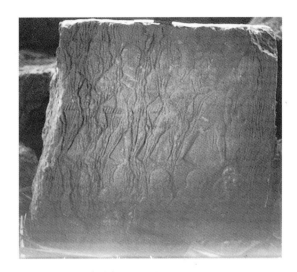

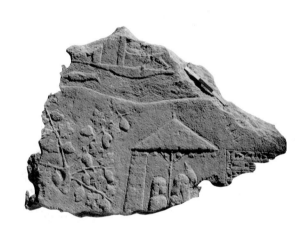

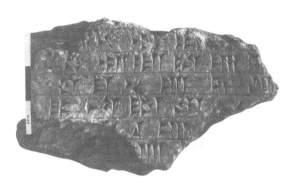

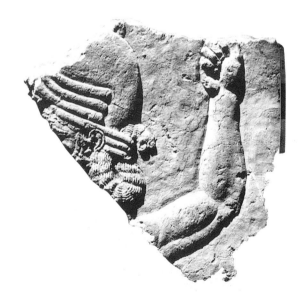

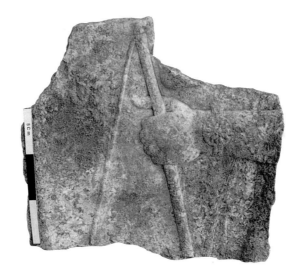

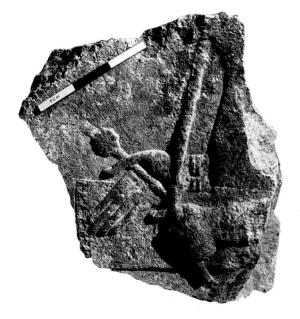

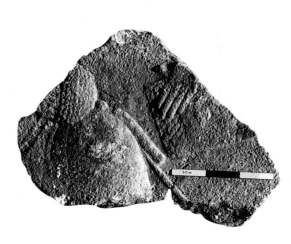

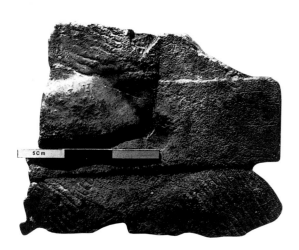

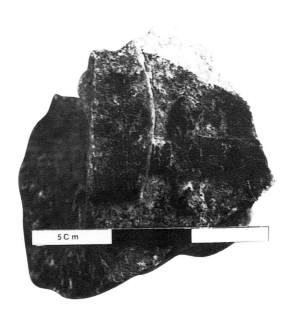

from left to right

214: Nineveh, Nabu temple, probably originally in the Ishtar temple, fragments of a lion hunt of Assurnasirpal II, drawing by W. E. Stevens (after Thompson and Hutchinson 1929a, pl. VII).

215: Nineveh storage, Assurnasirpal II, king's left hand holding his bow, 1989 (photo: author).

216: Nineveh storage, Assurnasirpal II, courtier holding the king's quiver and mace, fragment 1, 1989 (photo: author).

217: Nineveh storage, Assurnasirpal II, courtier holding the king's quiver and mace, fragment 2, 1989 (photo: author).

218: Nineveh storage, Assurnasirpal II, courtier holding the king's quiver and mace, fragment 3, 1989 (photo: author).

219: Nineveh storage, Assurnasirpal II, courtier holding the king's quiver and mace, fragment 4, 1989 (photo: author).

from left to right

220: Nineveh storage, Assurnasirpal II, lower garment and left foot of a courtier, 1989 (photo: author).

221: Nineveh storage, Assurbanipal?, torso of a protective figure, 1989 (photo: author).

222: Nineveh storage, fragment of a winged figure, 1989 (photo: author).

223: Nineveh storage, Sargon II, fragment of a figure walking to the right with a bag on his shoulder, 1989 (photo: author).

224: Nineveh storage, Sargon II, sandaled right foot of a figure facing right, 1989 (photo: author).

225: Nineveh storage, Sargon II(?), torso of a winged protective figure with cone and bucket, facing right, 1989 (photo: author).

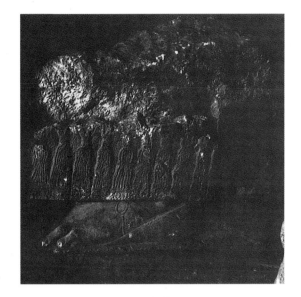
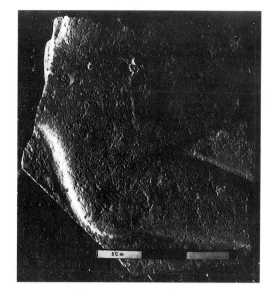
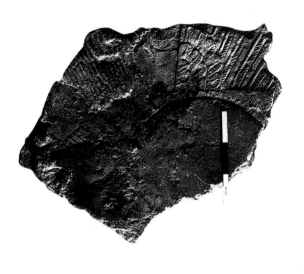
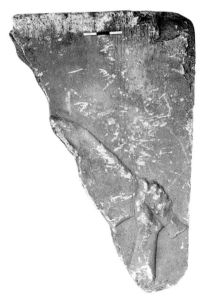
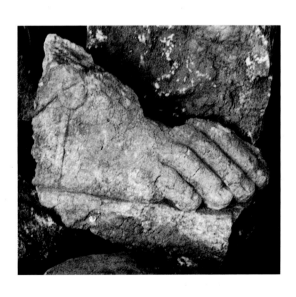
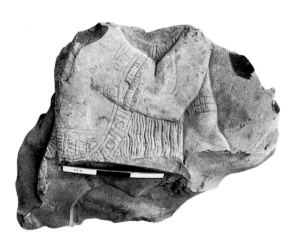

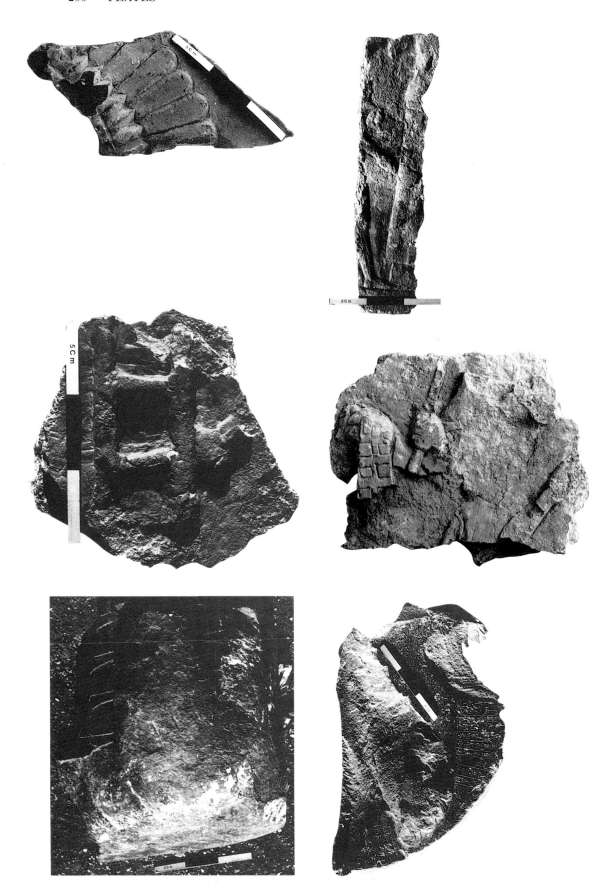

from left to right

226: Nineveh storage, Sargon II(?), fragment, possibly from an apotropaic figure, in black stone, 1989 (photo: author).

227: Nineveh storage, parts of a female and male figure moving to the right in a prisoner procession, 1989 (photo: author).

228: Nineveh storage, fragment of an Assyrian siege ladder, 1989 (photo: author).

229: Nineveh storage, fragment, possibly of a figure in a headdress with earflaps moving to the left, 1989 (photo: author).

230: Nineveh storage, fragment from the base of a black stone statue of an Egyptian king, 1989 (photo: author).

231: Nineveh storage, fragment of a statue base in black diorite with a Sumerian inscription, 1989 (photo: author).

from left to right

232: Dohuk Museum, glazed brick, beginning of the name of Assurnasirpal II, 1990 (photo: author).

233: Dohuk Museum, stone figurine from Tell es-Sawwan, 1990 (photo: author).

234: Dohuk Museum, small stone vessels from Tell es-Sawwan, 1990 (photo: author).

235: Dohuk Museum, small stone bowls from Tell es-Sawwan, 1990 (photo: author).

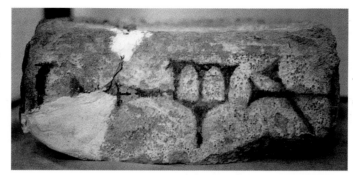

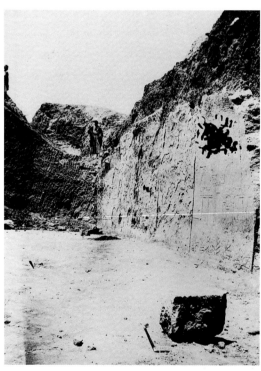

236: Sennacherib's palace, Room I, Door *e*, Bull 2 from the front, with the left part of Slab 5, 1903–4, photo by L. W. King, neg. PS 139268 (photo: Trustees of the British Museum).

237: Sennacherib's palace, Room I, Slab 3, 1903–4, photo by L. W. King, neg. PS 202212 (photo: Trustees of the British Museum).

238: Sennacherib's palace, Room I, Slab 7, left 3/4, 1903–4, photo by L. W. King, neg. PS 96160 (photo: Trustees of the British Museum).

239: Sennacherib's palace, Room I, Slabs 24–8, 1903–4, photo by L. W. King, neg. PS 139285 (photo: Trustees of the British Museum).

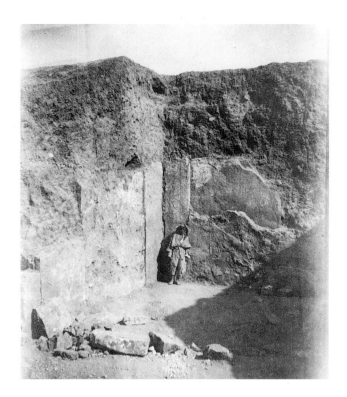

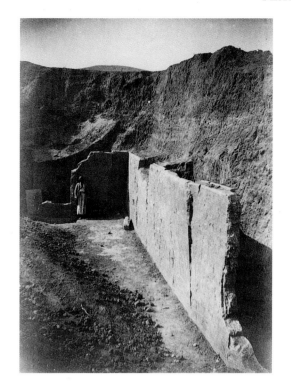

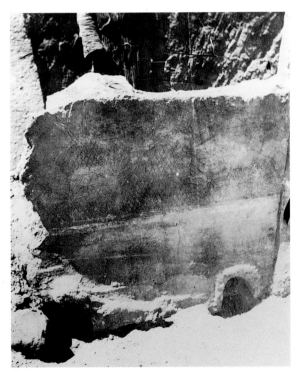

240: Sennacherib's palace, Room V, Slabs 1–5, 1903–4, photo by L. W. King, neg. PS 139291 (photo: Trustees of the British Museum).

241: Sennacherib's palace, Room V, Slabs 31–9, 1903–4, photo by L. W. King, neg. PS 139288 (photo: Trustees of the British Museum).

242: Sennacherib's palace, Room V, Slab 31, 1903–4, photo by L. W. King, neg. PS 139296 (photo: Trustees of the British Museum).

243: Sennacherib's palace, Room V, Slab 34, 1903–4, photo by L. W. King, neg. PS 139277 (photo: Trustees of the British Museum).

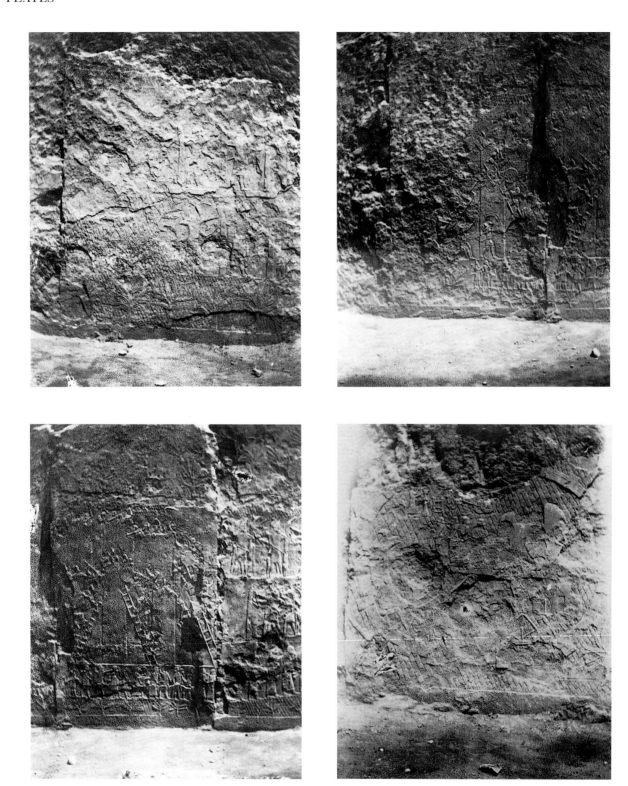

244: Sennacherib's palace, Room V, Slab 35, 1903–4, photo by
L. W. King, neg. PS 139276 (photo: Trustees of the British
Museum).

245: Sennacherib's palace, Room V, Slab 37, 1903–4, photo by
L. W. King, neg. PS 139273 (photo: Trustees of the British
Museum).

246: Sennacherib's palace, Room V, Slab 38, 1903–4, photo by
L. W. King, neg. PS 139281 (photo: Trustees of the British
Museum).

247: Sennacherib's palace, Room V, Slab 43, 1903–4, photo by
L. W. King, neg. PS 139278 (photo: Trustees of the British
Museum).

left column

248: Originally Nineveh, Sennacherib Palace Site Museum, Room I, Slab 7, looted fragment, 1996 (from a photocopy).

249: Nineveh, Sennacherib Palace Site Museum, Room I, Slab 7, detail of looted area, 1990 (photo: author).

250: Nineveh, Sennacherib Palace Site Museum, Room I, Slab 7, condition after looting, 1997 (photo: courtesy of Muayad Damerji).

right column

251: Originally Nineveh, Sennacherib Palace Site Museum, Room I, Slab 16, looted fragment, 1996 (from a photocopy).

252: Nineveh, Sennacherib Palace Site Museum, Room I, Slab 16, detail of looted area, 1990 (photo: author).

253: Nineveh, Sennacherib Palace Site Museum, Room I, Slab 16, condition after looting, 1997 (photo: courtesy of Muayad Damerji).

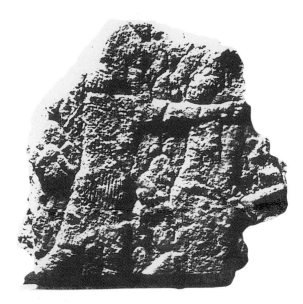

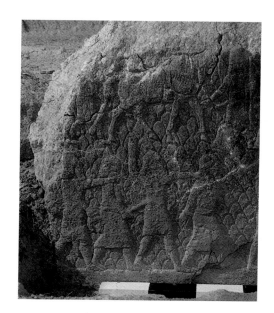
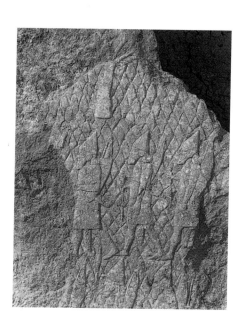
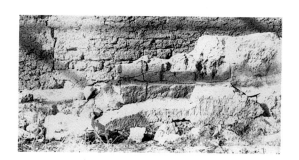

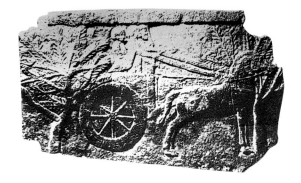

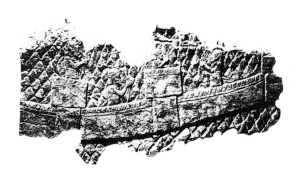

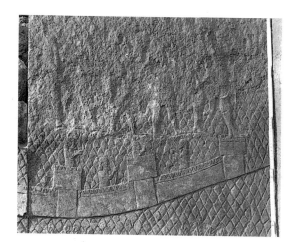

left column

254: Originally Nineveh, Sennacherib Palace Site Museum, Room I, Slab 24, looted fragment (from a photocopy).

255: Nineveh, Sennacherib Palace Site Museum, Room I, Slab 24, detail of looted area, 1989 (photo: author).

256: Nineveh, Sennacherib Palace Site Museum, Room I, Slab 24, condition after looting, 1997 (photo: courtesy of Muayad Damerji).

right column

257: Originally Nineveh, Sennacherib Palace Site Museum, Room IV, Slab 4, left part, looted fragment, 1996 (from a photocopy).

258: Nineveh, Sennacherib Palace Site Museum, Room IV, Slab 4, left part, detail of looted area, 1990 (photo: author).

259: Nineveh, Sennacherib Palace Site Museum, Room IV, Slabs 2–5, condition after looting, Slabs 3–4 have been destroyed, 1997 (photo: courtesy of Muayad Damerji).

: invalid

from left to right

260: Nineveh, Sennacherib Palacc Site Museum, Room IV, Slabs 8–11, condition after looting, Slabs 8–9 have been destroyed and 10 is damaged, 1997 (photo: courtesy of Muayad Damerji).

261: Nineveh, Sennacherib Palace Site Museum, Room IV, Slabs 11–13, condition after looting, Slab 13 has been destroyed, 1997 (photo: courtesy of Muayad Damerji).

262: Originally Nineveh, Sennacherib Palace Site Museum, Room V, Slab 1, looted fragment, 1996 (from a photocopy).

263: Nineveh, Sennacherib Palace Site Museum, Room V, Slab 1, detail of looted area, 1990 (photo: author).

264: Nineveh, Sennacherib Palace Site Museum, Room V, Slab 14, condition after looting, 1997 (photo: courtesy of Muayad Damerji).

265: Originally Nineveh, Sennacherib Palace Site Museum, Room V, Slab 15, looted fragment, 1996 (from a photocopy).

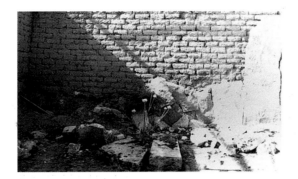

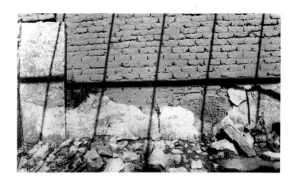

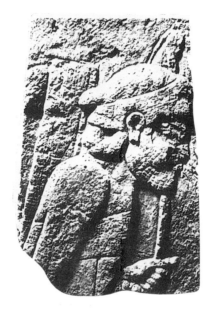

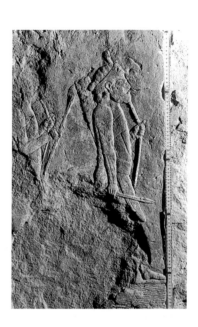

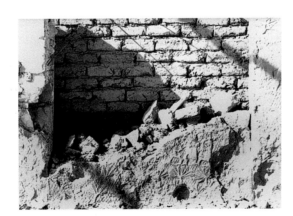

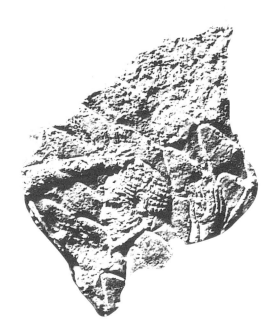

left column

266: Nineveh, Sennacherib Palace Site Museum, Room V, Slab 15, detail of looted area, 1990 (photo: author).

267: Nineveh, Sennacherib Palace Site Museum, Room V, Slab 15, condition after looting, 1997 (photo: courtesy of Muayad Damerji).

268: Originally Nineveh, Sennacherib Palace Site Museum, Room V, Slab 16, looted fragment, 1996 (from a photocopy).

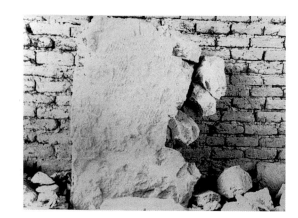

right column

269: Originally Nineveh, Sennacherib Palace Site Museum, Room V, Slab 17, looted fragment, 1996 (from a photocopy).

270: Nineveh, Sennacherib Palace Site Museum, Room V, Slab 17, condition after looting, 1997 (photo: courtesy of Muayad Damerji).

271: Nineveh, Sennacherib Palace Site Museum, Room V, Slab 32, condition after looting, 1997 (photo: courtesy of Muayad Damerji).

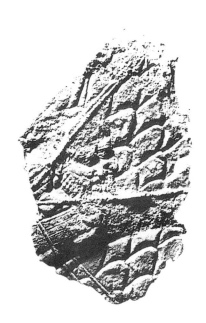

from left to right

272: Nineveh, Sennacherib Palace Site Museum, Room V, Slab 37, condition after looting, 1997 (photo: courtesy of Muayad Damerji).

273: Originally Nineveh, Sennacherib Palace Site Museum, Room V, Slab 39, looted fragment, 1996 (from a photocopy).

274: Nineveh, Sennacherib Palace Site Museum, Room V, Slab 39, detail of looted area, 1990 (photo: author).

275: Nineveh, Sennacherib Palace Site Museum, Room V, Slab 39, condition after looting, 1997 (photo: courtesy of Muayad Damerji).

276: Originally Nineveh, Sennacherib Palace Site Museum, Room V, Slab 43, looted fragment, 1995 (from a photocopy).

277: Nineveh, Sennacherib Palace Site Museum, Room V, Slab 43, detail of looted area, 1990 (photo: author).

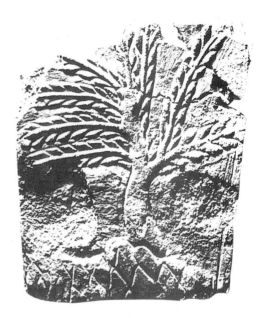

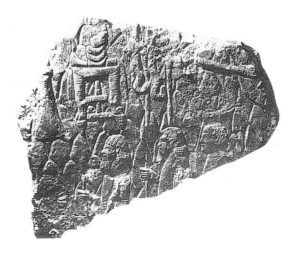

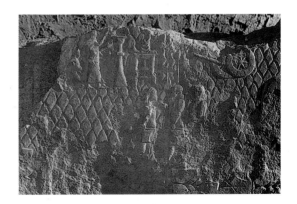

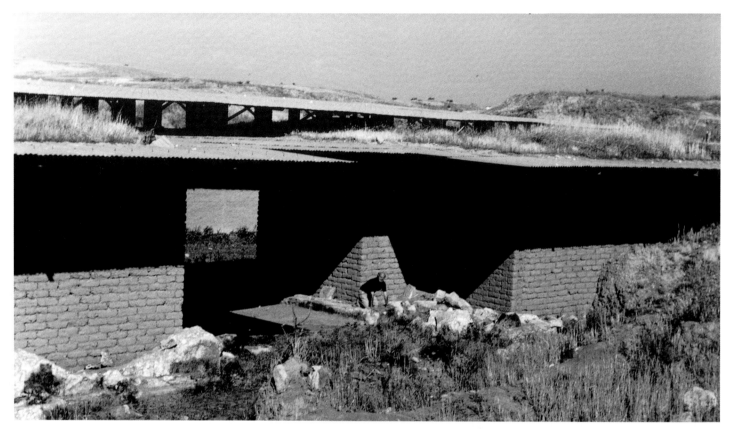

fig. 30: Nineveh, Sennacherib Palace Site Museum, throne-room façade (Court H), view, excavation director David Stronach demonstrates the pose of Bull 7 in Door *a*, 1989 (photo: author).

fig. 31: Khorsabad, palace of Sargon II, throne-room façade (Court VIII, Façade n, southwest wall), Slabs 42–57 (after Botta and Flandin 1849, vol. 1, pl. 30).

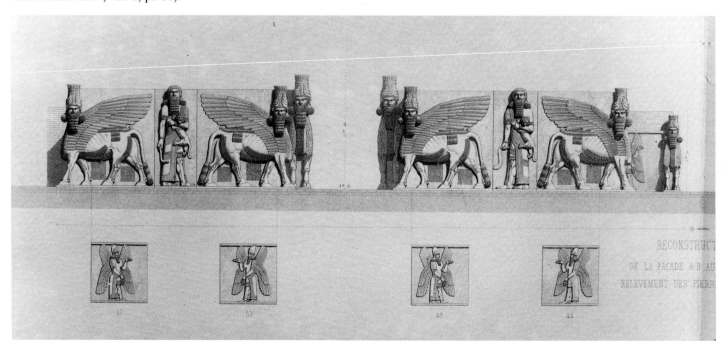

CATALOGUE OF SCULPTURES
IN SENNACHERIB'S THRONE-ROOM SUITE

The catalogue that follows provides basic measurements, a description, and a chronological summary of the condition of every known slab from Sennacherib's throne-room suite. Nearly all of the sculptures are illustrated in the Plates, in most cases reproduced at a constant scale of 1:12. The surviving slabs were numbered sequentially. In each room, I began with Layard's "Slab 1," but our numbers soon diverged, as I assigned a number to every surviving slab whereas Layard did not, and I did not number slabs that had disappeared completely since Layard's day. Only the width at the base of wall slabs is given; their height is difficult to specify because their bases are buried to varying degrees and their top edges are often irregular due to breakage. Approximate heights may easily be determined from the photographs. All Layard quotations are taken from his handwritten excavation reports, published in Russell 1995, unless specified otherwise. Measurements are as they were in 1990, unless noted otherwise.

THRONE-ROOM FAÇADE, COURT H (fig. 30)

Sennacherib's throne-room façade was patterned on that of the palace of Sargon II at Khorsabad (fig. 31). Much of it was fairly well preserved when Layard first excavated it, but by the time of Madhloom's excavations, most of the sculptures were lost or badly deteriorated. Details on the fate of individual slabs are given below.

Court H, Door *b*
LENGTH: of north bull 35 cm

1849: Layard reported that the wall to the south of Façade Bull 1 led to "a smaller entrance into the palace, and to a wall of sculptured slabs; but here all traces of building and sculpture ceased, and we found ourselves near the edge of the water-worn ravine" (Layard 1853a: 136). On his plan, Layard showed this area as lost (pl. 3).

1990: The location of this door is marked by Slabs 33 and 34. No trace of the south bull survived. A small part of the base at the west end of the north bull survived *in situ*.

Court H, Door *c*, Bull 1 (pl. 6)
LENGTH: 345 cm

1847: Layard wrote, "The bulls which form entrance [*c*] are better preserved than those of the other entrances. The upper parts & heads being still nearly entire. The inscriptions have been copied."

1965: By the time Madhloom reexcavated it, this bull had apparently deteriorated considerable since Layard's day (el-Wailly 1965: fig. 2).

1990: This bull was still *in situ*, in the same condition as when Madhloom reexcavated it.

SUBJECT: Human-headed bull colossus, facing left.

INSCRIPTION: The text that began on this bull and concluded on Bull 17 was devoted entirely to an account of the building of Sennacherib's palace. At the time of its discovery by Layard, this was the best preserved of the Sennacherib colossus inscriptions, though much of it has since been lost. Layard's hand copy of this text is now in the British Museum (Layard 1845–7: 141–8). He published it in *Inscriptions in the Cuneiform Character* (1851: 38–42, Luckenbill 1924: 21, 117–25). The inscription consisted of 106 lines distributed as follows:

Column i: 29 lines under belly of Bull 1
Column ii: 24 lines between hind legs of Bull 1
Column iii: 24 lines between hind legs of Bull 2
Column iv: 29 lines under belly of Bull 2

Court H, Door *c*, Bull 2 (pl. 7)
LENGTH: 408 cm

1903: As may be seen in King's photo, this bull was very well-preserved when he reexcavated it. Only the head and upper part of the wing were missing (pl. 60). The people in the photograph are King and an unidentified woman, who may be the person referred to in a postscript to one of King's letters to Budge: "[R. C.] Thompson tells me in a pencil note to his last letter that my missionary lady had just turned up at the Museum. What do you think of her? She may perhaps seem a little odd at first but she is really a good sort" (20.V.03, King 1903c: no. 320, D'Andrea 1981: 159).

1990: The lower part of this bull, including part of Column iv of the inscription, was still *in situ*, but most of the figure had been destroyed since King's day.

SUBJECT: Human-headed bull colossus, facing right.

INSCRIPTION: see Bull 1.

Court H, Façade Bull 1 (pls. 8, 9)
WIDTH: 427 cm

1849: Layard wrote, "Beyond this entrance [a] was a group similar to and corresponding with that on the opposite side" (Layard 1853a: 136). Layard did not comment on the condition of these figures.

1990: Only the base of this colossus survived, together with two large fragments from the upper body.

SUBJECT: Human-headed bull colossus, facing left.

INSCRIPTION: The original text, which was the same on all of the façade bulls, began with a brief historical summary of Sennacherib's first six campaigns, followed by a palace building account. Parts of the last 8 lines of Column i, under the belly, and parts of the first 6 and last 8 lines of Column ii, between the hind legs, survived *in situ* (pls. 202, 203). All belong to the palace building account. The text is published here in Appendix 1.

Court H, Slab 2 (pls. 8, 10)

WIDTH: 269 cm

1849: see Bull 1.

1990: Only the lower part of the legs and feet of this figure survived.

SUBJECT: Colossal human figure facing right. For a description, see Slab 11.

Court H, Façade Bull 3 (pls. 8, 11)

WIDTH: 495 cm

1849: See Façade Bull 1.

1990: Only the lower part of this figure survived.

SUBJECT: Human-headed bull colossus, facing right.

INSCRIPTION: The original text, which was the same on all of the façade bulls, began with a brief historical summary of Sennacherib's first six campaigns, followed by a palace building account. Parts of the last 19 lines of Column i, between the hind legs, and parts of the last 21 lines of Column ii, under the belly, survived *in situ* (pls. 204, 205, 206). Column i, lines 1'–18a' are from the historical summary. Column i, lines 18b'–19', and Column ii, lines 1'–21' are from the palace building account. The text is published here in Appendix 1.

Court H, Slab 4 (pl. 12)

DIMENSIONS: the space available for this slab was approximately 260 cm wide.

1849: Layard wrote, "Forming the angle between them and the outer bulls were gigantic winged figures in low relief . . . These figures were those of winged priests, or deities, carrying the fir-cone and basket" (Layard 1853a: 136). According to Layard's drawing, which is mislabeled "No. 5," this figure was preserved to just below the waist.

1990: No trace of this slab survived.

SUBJECT: Winged human figure with bucket, facing left.

Court H, Slab 5 (pl. 13)

DIMENSIONS: According to the scale on Layard's drawing, the part he drew was 87 cm wide.

1849: Layard wrote, "flanking them were two smaller figures, one above the other" (Layard 1853a: 136). Layard's drawing presumably shows the lower figure of the left pair.

1990: No trace of this slab survived.

SUBJECT: A pair of six-curled human figures, one above the other, each holding a spear or doorpost, facing right. For the figure type, see Russell 1991: 180–4.

Court H, Door *a*, Bull 6 (pl. 14)

LENGTH: 652 cm

1849: Layard wrote, "The façade then opened into a wide portal, guarded by a pair of winged bulls, twenty feet long, and probably, when entire, more than twenty feet high" (Layard 1853a: 136). This figure is not shown in any of the drawings from Layard's excavations.

1990: Only the base of this colossus remained *in situ*.

SUBJECT: Human-headed bull colossus, facing left.

INSCRIPTION: The text that began on this bull and concluded on Bull 7 consisted of an annalistic account of Sennacherib's first six campaigns, followed by a palace building account. The inscription, which was almost completely preserved, was sawn from the bulls on Henry Rawlinson's instructions in 1854 and sent to the British Museum (Russell 1991: fig. 125). The cuneiform text was later edited by George Smith and published by Rawlinson (Rawlinson 1870: pl. 12–13, Luckenbill 1924: 21, 66–76, 117–25, Russell 1998: Catalog 3). The inscription was 164 lines in length, and was distributed as follows:

Column i (WA 118815a and b): 46 lines under belly of Bull 6 (286 cm wide)

Column ii (WA 118821): 39 lines between hind legs of Bull 6 (167 cm wide)

Column iii (WA 118819): 34 (+2 missing) lines between hind legs of Bull 7 (171 cm wide)

Column iv (WA 118817): 43 lines under belly of Bull 7 (292 cm wide)

COMMENT: This was the first text to be discovered that gave Sennacherib's account of the siege of Jerusalem and Hezekiah's tribute (Col. i, lines 27–32), which may account for the British Museum's interest in acquiring it (Layard 1853a: 143–5).

Court H, Door *a*, Bull 7 (pls. 15, 16)

LENGTH: 598 cm

1849: For Layard's description, see Bull 6. Part of this colossus is shown in a brown wash drawing, perhaps by Layard.

1990: Only the base of this colossus remained *in situ*.

SUBJECT: Human-headed bull colossus, facing right.

INSCRIPTION: see Bull 6.

Court H, Slab 8 (pl. 16)

WIDTH: 59 cm

1849: See Slab 5. According to the contemporary drawing, this slab was already broken up when Layard found it.

1990: The right end of the base survived.

SUBJECT: A pair of six-curled human figures, one above the other, each holding a spear or doorpost, facing left.

Court H, Slab 9

WIDTH: 315 cm

1849: See Slab 4. S. C. Malan's brown wash drawing of this area shows the lower half of this figure as preserved (Gadd 1938: pl. XVIII).

1990: Only the base of this slab survived.

SUBJECT: Winged human figure with bucket, facing right.

Court H, Façade Bull 10 (pls. 16, 17, 18)

WIDTH: 165 cm

1849: Layard wrote, "Beyond this figure [11], in the same line, was a second bull" (Layard 1853a: 136). According to Layard's drawings, this was the best-preserved of the façade colossi.

1990: Only the front of the base was preserved.

SUBJECT: Human-headed bull colossus, facing left.

INSCRIPTION: There is no record of the inscription, which must have been the same text that was carved on the other three façade bulls.

Court H, Slab 11 (pls. 16, 17)

1849: Layard wrote, "The upper half of the next slab [11] had been destroyed, but the lower still remained, and enabled me to restore the figure of the Assyrian Hercules strangling the lion, similar to that discovered between the bulls in the propylaea of Khorsabad, and now in the Louvre. The hinder part of the animal was still preserved. Its claws grasped the huge limbs of the giant, who lashed it with the serpent-headed scourge. The legs, feet, and drapery of the god were in the boldest relief, and designed with great truth and vigor" (Layard 1853a: 136). Layard's drawings show its state of preservation.

1990: This slab had completely disappeared.

SUBJECT: see Layard's description.

Court H, Façade Bull 12 (pls. 16, 17, 19, 20)
WIDTH: 78 cm

1847, 1849: Layard wrote, "Entr. a [no. 12] is formed by two winged Bulls – the one adjoining No. [13] has fallen down – the other has not been uncovered" (Russell 1995: fol. 53v-54r). "The workmen having been then ordered to uncover the bull which was still partly buried in the rubbish, it was found that adjoining it were other sculptures, and that it formed part of an exterior façade" (Layard 1853a: 136). Layard's drawings show its state of preservation.

1990: Fragments of the front of the base, chest, and head of this colossus were all that survived.

SUBJECT: Human-headed bull colossus, facing right.

INSCRIPTION: The original text, which was the same on all of the façade bulls, began with a brief historical summary of Sennacherib's first six campaigns, followed by a palace building account. The final two or three signs from each of the first fifteen lines of Column ii, under the belly, survived *in situ* (pl. 207). The fragment is published here in Appendix 1. This fragment joins to the right side of a paper cast published by Meissner and Rost that gives the remainder of the first 15 lines of the building account (Meissner and Rost 1893: pl. 8, Russell 1985: 509–12). The historical summary from Column i of the text – originally between the hind legs, but now lost – was published by George Smith (Smith 1878, "Bull 3"; Russell 1998: Catalog 3).

Court H, Slab 13 (pls. 19, 21)
WIDTH: 343 cm

1847: Layard wrote, "No. [13] A gigantic winged figure more than 16 feet high – the head which was probably that of the divinity or genius with the horned cap, or that of an eagle – has been destroyed. The right hand, which probably held the fir cone, has also been destroyed – in the left is the usual basket." Layard did not draw this figure.

1990: The lower part of the figure, from the knees down, was well preserved. The bottom of the slab was buried.

SUBJECT: Winged human figure with bucket, facing left.

Court H, Slab 14
WIDTH: 244 cm

1847: Layard wrote, "No. 1 & 2 [my no. 15 and 14] & the whole of the wall to the left of the Bulls have been purposely destroyed – at the bottom & edge of the slabs some traces of sculpture remain." Layard did not draw any of these reliefs.

1990: The lower part of this slab survived, but was buried, and I did not uncover it.

SUBJECT: Unknown – probably reeds and palm trees at the bottom, defaced above.

Court H, Slab 15 (pl. 22)
WIDTH: 212 cm

1847: See Slab 14.

1990: The lower part of this slab survived, and was partially buried. The relief carving at the bottom was in excellent condition.

SUBJECT: At the bottom were reeds and palm trees, above which the surface of the slab had been chiseled smooth, possibly preparatory to recarving.

Court H, Slab 16 (pl. 23)
WIDTH: 201 cm

1847: See Slab 14.

1990: The lower part of the slab was preserved, and was partially buried. The relief carving at the bottom was in excellent condition.

SUBJECT: At the bottom were reeds and palm trees, above which the surface of the slab had been chiseled smooth, possibly preparatory to recarving.

Court H, Slab 17
WIDTH: 186 cm

1847: See Slab 14.

1990: The lower part of this slab survived, but was mostly buried.

SUBJECT: Probably the same as Slabs 15–16.

ROOM I (fig. 32)

The throne room, labeled "B" in Layard's first plan and "I" thereafter, was evidently patterned on the plan of the throne room in the palace of Sargon II at Khorsabad. In 1847, Layard wrote: "The southern end of this chamber has been destroyed by the action which formed the ravine." The throne base, which should have been at the southern end of the room, was lost. By the time of Madhloom's excavations, the north end of the room was lost as well. Madhloom published several photographs of this room from the time of his excavations (el-Wailly 1966: fig. 4, Madhloom 1968: Arabic section, pl. 8b). The details for individual slabs are summarized below.

Room I, Door *d* (pls. 24, 25)
No dimensions are available for these colossi.

1847: Layard wrote, "A spacious entrance at the upper end of

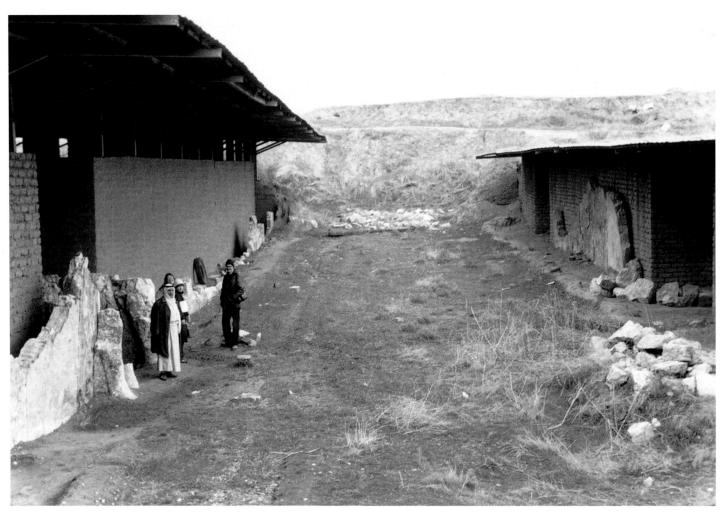

fig. 32: Nineveh,
Sennacherib Palace Site
Museum, throne room
(Room I), view looking
northwest, 1981 (photo:
author).

fig. 33: Nineveh,
Sennacherib Palace Site
Museum, Room I, Door *e*,
view of colossi and floral
threshold from Room V, 1990
(photo: author).

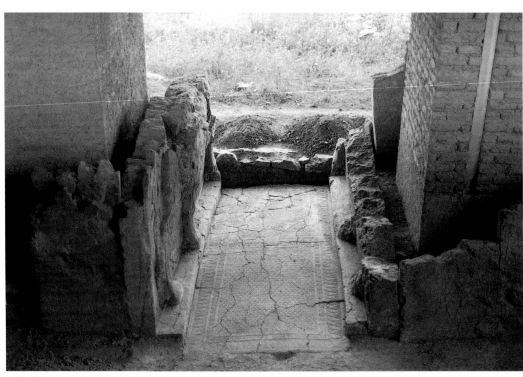

the hall opened into a small chamber [III], which will be hereafter described. The bulls forming this portal were in better preservation than those discovered at the first entrance [*e*]. The human heads, with the high and elaborately adorned tiara of the later Assyrian period, although greatly injured, could still be distinguished. Of the inscription also a considerable portion remained entire" (Layard 1849a: vol. 2, 128).

1903: The condition of these colossi is clear from King's photographs.

1965: No trace of these colossi remained.

SUBJECT: A pair of winged, human-headed bull colossi.

INSCRIPTION: The text that began on Bull 1 and concluded on Bull 2 consisted of a resumé of Sennacherib's first five campaigns, followed by an account of the building of Sennacherib's palace. Most of the inscription was preserved when Layard excavated it, but it has since completely vanished. Layard's hand copy of the inscription is in the British Museum (Layard 1845–7: 136–1). He published most of it in *Inscriptions in the Cuneiform Character* (1851: 59–62, Russell 1985: 499–504, Russell 1998: Catalogue 3). The inscription originally consisted of some 112 lines distributed as follows:
Column i: 31 lines under belly of Bull 1
Column ii: ca. 25 lines between hind legs of Bull 1 (entirely lost)
Column iii: 25 lines between hind legs of Bull 2
Column iv: 31 lines under belly of Bull 2

Room I, Door *e* (fig. 33, pls. 26, 27, 28, 29)
LENGTH: Bull 1: 525 cm; Bull 2: 525 cm

1847: Layard wrote, "Entrance a [*e*] is formed by two gigantic human headed winged Bulls, the lower parts of which alone remain. Their length is about 16½ feet, & their height was probably about the same. They have but four legs – as the Bulls & Lions of the later palace of Nimroud. The inscriptions on both Bulls are too much destroyed to be copied. Between the Bulls a large slab of marble richly carved." Layard drew this pavement slab.

1903: In King's photographs, these colossi appear much as they did in 1990 (pl. 236 and unpublished British Museum photos PS 139293, 139301).

1966: The condition of these colossi appears unchanged in Madhloom's excavation photograph (el-Wailly 1966: fig. 5).

1990: The condition of these colossi is clear from the photographs. The pavement slab in the door was very well-preserved. Its brief inscription is published by Russell (1991: 269).

INSCRIPTION: The text that began on Bull 1 and concluded on Bull 2 apparently began with a resumé of Sennacherib's first five campaigns, and definitely concluded with an account of the building of Sennacherib's palace (Russell 1998: Catalogue 3). Layard wrote that this inscription "was so much defaced, that I was only able to copy a few lines of it" (1849a: vol. 2, 126). In 1990, only the feet of Bull 1 were preserved. On Bull

2, both inscribed panels were still intact, but were so badly worn that the inscription was largely illegible. Layard's hand copy of the inscription is in the British Museum (Layard 1845–7: 135–6). It is unpublished. Layard copied parts of the inscription from Bull 2 only. The inscription apparently originally consisted of some 126 lines distributed as follows:
Column i: ca. 33 lines under belly of Bull 1 (entirely lost)
Column ii: ca. 30 lines between hind legs of Bull 1 (entirely lost)
Column iii: 30 lines between hind legs of Bull 2
Column iv: 33 lines under belly of Bull 2

Room I, Slab 1 (pls. 30, 31)
WIDTH: 264 cm

1847: Layard wrote, "As much as remains of No. 1 [. . . has] been drawn."

1990: The relief surface was in poor condition, as it was when Layard drew it.

SUBJECT: The Assyrian army is depicted carrying off booty in front of a burning city. The details are clear from Layard's drawing. For the long epigraph, omitted from Layard's drawing, see Russell 1998: Catalogue 4.

Room I, Slab 2 (pls. 32, 33)
WIDTH: 247 cm

1847: Layard wrote, "part of No. 2 [has] been drawn. The remainder of No. 2 [. . . has] been destroyed" (pl. 31).

1990: The left third of the relief appeared to be in much the same condition as when Layard drew it, except for the loss of part of the mountain pattern to the left of the building in the upper register. The remainder of the surface was in poor condition, but some details were preserved. In the new photograph and drawing, the trees at the lower right are partially buried.

SUBJECT: At left is the continuation of the booty procession from Slab 1. In the remainder of the relief, the soldiers leave the vineyard-filled farmland of the city and proceed rightward into wooded mountains.

Room I, Slab 3 (pls. 34, 35, 237)
WIDTH: 242 cm

1847: Layard wrote, "No. 3 has been drawn."

1903: King's photograph shows the left part of this slab in the same condition as when Layard drew it.

1981: The condition of the slab was still unchanged.

1990: The relief surface was in good condition. There had been some loss from the top of the left half of the slab since 1981.

SUBJECT: The Assyrian army rounds up fugitive enemy soldiers in the mountains and marches them off to the right. The left edge of an Assyrian fortified camp is at the lower right. The details are clear from Layard's drawing.

Room I, Slab 4 (pls. 36, 37)
WIDTH: 150 cm

1847: Layard wrote, "the whole of No. 4 [has] been destroyed."

1965: Madhloom's photograph of this relief shows the general shape and condition of the slab, but no details of the relief are visible (el–Wailly 1966: fig. 5).

1990: The relief surface, which appeared much the same as in Madhloom's photograph, was in poor condition, but some details were preserved. In the new photograph and drawing, the lower right corner is obscured by the overlap of the bull colossus in the adjacent doorway.

SUBJECT: A wooded mountain landscape. At the bottom left is the Assyrian fortified camp, within which may be seen traces of the king's tent at left, the lower part of the enthroned king with an attendant standing behind him, and part of a service tent below them. Prisoners are led toward the camp from above and from the right.

Room I, Slab 5 (pls. 38, 39, 40, 236)

WIDTH: 252 cm

1847: Layard wrote, "The whole of the slabs from entrance a to No. 6 [my no. 11?] have been almost completely destroyed . . . On the remainder appears to have been warriors ascending mountains covered with forests, as on Nos. 3 & 13 [my no. 20], but the sculptures have suffered so much from fire that little can be distinguished."

1903: The earliest illustrations of this slab are L. W. King's photographs. This relief was in much better condition than Layard's description suggests.

1966: Madhloom's photograph of this relief shows the general shape and condition of the slab, but no details are visible (el–Wailly 1966: fig. 5).

1990: The relief surface was in good condition, except for patches where the surface had flaked away. The slab appeared to be in the same condition as when King photographed it. In the new photograph and drawing, the lower left corner is obscured by the overlap of the bull colossus in the adjacent doorway, and the row of trees at the bottom is buried.

SUBJECT: Below, prisoners and booty from a burning city, labeled A-ta-un-[. . .], are marched off to the left. Above, soldiers descend from the mountains carrying heads toward the left and driving a file of prisoners down out of the mountains toward the right. For the epigraph above the city, see Russell 1998: Catalogue 4.

Room I, Slab 6 (pl. 40)

WIDTH: 284 cm

1847: According to Layard, this slab was "almost completely destroyed" (see Slab 5).

1903: L. W. King's photograph of Slab 5 shows the left part of Slab 6, on which the continuation of the file of prisoners being driven down toward the right is visible.

1966: Madhloom's distant photograph shows the same area, but no details are visible (el–Wailly 1966: fig. 5).

1990: Only the lower left corner of this slab survived, and the surface of the exposed part was completely lost. The slab was thicker than usual, as was Slab 7.

Room I, Slab 7 (pls. 41, 42, 238)

WIDTH: 251 cm

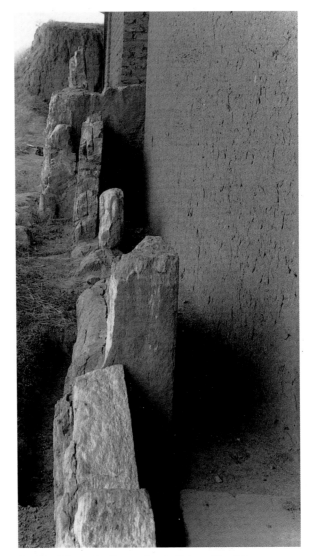

fig. 34: Nineveh, Sennacherib Palace Site Museum, Room I, Slab 7, edge view, 1989, thickness of slab: 48 cm (photo: author).

1847: Layard wrote, "On No. 5 [my no. 7] may be distinguished the feet of a gigantic figure."

1903: The earliest illustration of this slab is L. W. King's photograph. The preserved part of the relief is in good condition.

1990: The relief surface was in good condition, much as when King photographed it, though somewhat difficult to see due to discoloration.

1996: A fragment that includes the Assyrian soldier striking a prisoner at the left end of the lower procession was offered on the art market in 1996 (pls. 248–50). A 1997 photograph confirms that this part of the slab has been destroyed by looters.

SUBJECT: This slab was thicker than usual (ca. 50 cm) to accommodate the niche that was cut into its upper part (fig. 34). The preserved part of this niche contains both feet of a large-scale anthropomorphic figure at right, and the left foot of a similar large figure in a tassel-fringed garment at left. This composition probably extended also onto Slab 6, and showed the same subject that was in the similar niche opposite the main door of Assurnasirpal II's throne room at Nimrud: the king and a winged figure depicted twice, symmetrically flanking the central image of a stylized tree.

The area of the slab below the niche, by contrast, is carved with a small-scale narrative image of a campaign in the mountains. Two files of figures are shown moving toward the right. The lower file is a typical procession of prisoners and booty, driven along by Assyrian soldiers. The upper file, which is unique among Sennacherib's known reliefs, depicts the king's personal procession. The king sits in a throne placed on a carrying platform that is borne along by attendants (see fig. 24). He is preceded by a file of soldiers, and behind him are more soldiers and a led horse.

COMMENT: A textual equivalent to this scene is in Sennacherib's annalistic account of his fifth campaign: "With great effort, I myself in a *nēmedu* throne, together with my perfect battle troops, entered the narrow mountain passes" (Luckenbill 1924: 37:19–22; CAD, N/2, 1980, 156, sub. 2a; CAD, G, 1956, 111, sub. 1b). Another occurrence of the term *nēmedu* in Sennacherib's campaign accounts is in the epigraph that accompanies the image of the enthroned king at the siege of Lachish, in Room XXXVI of this palace (Russell 1991: 276 and fig. 3). The Lachish throne is similar to this one, but more elaborately decorated, and no carrying platform is shown. A closer visual parallel is Sennacherib's wheeled throne from the Ishtar Temple procession, where the chair appears to be virtually identical to this one (Gadd 1936, pl. 23). This suggests that the heretofore unclear *nēmedu* may refer to a throne that is movable, and this meaning is also consistent with other textual attestations, several of which refer to the carrying of such a throne (CAD, N/2, 1980, 156, sub. 2a).

On the basis of the epigraph, Frahm (1994) suggested that Slab 1 depicted Sennacherib's conquest of the city Ukku during his fifth campaign. Since the reference to the carrying chair is from the same account, this suggests that all of the reliefs on Slabs 1 to 7 may depict the fifth campaign.

Room I, Slab 8
WIDTH: 256 cm
1847: According to Layard, this slab was "almost completely destroyed" (see Slab 5). This slab is not numbered in Layard's plan.
1990: Only the lower left corner of this slab was preserved, and its sculptured surface was lost.

Room I, Slab 9
WIDTH: 154 cm
1847: According to Layard, this slab was "almost completely destroyed" (see Slab 5). This slab is not numbered in Layard's plan.
1990: Only the bottom of this slab was preserved, and its sculptured surface was lost.

Room I, Slab 10
WIDTH: 224 cm
1847: According to Layard, this slab was "almost completely destroyed" (see Slab 5). This slab is apparently not numbered in Layard's plan.
1990: Only the bottom of this slab was preserved, and its sculptured surface was lost.

Room I, Slab 11
WIDTH: 226 cm
1847: According to Layard, this slab was "almost completely destroyed" (see Slab 5). This is probably Slab "6" in Layard's plan.
1990: Only the bottom of this slab was preserved, and its sculptured surface was lost.

Room I, Slab 12
WIDTH: 205 cm
1847: According to Layard, this slab was "almost completely destroyed" (see Slab 5). This is probably Slab "7" in Layard's plan.
1990: Only the bottom of this slab was preserved, and its sculptured surface was lost.

Room I, Slab 13
WIDTH: 222 cm
1847: According to Layard, this slab was "almost completely destroyed" (see Slab 5). This is probably Slab "8" in Layard's plan.
1990: Only the bottom of this slab was preserved, and its sculptured surface was lost.

Room I, Slab 14 (pls. 43, 44)
WIDTH: of full slab: 241 cm; width of portion shown in pl. 44: 62 cm; width of fragment shown in Layard's drawing: 175 cm, assuming it is at Layard's usual scale of 1:6.
1847: Layard wrote, "part of No. 9 [. . .has] been drawn." This detail, evidently the lower left corner of a slab, is probably from the slab designated "14" in my plan.
1990: Only the lower right corner of this slab was preserved in 1990. There was no trace on any of the preserved slabs in this area of the fortified camp shown in Layard's drawing.
SUBJECT: Layard's drawing, apparently from the lower left corner of either Slab 14 or 13, shows Sennacherib enthroned in his fortified camp. A procession of courtiers approaches the king from the left. Below them is a file of manacled prisoners, also coming from the left. In the lower right corner of my Slab 14, the legs and feet of an Assyrian soldier moving leftward are visible at the far right, with the feet of two more striding figures in front of him.
COMMENT: Since Layard's plan did not number the slabs to either side of his "6–12," it is difficult to correlate his

numbers with those on my new plan, where every slab is shown. It seems most likely that the gap between his "5" and "6" contained three slabs, while the narrower gap between his "12" and "13" contained two. If this is true, then his Slab "9," the subject of this drawing, would be my Slab 14. There is no way to check the accuracy of Layard's plan in this area, however, and his plan is too inaccurate in other areas to be trusted uncritically here.

Room I, Slab 15 (pls. 45, 46)
WIDTH: 175 cm

1847: According to Layard, this slab was "almost completely destroyed" (see Slab 5). This is probably Slab "10" in Layard's plan.

1989: Much of the relief surface was missing, but enough was preserved of the lower part to see the subject.

SUBJECT: Two files of Assyrian soldiers march to the left across a wooded mountainous landscape. The general composition and details are clear from the new drawing.

Room I, Slab 16 (pls. 47, 48)
WIDTH: 186 cm

1847: According to Layard, this slab was "almost completely destroyed" (see Slab 5). This is probably Slab "11" in Layard's plan.

1990: This relief was in better condition than Layard's description suggests. The surface was well-preserved in some areas, but large patches had flaked away. The trees at the bottom are buried in the 1990 photograph.

1996: A fragment that includes the three soldiers at the left end of the upper procession was offered on the art market in 1996 (pls. 251–3). A 1997 photograph confirms that the slab has been completely destroyed by looters.

SUBJECT: Two files of Assyrian soldiers proceed to the left across a wooded mountainous landscape, continuing the processions from Slab 15. At the right end of the top row is a horse, apparently held by its owner who walks beside it. The general composition and details are clear from the new drawing.

Room I, Slab 17 (pl. 49)
WIDTH: 189.5 cm

1847: According to Layard, this slab was "almost completely destroyed" (see Slab 5). This is probably Slab "12" in Layard's plan.

1990: Only a small area of the sculptured surface survived.

SUBJECT: All that is visible is the upper part of a tree against a mountain landscape pattern.

Room I, Slab 18
WIDTH: 221 cm

1847: According to Layard, this slab was "almost completely destroyed" (see Slab 5). This slab is not numbered in Layard's plan.

1965: The upper right corner of this slab is shown in a Madhloom photograph (Madhloom 1976: pl. 31).

1990: Only the bottom of this slab was preserved, and its sculptured surface was either lost or buried.

SUBJECT: Madhloom's photograph of the lower right corner shows only trees against a mountainous landscape.

Room I, Slab 19 (pls. 50, 51)
WIDTH: west face: 81 cm; north face: 7 cm

1847: According to Layard, this slab was "almost completely destroyed" (see Slab 5). This slab is not numbered in Layard's plan.

1965: Madhloom's photograph shows that this relief was in better condition than Layard's description suggests, with its surface well preserved on the surviving portion (Madhloom 1976: pl. 31).

1990: The bottom of the slab is buried in the 1990 photograph, but the visible part looks much the same as in Madhloom's photograph.

SUBJECT: Assyrian soldiers climb upwards toward the right in a wooded mountainous landscape. The composition and details are clear from the new drawing.

Room I, Slab 20 (pls. 52, 53)
WIDTH: 132 cm

1847: Layard wrote, "No. 13 [has] been drawn." The drawing shows the slab as almost completely preserved. This is certainly slab "13" in Layard's plan.

1903: In L. W. King's photograph of Door d, Bull 1, this slab is essentially the same size and shape as in Layard's drawing, though the condition of its surface cannot be discerned (pl. 24).

1965: As with the other sculptures at this end of the throne room, this slab suffered grievously following its excavation by King. By the time this area was re-excavated by Madhloom, most of the slab had disappeared. Madhloom's photograph shows the bottom of the slab, which was buried in 1990 (el-Wailly 1965: fig. 4).

1990: Only the lower left part of the slab was preserved, to a height just above the second row of trees shown in Layard's drawing. The lowest row of trees and part of the lower row of figures are buried in the 1990 photograph.

SUBJECT: The relief shows a battle in the mountains, with the Assyrians triumphing over their enemies and bringing down captives and severed heads. The details are clear from Layard's drawing. Note that Layard omitted the mountain background pattern from the lower two thirds of his drawing, though the photograph shows that it was there.

Room I, Slab 20a (pls. 54, 56, 57)
WIDTH: 206 cm, plus the width of the part covered by the front part of the bull. This measurement is based on the assumption that Layard's drawing was at his usual scale of 1 : 6.

1847: Layard wrote, "No 14 [my no. 20a] [. . .has] been drawn." In the drawing, the slab appears to be completely preserved.

1903: King's photographs show that by 1903 the upper half of this slab, with the top four ships, was missing.

1965: By the time Madhloom re-excavated this area, the slab

had entirely disappeared.

SUBJECT: The sculpture depicts the evacuation by sea of a maritime city, shown on the adjacent slab. The details are clear from Layard's drawing.

Room I, Slab 20b (pls. 55, 56, 57)

WIDTH in 1847: 149 cm for the combined width of both sculptured faces. This measurement is based on the assumption that Layard's drawing was at his usual scale of 1 : 6.

1847: Layard wrote, "part of No. 15 [my no. 20b] [has] been drawn – the upper part of No. 15 has been destroyed. The castle on No. 15 stands amongst mountains which rise from the seashore."

1903: King's photographs show only the part of the slab to the left of the corner. It appears to be much as Layard had drawn it.

1965: This slab had entirely disappeared by the time of Madhloom's excavations.

SUBJECT: Evacuation by sea of a coastal city. The architecture is depicted with the typically western features of windowed towers and round shields on the ramparts.

Room I, Slab 20c (pls. 58, 59)

1847: Layard wrote, "A row of warriors discharging arrows on the lower part of the slab is all that is preserved of No. 16 [my no. 20c]. Beneath these warriors, corresponding with each group, are legs from the knee – they may have belonged to figures which were subsequently erased." Layard cut a piece out of the bottom of this slab and sent it to the British Museum.

1903: The earliest illustration of this slab is L. W. King's photograph.

1965: This slab had apparently entirely disappeared by the time of Madhloom's excavations.

SUBJECT: Layard's description is accurate. The soldiers attack the city on the neighboring Slab 20b. In the lower right corner is the beginning of a procession of captives that continues onto the next slab.

Room I, Slab 20d (pls. 58, 60)

1847: Layard wrote, "On the lower part of No. 17 is a row of prisoners & warriors."

1903: The earliest illustrations of this slab are L. W. King's photographs.

1965: This slab had apparently entirely disappeared by the time of Madhloom's excavations.

SUBJECT: Layard's description is accurate.

Room I, Slab 21 (pl. 60)

WIDTH: 40 cm

1847: Layard wrote, "No. 18 [my no. 21] a row of prisoners at the bottom, above them warriors discharging their arrows. The rest of the slab occupied by mountains & pines. The figures are such as have been frequently drawn."

1903: The earliest illustration of this slab is L. W. King's excellent photograph. The slab was evidently preserved to its

full height and the relief surface was in excellent condition.

1965: By the time of Madhloom's excavations, only the lower right corner of this slab survived, and the carving was entirely lost.

SUBJECT: Layard's description is accurate.

Room I, Slab 22 (pl. 61)

WIDTH: 128 cm

1847: Layard wrote, "The wall from entrance c to 20 [my no. 24] destroyed."

1990: Contrary to Layard's report, the lower part of the slab was preserved. Its surface was in good condition.

SUBJECT: The preserved part shows a wooded mountainous landscape with a fish-filled river running through it.

Room I, Slab 23 (pls. 62, 63, fig. 29)

WIDTH: 134 cm

1847: See Slab 22.

1989: Contrary to Layard's report, a considerable part of the slab was intact, though seriously cracked, when re-excavated by Madhloom. The condition of the surface was fair at the top and excellent at the bottom, but had mostly flaked away from the center.

1990: The top half of the slab had disintegrated along the lines of the existing cracks, evidently as the result of being climbed on by thieves who had removed sections from the metal roof directly above.

SUBJECT: At the top is an Assyrian soldier holding a horse. The lower part shows the sequel to the battle scene from the adjoining Slabs 23–7: fleeing enemy chariots, cavalry, and foot soldiers are driven toward the left into a river by pursuing Assyrian cavalry.

COMMENT: The motif of the defeated enemy being driven into a river is unique in Sennacherib's known palace reliefs. A similar subject is shown less dramatically in the throne room of Assurnasirpal II at Nimrud (Slabs B-17 to 18), where fugitives from a defeated enemy city try to escape their pursuers by swimming across a river, in vain (Curtis and Reade 1995: 48–9). The most dramatic such scene is Assurbanipal's great battle at Til Tuba, Slabs 1-3 of Room XXXIII in Sennacherib's palace, where the routed enemy are driven into the Ulai River (Curtis and Reade 1995: 74–5). Since the Til Tuba battle was apparently carved when Assurbanipal still resided in Sennacherib's palace, it is tempting to see the image on Slab 23 of Sennacherib's throne room as a source for the Assurbanipal version.

Room I, Slab 24 (pls. 64, 65)

WIDTH: 226 cm

1847: Layard wrote, "No. 20 [my no. 24] has been drawn."

1903: King's oblique photograph seems to show this slab in substantially the same condition as when Layard drew it (pl. 239).

1965: Only the lower two registers of this slab remained at the time that Madhloom re-excavated it. He published a view of most of the slab, as well as a detail of the chariot at the lower left, which subsequently appeared on the art market

(el-Wailly 1965: fig. 3, Madhloom 1976: pl. 32).

1990: The slab was apparently in the same condition as Madhloom found it.

1996: A fragment that includes the enemy chariot in the lower left corner was offered on the art market in 1996 (pls. 254–6). A 1997 photograph confirms that the slab has been completely destroyed by looters.

SUBJECT: The upper half of the relief shows Assyrian cavalry defeating a force of cavalry, chariots, and foot soldiers. At the top, Assyrians bring carts and animals out of an enclosure, probably the camp of the defeated enemy. In the lower half is the line of battle of the enemy chariots and cavalry, facing toward the approaching Assyrian army on Slab 26. The details are clear from Layard's drawing. At the left end of the second register from the bottom, only partially shown in Layard's drawing but preserved on the slab itself, is a galloping Assyrian cavalryman who is overrunning an enemy foot soldier and chariot. This is the beginning of the rout that continues on Slab 23.

Room I, Slab 25 (pls. 66, 67)
WIDTH: 196.5 cm

1847: Layard wrote, "No 21 [my no. 25]: Only a few figures on the bottom of this slab can be traced – they are warriors fighting. The rest of the slab has been entirely destroyed."

1903: In King's photograph, this slab seems to be intact to its entire height, but the relief surface on the upper part of the slab appears to be destroyed (pl. 239).

1981: When Madhloom re-excavated this slab, only the lower part remained. The sculptured surface was badly damaged, but many figures were still legible. Its condition was unchanged in 1989.

SUBJECT: Assyrian foot soldiers, approaching from the right at the head of the Assyrian army shown on Slabs 26–7, join battle with enemy foot soldiers who are the vanguard of the enemy army on Slab 24.

Room I, Slab 26 (pls. 67, 68)
WIDTH: 235 cm

1847: Layard apparently did not mention this slab (see Slab 27).

1903: In King's photograph, the surface of this slab appears to be entirely destroyed (pl. 239).

1990: The only place I could distinguish any sculpture on this slab was in the lower left corner. This detail has been included in the new drawing of Slab 25.

SUBJECT: Assyrian archers march to the left.

Room I, Slab 27 (pls. 69, 70, 71)
WIDTH: 216 cm

1847: Layard wrote, "No. 22 [my no. 27] – The whole slab destroyed – a few lines of inscription may be traced, but the characters cannot be copied." According to Layard's plan, this should be my Slab 26, but Layard's reference to "a few lines of inscription" would only be appropriate for my Slab 27, at least in 1990.

1903: In King's photograph, this slab is intact to its full height. Its surface appears to be in poor condition (pl. 239).

1990: Though the surface is in very poor condition, most of the original composition may be reconstructed on the basis of the surviving details.

SUBJECT: On the lower half of the slab are Assyrian footsoldiers, dismounted cavalry, and chariots facing left, the continuation of the Assyrian army shown on Slabs 25–6. In the upper half is the royal chariot – though only the harness at the front of the chariot box and the torso of the soldier who steadies the wheel survive, comparison with better-preserved examples leaves no doubt that this is what is depicted (pl. 119). Sennacherib presumably originally stood in the chariot, but no trace of his figure remains. Behind the chariot at the right are the remains of a soldier and horses. Above the chariot at the left is an epigraph, probably originally giving the name of the city on Slab 28 and some account of the battle on Slabs 23–7, but I have been unable to suggest a reading on the basis of the few surviving traces (Russell 1998, Catalogue 4).

Room I, Slab 28 (pls. 72, 73, 74, fig. 25)
WIDTH: 230.5 cm

1849: Layard did not mention this relief in his writings, though according to his second plan of the palace, he excavated it during his campaign of 1849–51. It was drawn by William Boutcher, the British Museum artist at Nineveh in 1854–5. In the drawing, the relief is preserved to its full height and is in very good condition.

1903: King's excellent photograph of this slab shows it unchanged since Layard's day.

1965: Madhloom's photograph of this slab shows it still in excellent condition (Madhloom 1967: pl. 10; 1976: pl. 29).

1990: The condition remained very good. In my recent photographs the relief appears flatter than it should because lighting conditions were not ideal.

SUBJECT: A walled city with windows at the tops of the towers and round shields on the battlements. It appears to be deserted except for a man holding a standard(?) on the highest tower. Orchards in the foreground. At left, dismounted cavalrymen of the Assyrian army, which continues on the slabs to the left.

COMMENT: The architecture here is typical for Sennacherib's representations of the Levant, which would make this his third campaign (Russell 1991: 161). The great battle shown here outside this city might then be Sennacherib's defeat of the Egyptian army at Eltekeh, which is the only field battle that Sennacherib reported during this campaign.

Room I, Slab 29
WIDTH: 122 cm

1990: Only the worn base of this slab survived. No sculpture could be distinguished on it.

Room I, Slabs 30–32 (pl. 75)
WIDTH: Slab 30: 260 cm; Slab 31: 244 cm; Slab 32: 236 cm

1990: Only the worn bases of these slabs survived. No sculpture could be distinguished on them.

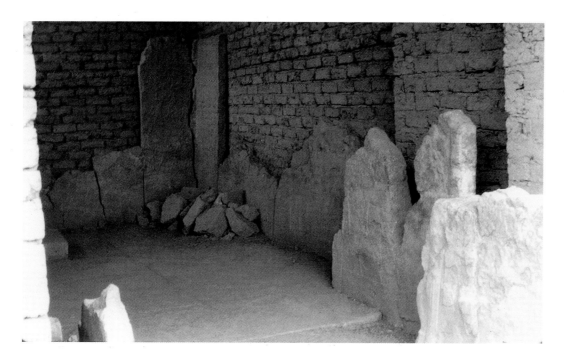

fig. 35: Nineveh, Sennacherib Palace Site Museum, Room IV, view through Door *f*, 1981 (photo: author).

Room I, Slab 33 (pls. 75, 76)

WIDTH: 172 cm

1990: A substantial part of this slab survived. Its surface appeared to be intact, but unsculptured. I cannot account for this.

Room I, Slabs 34–37 (fig. 23)

WIDTH: Slab 34: 41 cm; Slab 35: 73 cm; Slab 36: 84 cm; Slab 37: 53 cm

1990: Only fragments of the uncarved bases of these slabs survived.

COMMENT: The placement of Slabs 36 and 37 (covered by weeds in the photograph) fix the location of the south wall of the throne room.

ROOM III

1847: Layard wrote, "The bas reliefs in this chamber celebrate the conquest of a city in the midst of palm groves, & standing on the banks of a river. Unfortunately all the slabs are greatly injured – in the W part of the chamber so much so that they can scarcely be traced . . . There is no mountain scenery in these basreliefs – the palm trees appear on every slab."

1903: King did not claim to have re-excavated this room, though he dug it partly out in excavating Door *d*. None of its sculptures are visible in his photographs of Door *d* (pls. 24, 25).

1965: The sculptures in Room III had apparently completely disappeared by the time of Madhloom's excavations.

Room III, Slabs, 1, 2, 3

1847: Layard wrote, "Of No. 1, 2, & 3 the lower part alone remains – a river, & horses walking on its banks may be traced. On 2 & 3 may be distinguished horsemen & beneath them, at the bottom of the slab, a river."

Room III, Slab 4 (pl. 77)

1847: Layard wrote, "No. 4 has been drawn."

SUBJECT: Below, Sennacherib in his chariot moving to the left along a river in a palm-lined Babylonian landscape. Above, an Assyrian archer and shield bearer fire to the right. Behind them, the legs of an Assyrian proceeding to the left. Above them is the lower part of a kneeling(?) figure facing right. The details are clear from Layard's drawing.

Room III, Slab 5

1847: Layard wrote, "No. 5 warriors & a river may be traced. On No. 5, preceding the King, 3 high capped warriors with the shield, as in No. 4, & four archers."

Room III, Slab 6

1847: Layard wrote, "On No. 6 only a line of warriors can be traced."

Room III, Slab 7

1847: Layard wrote, "No. 7 The King in his chariot, two rows of warriors beneath – the slab has been too much injured to be drawn."

Room III, Slab 8 (pl. 78)

1847: Layard wrote, "No. 8 drawn. There are two lines of inscription on this slab – it is doubtful whether the lines were continued on No. 7 – no traces of characters remain on that slab."

SUBJECT: Above, Assyrians cutting down palm trees. Below, Sennacherib in his chariot supervising the sack of Dilbat. For the epigraph, see Russell 1998, Catalogue 4.

ROOM IV (fig. 35)

In 1847, Layard wrote, "Room [IV] is in the edge of a ravine, which runs to a considerable distance into the mound and was the first part of the ruins discovered . . . All the slabs in the chamber were destroyed to within two or

three feet of the bottom and were otherwise so much injured that drawings could not be made of what remained. Most of the slabs appeared to have been occupied by processions of warriors & captives, forests & mountains." My examination of the reliefs in 1990 confirmed Layard's observation that the upper part of most of these slabs was missing, but the condition of the relief surface of the surviving part was superb.

Room IV, Slab 1 (pl. 79)
WIDTH: 222 cm

1847: Layard wrote, "The entrance [/] was formed by two slabs upon each of which were two winged figures facing Chamber B. The first figure on each had the feet of an eagle, & was probably eagle headed. The feet & lower part of the legs of these figures could alone be distinguished."

1990: This slab was very poorly preserved. The bird feet described by Layard were worn but recognizable, and belonged to the rear figure, not the front one. The front figure had completely disappeared. For a better-preserved example, see fig. 26.

SUBJECT: See Slab 16.

Room IV, Slab 2 (pl. 81)
WIDTH: 165 cm

1981: The lower part of the slab survived, in good condition.

1990: A small part of the right edge of the slab had disappeared.

SUBJECT: A wooded mountainous landscape. The left end of the slab was unsculptured, presumably because it would have been covered by the doorpost.

Room IV, Slab 3 (pl. 82)
WIDTH: 110 cm

1990: The lower part of the slab survived, in good condition.

1997: The slab has been destroyed by looters (pl. 259).

SUBJECT: A wooded mountainous landscape. At the top right is the wall of a fortified camp or city with one small figure of a soldier standing behind it.

Room IV, Slab 4 (pls. 83, 84, 85, 86)
WIDTH: left panel: 78 cm; right panel: 79 cm

1990: This monolithic corner slab survived to nearly its full height, except that the upper right part was broken away. The lower half was in very good condition. The upper half was badly worn and largely illegible, suggesting that it was exposed to the elements or fire after the lower half was buried.

1996: A fragment of the left panel that includes the small soldiers and the city wall was offered on the art market in 1996 (pls. 257–9). A 1997 photograph confirms that the slab has been completely destroyed by looters.

SUBJECT: A wooded mountainous landscape. On the lower part of the left panel is the continuation of the fortified camp or city wall on Slab 3. Above this is a line of large figures, evidently Assyrian soldiers escorting a procession of tribute or booty. On the right panel is the continuation of the lower

procession from the left panel of the slab, and a second similar procession above.

Room IV, Slab 5 (pls. 87, 88)
WIDTH: 124.5 cm

1981: Only the lower half of the slab was preserved. Its relief surface was in excellent condition.

1990: A piece of the upper right corner, including the front of the foremost figure, had disappeared.

SUBJECT: On the face of the slab, a wooded mountainous landscape with the continuation of the lower procession from Slab 4. The landscape continues on the right edge, which forms part of the side of a niche.

Room IV, Slab 6 (pl. 89, fig. 22)
WIDTH: 194.5 cm

1982: This slab formed the back of a shallow niche. The upper half was missing, but the condition of the surviving part was excellent.

1990: The shallow return at the right edge of the slab had disappeared.

SUBJECT: Continuation of the wooded mountainous landscape. At the far left is the Assyrian soldier at the head of the procession on Slabs 4–5. He faces a line of Assyrian officials: a pair of figures in long robes, possibly scribes, and six soldiers.

COMMENT: The original brickwork behind this slab was apparently retained in the restoration. It forms an arch above the drain that ran under the wall from this niche.

Room IV, Slab 7 (fig. 22)

1981: I do not know what, if anything, Layard or Madhloom found in this position. By 1981 there was no evidence of a slab here.

Room IV, Slab 8 (pls. 90, 91, 92, fig. 14)
WIDTH: left panel: 75 cm; right panel: 76 cm

1965: When Madhloom found this corner slab, the upper part was evidently broken away from the lower, and he put them back together. The relief surface was in excellent condition.

1990: The upper part had become detached from the lower and was on the ground.

1997: The lower right part of the slab, broken in half between the horse and soldier, was offered on the art market in 1997 (Paley 1997: fig. 4). A 1997 photograph confirms that the entire slab has been looted (fig. 15).

SUBJECT: Only the base and a bit of the upper part of the left panel survived. Both areas were carved with a mountain pattern, and what is probably the lower part of a tree trunk was visible on the base. The wooded mountainous landscape continued on the right panel, which was better preserved. At the bottom was an Assyrian soldier holding a horse, and above him was another Assyrian soldier.

Room IV, Slab 9 (pl. 93)
WIDTH: 167 cm

1990: Only the lower part of this slab survived. The relief

was beautifully preserved. A small section that included a tree had disappeared from the upper right corner since 1981.

1997: The slab has been destroyed by looters (pl. 260).

SUBJECT: Continuation of the wooded mountainous landscape. At right is an Assyrian soldier holding a horse. At left are the legs of another horse, probably also led, but his owner is not preserved.

Room IV, Slab 10 (pls. 94, 95)

WIDTH: 207.5 cm

1981: Only the lower part of this slab was preserved. The relief surface was in excellent condition. The slab was in the same condition in 1989.

1990: Between 1989 and 1990 a large piece of the sculptured surface at the right side, including a tree and a section of the city wall, had disappeared.

1997: Most of the slab has been destroyed by looters (pl. 260).

SUBJECT: Continuation of the wooded mountainous landscape, with part of a city wall at the top.

Room IV, Slab 11 (pls. 96, 97, 98, 99)

WIDTH: left panel: 85 cm; right panel: 90.5 cm

1990: This corner slab was preserved to its full height. The relief surface of the lower part was in excellent condition, while the upper part was badly worn, but legible.

SUBJECT: In a wooded mountainous landscape, Assyrian soldiers drive two files of figures carrying booty or tribute.

Room IV, Slab 12 (pl. 100)

WIDTH: 202 cm

1847: Layard wrote, "On No. 11 [my no. 12] could be distinguished part of a tripod, several vessels of various shapes, & (?) a censer."

1990: Only the lower part of this slab was preserved. Its relief surface was in excellent condition.

1997: Most of the slab has been destroyed by looters (pl. 261).

SUBJECT: The subject described by Layard is still clearly visible. It appears that what is actually shown here is the weighing of tribute or booty: the "tripod" is the support for a scale, the "censer" is one of the balance pans, in which is what appears to be an Assyrian lion weight, and the vessels at the left are evidently what is being weighed.

COMMENT: The subject of the weighing of booty is also depicted on Slab 3 of Room 13 in Sargon's palace at Khorsabad, where the subject is the capture of Muṣaṣir (Albenda 1986: pl. 133).

Room IV, Slab 13 (pl. 101)

WIDTH: 200.5 cm

1990: Only the lower part of the slab was preserved, but its relief was in excellent condition.

SUBJECT: A file of Assyrian soldiers and horses facing left, standing in a wooded mountainous landscape.

Room IV, Slab 14 (pls. 102, 103)

WIDTH: left panel: 83.5 cm; right panel: 65 cm

1990: Only the lower part of this monolithic corner slab was preserved. Most of the right panel was lost. The relief surface was in excellent condition.

SUBJECT: Continuation of the file of standing Assyrian soldiers and horses from Slab 13. On the left panel is a led horse, whose owner is on Slab 13, and a soldier who holds the horse shown on the right panel.

Room IV, Slab 15 (pl. 104)

WIDTH: 172 cm

1989: Only the lower part of this slab was preserved. Its relief surface was slightly worn, but still clearly legible.

SUBJECT: At left is an Assyrian soldier with a led horse, continuing the file from Slab 14. As on Slab 2, the mountain pattern does not continue all the way to the right edge, presumably because it would have been covered by the doorpost.

Room IV, Slab 16 (pl. 80)

WIDTH: 205 cm

1847: See Slab 1.

1990: Only the lower part of this slab was preserved. Its relief surface was worn, but still clearly legible.

SUBJECT: Two doorway guardian figures, the front one with human legs and feet, and the back one with human legs and the feet of a bird. A slab with fully preserved examples of these two figures was found in Door *o* of Room XXXI in Sennacherib's palace (fig. 26).

ROOM V (fig. 36)

Layard wrote, "In this chamber, at the foot of Slab No. 2, were found several of the small pieces of clay impressed with cuneiform inscriptions." This was what led King to reexcavate this area in 1903. For views of Madhloom's excavations in this room in 1967, see Madhloom (1967: pl. 8b, 12a; 1969: pl. 20; 1976: pl. 35a – printed in reverse, 35b). In 1990, this was still the best preserved room in the throne-room suite, but its sculptures have suffered considerable damage since then.

Room V, Slab 1 (pls. 105, 106, fig. 10)

WIDTH: 121.5 cm

1847: Layard wrote, "On No. 1 there appear to have been three lines of warriors one above the other. The lower are alone sufficiently well preserved to be drawn." Layard drew only the lower right figure from this slab.

1903: King's oblique photograph appears to show the slab in the same condition as in 1990 (pl. 240).

1967: Madhloom published a photograph of the lower row of soldiers, one of which was on the art market in 1996 (Madhloom 1967: pl. 8a; 1976: pl. 33a).

1990: Only the lower half of the slab survived, with the remains of two lines of soldiers. If Layard actually distinguished three lines of soldiers, then the slab must have been preserved to its full height when he excavated it. If so, there is no documentation of when the upper half

fig. 36: Nineveh,
Sennacherib Palace Site
Museum, Room V, view
looking northwest, 1981
(photo: author).

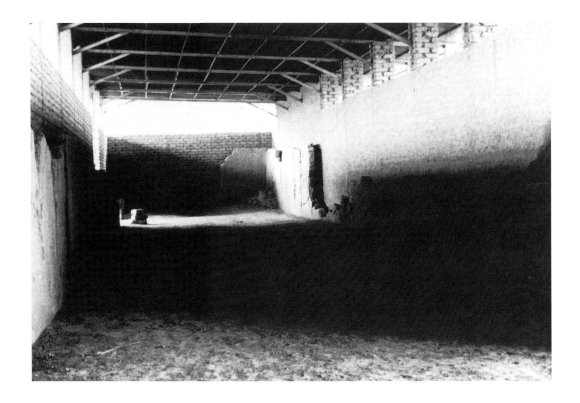

disappeared. The relief surface was in good condition in the areas where it was preserved.

1996: A fragment that includes the head and torso of the front archer was offered on the art market in 1996 (fig. 11, pls. 262–3). A 1997 photograph confirms that this slab has been completely destroyed by looters (fig. 11).

SUBJECT: Below is a file of three Assyrian archers marching to the right along a river with a mountain pattern below it. Above are the feet of another file of marching figures. The left part of the slab, adjacent to the bull colossus in Door *e*, was uncarved, presumably because it would have been covered by the doorpost.

Room V, Slab 2 (pl. 107)
WIDTH: 238 cm

1847: Layard wrote, "No. 2 probably a continuation of the same subject, but the slab is so much injured that little can be distinguished."

1903: King's oblique photograph appears to show the slab in the same condition as in 1990 (pl. 240).

1990: Layard's description is accurate. Except for bits of three wavy lines from the river near the bottom right, the relief surface had completely disappeared.

Room V, Slab 3 (pls. 106, 108, 109)
WIDTH: left panel: 80 cm; right panel: 61.5 cm

1847: Layard wrote, "No. 3 three lines of warriors as on No. 1 – the two upper are slingers. One from No. 1 & 2 from No. 3 have been drawn. The rest are similar." Layard drew the lower right spear bearer on the left panel and the lower left slinger on the right panel.

1903: King's photographs appear to show the slab in the same condition as in 1990 (pl. 240).

1990: This monolithic corner slab was preserved to its full height. Its relief surface was in good condition, though somewhat worn at the top.

SUBJECT: At the bottom of the left panel is a river with a mountain pattern below it, as on Slab 1, while on the right panel the mountain pattern extends some distance above the river as well. The top of both panels is covered with the mountain pattern and trees. The central area of the slab has no background pattern, save for a lone tree near the top on the left panel. On the left panel, three files of soldiers approach from the left, continuing the files from Slab 1. The soldiers in the lower two files carry shields and spears, while those in the upper are archers with their bows held up ready for action. On the right panel, two files of slingers attack toward the right.

Room V, Slab 4 (pl. 110)
WIDTH: 209 cm

1847: Layard wrote, "No. 4 – the upper part of the slab destroyed – the lower part contains archers & warriors besieging a castle, but too much injured to be drawn."

1903: King's photograph appears to show the relief in much the same condition as in 1990 (pl. 240).

1990: Only the lower part of the slab survived. Most of the relief surface had flaked away, but the preserved part was in good condition.

SUBJECT: At the left side of the slab, the mountainous landscape is continued from Slab 3. Parts of two files of attacking Assyrian soldiers are preserved. In the lower are the

remains of three pairs of soldiers, each pair comprising an archer and a shield bearer to protect him. The two left shield bearers each also carry a spear, while the fragmentary one at the right evidently held a sword. At the upper left is all that remains of the second file: the striding legs of a single figure whose weapon is not preserved.

Room V, Slab 5 (pls. 111, 112)
WIDTH: 189 cm

1847: Layard wrote, "No. 5 & 6 are continuation of the same subject & have been drawn."

1981: Madhloom was able to consolidate this relief to much the same condition as when Layard drew it, except that there was some additional surface damage at the lower right. He even located and reattached the fragment with the lower bodies of the pair of archers at the far left, which Layard had shown as missing.

1990: The upper parts of the Assyrian soldiers at the left had disappeared.

SUBJECT: An Assyrian attack on a walled city in a wooded mountainous landscape with a river at the bottom. Defenders tumble headfirst from the walls, which are being undermined by an Assyrian soldier. The details are clear from Layard's drawing.

Room V, Slab 6 (pls. 113, 114)
WIDTH: 204.5 cm

1847: See Slab 5.

1981: Madhloom found this relief in the same condition as when Layard drew it.

1990: The left edge of the slab, with images of an enemy spear bearer and stone thrower on the city walls, had disappeared.

SUBJECT: Assyrian soldiers attack the walled city on Slab 5 from the right, some of them ascending toward the city from the rooftops of suburban houses. At the center right part of the slab, prisoners from the fallen city are marched off toward the right. The details are clear from Layard's drawing.

Room V, Slab 7 (pls. 115, 116, 117)
WIDTH: left panel: 78 cm; right panel: 86.5 cm

1847: Layard wrote, "Half of No. 7 has been drawn – the remainder contains lines of prisoners & warriors continued (without variety) from No. 6."

1990: This monolithic corner slab was preserved to its full height. Its relief surface was somewhat worn and pitted, but still easily legible. The right panel was in much the same condition as when Layard drew it, though the drawing itself is inaccurate in some details.

SUBJECT: The bottom of the left panel is covered with the mountain pattern, which slopes gradually upward, and through which runs a river. Atop this stands a row of attacking Assyrian archers and slingers, continuing the group from Slab 6. Above them continues the row of prisoners from Slab 6. At the top is a band of wooded mountainous landscape. At the bottom of the right panel the river has disappeared, but the mountain pattern continues, bounded by

the upward sloping contour continued from the left panel. Growing from the top of this contour at the far left are two trees. Near the bottom of the right panel are three Assyrian soldiers facing left. Above them is the front of the booty procession: three soldiers approach from the left carrying severed heads, which they drop at the feet of a pair of scribes, one of whom writes on a scroll, and the other possibly on a clay tablet or writing board, though the image is not clear here. Behind the scribes is a standing soldier. At the top, the wooded mountains continue from the left half.

COMMENT: Layard's drawing is inaccurate in the lower part, where it shows a horizontal upper contour for the mountain pattern and places the two trees incorrectly. It also shows three trees at the bottom of the slab that are not on the original. In addition, the soldiers at the left and right ends of the upper row of figures and the leftmost tree at the top were omitted.

Room V, Slab 8 (pls. 118, 119)
WIDTH: 203.5 cm

1847: Layard wrote, "No. 8 is much injured – it appears to have contained the King in his chariot preceded by warriors – with the river and the usual mountain scenery, as in the previous slabs."

1990: The slab was preserved to nearly its full height. As Layard reported, its surface was badly damaged.

SUBJECT: The setting is a wooded mountainous landscape, which is shown on the upper and lower thirds of the slab. Contrary to Layard, no river is depicted. The composition is clear from the new drawing. At the bottom is a row of soldiers and led horses, continued from Slab 8. Above at the left is another row of soldiers, behind whom is the king in his chariot.

Room V, Slab 9 (pls. 120, 121)
WIDTH: 231 cm

1847: Layard wrote, "Nos. 9 & 10 greatly injured – led horses, a castle & the usual mountain scenery can be distinguished."

1990: The slab is preserved to most of its original height. A considerable part of the relief surface was broken away, but where it was preserved it was in very good condition.

SUBJECT: This slab completes the relief series that begins on Slab 1. The background is the wooded mountainous landscape of the previous slabs, which covers the top and bottom thirds of the slab at the left side, and the entire height of the slab at the right. In the lower center is an Assyrian walled camp, with the king's tent visible inside at the upper right. Beneath it is a small kneeling figure in a service tent who is engaged in some unclear activity, possibly cooking, next to a laden table. Above the camp is a led horse, the last in the row that follows the royal chariot on Slab 8.

Room V, Slab 10 (pls. 122, 123)
WIDTH: 204 cm

1847: See Slab 9.

1990: The slab was preserved to its full height. The surface

was badly pitted, but the relief was in good condition where it was intact.

SUBJECT: A wooded mountainous landscape overall, with two rows of soldiers and led horses facing right. The composition and details are clear from the new drawing.

Room V, Slab 11 (pls. 124, 125)
WIDTH: 225 cm

1847: Layard wrote, "No. 11 is also much injured – the King in his chariot preceded by warriors can be traced. Above the King was an inscription, which is partly preserved."

1990: The slab was preserved to its full height. The surface was badly damaged, but the relief was in good condition where it was intact.

SUBJECT: Continuation of the subject on Slab 10. Below, a row of four led horses. Above, the king's chariot, behind which is a row of four standing soldiers, one of whom steadies the chariot wheel. The composition is clear from the new drawing. For the epigraph, which refers to the city of Kasuşi(?), see Russell 1998: Catalogue 4.

Room V, Slab 12 (pls. 126, 127)
WIDTH: 220.5 cm

1847: Layard wrote, "No. 12 Almost entirely destroyed – warriors, trees, mountains may be distinguished."

1990: The slab was preserved to its full height. The surface was mostly destroyed, but a few well preserved areas survived.

SUBJECT: Against an overall background of wooded mountains are the remains of two rows of standing Assyrian soldiers facing right. The composition and surviving details are clear from the new drawing.

Room V, Slab 13 (pls. 128, 129)
WIDTH: 192.5 cm

1847: Layard wrote, "No. 13 in the same state as previous – warriors driving prisoners & cattle may be traced."

1990: The slab was preserved nearly to its full height in the center, but the upper right and left corners were broken away. The surface was badly damaged, but quite a few traces of the relief were still legible.

SUBJECT: Against an overall background pattern of wooded mountains, two rows of captives proceed to the left. The lower procession, much of which is preserved, comprises only human figures carrying bags. The upper procession includes at least one cow. The composition is clear from the new drawing.

Room V, Slab 14 (pls. 130, 131)
WIDTH: 204 cm

1847: Layard wrote, "No. 14 has been partly drawn – beneath the captives &c there is another row of prisoners & warriors but much injured."

1990: The slab was preserved nearly to its full height. The relief surface was generally in good condition.

1997: Most of the slab has been destroyed by looters (pl. 264).

SUBJECT: Against an overall background pattern of wooded mountains, the two processions of captives from Slab 13 continue. The lower procession comprises mainly bound captive men in the front and women behind, urged onward in the center by an Assyrian soldier with a spear. The details of the upper procession are clear from Layard's drawing.

Room V, Slab 15 (pls. 132, 133)
WIDTH: 224 cm

1847: Layard wrote, "No. 15 a double row of prisoners can be traced."

1990: The slab was preserved to its full height. The relief surface was badly damaged, but substantial areas of relief carving were still legible.

1996: A fragment that includes the heads of the two Assyrian soldiers at the upper right was offered on the art market in 1996 (pls. 265–7). A 1997 photograph confirms that the right edge of the slab has been damaged by looters.

SUBJECT: Against an overall background pattern of wooded mountains are two rows of figures. Most of the upper row and the left end of the lower row show prisoners marching to the left, driven forward at the bottom by an Assyrian soldier with a mace. These figures conclude the prisoner processions on Slabs 13–14. The remainder of the lower row and the right end of the upper row is composed of Assyrian slingers and archers facing right, attacking the city on Slab 17. The composition is clear from the new drawing.

Room V, Slab 16 (pls. 134, 135, fig. 12)
WIDTH: 185 cm

1847: Layard wrote, "No. 16. Under the mountains & trees is a row of warriors discharging arrows, with the shields (as in No. 37) – beneath a second line of warriors also discharging arrows but without the shields. Other warriors appear to be mounting to the assault of the city."

1990: Only the lower half of the slab survived. The relief surface was very well preserved.

1996: A fragment that includes the heads of the third pair of archers from the left in the lower row was offered on the art market in 1996 (pls. 135, 268). A 1997 photograph confirms that the entire slab has been destroyed by looters (fig. 13).

SUBJECT: Against an overall background pattern of wooded mountains, the two rows of attacking Assyrian soldiers continue from Slab 15. In the lower row, climbing upward toward the city on Slab 17, are archers and foot soldiers with round shields and spears. In the upper row, archers fire toward the city. They stand behind tall shields at the left and out in the open at the right.

Room V, Slab 17 (pls. 136, 137, 138, 139)
Maximum width of preserved relief surface: 139 cm

1847: Layard wrote, "No. 17 A castle on the summit of a hill – on the summit of the towers, which are defended by the enemy, are rows of circular bucklers. Some of the enemy appear to be falling from the castle walls. Warriors are climbing the hill, at the foot of which appears to be a town. Warriors have ascended the houses & are slaughtering the enemy. A sketch has been made of the castle, but this & the

previous slab are too much injured to be drawn."

1990: The top and right edges of this slab were lost. The surviving relief surface was abraded and chipped, but easily legible. Most of the "castle" at the top that was drawn by Layard had disappeared. This probably happened while the sculptures in this area were exposed unprotected before 1901.

1996: A fragment that includes the head of the enemy soldier kneeling atop the building at the middle right was offered on the art market in 1996 (pls. 138, 269–70). A 1997 photograph confirms that the right part of the slab has been destroyed by looters.

SUBJECT: Layard's description is accurate. The details and composition are clear from the new drawing and from Layard's drawing of the "castle," the central arched doorway of which was preserved at the center top of the 1990 photo.

Room V, Slab 18 (pl. 140)
WIDTH: 67.5 cm

1847: Layard wrote, "No 18 A double row of warriors with shields & bows – the greater part of this slab is wanting."

1990: Only a fragment from the bottom of this slab was preserved. The relief surface was in excellent condition. The upper part of the slab must have been lost since Layard's day, as the surviving portion shows only a single row of archers.

SUBJECT: Assyrian archers standing behind tall shields fire to the left at the city on Slab 17. According to Layard, there was originally a second row of archers above them.

Room V, Slab 19 (pl. 141)
WIDTH: 219 cm

1847: Layard wrote, "The remaining slabs of this side of the chamber are completely effaced."

1990: Only the base of the slab remained. The relief had almost completely disappeared.

SUBJECT: All that survive are small areas of mountain pattern at the lower left and right sides.

Room V, Slab 20 (pl. 142)
WIDTH: 181.5 cm

1847: Layard wrote, "completely effaced."

1990: Only the base of the slab remained. A small area of relief survived at the left side.

SUBJECT: Mountain background pattern with a horizontal ground line with an unidentifiable object, perhaps a tree trunk or the front leg of a horse, projecting up and slightly to the right from it.

Room V, Slab 21 (pls. 143, 144)
WIDTH: 164.5 cm

1847: Omitted from Layard's plan, "completely effaced."

1990: Only the lower part of the slab was preserved. The relief surface was fairly well preserved.

SUBJECT: A row of led horses and their owners facing left. The composition is clear from the new drawing.

Room V, Slab 22 (pls. 145, 146)
WIDTH: 128.5 cm

1847: Omitted from Layard's plan, "completely effaced."

1990: Only the lower part of the slab was preserved. The relief surface was badly worn, but legible.

SUBJECT: A row of led horses and their owners facing left, continuing the subject of Slab 21. The composition is clear from the new drawing.

Room V, Slab 23 (pl. 147)
WIDTH: 82.5 cm

1847: Omitted from Layard's plan, "completely effaced."

1990: Only the lower part of the slab was preserved. The relief surface was badly worn and barely legible.

SUBJECT: The left two-thirds of the slab appears to show two trees against a mountain pattern. The right third, adjacent to Door a, seems to be unsculptured, presumably because it would have been covered by the doorpost.

Room V, Slab 24 (pl. 148)
WIDTH: 160 cm

1847: Layard's Slab 21, "completely effaced."

1990: Only the lower part of the slab was preserved. The surface had flaked off in a few areas, but the preserved parts were in beautiful condition.

SUBJECT: Trees against a mountain pattern. The left end, adjacent to Door a, is unsculptured, as with Slab 23, presumably because it would have been covered by the doorpost.

Room V, Slab 25 (pl. 149)
WIDTH: 110.5 cm

1847: Layard's Slab 22, "completely effaced."

1990: Only the lower part of the slab was preserved. The surface was mostly lost, except at the bottom of the slab.

SUBJECT: All that survived were trees against a mountain pattern.

Room V, Slab 26 (pl. 150)
WIDTH: 125 cm

1847: Layard's Slab 23, "completely effaced."

1990: Only the lower part of the slab survived, and the surface was preserved only in one small area at the right.

SUBJECT: The small preserved area was apparently unsculptured.

Room V, Slab 27 (pl. 151)
WIDTH: 139.5 cm

Layard's Slab 24, "completely effaced."

1990: Only the lower part of the slab survived, and its surface was completely destroyed.

Room V, Slab 28 (pl. 152)
WIDTH: 97 cm

1847: Layard's Slab 25, "completely effaced."

1990: Only the lower part of the slab survived. Its surface was damaged at the right, but otherwise fairly well-preserved.

SUBJECT: Curiously, the preserved part of the slab was unsculptured.

Room V, Slab 29 (pl. 153)
WIDTH, WEST FACE: 57 cm; NORTH FACE: 18 cm
1847: Layard's Slab 26, "completely effaced."
1990: Only the lower part of this monolithic corner slab survived. Its surface was very well preserved.
SUBJECT: As with Slabs 28 and 26, the preserved part of this slab was unsculptured.
COMMENT: The absence of sculpture on Slabs 26–9 is surprising. There is no way to know if the upper part of these slabs was originally sculptured, with the lower part left blank because of the presence of some fixture such as a dais, or whether the entire slabs were left uncarved, which would suggest that the sculptures here were never finished or that the wall was covered by some other material, or whether the images on these slabs had been erased as were those on Slabs 14–17 in Court H.

Room V, Slab 30 (pls. 154, 155)
WIDTH: 157.5 cm
1847: Layard wrote, "No. 27 [my no. 30]. A double line of warriors (facing 28) the first kneeling, with spears & shields, the second discharging arrows, & sheltered by the usual high shield. These warriors are separated by a river from horsemen ascending mountains (as in No. 30 [my no. 32]) – slab much injured – a fragment of a castle can be traced on the edge."
1990: Most of this slab had disappeared since Layard's day – only the lower part survived. The sculptured surface was in good condition.
SUBJECT: Layard's description is all that survives of most of this slab. The relief had a wooded mountainous landscape above and below, divided across the center by a river, as on Slab 32. The upper part showed the Assyrian assault on the city on Slab 30a. The lower part showed Assyrian cavalry moving to the right over mountains. The rear legs of one horse survive at the left, and the front of another at the right. The details are clear from the new drawing.

Room V, Slab 30a
1847: Layard wrote, "No. 28 [my 30a] has been entirely destroyed & a well has been sunk in the place where it stood. It probably contained a castle, forming the sequel to No. 27."
1990: There was no trace of a slab in this position.
SUBJECT: As Layard speculated, the upper part of this slab would have showed the city under assault by the Assyrian army on Slab 30. The lower part probably continued the subject of Assyrian cavalry moving to the right over the mountains. The landscape and river should have been the same as on Slab 32.

Room V, Slab 31 (pls. 156, 242)
WIDTH: 128.5 cm
1847: Layard wrote, "No. 29. In the upper part of this slab were horses led by warriors – beneath them warriors bringing the heads and prisoners to scribes who are making a list – these are separated by a river from horsemen ascending mountains."

1903: King's excellent photograph shows that most of this slab had disappeared since Layard's day – only the lower part survived. In the photograph, the bottom of the slab has been dug out to expose a feature that Madhloom described as "two or more holes at the foot of each slab, the purpose of these being to help the sculptor to handle and fix the slab in position by the aid of wooden beams" (Madhloom 1969: 48).
1990: The slab was in the same condition as in King's photograph. The sculptured surface was worn at the top, but still legible.
SUBJECT: Layard's description is all that survives of most of this slab. The landscape and river should have been the same as on Slab 32. The led horses at the top probably faced left and preceded the king's chariot on Slab 32. Beneath them, the soldiers bringing severed heads and prisoners would have approached from the left, while the scribes would have been at the right side of the slab facing left, directly in front of the standing soldiers on Slab 32. The lower part continued the subject of cavalry moving to the right over the mountains. Parts of two horses are visible at the left.

Room V, Slab 32 (pls. 157, 158, 159)
WIDTH: 167 cm
1847: Layard wrote, "No. 30 has been drawn." The slab appears to be completely preserved in Layard's drawing, except for a few damaged areas. The almost complete loss of the epigraph, however, suggests that the upper part of the slab may have been in poor condition, as it was in 1990, and that Layard restored the trees and mountain pattern, but could not restore the epigraph.
1903: In King's poor photograph of the right two-thirds of this slab, the sculpture appears to be in essentially the same condition as in 1990 (unpublished British Museum photo PS 139284).
1990: The slab had evidently suffered some damage since Layard's day, most notably the loss of the upper left corner and the standing soldier at the left edge. This could have happened at the same time that the tops of Slabs 30–31 were lost. The relief surface also appeared much more pitted in 1990 than in Layard's drawing, but it could be that some areas were restored in the drawing.
1997: The slab had been broken and the chariot removed by looters (pl. 271).
SUBJECT: The landscape is the same as on the previous slabs. Above the river is the king in his chariot receiving the booty of the city on Slab 30a. This city must originally have been named in the epigraph in front of the king, but the part with the name is now lost (Russell 1998: Catalogue 4). Below the river is the continuation from Slabs 30–31 of the Assyrian cavalry moving over the mountains. The details are clear from Layard's drawing, but note that he omitted the arm of the soldier who steadies the chariot wheel. See also the comment below.
COMMENT: Layard got the proportions of the mountains wrong – they occupy considerably more vertical space in his drawing than on the original. He remedied this by adding

three more trees than are in the original, one slightly above the baseline at the left, and two halfway up at the right. The shapes of the trees in the drawing are also different from that of their models in the original, which suggests that Layard was not in front of the original when he finished the landscape details.

Room V, Slab 33 (pls. 160, 161, 162)
WIDTH, LEFT PANEL: 71 cm; RIGHT PANEL: 86.5 cm

1847: Layard wrote, "The whole of the wall from No. 31 to 47 [my no. 33 to 51], except such slabs as have been drawn, is in a very dilapidated state. The subjects of all the bas reliefs, as far as they can be traced from fragments, were sieges of cities & battles in a mountainous country."

1903: In King's poor photograph, this slab appears much the same as in 1990 (unpublished British Museum photo PS 139284).

1990: This monolithic corner slab was preserved to its full height. Contrary to Layard, the relief surface was in generally good condition.

SUBJECT: The landscape is a continuation of that on Slabs 30–32 – wooded mountains at the top and bottom, and a river running across the center. In the upper part is a row of Assyrian soldiers standing behind the king's chariot: the first holds the spoke of the chariot wheel, the next three hold maces, and the last two hold horses. Above them on the left panel, stands a single figure with a mace. The back part of this figure and the one directly below him appears either to have been erased or never finished, as the surface here in the corner appears to be uncarved. On this slab we finally learn the subject of the lower scene: Assyrian cavalry pursuing fleeing enemy horsemen, evidently fugitives from the city on Slab 30a. On the left panel, the file of Assyrian cavalry is continued from the previous slabs, while on the right panel the foremost of the Assyrian cavalrymen spears the hindmost of a pair of fleeing foes, both of whom look back at their pursuers.

Room V, Slab 34 (pls. 163, 164, 243)
WIDTH: 202.5 cm

1847: Layard wrote, "No. 32 [my no. 34] [. . . has] been drawn."

1903: In King's photograph, the slab was preserved to its original height. Its upper surface was badly damaged, and was evidently in considerably worse condition than when Layard drew it. The surface on the lower part was fairly well preserved, except that a hole had been cut completely through the slab, apparently to remove the heads of the foremost horse and rider. I do not know where this fragment is now.

1990: The slab was in much the same condition as in King's photograph.

SUBJECT: This is the end of the sequence that began on Slab 30. The landscape is the same as on the previous slabs. At the left above the river is the conclusion of the row of Assyrian soldiers and led horses that followed the king's chariot on Slab 32. At the right side is the Assyrian fortified camp.

Below the river is the front of the line of fugitive enemy horsemen that are being pursued by the Assyrian cavalry on the previous slabs. The details are clear from Layard's drawing.

Room V, Slab 35 (pls. 165, 166, 244)
WIDTH: 202.5 cm

1847: Layard's Slab 33, "in a very dilapidated state."

1903: In King's photograph, this slab appears to be in the same condition as it was in 1990.

1990: The slab was preserved to most of its original height. The surface showed considerable damage, but most of the relief decoration was preserved.

SUBJECT: This is the beginning of a new sequence. The landscape is again wooded mountains, but now the river is near the top. The mountain pattern may have covered the entire height of the left side of the relief. At the right, Assyrian archers, protected by soldiers holding tall shields, fire upon the city on Slab 37. The composition and details are clear in the new drawing.

Room V, Slab 36 (pls. 167, 168)
WIDTH: 202 cm

1847: Layard's Slab 34, "in a very dilapidated state."

1990: The slab was preserved nearly to its original height. The surface was very badly damaged, but enough of the relief decoration was preserved to determine the subject.

SUBJECT: Continuation of the wooded mountainous landscape below, and possibly a trace of the river above. The two rows of Assyrian soldiers from the previous slab are continued here. Those in the upper row are archers, while the weapons of those in the lower row are not distinguishable. The composition and surviving details are clear from the new drawing.

Room V, Slab 37 (pls. 169, 170, 245)
WIDTH: 148 cm

1847: Layard wrote, "35 [my no. 37] [. . . has] been drawn."

1903: In King's photograph, this slab appears to be in the same condition as it was in 1990.

1990: The slab was preserved to its original height. The surface on the left side was very badly damaged, but the right side was well preserved. Its condition seems to be the same as when Layard drew it.

1997: The sculpture at the right part of the slab had been hacked away by looters (pl. 272).

SUBJECT: Wooded mountains at the bottom and top, with a river running near the top. The Assyrian army attacks a walled city, identified above by a damaged epigraph. The details are clear from Layard's drawing. For the city name, which I have suggested is [Aranz]iaš, see Russell 1998: Catalogue 4.

Room V, Slab 38 (pls. 171, 172, 246)
WIDTH: 146.5 cm

1847: Layard wrote, "36 [my no. 38] [. . . has] been drawn." The relief was preserved to its full height and its surface was

fig. 37: Nineveh,
Sennacherib's palace, Room
V, Slab 43, 1847, engraved
from a drawing by A. H.
Layard (after Layard 1849a,
vol. 2, p. 469).

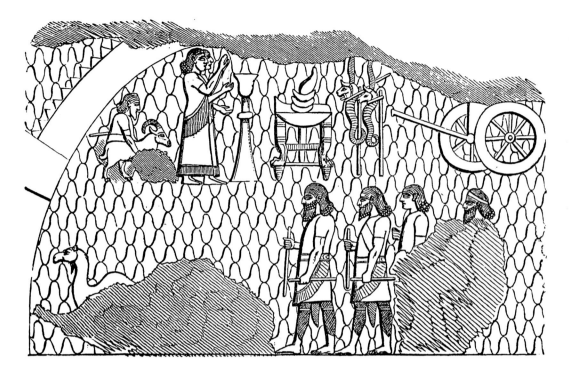

in generally good condition.

1903: King's photograph shows the slab in essentially the same condition as in Layard's drawing.

1965: The slab was nearly complete when Madhloom reexcavated it, though it was badly broken and some fragments from the edges were missing (Madhloom 1976: pl. 33b). It was still in the same condition in 1989.

1990: A fragment from the right edge that showed a siege ladder had disappeared.

SUBJECT: The landscape is the same as on the previous slabs. The Assyrian army scales the walls of an enemy city, while prisoners are marched off towards the right below. The details are clear from Layard's drawing.

Room V, Slab 39 (pls. 173, 174)
WIDTH: 206 cm

1847: Layard wrote, "37 [my no. 39] [. . . has] been drawn." The relief was preserved to its full height and its surface was in generally good condition.

1903: King's oblique view and photograph of the left half show the slab in essentially the same condition as in Layard's drawing (pls. 241, 246).

1967: Madhloom published a detail of the third pair of soldiers from the left in the top row (Madhloom 1967: pl. 11; 1976: pl. 30).

1990: The relief surface in some areas, particularly at the top, had deteriorated considerably from the condition shown in Layard's drawing and King's photograph, though it is possible that Layard restored some figures. The figure published by Madhloom appeared to have suffered some damage to its torso since then.

1996: A fragment that includes the tree in the upper left

corner was offered on the art market in 1996 (pls. 273–5). A 1997 photography shows that the slab is still largely intact, but in desperate need of consolidation (pl. 275).

SUBJECT: Continuation of the landscape and subject of the previous slabs. There are three rows of figures. At the top, Assyrian archers fire on the city on Slabs 37–8. In the center, archers fire on the city at the left side, while in the remainder an Assyrian soldier drives off livestock booty toward the right. At the bottom, prisoners from the fallen city are marched off to the right. The details are clear from Layard's drawing.

Room V, Slab 40 (pl. 175)
WIDTH: 199.5 cm

1847: Layard's Slab 38, "in a very dilapidated state."

1903: King's oblique photograph shows that this slab was mostly lost (pl. 241).

1990: Only the bottom of this slab survived. The relief surface was in excellent condition.

SUBJECT: A wooded mountainous landscape. At the left are a few feet that presumably represent the continuation of the procession of prisoners from the bottom of Slab 39.

Room V, Slab 41 (pl. 176)
WIDTH: 210 cm

1847: Omitted from Layard's plan, "in a very dilapidated state."

1990: Only the bottom of this slab survived. The relief surface was in excellent condition.

SUBJECT: Against a mountainous background are the lower parts of Assyrian soldiers and led horses, facing left.

Room V, Slab 42 (pl. 177)

WIDTH: 226 cm

1847: Omitted from Layard's plan, "in a very dilapidated state."

1990: Only the bottom of this slab survived. The relief surface was mostly lost, except for a small area at the left.

SUBJECT: Against a mountainous background are the back legs of the led horse from Slab 41, one leg of an Assyrian soldier, and the front legs of a second horse, all facing left.

Room V, Slab 43 (pls. 178, 179, 247, figs. 6, 37)
WIDTH: 179.5 cm

1847: Layard wrote, "39 [my no. 43] [. . . has] been drawn." Layard's drawing of this slab has not been located. A detail of the interior of the Assyrian fortified camp was engraved for *Nineveh and Its Remains* (fig. 37).

1903: King's photograph of the left two-thirds of this slab is the earliest record of its condition.

1981: The relief appeared to be in much the same condition as when King photographed it.

1990: By 1990, the left edge of the relief, including the stretch of wall and the crouching figure holding a goat, and a fragment at the top that included the hindquarters of the left horse, had disappeared.

1996: A fragment that includes the group of figures making an offering at the upper left was offered on the art market in 1995 (fig. 7, pls. 276–7). A 1997 photograph confirms that this part of the slab has been broken away by looters.

SUBJECT: This is apparently the end of the sequence that began on Slab 35. It shows an Assyrian fortified camp in a wooded mountainous landscape. Inside, a goat is evidently being prepared for sacrifice at the upper left. In front of the priests(?) are an incense stand, a table with something stacked on it, a pair of standards bearing images of dragons, and a chariot. Beneath this scene are a camel and four Assyrian officers standing in front of the king's(?) tent. The camp is divided across the center by an epigraph: ⌈uš⌉-[man-nu šá^m] ⌈d⌉30-PAP.MEŠ-SU MAN ⌈KUR⌉ [aš+šur], "[Camp of] Sennacherib, King [of Assyria]." The lower part of the camp is filled with service tents and one enclosed tent with a post and table(?) in front of it. At the upper right, above the camp, two horses are led up the hill toward the left. The details are clear from Layard's engraving and the new drawing.

Room V, Slab 44 (pls. 180, 181)
WIDTH: 211 cm

1847: Layard's Slab 40, "in a very dilapidated state."

1990: Only the lower part of the slab was preserved. Much of the surface was destroyed, but several areas were still legible.

SUBJECT: A wooded mountainous landscape with some sort of architecture at the top right. No figures are preserved. The composition is clear from the new drawing.

Room V, Slab 45 (pls. 182, 183)
WIDTH: 229 cm

1847: Layard's Slab 41, "in a very dilapidated state."

1990: Roughly the lower half of the slab was preserved. The surface was badly damaged, especially near the top, but much of the composition was still legible.

SUBJECT: The Assyrian army overruns a walled city beside a river in a wooded mountainous landscape. At the upper left are the remains of what are apparently an Assyrian siege ramp and the toggle pins that hold the covering on an Assyrian siege engine. It appears that the ramp has either topped or breached the outer wall and the siege machine is at work on the structures within. Below, Assyrian soldiers defeat the defenders of the outer wall. The composition and details are clear from the new drawing.

Room V, Slab 46 (pls. 184, 185)
WIDTH: 225 cm

1847: Layard's Slab 42, "in a very dilapidated state."

1990: Only the lower part of the slab survived. The surface was badly damaged, but the subject was still legible at the left side.

SUBJECT: A wooded mountainous landscape. At the left are the continuation of the outer wall and river from Slab 45. The details are clear from the new drawing.

Room V, Slab 47 (pls. 186, 187)
WIDTH: 185 cm

1847: Layard's Slab 43, "in a very dilapidated state."

1990: Only the lower part of the slab survived. The surface was badly damaged, but the subject was still partially legible.

SUBJECT: The subject is the aftermath of the siege on slab 45. At the upper right, a pair of Assyrian soldiers prepare to add their contribution to a pile of severed enemy heads. The details are clear from the new drawing.

Room V, Slab 48 (pls. 188, 189)
WIDTH: 242 cm

1847: Layard's Slab 44, "in a very dilapidated state."

1990: The slab was preserved to its full height at the right side, but the upper left part was lost. The surface was mostly destroyed, but bits of the composition could still be made out.

SUBJECT: The setting is the wooded mountainous landscape with a river from the previous slabs. At the left, a row of four Assyrian soldiers receive the heads of the defeated enemies shown on Slab 47. Behind them was the king in his chariot, though only the king's head, his driver's hair, and the handle of his sunshade survive. The details are clear from the new drawing.

Room V, Slab 49 (pls. 190, 191)
WIDTH: 94 cm

1847: Layard wrote, "45 [my no. 49] [has] been drawn."

1990: The slab was in the same condition as when Layard drew it. It was preserved to its full height, but the relief surface was missing in several areas, particularly at the top and left side. The preserved relief surface was in good condition.

SUBJECT: In a wooded mountainous landscape with a river

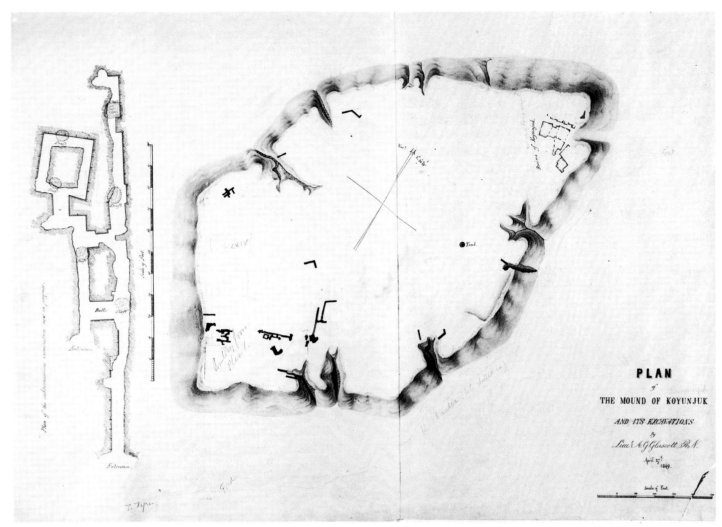

fig. 38: Nineveh, mound of Kuyunjik and the excavations in
Sennacherib's palace, plan by A. G. Glascott, April 1849 (photo:
Trustees of the British Museum).

running across the lower part, are a pair of led horses, one
above the other, with a soldier and the head of a third horse
at the middle right. These figures follow the king's chariot on
Slab 48.

Room V, Slab 50 (pl. 192)
WIDTH: 132 cm
1847: Layard's Slab 46, "in a very dilapidated state."
1990: The slab was very badly damaged, and not a trace of
relief carving survived.
SUBJECT: Though destroyed, the subject of this slab would
have included the body of the led horse on Slab 49 and the
owner and head of the horse on Slab 51.

Room V, Slab 51 (pl. 193)
WIDTH: 121 cm
1847: Layard's Slab 47, "in a very dilapidated state."
1990: The slab was preserved to most of its original height.

Contrary to Layard, the relief surface was somewhat worn,
but generally in good condition.
SUBJECT: Continuation of the wooded mountainous landscape
and river from Slab 49. In the center is the body of a led
horse. The right side of the slab, adjacent to the bull colossus
in Door *e*, was uncarved, presumably because it would have
been covered by the doorpost.

COURT VI

Layard excavated Slabs 1–8 of Court VI during his first
campaign of May–June 1847 (pl. 2). After Layard's departure
the remainder of the south wall was excavated, between July
1848 and April 1849, by means of tunnels dug under the
supervision of Layard's foreman, Toma Shishman, working
under the general control of Christian Rassam, the English
vice-consul. Room XIV and parts of Rooms XII and XIII
were also excavated at that time (Layard 1853a: 67, 69–74). A
plan made by Royal Navy Lieutenant A. G. Glascott, dated

27 April 1849, shows the state of these excavations before Layard's return to Nineveh in late September 1849 (fig. 38).

Court VI, Door a (pl. 194, figs. 27, 28)
LENGTH OF BULL 2: 420 cm. No dimensions are available for Bull 1.

1847: Layard wrote, "The entrance [a] to this chamber is also formed by winged bulls – the heads of which are wanting."

1901: According to King's photographs, Bull 2 was fully exposed to the elements and Bull 1 had entirely disappeared.

1990: Bull 2 appeared to be in the same condition as when King photographed it. There was no trace of Bull 1.

SUBJECT: A pair of winged, human-headed bull colossi.

INSCRIPTION: The text that began on Bull 1 and concluded on Bull 2 was devoted entirely to an account of the building of Sennacherib's palace. The inscription was apparently completely preserved at the time it was copied by Layard, but Bull 1 has since been lost. Layard copied only a part of this text out in full (Layard 1845–7: 148–51), and recorded the rest as variants to the text from Court H, Door c (Layard 1845–7: 141–8). He published only the variants (Layard 1851: 38–42, Luckenbill 1924: 117–25, Russell 1998: Catalogue 3). The inscription apparently originally consisted of some ninety-eight lines distributed as follows:

Column i: ca. 27 lines under belly of Bull 1 (only variants copied)

Column ii: ca. 22 lines between hind legs of Bull 1 (only variants copied)

Column iii: 22 lines between hind legs of Bull 2 (copied in full)

Column iv: ca. 27 lines under belly of Bull 2 (lines 1–13 copied in full, then variants only)

Court VI, Slab 1 (pl. 195)
WIDTH IN 1847: 197 cm, assuming that Layard's drawing was at his usual scale of 1:6.

1847: Layard wrote, "No. 1 has been drawn."

1901: King's photograph of this area shows no trace of this slab (fig. 28).

1990: No trace of this slab was visible.

SUBJECT: A pine-covered mountainous landscape covering the entire height of the slab at left, changing at the right into an open vine-filled river valley bounded by wooded hills. A river runs across the center. At the top, the Assyrian king and army descend rightward toward the valley.

Court VI, Slab 2
1847: Layard wrote, "No. 2 Contains three lines of warriors the first descending from the top of the slab, the two others proceeding corresponding lines of previous slab – the warriors have the usual pointed caps. Underneath these are vines & trees but no pines – near river. A part of an inscription is on the slab – the rest was probably on No. 1 & the whole appears to have referred to the King."

1990: No trace of this slab was visible.

SUBJECT: See Layard's description. The epigraph reads: "[Sennacherib] king of the world, king of Assyria, the cities of [PN or GN] he goes to conquer" (Russell 1998: Catalogue 4).

Court VI, Slabs 3–6
1847: There is no mention of these slabs in Layard's writings, beyond their inclusion in his published plans.

1990: No trace of these slabs was visible.

Court VI, Slab 7 (pls. 197, 198)
WIDTH: 150 cm

1847: Layard wrote, "All the remaining slabs appear to have been covered with lines of small figures extending from the top to the bottom of the slab – probably 2 or 3 hundred figures in all – being rows of warriors, warriors & prisoners & horsemen alternating."

1849: He later added: "I have been unable to connect the narrow passage [m] at the SE corner, the walls of which are carved with rows of warriors, with the chambers to the south, owing to the dilapidated state of this part of the building." The slab that Layard labeled "7" on his second plan is the rightmost of two slabs on the west jamb of Door m.

1901: The south edge of this slab is visible in King's photograph of this area (fig. 28).

1990: Only the lower part of the slab was preserved, as in the King photograph. The relief surface was generally well preserved.

SUBJECT: The wooded hilly landscape at the bottom with vines just above seems to be a continuation of that in Slab 1. At the top of the preserved part of the slab, two rows of Assyrian soldiers march toward the right.

Court VI, Slab 7a (pls. 196, 197)
WIDTH: 171 cm

1847: This is the slab to the left of Slab 7. It is shown but not labeled on Layard's plans.

1990: Only the base of this slab survived. A small amount of the relief surface was preserved.

SUBJECT: Continuation of the wooded hills and vines on Slab 7.

Court VI, Slab 8 (pls. 197, 199)
WIDTH, NORTH FACE: 69 cm; EAST EDGE: 26 cm

1847: See Slab 7.

1990: Only the left side and edge of this slab were exposed. The surface was well preserved at the bottom, but eroded away above.

SUBJECT: The front of the slab shows the continuation of the wooded hills and vines on Slab 7. On the east end of the slab, adjacent to Slab 7, the mountain pattern continues a bit at the bottom, while the remainder of the surface appears to be unsculptured.

Court VI, Slabs 8–13 (pls. 200, 201)
These slabs, which were excavated and drawn by Layard, were not reexcavated for the Sennacherib Palace Site Museum. They are included here to provide the context for

Slabs 7–8. For a description of the subject, see Chapter 2, sculptures.

MISCELLANEOUS FRAGMENTS FROM NINEVEH

I made hurried record photographs of a number of fragments of relief and inscription that were being kept in the Sennacherib Palace Site Museum and in another storage facility at Nineveh when I was there in 1989. Since then, at least three of these fragments have appeared on the art market, evidently smuggled out of Iraq illegally. In order to facilitate identification in the event that others are offered for sale, all of the pieces I photographed are published here. This is not intended as a complete scholarly analysis of these pieces – the entries are limited to brief descriptions and, where possible, speculations on their original location. I did not measure these fragments, but most of the photographs include a 15 cm scale, from which the rough dimensions may be calculated. The fragments in the site museum were as follows:

Pl. 208: Led(?) horse in a wooded mountainous landscape. This fragment probably belongs to a slab in one of the three restored rooms in the Sennacherib Palace Site Museum, but I was unable to find a direct join.

Pl. 209: Two lines of laborers towing an object towards the right, evidently from Room XLIX of Sennacherib's palace (Layard 1853b: pl. 11). This piece was recently on the art market (Russell 1996a: fig. 3). It was sold to an English private collection, and was identified when the buyer applied for a British export permit.

Fig. 8: Two dead sheep and a dead man floating in the water. I know of no occurrence of domestic livestock shown this way, other than a fragment that shows a dead buffalo in the water, which was found by George Smith (1875: 148) at the west end of the palace. Both of these fragments may have belonged to the campaign "to the Persian Gulf" that Thompson (1929: 61) said embellished the west façade of the palace. This piece was recently on the art market (Russell 1996a: fig. 4).

Pl. 210: Sennacherib in his chariot beside a vine, with a river and walled city(?) above, possibly from Court VI (published in Russell 1998: fig. 43, Catalogue 4).

Pl. 211: Fragment of a Sennacherib inscription, possibly from a bull colossus (published in Russell 1998: fig. 114, Catalogue 3).

Pl. 212: Head and right arm of a protective doorway figure, probably from Sennacherib's palace. For a complete example, see fig. 26.

Pl. 213: Assyrian soldiers marching in front of a river, probably from Sennacherib's palace.

From October 1927 to February 1928, R. Campbell Thompson completed the excavation of the outer parts of the Nabu Temple at Nineveh, the inner court of which he had previously excavated in 1904–5. Among the finds were a number of fragments of a relief of Assurnasirpal II that was originally about ten feet (3 m) tall. The subject was the king

hunting lions in the upper register and pouring a libation over a dead lion in the lower, separated by a fourteen-line inscription (pl. 214). The composition is similar to that of Slab 19 in Room B (the throne room) of Assurnasirpal's palace at Nimrud, but reversed and larger. Thompson published drawings of the preserved parts of the upper and lower registers, a photograph of the fragments that showed the king shooting a lion, and copies of the text on the fragments (Thompson and Hutchinson 1929a: 80, plates 6, 7; Thompson and Hutchinson 1929b: 109, 118–19, pl. XLI:4–10, LIX:4). A number of fragments from the lower register of this slab were in storage at Nineveh in 1989, when I photographed them, and there were probably others that I did not see.

Fig. 9: Head of a courtier facing right, with a fragment of lines 11–14 of the inscription above. This head is at the upper left of Thompson's drawing, which does not show the inscription. He also published a copy of the inscribed portion of this fragment, with a note that it was above a "head facing right" (Thompson and Hutchinson 1929b: pl. XLI:9). This fragment was removed from Nineveh some time after 1989 and was reportedly on the art market.

Pl. 215: King's left hand holding his bow.

Pls. 216, 217, 218, 219: Four fragments of the section that shows the courtier who holds the king's quiver and mace. The lower end of the quiver is engraved with two figures flanking a tree.

Pl. 220: Lower garment and left foot of a courtier.

Two other fragments I photographed may also come from Thompson's excavations on the Nabu Temple:

Pl. 221: Thompson reported finding "two pieces of reliefs of tutelary deities." He published a photograph of only one of these fragments, which was evidently from a figure like the one at the right in fig. 26 (Thompson and Hutchinson 1929b: pl. LXI:2). The fragment in my photograph may be the other one. The apparently bare torso and absence of a beard suggests that it may be from a figure like the one at the left in fig. 26, though it is stylistically closer to examples from the North Palace of Assurbanipal than to those from Sennacherib's palace.

Pl. 222: Thompson also reported finding a "piece of winged figure," which he did not illustrate (Thompson and Hutchinson 1929b: 109). This may be the fragment in my photograph.

Several fragments being stored at Nineveh in 1989 evidently originated from the palace of Sargon II at Khorsabad:

Pl. 223: Top right corner of a slab that originally showed a figure walking to the right with a bag on his shoulder. The fragment derives from a relief similar to Slab 22 of Façade n, perhaps from that very slab (Albenda 1986: pl. 24).

Pl. 224: Sandaled right foot of a figure facing right. This could be from any of the processions in Sargon's palace.

Pl. 225: Torso of a winged protective figure with cone and bucket, facing right. The material of this relief is apparently black stone. The only place that I know black stone was used

for relief sculpture in the Assyrian heartland was in the detached building ("Monument x") of Sargon's palace at Khorsabad, which was apparently patterned on a North Syrian *bit hilani* (Albenda 1986: 47–8, 79–80).

Pl. 226: Unidentified fragment, possibly from an apotropaic figure, in black stone. This may derive from the same source as the previous figure.

Three fragments that I photographed at Nineveh in 1989 seem to be of recognizable Assyrian subjects, but I cannot determine which palace they came from:

Pl. 227: Parts of a female and male figure moving to the right, probably part of a prisoner procession.

Pl. 228: Fragment of an Assyrian siege ladder.

Pl. 229: Possibly a figure in a headdress with earflaps moving to the left, urged on from behind by an Assyrian with a stick. Though the fragment is not easy to read, it may be related to images from Sennacherib's palace that show figures in flapped headdresses hauling bull colossi toward the right, similar to the subject of the fragment in pl. 209 (Russell 1991: 105–13).

Two of the pieces I photographed at Nineveh in 1989 had been brought there from a considerable distance, one in antiquity and the other recently:

Pl. 230: Fragment from the base of a black stone statue of an Egyptian king. Beneath the badly damaged foot, three of the nine bows representing Egypt's traditional enemies are clearly visible. This fragment presumably derives from one of three fragmentary statues of the Egyptian King Taharqa (690–664 BC), which were found in the outer chamber of the main gate of the Nebi Yunus arsenal during Iraqi excavations in 1954 (al-Asil 1954, Weidner 1954–6). They were probably brought as booty from the Egyptian campaigns of Esarhaddon or Assurbanipal, and erected in this prominent location just inside the main gate of the arsenal.

Pl. 231: Fragment of a statue base in black diorite, with two sections of a Sumerian inscription. A photograph and the text of this fragment were published by Civil (1989: 60–61, fig. 2). The piece was excavated in the Inanna temple at Nippur in 1958 (reg. no. 6N-351). The inscription is a text of King Šu-Suen (2037–2029) from the Third Dynasty of Ur. I do not know how the piece came to be at Nineveh.

Finally, in 1990 I took photographs of a few pieces in the Dohuk regional museum in northern Iraq. Since this museum was looted shortly thereafter during the uprisings that followed the Gulf War, I include these photographs here to facilitate identification in the event that they left Iraq.

Pl. 232: Glazed brick with the beginning of the name of King Assurnasirpal II.

Pl. 233: Stone figurine from Tell es-Sawwan.

Pl. 234: Small stone vessels from Tell es-Sawwan.

Pl. 235: Small stone bowls from Tell es-Sawwan.

APPENDIX
THE COURT H COLOSSUS INSCRIPTIONS

These are my rough provisional transliterations of the inscriptions on the three fragmentary bull colossi on the throne-room façade. For illustrations of the originals, see pls. 202–7.

COURT H, BULL 1 (pls. 202, 203)

Bottom of col. i, under belly:

1′ [ša NA₄.GIŠ.NU₁₁.GAL] ⌈ša⌉ [i]-⌈na tar-ṣi⌉ [LUGAL.MEŠ . . . KUR am-ma-na]-⌈na⌉

2′ [ú-šap-tu-ni pa]-⌈ni⌉-šu ù NA₄.DÚR.MI.⌈NA.BÀN.DA⌉ [ma-la . . . URU kap-ri-da-ar]-⌈gi⌉-la-⌈a⌉

3′ [ú-kal-lim ra-ma]-⌈nu⌉-uš i-te-e NINA.KI.KI i-[na . . . in]-⌈u⌉-mir-ma

4′ [ᵈÁLAD].⌈ᵈLAMMA⌉.MEŠ NA₄.GIŠ.⌈NU₁₁⌉.GAL ša i-na 1-[en . . . ki]-⌈ma⌉ u₄-me

5′ [na-pir-de]-e nu-um-mu-ru zu-mur-šin KUN₄.MEŠ [NA₄.GIŠ.NU₁₁.GAL . . . ki]-⌈lal-la⌉-an

6′ [i]-⌈na⌉ šad-di-šu-un ab-tuq-ma a-na šip-ri É.GAL-⌈ia⌉ [ú-šal-di-da . . . ᵈÀLAD.ᵈLAMMA].MEŠ

7′ [GAL].MEŠ ù ꜠ÁB.ZA.ZA-a-ti NA₄ pi-i-li pe-⌈ṣe⌉-[e . . . i-na] ⌈er⌉-ṣe-et

8′ ⌈URU⌉ ba-la-ṭa-a-a ú⌉-šá-⌈a⌉⌉-lid-ma ú-šak-⌈li⌉-[la . . . ṭè-em] ⌈DINGIR-ma⌉

Top of col. ii, between hind legs:

1 [ša] ⌈giš⌉-mah-hi a-di a-la-mit-ta

2 [GIŠ meš-re-e] 12 UR.MAH.MEŠ né-'i-ru-ti

3 [a-di] 12 ᵈÀLAD.ᵈLAMMA.MEŠ MAH.MEŠ

4 [ša šuk]-lu-⌈lu⌉ nab-ni-⌈tu⌉ 22꜠ ÁB.⌈ZA⌉.[ZA-a-te]

5 [ša] ⌈ku⌉-uz-bu [ù ul-ṣu]

6 [hi-it]-⌈lu⌉-[pa] bal-[tu . . .]

Bottom of col. ii, between hind legs:

1′ áš-šú ⌈u₄⌉-me-⌈šam⌉-ma A.MEŠ ⌈di⌉-[lu-ú-ti . . . gu]-haṣ-ṣa-a-te ZABAR [. . .]

2′ ú-še-peš-ma ki-mu-ú ma-⌈ka⌉-[ti giš-mah]-⌈hi⌉ ù a-la-mit-⌈ta⌉ URUDU ṣi-ir [PÚ].MEŠ ⌈uš⌉-[ziz]

3′ É.GAL.MEŠ šá-ti-na ú-[šá-lik] ⌈aṣ⌉-mì-iš si-hi-ir-ti [x?] ana? [x]-e

COURT H, BULL 3 (pls. 204, 205, 206)

Bottom of col. i, between hind legs

1′ ⌈la⌉ iz-zi-⌈ba⌉ [. . .]

2′ LÚ KÚR ag-[ṣi . . .]

3′ ù ᵐlu-⌈li⌉-[i . . .]

4′ ša qé-reb tam-tim [. . .]

5′ i-na ra-šub-⌈bat⌉ [. . .]

6′ LUGAL-ti-šú ú-še-[. . .]

7′ rap-šu na-gu-⌈ú⌉ [. . .]

8′ ú-šak-niš še-⌈pu⌉-[ú-a . . .]

9′ ⌈mar⌉-ṣi i+na GIŠ.TUKUL ú-[šam-kit . . .]

10′ ú-ab-bit UN.MEŠ KUR ⌈hi-lak⌉-[ki . . .]

11′ ⌈URU⌉ tíl-ga-rim-me ša pa-a-[ṭi . . .]

12′ [KUR] kal-di ša ti-ib ta-⌈ha⌉-[zi-ia . . . DINGIR].MEŠ nap-har [KUR-šu]-⌈un⌉

13′ ⌈i⌉-na šub-ti-šu-un ⌈id⌉-[ku-ú tam-tim i-bi]-⌈ru⌉-ma i-na URU ⌈na⌉-gi-a-ti

14′ ⌈id⌉-du-ú šu-bat-sún i-⌈na⌉ [GIŠ.MÁ.MEŠ KUR] ha-at-ti EGIR-šú-un e-bir

15′ ⌈URU⌉ na-gi-a-tu URU ⌈na⌉-[gi-a]-⌈tu⌉-di-i'-bi-na KUR hi-il-mu KUR bil-la-tu

16′ ⌈ù⌉ KUR hu-pa-pa-nu na-⌈gi⌉-e ša e-bir-tan ÍD mar-ra-ti ak-šud-ud-ma

17′ te-ne-šit KUR kal-di a-di DINGIR.MEŠ-ni-šú-nu UN.MEŠ LUGAL KUR ELAM.MA.⌈KI⌉

18′ ⌈áš⌉-lu-lam-ma la iz-zi-ba mul-tah-ṭu i-na u₄-me-šu-ma

19′ te-ne-šit na-ki-ri ki-šit-ti ŠU꜡꜡-ia ṭup-šik-ku

(Bull 2, right column)

4′ a-na tab-ra-a-ti kiš-šat UN.MEŠ ul-la-a ri-ši-šá É.⌈GAL⌉

5′ ša šá-ni-na la i-šu-ú ni-bit-sa az-kur i-na qí-⌈bit⌉

6′ ᵈaš+šur AD DINGIR.MEŠ ù ᵈiš-tar šar-ra-ti ᵈÀLAD dum-[qí]

7′ ᵈLAMMA du-un-qí qé-reb É.GAL šá-a-tu da-a-riš [liš]

8′ tab-ru-ú a-a ip-par-ku-ú i-da-a-šá

Bottom of col. ii, under belly

(a detached fragment of this bull inscription found sitting on
H, 3 joins to the left end of this panel and gives the begin-
nings of lines 9′ to 14′):

1′ [. . . ᵈ] ÀLAD ᵈ⌈LAMMA⌉.[MEŠ . . .]

2′ [. . . zu]-⌈mur⌉ (copy bar)-ši-⌈in⌉ [. . .]

3′ [. . .] ⌈x⌉ [. . .]

4′ [. . .] ⌈ina² er⌉-ṣe-⌈et⌉ [. . .]

5′ [. . . a]-⌈la⌉-mit-⌈ta⌉ [. . .]

6′ [. . .] ša ku-⌈uz⌉-[bu]

7′ [. . .] ⌈e⌉-ra-a ⌈qé-reb²⌉-[šú]

8′ [. . . lìb]-⌈bi⌉ [za-ha]-lu-ú ⌈lit-bu⌉-[šú]

9′ [ᵈÀLAD.ᵈLAMMA].⌈MEŠ⌉ NA₄.⌈GIŠ.NU₁₁⌉.[GAL . . .]
⌈ᶠÁB⌉.ZA.ZA-⌈a⌉-ti NA₄ pi-i-li ⌈pe⌉-ṣe-e

10′ [ša É.GAL.MEŠ]-⌈ia⌉ ú-šá-aṣ-[bi-ta . . .] ⌈MAH.MEŠ⌉ a-
di GIŠ dim-me GIŠ eri₄-ni GAL.MEŠ bi-ib-lat KUR ha-
ma-nim me-sir URUDU

11′ [ú-rak-kis]-⌈ma⌉ ṣi-ir úg-⌈gal⌉-[le-e . . . KÁ].⌈MEŠ⌉-šin e-
mid ᶠÁB.ZA.ZA-a-aʾ-ti NA₄.GIŠ.NU₁₁.GAL a-di
ᶠ<ÁB>.ZA.ZA-a-ti

12′ [pi-ti]-⌈iq⌉ ú-ru-de-e [. . . ᶠ]ÁB.ZA.ZA-a-ti pi-ti-iq
GU.AN.NA ša nu-um-mu-ru gat-tá-ši-in

13′ [. . .] GIŠ.KAL GIŠ.ŠUR.⌈MÌN⌉ [. . .] ⌈ŠEM⌉.LI ù GIŠ si-
in-da-a ih-zi-it pa-šal-li

14′ ⌈ù kas-pi⌉ ṣi-ru-⌈uš⌉-[šin . . . be]-lu-ti-ia e-mid
GIŠ.GAN.DU₇.MEŠ-šu-un

15′ ⌈KUN₄⌉.[MEŠ NA₄.DÚR.MI.NA].BANDA₅-a [. . .]
⌈KUN₄⌉.MEŠ NA₄ pi-i-li GAL.MEŠ a-sur-ru-ši-in

16′ [. . . aš]-⌈šu u₄-me⌉-šam-ma A.MEŠ di-lu-ú-ti

17′ [. . .] ⌈ZABAR⌉ ú-še-peš-ma ki-mu-ú ma-ka-a-ti

18′ [. . . uš]-ziz É.GAL.MEŠ šá-ti-na ú-šá-a-lik as-mì-iš

19′ si-hir-ti [. . . kiš]-⌈šat⌉ UN.MEŠ ul-la-a ri-ši-šá É.GAL ša
šá-ni-na

20′ la i-⌈šu⌉-ú ni-bit-sa az-kur ⌈i-na⌉ [qí]-bit ᵈaš+šur AD DIN-
GIR.MEŠ ù ᵈiš-tar šar-ra-ti ᵈÀLAD dum-qí

21′ ᵈLAMMA dum-qí qé-reb É.GAL šá-a-⌈tu⌉ da-⌈a⌉-riš liš-
tab-ru-ú a-a ip-par-ku-ú i-da-a-šá

Court H, Bull 12 (pl. 207)

Top of col. ii, under belly:

matches perfectly with Meissner and Rost 1893: 8, lines 1–15

1 [. . . ina 1] KÙŠ ÚS

2 [. . . i-ba-ʾu]-ú-ma

3 [. . . be-lu-ti]-šu-un

4 [. . . qa]-⌈bal⌉-ti URU

5 [. . . šap-la]-nu GI.MEŠ

6 [. . . ina 1] KÙŠ DAGAL

7 [. . .] ⌈mah⌉-re-e

8 [. . .] ⌈ù⌉ 4-me 40

9 [. . . NA₄.AN.ZA].GUL.ME

10 [. . . GIŠ si]-⌈in⌉-da-a

11 [. . . ú]-še-peš

12 [. . . ú-rak]-kis-ma

13 [. . . ZÚ].AM.SI

14 [. . . ú-šal]-me

15 [. . . É.GAL]-⌈ia⌉

BIBLIOGRAPHY

ALBENDA, PAULINE

1986 *The Palace of Sargon, King of Assyria: Monumental Wall Reliefs at Dur-Sharrukin, from Original Drawings Made at the Time of Their Discovery in 1843–1844 by Botta and Flandin.* Éditions Recherche sur les Civilizations. Synthèse, 22. Paris.

ALBERGE, DALYA

1997 "British dealers sell ancient treasures looted from Iraq." *The Times*, 2 January 1997, p. 7.

ANON.

1995 "Baghdad International Appeal." *Sumer* 47: 6–18.

1996a "From Nineveh, Iraq: stolen and sold?" *The Art Newspaper*, no. 62, Sept. 1996, p. 30.

1996b "Iraqi Archaeological Site Looted." *Art in America* 84, no. 11, November 1996, p. 29.

1997 "Stolen Iraqi Antiquities." *AIA Newsletter* 12, no. 2, Winter 1997, p. 3.

AL-ASIL, NAJI

1954 "The Assyrian Palace at Nebi Unis." *Sumer* 10: 110–11, figs. 1, 4, 5, pp. 193–4.

BARNETT, RICHARD D.

1976 *Sculptures from the North Palace of Ashurbanipal at Nineveh.* London: British Museum Publications.

BOTTA, PAUL E., and EUGÈNE N. FLANDIN

1849–50 *Monument de Ninive.* 5 vols. Paris: Imprimerie Nationale.

CAD

1956– *The Assyrian Dictionary of the Oriental Institute of the University of Chicago.* Chicago: Oriental Institute.

CIVIL, MIGUEL

1989 "The Statue of Šulgi-ki-ur$_5$-sag$_9$-kalam-ma. Part One: The Inscription." In *DUMU-E$_2$-DUB-BA-A: Studies in Honor of Åke W. Sjöberg* (Occasional Publications of the Samuel Noah Kramer Fund, 11), ed. Hermann Behrens et al, pp. 49–64. Philadelphia: Babylonian Section, The University Museum.

CROSSETTE, BARBARA

1996a "Iraqis, Hurt by Sanctions, Sell Priceless Antiquities." *New York Times*, 23 June 1996, sec.1, pp. 1, 8.

1996b "Ancient, Priceless and Gone with the War," *New York Times*, 8 Dec. 1996, sec.4, pp. 1, 5.

CURTIS, JOHN E., JULIAN E. READE, et al

1995 *Art and Empire: Treasures from Assyria in the British Museum*, London: British Museum Press.

D'ANDREA, MARY MAGNAN

1981 "Letters of Leonard William King: 1902–1904; Introduced, Edited and Annotated with Special Reference to the Excavations of Nineveh." M.A. thesis, Department of History, University of Wisconsin, River Falls.

DANISZEWSKI, JOHN

1996 "Antiquities Theft in Iraq Threatens Legacy to World." *Los Angeles Times*, 30 December 1996, sec. A, pp. 1, 12.

FRAHM, ECKART

1994 "Die Bilder in Sanherib's Thronsaal." *N. A. B. U.*, 1994, no. 3, pp. 48–50.

GADD, CYRIL J.

1936 *The Stones of Assyria.* London: Chatto & Windus.

1938 "A Visiting Artist at Nineveh in 1850." *Iraq* 5: 118–22.

GALLAGHER, WILLIAM

1997 "Room I, Slabs 14–18 of Sennacherib's Palace: Not a Depiction of Tyre." *N. A. B. U.*, 1997, no. 2, pp. 52–3.

HARRINGTON, SPENCER

1996 "Assyrian Wall-Reliefs for Sale." *Archaeology* 49, no. 6, November/December 1996, p. 20.

1997 "More Nineveh Fragments for Sale." *Archaeology* 50, no. 2, March/April 1997, p. 16.

KING, LEONARD WILLIAM

1902 Manuscript, Report to the British Museum Trustees, "Report of a Journey to the Various Sites of Excavations in Assyria and Babylonia during the Autumn of 1901," 30 Jan. 1902, report no. 355, received 4 Feb. 1902. London, British Museum, Central Archives, Excavation Papers, "Excavations at Nineveh. Kouyunjik. 1902–5 (King)" (reprinted in D'Andrea 1981: 80–89).

1903a Manuscript, Report to the British Museum Trustees, "Report on the progress of the excavations at Kouyunjik up to the date, and on the probable cost of work suggested for the future," 12 May 1903, stamped #1748. London, British Museum, Central Archives, Excavation Papers, "Excavations at Nineveh. Kouyunjik. 1902–5 (King)" (reprinted in D'Andrea 1981: 97–101).

1903b Manuscript, Correspondence from L. W. King to E. M. Thompson. London, British Museum, Central Archives, Excavation Papers, "Excavations at Nineveh. Kouyunjik. 1902–5 (King)" (reprinted in D'Andrea 1981).

1903c Manuscript, Correspondence from L. W. King to E.
 A. Wallis Budge. London, British Museum,
 Department of Western Asiatic Antiquities,
 Departmental Archives, "Correspondence, 1903."
 (reprinted in D'Andrea 1981).

1903d Manuscript, "Draft Letters. Rough Notes. Nov.
 1902–June 1903." London, British Museum,
 Department of Western Asiatic Antiquities,
 Departmental Archives, box labeled "LW King.
 Diaries, Notes, Accounts, Etc."

1903e Manuscript, "Draft Letters. Oct. 1903–June 1906."
 London, British Museum, Department
 of Western Asiatic Antiquities, Departmental
 Archives, box labeled "LW King. Diaries, Notes,
 Accounts, Etc."

1904 Manuscript, Report to the British Museum Trustees,
 "Report on the progress of the Excavations at
 Kuyunjik from May 12th, 1903 to June 21st, 1904,"
 dated 2 August 1904, no accession number. London,
 British Museum, Central Archives, Excavation
 Papers, "Excavations at Nineveh. Kouyunjik. 1902–5
 (King)" (reprinted in D'Andrea 1981: 109–14).

KLEIN, THOMAS G.

1992 "The Letters of Reginald Campbell Thompson,
 from the 1904–05 Excavation of Nineveh
 Introduced, Edited and Annotated." M.A. thesis,
 Department of History, University of Wisconsin,
 River Falls.

LARSEN, MOGENS TROLLE

1996 *The Conquest of Assyria: Excavations in an Antique
 Land, 1840–1860.* London: Routledge.

LAYARD, AUSTEN HENRY

1845–47 Ms. A. London, British Museum, Department
 of Western Asiatic Antiquities, Departmental
 Archives.

1849a *Nineveh and Its Remains.* 2 vols. London: John
 Murray.

1849b *Monuments of Nineveh from Drawings Made on the
 Spot.* London: John Murray.

1851 *Inscriptions in the Cuneiform Character from Assyrian
 Monuments, Discovered by A. H. Layard.* London:
 British Museum.

1853a *Discoveries in the Ruins of Nineveh and Babylon.*
 London: John Murray.

1853b *A Second Series of the Monuments of Nineveh.*
 London: John Murray.

LOUD, GORDON, HENRI FRANKFORT and THORKILD JACOBSEN

1936 *Khorsabad: Part I: Excavations in the Palace and at a
 City Gate.* Oriental Institute Publications, 38.
 Chicago: The University of Chicago Press.

LUCKENBILL, DANIEL D.

1924 *The Annals of Sennacherib.* Oriental Institute
 Publications, 2. Chicago: The University of Chicago
 Press.

MADHLOOM, TARIQ

1967 "Excavations at Nineveh, 1965–67." *Sumer* 23: 76–9.

1968 "Nineveh: The 1967–68 Campaign." *Sumer* 24:
 45–51.

1969 "Nineveh: The 1968–69 Campaign." *Sumer* 25:
 43–58.

1976 *Nineveh.* Historical Monuments in Iraq, 4. Baghdad:
 Directorate General of Antiquities.

MEISSNER, BRUNO and PAUL ROST

1893 *Die Bauinschriften Sanheribs.* Leipzig: Eduard
 Pfeiffer.

MEUSZYNSKI, JANUSZ

1981 *Die Rekonstruktion der Reliefdarstellungen und
 ihrer Anordnung in Nordwestpalast von Kalhu
 (Nimrud).* Baghdader Forschungen, 2. Mainz am
 Rhein: Verlag Philipp von Zabern.

PALEY, SAMUEL M.

1997 "Nimrud and Nineveh Again: Documented Bas-
 Reliefs from Iraq Offered in the West." *IFARreports*
 18, no. 6, June 1997, pp. 4–6.

RAWLINSON, HENRY C.

1870 *The Cuneiform Inscriptions of Western Asia, III: A
 Selection from the Miscellaneous Inscriptions of
 Assyria.* London: British Museum.

RUSSELL, JOHN M.

1985 "Sennacherib's 'Palace without Rival': A
 Programmatic Study of Texts and Images in a Late
 Assyrian Palace." Ph.D. diss., University of
 Pennsylvania, Philadelphia.

1991 *Sennacherib's "Palace without Rival"
 at Nineveh.* Chicago: University of Chicago Press.

1995 "Layard's Descriptions of Rooms in the Southwest
 Palace at Nineveh." *Iraq* 57: 71–85.

1996a "Loss of Wall Reliefs from Sennacherib's Palace at
 Nineveh, Iraq (704–681 BC)." *IFARreports* 17, no. 5,
 May 1996, pp. 6–7.

1996b "More Sculptures from Nineveh on the Market."
 IFARreports 17, no. 12, December 1996, pp. 9–11.

1996c "Stolen Stones: The Modern Sack of Nineveh,"
 electronic article, *Archaeology* magazine,
 http://www.archaeology.org/online/.

1997a *From Nineveh to New York: The Strange Story of the
 Assyrian Reliefs in the Metropolitan Museum and the
 Hidden Masterpiece at Canford School.* New Haven
 and London: Yale University Press.

1997b "Looted Sculptures from Nineveh." *Minerva* 8, no.
 3, May 1997, pp. 16–26.

1998 *The Writing on the Wall: Studies in the Architectural
 Context of Late Assyrian Palace Inscriptions.* Winona
 Lake: Eisenbrauns.

SMITH, GEORGE

1875 *Assyrian Discoveries.* London: S. Low, Marston, Low,
 & Searle.

1878 *History of Sennacherib*. London: Williams and Norgate.

THOMPSON, REGINALD CAMPBELL and R. W. HUTCHINSON

1929a *A Century of Exploration at Nineveh*. London: Luzac & Co.

1929b "Excavations on the Temple of Nabu at Nineveh." *Archaeologia* 79: 103–48.

TURNER, GEOFFREY

1970 "The State Apartments of Late Assyrian Palaces." *Iraq* 32: 177–213.

WATSON, PETER

1997 "Nineveh 'Palace Without Rival' Looted. London is Among Several Cities Where Reliefs Have Been Offered." *IFARreports* 18, no. 5, May 1997, pp. 6–7.

WEIDNER, ERNST

1954–6 "Ninive." *Archiv für Orientforschung* 17: 424–5.

EL-WAILLY, F.

1965 "Foreword: Nineveh." *Sumer* 21: 4–6, and Arabic section, figs. 2–4.

1966 "Foreword: Nineveh." *Sumer* 22: b–c, and Arabic section, figs. 4–5.

WINTER, IRENE J.

1981 "Royal Rhetoric and the Development of Historical Narrative in Neo-Assyrian Reliefs." *Studies in Visual Communication* 7, no. 2: 2–38.

INDEX

References in the three chapters of the introductory text are included in this index, but those in the catalogue section are not